OFFICE DESIGN SOURCEBOOK

ROCKPORT

First published in the United States of America by
Rockport Publishers, Inc.
33 Commercial Street
Gloucester, Massachusetts 01930-5089
Telephone: (978) 282-9590
Fax: (978) 283-2742
www.rockpub.com

Library of Congress Cataloging-in-Publication data available

ISBN 1-56496-989-4

10 9 8 7 6 5 4 3 2 1

Grateful acknowledgment is given to Justin Henderson for his work from *Workplaces and Workspaces* on pages 10-11, 16-155, and 264-265; and to Vernon Mays for his work from *Offices and Workspaces* on pages 6-9, 14-15, and 158-263.

Design: Benchmark Productions; Leann Leftwich-Zafas
Cover Images: Paul Worchol, Lucy Chen, Marco Lorenzetti

Printed in China

OFFICE DESIGN SOURCEBOOK

Solutions for Dynamic Workspaces

GLOUCESTER MASSACHUSETTS

ROCKPORT PUBLISHERS

CONTENTS

EVOLUTION AND CHANGE

Today's technology and manufacturing allows endless possibilities for the design of a workplace. From custom millwork to prefabricated workstations, the design community and its client base can improve the quality of life for corporations and institutions around the globe.

In their book, *The Demise of the Office,* Erik Veldhoen and Bart Piepers alert us to the need for change. "We are perched on the brink of a revolution in our society," they write. "The electronic highway, the digital city, the mobile telephone, the portable computer, listening televisions, talking computers, electronic mail, and teleworking are symptoms of a new era, a real one, and one that is very eminent."

At a recent group discussion, Duncan Sutherland, Jr., an office strategist for a major furniture manufacturer and adjunct professor in the School of Business and Public Management at George Washington University, suggested that "offices are not information factories, they are extensions of the mind."

Work process, new communication techniques, and office space are crucial for the functioning of any organization. An integrated approach is a necessity. Information technology, organizational development, and facility are now inseparable from one another and are all integral to the success of the user.

This form of work is new to designers. The linkage of offices and work spaces with the social and political objectives of the sponsor's business plan requires a new and expanded definition of design—a definition not limited to form and function, but inclusive of aspiration for moral productivity, brand identification, management systems, and financial objectives.

The profession of interior design as we know it today was borne out of a merger of aesthetics, rational planning, and technology. The profession's relative youth is aptly chronicled by Cindy Coleman, executive editor of *Perspective* magazine, in her essay "Reflections of an Industry: The Role of the Designer Over History." Coleman notes how the modern architecture of the post-World War II era required a new and innovative approach to the design of interior corporate environments. A key element in initiating this new direction was the establishment of Knoll Associates in 1946 by Florence and Hans Knoll to design and manufacture furniture in the Bauhaus style. Florence Knoll, who trained in architecture under Eliel Saarinen and Mies van der Rohe, founded the Knoll planning unit, a design studio that provided

furniture customers with interior architectural and planning services. Explains Coleman, "The unit became a laboratory for interior spaces, experimenting with the design, scale, and configuration of task-related furniture."

"Prior to this period, contract interiors—the planning and design of office environments—did not exist as a profession," she continues. "If a doctor, businessperson, or corporation wanted to arrange office space, they usually were referred to a furniture store, which would provide them with desks, chairs, and credenzas. As manufacturer representatives for the furnishing industry, furniture stores were responsible for sales, delivery, installation, and service to the customer base. As such, the selection of office furniture was primarily their domain. For most clients, hiring a professional designer was considered elitist."

In the early 1950s, the New York office of Skidmore, Owings & Merrill (SOM) became one of the first large architecture/engineering firms to offer interior design among its menu of professional services. SOM eventually established itself as the world leader in contract interiors, providing design services for major corporations including Pepsi Cola, Chase Manhattan, and Union Carbide.

"While the '50s saw the introduction of interior design services into existing architectural firms,"

Coleman notes, "the '60s bore witness to the maturation and transformation of these interiors studios into independent design firms offering a variety of services." The tradition of workplace design can be defined by five periods of modern history since the industrial revolution. Each period links social trends, dominant construction systems, and internal building systems with the design of offices and work spaces.

In the period before 1900, as American cities began to form and grow, the early technology of bearing wall construction and the inherent limits it placed on the creation of large continuous spaces gradually gave way to skeletal frame construction. This offered a new freedom that, along with the advent of elevators, allowed designers to move from individual office suites—inextricably tied to the structural limits of bearing walls—toward office spaces defined by an organization's size.

From 1900 to 1950, enormous economic growth brought forward the introduction of reinforced concrete. This structural development provided greater spans of leasable space. Expansive areas, along with the introduction of modular ceiling grid systems, created floor plates that could be utilized by larger organizational units. It was an era marked by building technology, which paved the way for the post-World War II building boom.

The period from 1950 to 1970 witnessed the growth of American corporate culture. The delineation of space by building modules gave birth to the organizational allocation of space by hierarchical standards. Organizations began differentiating job titles of staff and employees by the square footage of real estate assigned to them. This era was indelibly marked by the use of real estate as a noncompensation-based form of recognition. This period was also marked by the universal appeal of open planning—allowing large groups of individuals to be zoned together by function or organizational identity.

The years 1970 to 1990 were dominated by the explosion of information technology. Companies acquired the ability to pass information and shift capital investment rapidly from the building itself to desktop equipment, which in turn supported worker effectiveness. This era also was defined by the rising influence of the real estate developer in the form of the speculative office building. Before then, office building construction was dominated by corporations or institutions who were building for their own use. As speculative development increased, the built landscape became punctuated with stylistic, often arbitrary, and individualistic buildings.

The reliance on information technology provided the rationale for building interiors to be dominated by image and message rather than conservative planning. The ability of workers to communicate electronically freed them to inhabit alternative office settings. The workforce began to choose where and when the work was accomplished—either at home, in the car, on an airplane, or in a hotel room. Office design changed as a result, taking into account issues that went beyond the concern of mere efficiency toward examining issues of an organization's mission and identity. Sponsors looked to communicate the corporate culture of the occupants through the design of the workplace.

Buildings became intelligent through their management of voice and data. The capacity of electronically controlled security gave designers the freedom to explore new boundaries of functional relationships. The furniture industry, for example, responded by providing intelligent panel-based systems furniture that was modular, electrified, and movable. No longer were designers limited to defined groupings of people, but realized for the first time their ability to restructure such groupings on demand.

Moving from 1990 to the present, user control and employee empowerment have been supported by wireless technology. Adjustable seating and work surface ergonomics coupled with individual lighting and thermal environment control support the mobility of the worker to either collaborate or work independently in settings designed for specific tasks.

In her book *Citizen Office*, author Uta Brandes states, "New information and communication technologies throw fundamentally new light on our attitude towards the workplace." Brandes points out that, until recently, office organization had been based on old management concepts put forth by theorist Frederick Taylor. Taylor's "scientific management" model of the efficient factory—based on the notion that one worker equaled one unit of production—was later translated to the office. Hierarchy, order, and logistics of production and supervision became formalized within the office into a model of social organization based on virtues of order, which ultimately led to the dehumanization of the workplace.

Our current condition and the future of workplace effectiveness will allow us to abandon this rigid module. The new face of the interior design profession and the new design work depicted in Vernon Mays's *Office and Work Spaces* is the result of world-class design firms collaborating with some of the most prominent corporations, service firms, financial institutions, and telecommunication leaders. These projects benefit from the learning of cross-functional teams representing the disciplines of engineering, finance, human resources, the social sciences, and facility management. The result is a change in focus and priority.

The sponsor, or client, is no longer satisfied with identity. Today's goal is workplace effectiveness and performance along with an expression of corporate intent. The new criterion for design performance is the interactive relationship between the user and those who the user serves. Today, the hallmark of design achievement supports the union of social ambition with the technological aspiration of the user.

Neil Frankel, AIA, FIIDA

Prior to accepting the position of Fitzhugh Scott Distinguished Critic at the University of Wisconsin/ Milwaukee, School of Architecture and Urban Planning, Neil Frankel, AIA, FIIDA, was director of interior design for Skidmore, Owings & Merrill's Chicago architectural interiors practice. Internationally recognized through his numerous design awards, Neil Frankel's professional career has been characterized by a commitment to excellence in design and client services. Frankel was elected to the Interior Design Hall of Fame in 1994 and the International Interior Design Association's College of Fellows in 1997.

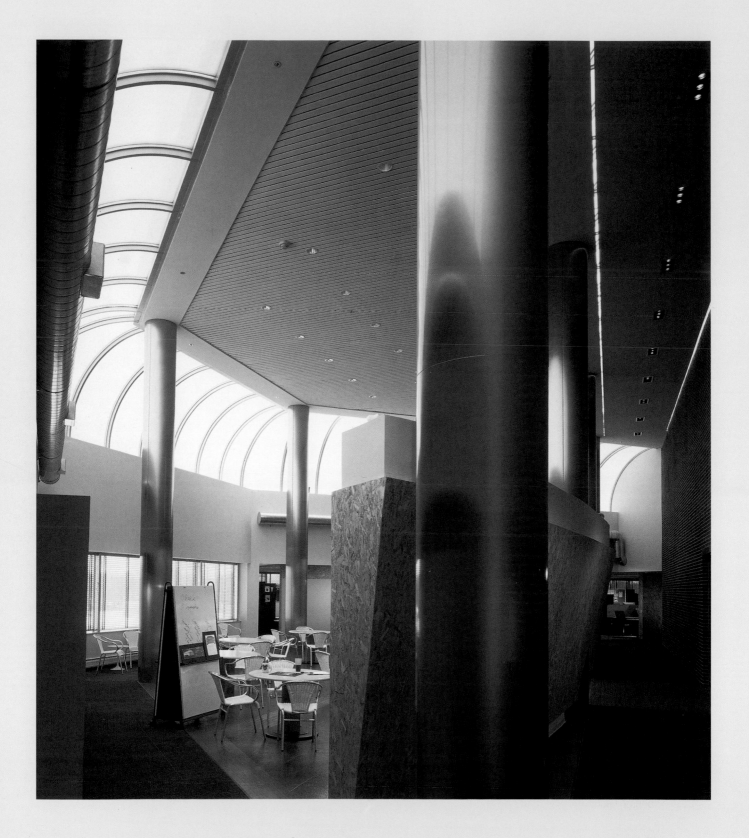

FOREWORD

SUSTAINING A CRITICAL ADVANTAGE THROUGH OFFICE SPACE DESIGN

Diane Hoskins

Design of the workplace today is a new kind of business, and today's designers bring new skills, methods, and teams to the creation of workplace environments. The profession of design continues to evolve as it becomes more about enabling business dynamics than about crafting office aesthetics. While there are many reasons that the design of the workplace has changed, there are two principal drivers that should be emphasized.

One critical driver of this change is the competitive business climate that clients now face. In this "hyper-competitive" environment, companies challenge existing strategies for creating and sustaining a critical advantage. Companies now must nimbly leverage their resources to achieve competitive positioning and then they must continue to change that position in response to market opportunities and competitor movement. It is clear that the workplace—as a management tool—has to provide maximum adaptability to leverage the optimum performance, even in a business environment in flux.

A second critical driver of this change, as business writer Peter Drucker emphasizes, is the dramatic shift in the type of work that people perform. We are quickly moving away from an industrial-based economy to a knowledge-based economy. Drucker notes "as recently as the 1960s, almost one-half of all workers in the industrialized nations were involved in making things. Already an estimated two-thirds of U.S. employees work in the service sector and 'knowledge' is becoming our most important 'product.'" Further, he states that such a transformation "calls for different kinds of organizations, as well as different kinds of workers." Certainly this calls for different kinds of work environments as well.

This combination of a more competitive business climate and the shift toward a knowledge-based economy creates a revolution in the requirements to which designers must respond. Because of these drivers, the design industry has moved away from typical static office design solutions to the creation of "strategic management environments." This shift requires new approaches and new solutions to workplace design, which in turn come out of an integrated strategy based on a multi disciplinary approach. The goal is to provide clients with viable, innovative solutions to support dynamic organizational performance.

Today, the appropriate workplace design strategy emerges from a process that focuses on critical business issues. Workplace design strategies, in order to be successful, must deliver economic value to business. Each assignment a design firm undertakes should begin with an exploration of the critical issues that drive change within that company. This exploration involves a diagnostic review of multiple kinds of information and an extensive evaluation of critical drivers in order to develop solutions and strategies that achieve business-specific results.

Because the business of design today is critically linked to business-specific outcomes and performance levels, companies look to designers to help them achieve business success. This new role creates unique opportunities for designers to bring a new and unprecedented level of innovation and collaboration to workplace design.

Diane Hoskins is Vice President, Managing Principal, Washington P.C. Office of Gensler. . . Architecture, Design & Planning Worldwide. She also serves as Chairman, Gensler Workplace Task Force.

INTRODUCTION

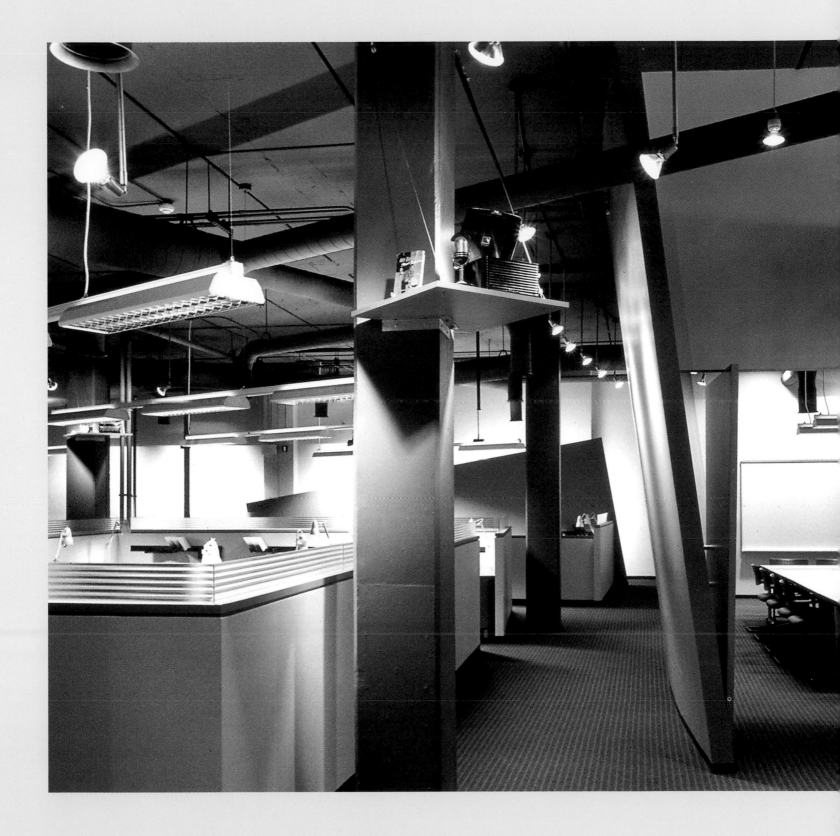

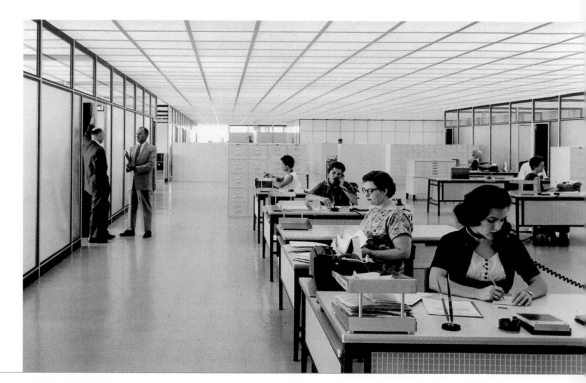

THEN AND NOW

Working on this book has forever changed the way I see—at least the way I see offices and work spaces. So it was with renewed vision that I recently took a personal tour of one of the modern era's prototypical suburban office buildings—the Reynolds Metals Headquarters in Richmond, Virginia. Designed in the mid-1950s by Gordon Bunshaft of Skidmore, Owings & Merrill, the aluminum company's elegant corporate offices have survived as a kind of time capsule—a tangible product of the corporate optimism that thrived in the post-World War II era. Its classically proportioned exterior, stately reflecting pool, and intelligent courtyard plan were all conceived to project an image of financial success, stability, and unparalleled accomplishment.

Aluminum, at the time, was a relative newcomer on the construction scene, having emerged as a versatile component of the war effort. Eager to demonstrate the material's potential applications, the company pressed Bunshaft to incorporate it wherever possible into the new building. He responded by using more than one million pounds (454,000 kilograms) of aluminum, mostly in the exterior cladding, but also in the custom furnishings, cellular ceiling panels, filing cabinets, and escalator enclosures. Even the carpets were woven with aluminum fibers. Having seen all

this first-hand, I was impressed by the logic and beauty of this icon of twentieth-century design and its masterfully executed interiors. But, at the same time, it struck me how the building constitutes the perfect foil against which the design of today's offices can be contrasted.

Stylistically the two are different, that's a given. But a more fundamental contrast, to my mind, is one of mentality. Although the Reynolds offices have long since been updated to accommodate new styles of working, documentary photographs of the original offices convey an attitude about business that today seems almost quaint. Bunshaft and his colleagues knew what an office was meant to be. They designed with that function in mind—and that function alone. That's how the 1950s were, of course: a male-dominated society in which the guys were executives and the gals were secretaries. It was orderly, controlled, predictable.

Would anyone dare say the same about business today? Technology advances at blinding speed. Yesterday's competitors are today's strategic partners. Wave after wave of corporate layoffs spell uncertainty, not security. How does one design for such realities? Culling through the sea of

photographs submitted for use in this book, I discovered many firms that address the question by designing not for constancy, but for change. Somehow they find ways to accommodate today's organizational makeup without building roadblocks to tomorrow's. It's a symptom of the times. Rooms become freestanding boxes that don't disturb the building shell; walls pose as partitions that can be cheaply dismantled and discarded; ceilings are nonexistent, save for the view of overhead mechanical and lighting systems afforded by their absence; and workstations adhere to the concept of flexibility so literally that some are even equipped with wheels.

For me, the separation between today's offices and those of Bunshaft's time is embodied by the accompanying photograph of Vitale, Caturano and Company, a New England accounting firm that occupies offices renovated by ADD Inc of Boston. There, work is about a process, not simply a set of bureaucratic restrictions. Just look at the computer programmers, jeans and all, working comfortably in their Netsurfer divans—recumbent work chairs that elevate ergonomics to new levels. Compared to the buttoned-down version of American business portrayed in the Reynolds photograph of the 1950s, this environment exudes an informality that speaks volumes about the heightened value of employees and their role in the workplace today.

With increasing frequency, businesses have forsaken "big and bureaucratic" in favor of "lean and mean." That can be attributed partly to a lack of knowledge about what the future will hold six years from now, even six months from now. And while some would argue that this uncertainty offers today's designers opportunity for innovation, I suspect, in their efforts to meet a client's program, the burden of responsibility is heavier for them than for pioneers such as Gordon Bunshaft. Which, with my renewed sense of vision, gives me greater appreciation for what many of the world's leading architecture and interior design firms are contributing to the field. Their accomplishments are the core of this book.

Vernon Mays

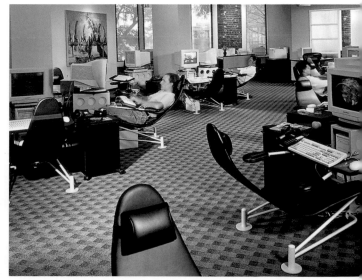

INTRODUCTION

REACHING FOR DAYLIGHT

Justin Henderson

In the civilized world, every day millions go to work in offices located in large urban towers and low-rise suburban office parks, in renovated warehouses and remodeled factories, in buildings that squat shapelessly on the landscape, or soar on the ramparts of inspired architecture. The white-collar workers of the world have done so for decades, and will continue to do so for decades to come. And yet, as we approach the millennium, the rituals and rules that govern the workplace are in a state of flux (at least in those parts of the world where the structures of the emerging knowledge-based global economy—the so-called Information Age—are in place). Though much remains the same, there is major change afoot. This book represents an effort to give an overview of this changing scene's design elements—to see where it's come from, and more importantly, where its going.

Considering how much time people spend in offices, it is surprising how few of them are well designed: Offices aesthetically satisfying and pleasant to work in, yet flexible enough to succeed in what master designer Diane Hoskins describes in the foreword as today's "hyper competitive" business environment. We're decades into the modern workplace era; at this point most of the fundamentals necessary to a successful office design are understood. And so, one asks, why are so few offices designed thoughtfully? Seemingly there is no shortage of reasons, or excuses, when it comes to the crime of bad design—ignorance, laziness, lack of funds or imagination, indifference to the needs of workers—you name it. Couple those basic human traits with more recent business trends like downsizing, globalization, and rapid-fire technological innovation—the ongoing shift to a knowledge-based economy—and you've got a recipe for disarray. A walk through just about any office reveals the usual suspects: poor space planning, bad lighting, haphazard furnishing, unpleasant colors, etc. All this adds up to an atmosphere that charitably can be described as oppressive. (Of course, any situation that dire can also be viewed as a great opportunity for change.)

In recent years vast numbers of people have educated themselves on the subject of home design, thanks to the myriad shelter magazines in the marketplace. At the same time, though many of those same magazines also feature office designs in every issue, it is a subject that remains unexamined outside the design industry and underexplored within it. Perhaps because, for the most part, the design of offices is beyond the control of the people who use them, there has been a shortage of information and interest in the subject. That need not be the case any longer. For those employers willing to spend the money—and it need not be vast amounts—to make their offices into worker-friendly environments, there are numerous qualified designers, and well-made spaces to learn from. And beyond the positive morale (and increased productivity) generated by employee-considerate design, global business trends have made it critical that designers plan for flexibility and adaptability, while attending to those issues critical to a successful business strategy for specific client companies. And so this book an attempt to bring to your attention a cross section of the successful design strategies employed by the best workplace designers in the world and their forward-thinking clientele.

As you peruse the projects herein, inevitably you will sense a certain sameness; after all, reception areas, workstations, conference rooms, light fixtures, seating, and many of the other elements are givens, fundamental pieces in the architectural and interior design puzzle that makes up an office. But, above and beyond these required elements, the work shown here makes it clear that imaginative, iconoclastic designers are shredding the playbook, tearing down the walls, (bending and even breaking) the rules by which offices traditionally have been designed. And those playing by the same old rules do so with increasing sophistication and grace.

Before considering some of the trends that have shaped the workplace designs in this book, a brief explanation of the book's organization might be useful. Given the nature of office design, a certain arbitrariness was inevitable. The book features four sections, the first covering corporate offices; the second, high tech and biotech companies; the third, law offices and financial institutions; and the fourth, media companies. The corporate offices of an advertising agency like McCann-Erickson in San Francisco, intent on re-inventing itself for a new generation, share certain design qualities with those of a hip high-tech software company like the Silicon Studio; nevertheless, there are logical ways to group office designs. Though some readers may perceive overlap, we had to draw divisions somewhere. Readers also might want to think about the differences in design approach employed by those trained as architects as opposed to interior designers. This dichotomy, blurred to gray at times and in sharp black and white at other times, is a fascinating aspect of the design scene, and adds another angle to the discussion.

Exploring this particular facet of the world of design, one cannot help but note how designers and architects reveal and interpret their influences within the rather strict programmatic parameters of office planning. At Chiron Corporation's Finance Department, BraytonHughes designers dragged the ragged edges of the city surrounding the building directly into the design. At Jeppesen in Colorado, Gensler designers created a building expansion as a metaphor for an expanding company, and employed the curve of an adjacent boulevard as a shaping tool. NBBJ's design for Burger King's headquarters sports the colors of hamburger condiments— lettuce, tomato, ketchup, and mustard—in a palette bright enough to evoke its tropical Florida locale as well. Just down the road in Miami, TAS Design's work for Sony Music International employs a cool, airy architectural style that simultaneously celebrates the light of Florida, the Art Deco magic of South Beach, and the whimsical Miami style originated by Morris Lapidus. Start-up software companies are housed in offices with randomness and spontaneity designed in, signaled by such elements as exposed structure, unpredictable floor plans, street-gritty materials, and pop art palettes.

One of the most significant trends of the 1990s is the flattening of heirarchies, a move intended to democratize corporate cultures across the land. And this trend can be linked to other significant changes, like improvements in lighting. The development of new lighting technology has been driven in part by the need for saving power, and in part by the ubiquitous presence of computer screens requiring non glare, non reflective illumination best supplied by custom-designed ceiling fixtures with special lenses—coupled with a good dose of daylight. To enable that daylight to reach the office core, it becomes necessary to keep window walls free and open, downsizing or even eliminating what was formerly the most desirable real estate in almost every office—the private window wall and the corner office. Turning this prime real estate into open-plan or shared space is one of the most compelling moves towards a non-hierarchical office that can be made—and with it comes practical, light-generating side effects. So it goes with good design that works on multiple levels.

Many of those much-discussed, tech-driven changes in workstyle—such as telecommuting—are still, for the most part, science fiction. There are a few groundbreaking companies moving that way, and no doubt many others will follow. Some employees do indeed work at home, work odd hours, and share workspace with other employees on different schedules. A few of those companies are represented in this book, with their flexible new approaches to office planning, and their freshly-minted language, where the noun "office" morphs into the verb "officing," a new word for the new world of work.

The teams that designed the overseas projects included in this book employ the best of the American designers, who, it can be said, have set the design standard. In most cases these offices tastefully borrow from the cultures of their locations, employing a French-style open plan in a Paris software office, for example. In ten years, globalization will make it more likely that what you see here could be in Sao Paulo as easily as San Francisco, in Moscow—maybe—as easily as Minneapolis.

Designs make corporate images. They inspire workers. They impress potential clients and visitors. They make businesses work better. They help shape corporate culture, and influence all who come in contact with them. The design of offices is integral to the culture we live in. The work shown in this book, a survey of some of the best offices of this decade, should inspire by example, helping shape a bright new millennium where working in an office might prove to be an experience that is rewarding aesthetically as well as financially.

CORPORATE AND INSTITUTIONAL OFFICES

Corporate and institutional office designers often struggle to reconcile a number of conflicting demands: budgetary limits, employee hierarchies and relationships, technological innovation (especially relating to computerization), and the need to create interiors that in some way enhance, establish, or promote the corporate image while functioning at optimal levels. All this takes place against a backdrop of "downsizing," globalization, and the growing use of part-time, temporary, and/or telecommuting workers.

Every office designer starts with the basics—the fundamental problems to be solved: programming, space planning, specification of fixtures, furnishings, and finishes, lighting, and ergonomics. Some designers work with restored or renovated spaces originally intended for drastically different enterprises; others work with floors empty of everything, including character, and must build a corporate identity literally and figuratively from the ground up. No hard and fast rules apply, because every space and every scale are different, and every corporation has a different set of needs when it approaches a design firm for help in space planning, corporate

identity-making, and the other considerations that come into play when offices are designed. A cutting-edge ad agency like Fallon McElligott and an international corporation like Burger King obviously have different perspectives on the world; the designs of their headquarters interiors to some degree reflect this difference. Yet many of the issues they contend with are the same.

Among the issues getting the most attention as we approach the end of the decade are the flattening of employee hierarchies, reflected in the movement of open-plan areas to more desirable perimeter locations and the use of fewer, smaller, and less formal private offices; and flexibility, reflected in workstation design, for example, which allows for expansion or movement of desks, storage, and other elements within workstations and is also reflected in the

deployment of offices and workspaces that are not assigned to a given person on a permanent basis. Another increasingly important element is communication, which has been improved by lowering the walls that separate workstations to abet visual as well as vocal contact, eliminating or downsizing private offices, creating informal gathering places, and even putting "back of house" spaces such as copy and coffee rooms into more heavily trafficked areas to gather people.

All these elements are related and, in the end, must be integrated. In the most successful office designs, that integration—and the resulting manifestation of corporate identity—has an air of inevitability. Like a good marriage, the well-designed office and the employees that occupy it seemingly are made for each other.

◈
**Lowe and Partners/SMS,
New York City**

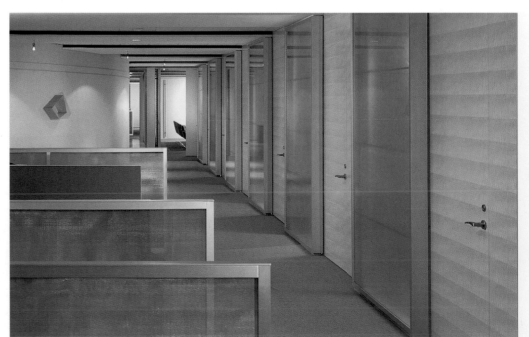

◈ **Amerin Guaranty Corporation, Chicago**

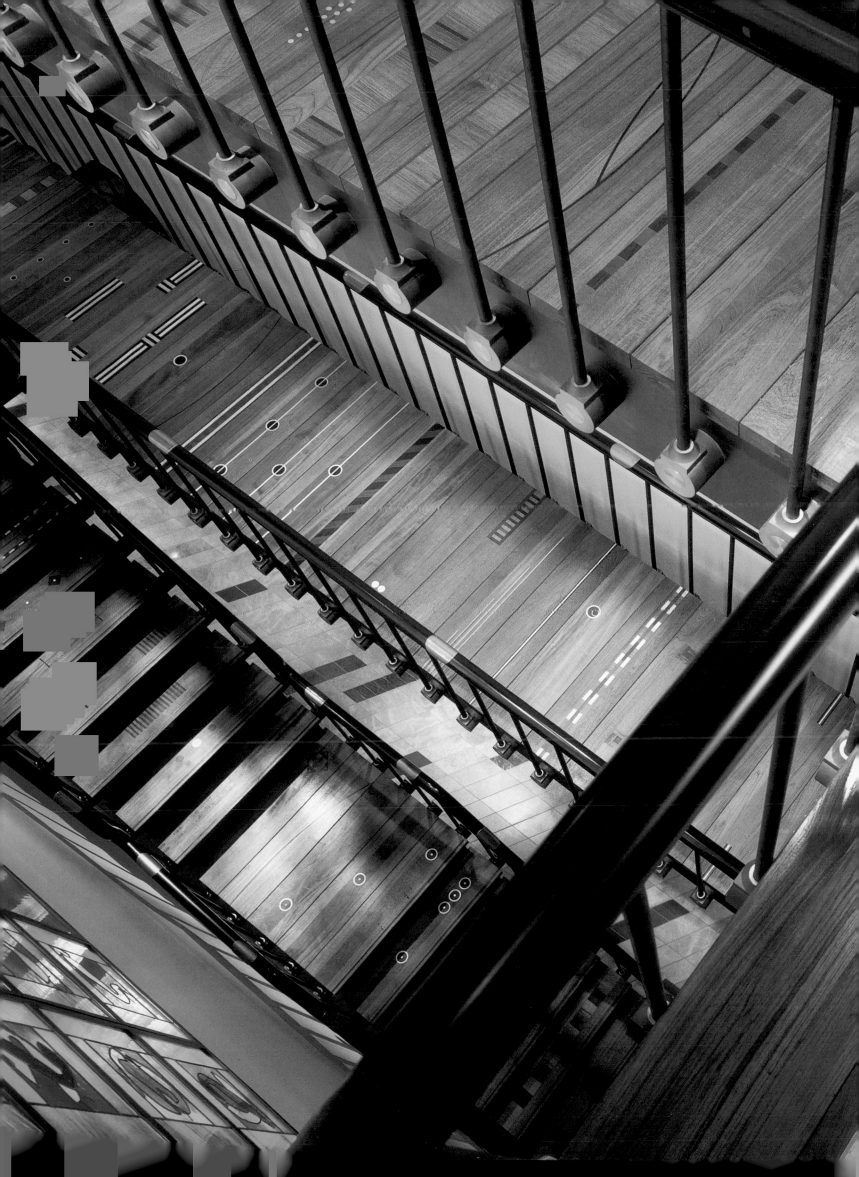

Inspiration for the administrative offices of the downtown branch of New York's Guggenheim Museum comes directly from the existing building that houses the museum and its location. The location is SoHo, famous for cast-iron buildings and famous as well for the artists who repopulated the district and thus saved it from the wrecking ball back in the 1960s and 1970s. The Guggenheim downtown offices occupy a highly visible spot on several floors of a classic SoHo building at the corner of Prince Street and Broadway.

SOLOMON R. GUGGENHEIM MUSEUM DOWNTOWN
New York, New York

Design by TAS Design, New York

Like most SoHo buildings, the museum's landmark home is a structure with large floor plates and oversized windows. The design team from TAS sought to retain these classic SoHo elements while accommodating the needs of a contemporary museum office located in the same building as the museum itself.

Contained within overscale windows and punctuated rhythmically by rows of original cast-iron columns, the 200-foot- (60-meter-) long floor

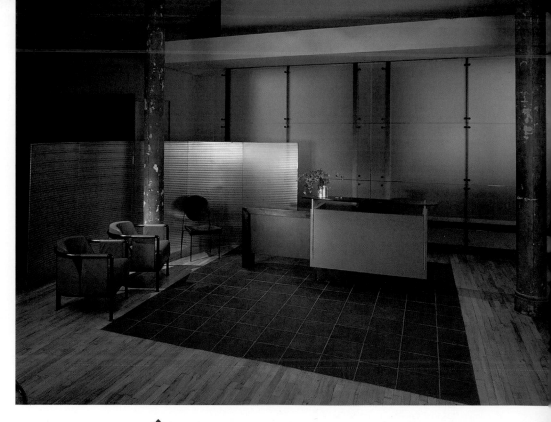

In the reception area, a custom-designed reception desk, inset stone flooring, and translucent glass partitions counterpoint the tough beauty of original cast-iron columns and maple flooring.

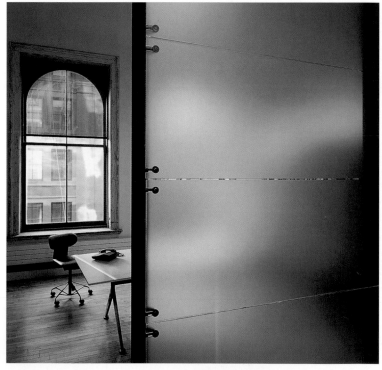

Glass partitions provide privacy for a private office without cutting off daylight into the interior. In a classic counterpoint of old and new, of industry and art, new sashes are framed by original window embrasures.

Framed by a pair of original columns, the reception area is furnished with a custom-designed desk crafted of lacquer-finished medium-density fiberboard and stained maple plywood.

Workstations feature custom-designed display platforms where curators can place objects relating to current shows or merchandise for sale in the museum store.

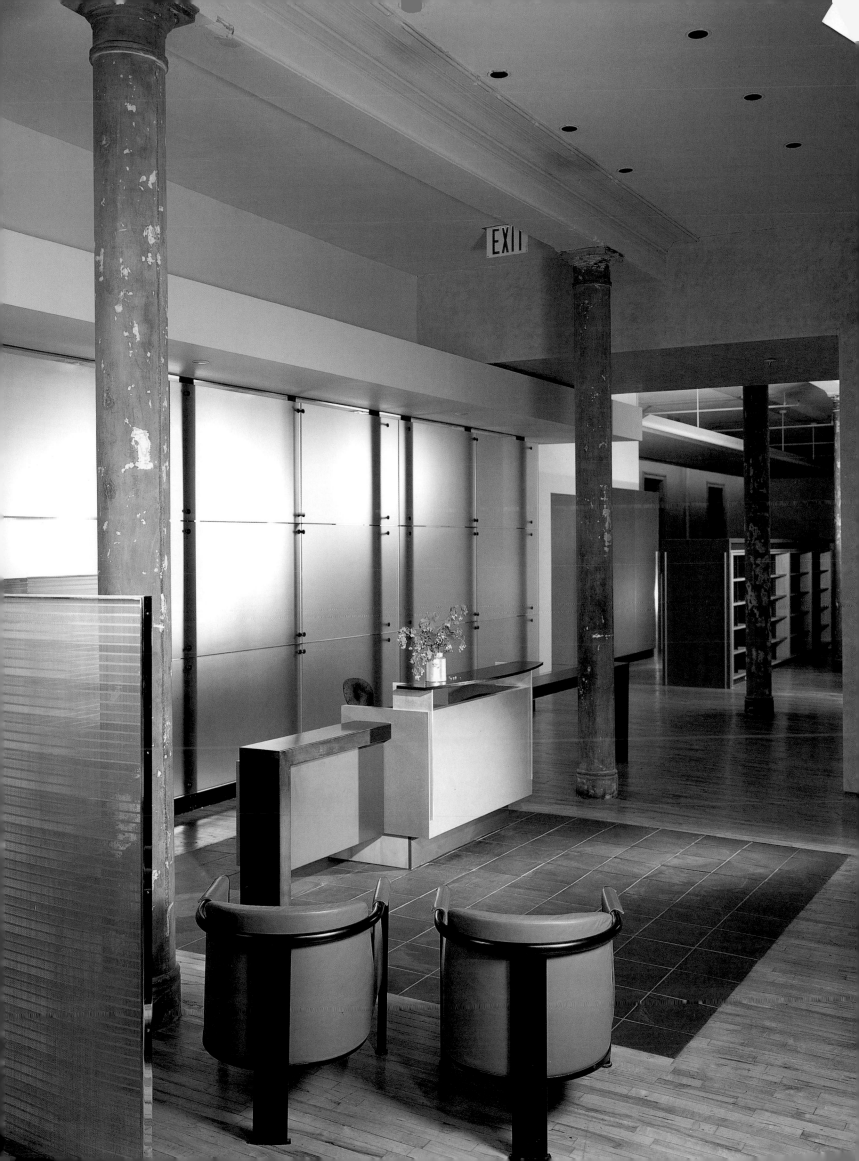

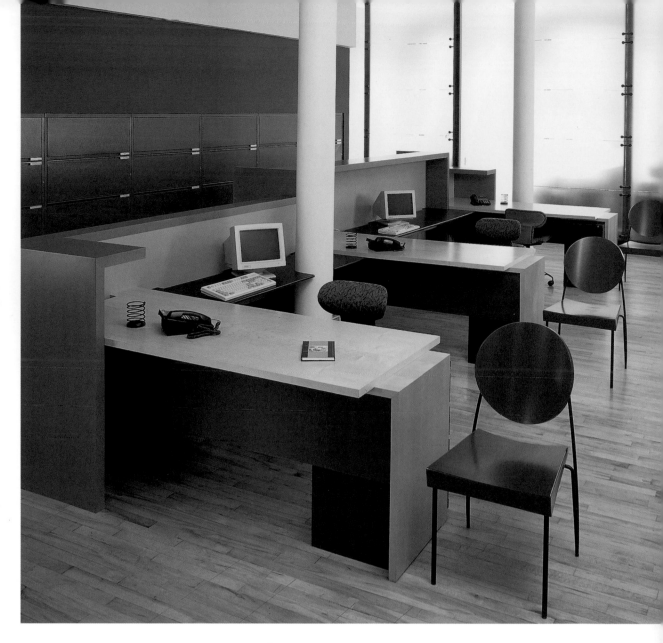

has been subdivided in a way that minimizes the sense of partition and celebrates the expansiveness of the volumes. Private offices are situated in the corners. A custom-designed furniture system carries power independent of adjacent walls and ceilings. Translucent glass walls at the ends of the floor define the limits of the space without obstructing the sense of openness.

Original maple floors, original columns, and the texture of cast iron counterpoint the new technologies used in the offices. The expansive volumes and white walls continue the gallery-like ambience of the adjoining museum; like the museum, the offices celebrate SoHo both as artistic center and as an historic architectural district.

❖
Workstations are made from medium-density fiberboard and maple. The glass partitions establish a sense of privacy and enclosure for different departments without cutting off the natural light or the sense of expansiveness.

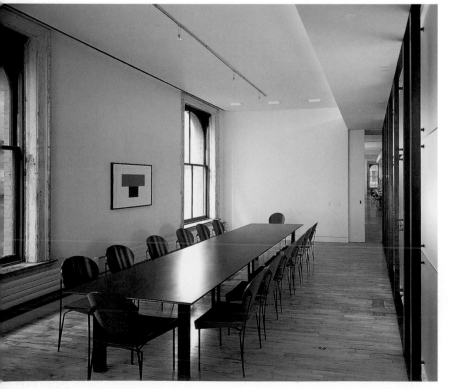

❖❖
Elements original to the classic SoHo building, including 12-foot (4-meter) ceilings and enormous windows, lend these interior volumes an incomparable sense of spaciousness, as is evident in this image of the conference room.

❖
Wooden shelves intended to house curatorial documentation flank a long corridor defined by a row of existing cast-iron columns. The circular white objects are architectural models of Frank Gehry's design for a new museum in Bilbao, Spain.

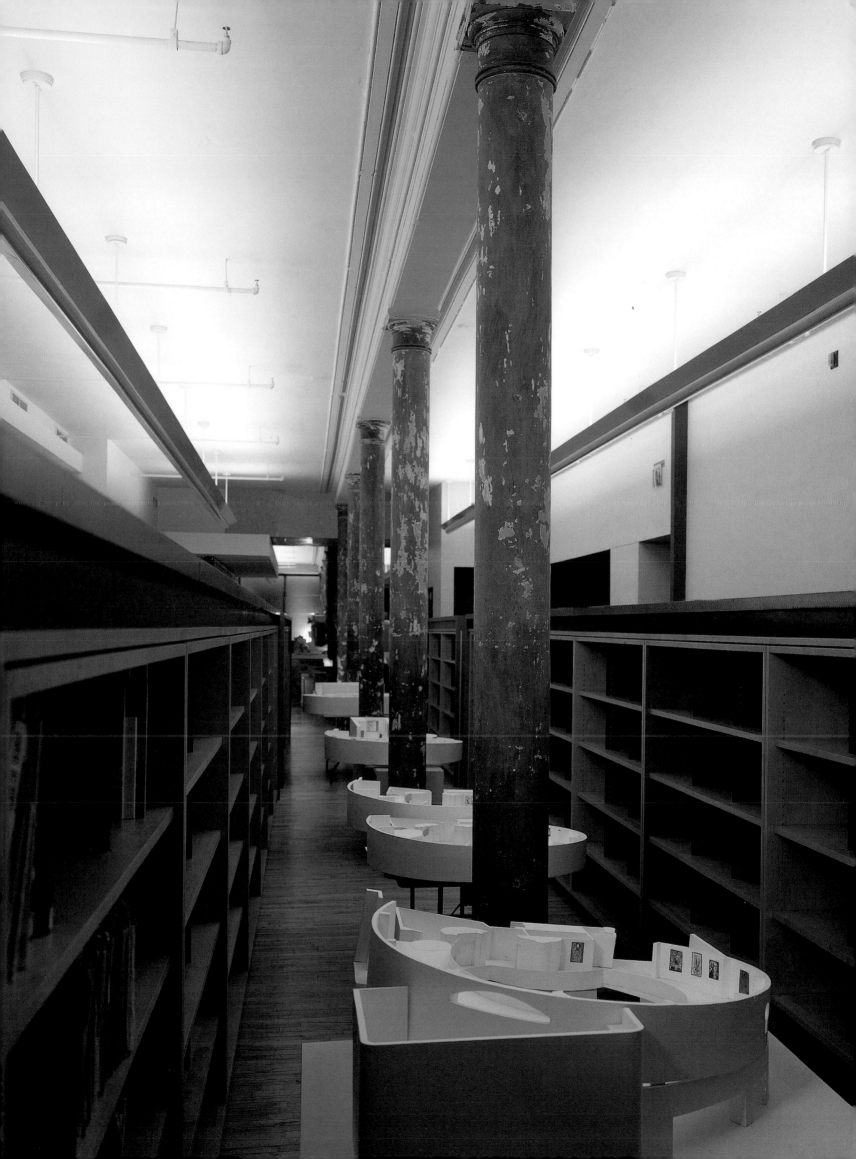

Completed as part of the renovation and expansion of the Guggenheim Museum, these offices are installed in an excavated area beneath the sidewalks adjacent to the museum on New York City's Upper East Side. TAS Design's plans for the offices are intended to make as comfortable and user-friendly as possible what is essentially a subterranean complex. Not surprisingly, the design also finds inspiration in the Guggenheim itself, since it is one of the landmark buildings of the twentieth century—an acknowledged Frank Lloyd Wright architectural masterwork.

SOLOMON R. GUGGENHEIM MUSEUM
New York, New York
Design by TAS Design, New York

The key to humanizing the long, narrow space was natural light, and the designers let a fair amount of it in through a series of circular skylights punched into planters located on street level. Ceilings more than 12 feet (4 meters) high also lend the sunken volumes a more spacious quality. The daylight is enhanced with quantities of artificial light from downlights and cold cathode lamps in strategically placed ceiling coves.

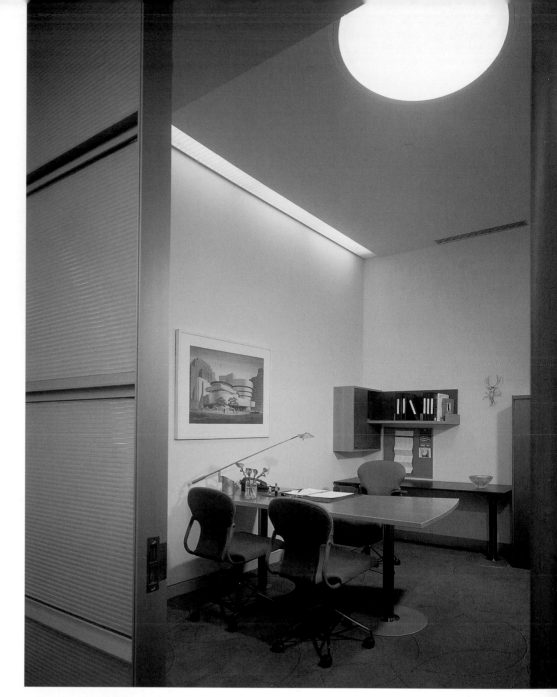

◈

Private office with round skylight and ceiling cove at top left. The high ceilings, natural light, and translucent glass walls enhance the sense of spaciousness in these underground quarters. On the wall, a drawing of the museum above.

◈

Lounge area at the south end of the complex features 1950s-influenced seating and round skylights (the skylights are punched into street level planters). The curving wall at left contains the foundation for the museum building.

◈

The wall at left contains the museum building's foundation. At rear, behind the seating area, the balance of horizontal and vertical elements in the glass walls is one of several subtle homages to the architecture of Frank Lloyd Wright.

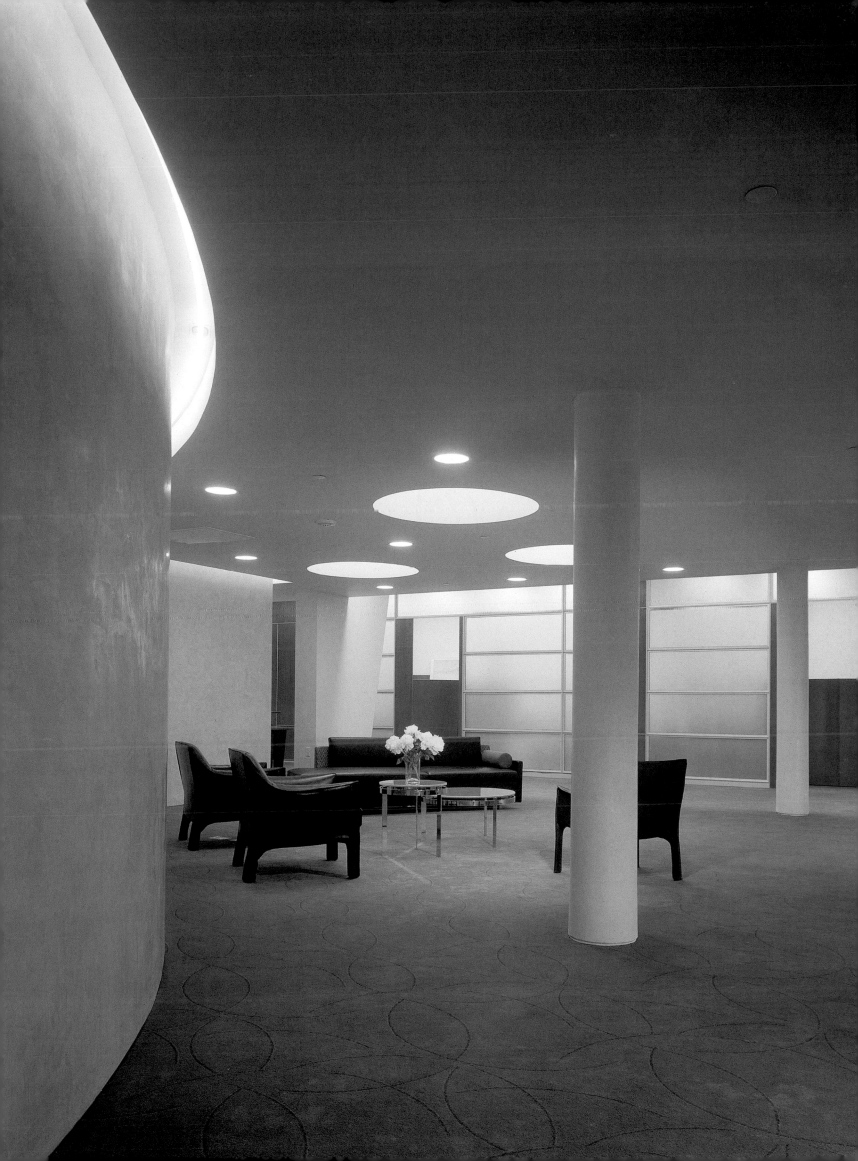

Given a long, narrow space to work with, the design team created a translucent wall of glass and aluminum separating office space from the circulation corridor and making a light-reflecting surface. Composed of acid-etched and ribbed glass with cherry wood accents, the wall lightly counterpoints the massive, curving walls of the museum foundations that define the interior perimeter of the office. Private offices are contained behind the glass wall, with a row of three two-tiered workstations located across the corridor. Throughout the interior, forms, furnishings, and finishes show the influence of Wright and the 1950s, when the museum was designed and built—but the project is up to date in its concern for the comfort of the workers who will be using the offices.

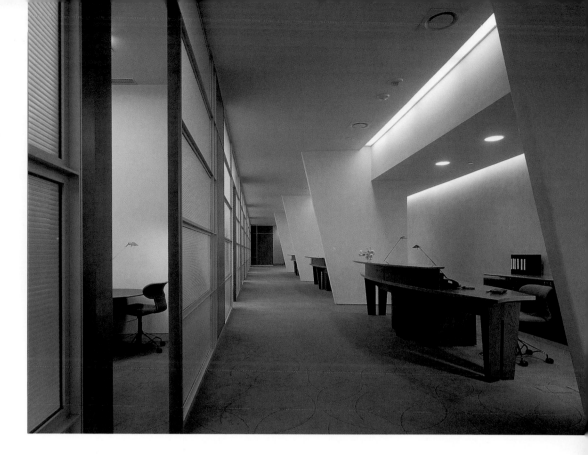

❖

The long, narrow complex is defined by the acid-etched, ribbed-glass wall that screens off private offices, left. Custom-designed, two-tiered desks for staff members are separated by wing walls.

❖

The counterpoint of powerful curves and rectilinear elements makes for interesting dynamics in this view of a foreground conference room and the lounge at rear.

❖

A ramp leading down from street level terminates in the stairs, left, which serve as the entry to the subterranean offices. The handrail is custom-designed and made of sandblasted stainless steel.

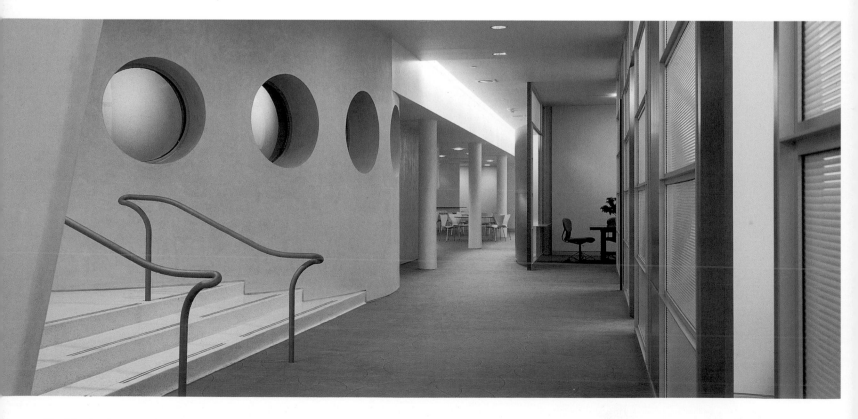

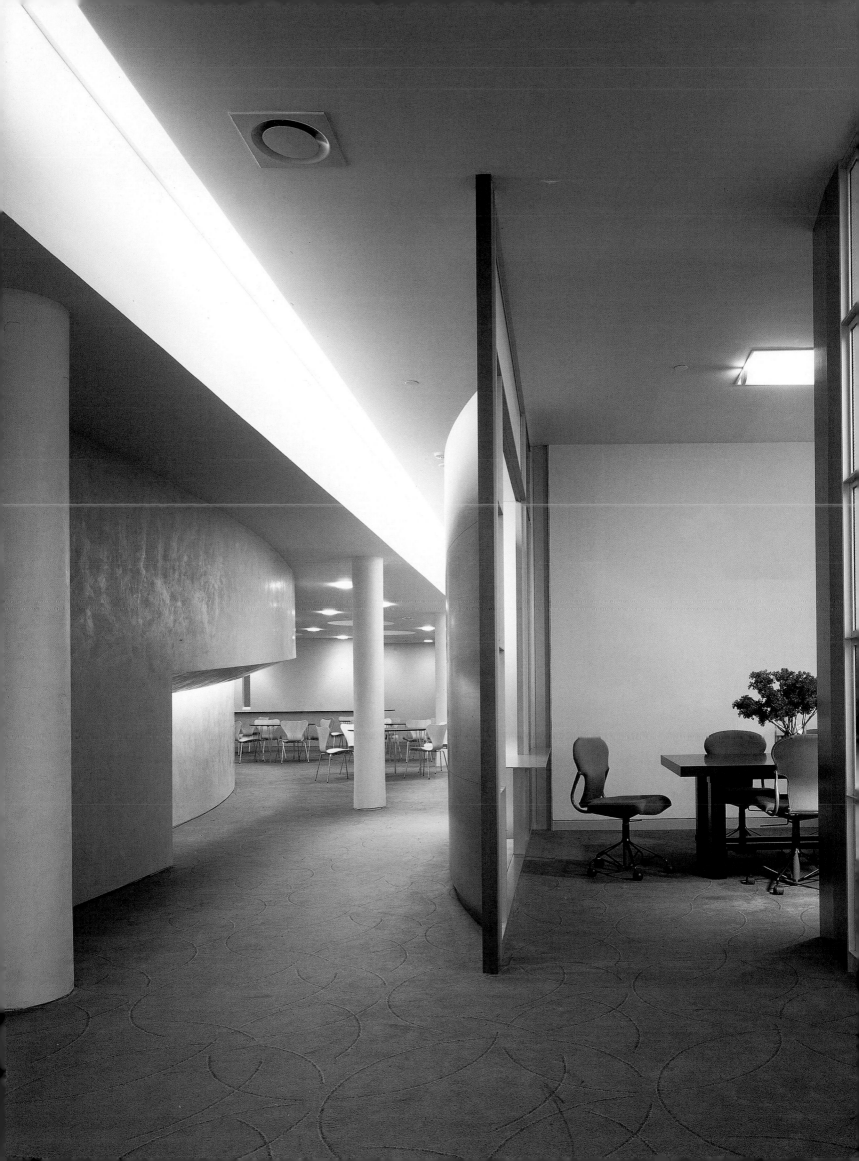

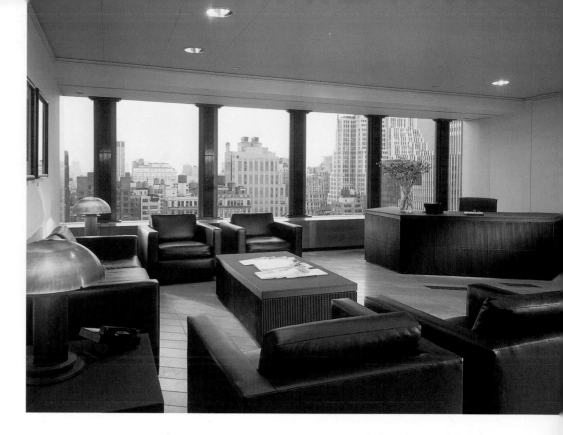

Having fitted out the London offices for Lowe Howard Spink, a major British advertising concern, the London-based Sedley Place won out over a number of well-known American firms and received the commission to design Lowe's New York offices. Lowe's subsequent merger with the American agency Scally McCabe Sloves (SMS) expanded the scope of the project, eventually encompassing 120,000 square feet (10,800 square meters) on four floors in the W. R. Grace Building in the heart of mid-town Manhattan.

LOWE AND PARTNERS/SMS
New York, New York
Design by Sedley Place, London

The single most important element in the design is a new staircase, carved out of a vertical space between a pair of elevator shafts. Built of ironwork and wood, and designed in a manner that is crisply modern yet traditionally detailed, the staircase literally and figuratively pulls all the floors together, enhancing the sense of community among the 400 employees. It also serves as a dramatic centerpiece for the entire project.

❖

The elevators open directly into reception, with its spectacular south window views into midtown Manhattan. The reception desk and table, clad in black, resin-ribbed blocks, and the table lamps are custom-designed by Sedley Place.

❖

The design team removed floors in order to insert the three-story staircase into a previously underused space between elevator shafts. Seen here from the top, or twenty-first, floor of the office, the staircase helps forge a sense of community among 400 employees spread out over four floors.

❖

The boardroom table is made of modular sections of cherry supported on lacquered cruciform bases. Full-height panels at the room's ends slide away to reveal rear-projection audiovisual equipment with a remote control that also controls the lighting and the window blinds.

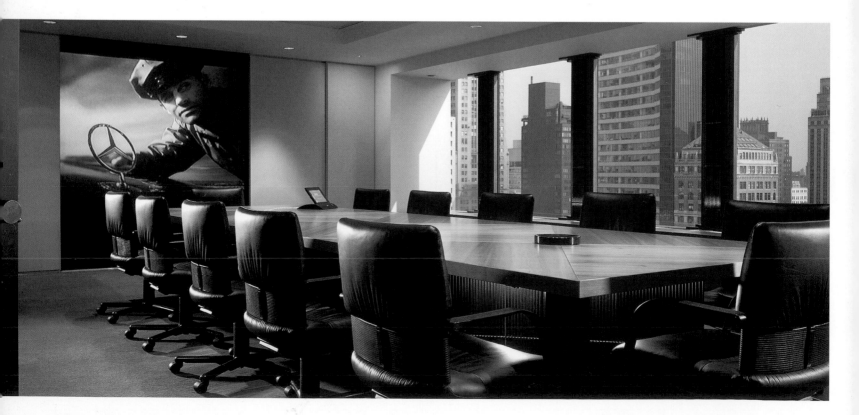

Once the connection between floors was established (with stair landings serving as informal gathering places), the design team combined imported and American materials and furnishings to create a distinctive interior, one that manages to suggest a respect for traditionalism—very British in that sense—while appearing entirely fresh and contemporary. Gray stone floors, inset with stone details in other tones and textures, are broken up here and there with sunken video monitors throwing up light and movement. Fluted wooden columns hint at Art Deco New York. Craftsmanship is celebrated in details such as the 139 steps, each with its own inlaid wood pattern, and in the inlaid wood around the doors.

Functionally speaking, the plan replaces multiple, small, dark individual offices with larger, shared spaces, taking valuable corner volumes—traditionally claimed by high-ranking executives—for common rooms. The offices have been furnished with elements from a custom-designed modular furniture system that includes variously shaped and sized tables and desks—trapezoids, triangles, and squares—that can be configured in myriad

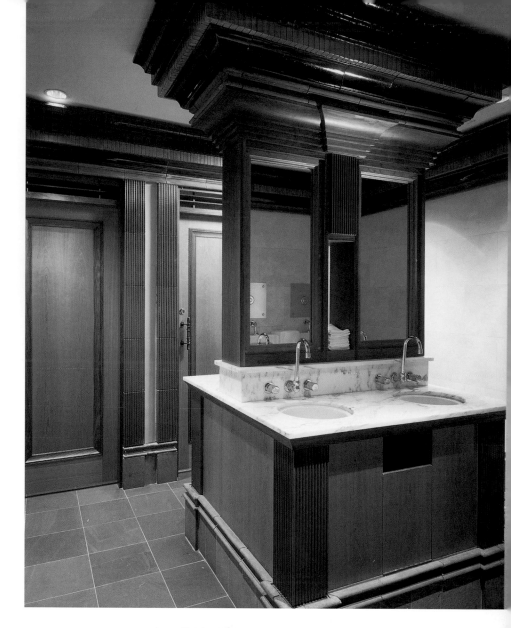

ways and are finished in a variety of wood stains. Similar flexibility has been built into the display walls, where metal panels supported in aluminum channels display materials held in place with magnets. In another example of the inventive spirit that characterizes this project, the designers created the look of expensive wood inlay by gluing together selected timbers to make blocks and then slicing the blocks at different angles to create different

patterns. The interiors were finished with framed artwork and a 14- by 17-foot (4- by 5-meter) stained glass piece by artist Brian Clarke spanning two floors in the stairwell. This unconventional strategy, of employing traditional means—what could be more traditional than stained glass?—to achieve contemporary ends, is one of the innovative approaches that make this project work.

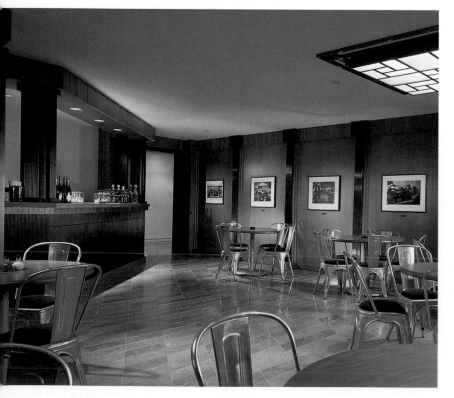

❖

The bathrooms are exquisitely wrought, intended to demonstrate the firm's commitment to its employees. Floors are kirkstone slate, vanities American cherry with glazed corner details, and there is a faux-painted, cast plaster cornice.

❖

The bar/café on the twenty-first floor is finished in wood panels and a stone floor, with cool metal chairs and pieces from the company's photography collection on display.

❖

The doors are framed with wings of inlaid wood created by gluing together and then cutting different types of wood. Note the unusual, custom-designed steel door levers with amber resin knobs. Multiple types of stone create a dynamic floor pattern.

The austere elegance of industrial minimalism is beautifully expressed in these headquarters sales offices for Paige Electric, a large-scale supplier of industrial wire and cable. The offices are located within the company's 30,000-square-foot (2,700-square-meter) warehouse in Union, New Jersey, and thus the design team from David Ling Architects found materials, forms, and objects that could be used to illustrate the nature of the business at the site.

PAIGE ELECTRIC
Union, New Jersey
Design by David Ling Architects, New York

The 8,000-square-foot (720-square-meter) office is positioned beneath a soaring, two-story-high trussed ceiling, which along with mechanical and other systems was left exposed and painted white. On ground level, the most dramatic architectural element is a floor-to-ceiling, rubber-clad, 12-foot- (4-meter-) diameter cylinder lined with copper to suggest a length of wire. This centrally placed cylinder contains the reception desk and a conference room, with a copper wall separating the two spaces. Also in reception, backlit wall sconces made from antique cable

◈

This view down the primary circulation corridor shows how the birch-veneered workstations form a rhythmic spine lengthwise through the space.

reel heads provide another visual reference to the company business.

With private offices on the perimeter, the inner courtyard of workstations glows with soft, filtered illumination, both natural and artificial, that reaches deeply into the space via clerestories and fluorescent-lit Plexiglas panels. Birch-veneered workstations with built-in task lighting troughs form the spine of the space, with partition heights shifting between 4, 7, and 10 feet (1, 2, and 3 meters) to accommodate differing levels of acoustic and visual privacy. Exposed screws and copper lightning rods serve as low-tech decorative elements. Spare, industrially inspired, and quietly luminous, this interior architecture has been beautifully executed.

◈

The reception cylinder counterpoints the otherwise rectilinear architecture of the warehouse. At left, stacked reels of company product serve as a kind of minimal art.

◈

Workstations are contained within birch-veneered paneled partitions. Heights differ to provide shifting levels of visual and acoustic privacy.

McCann-Erickson's new offices in San Francisco are meant to reflect a change in management and a rethinking of the corporate culture to attract a younger, hipper clientele—as well as to recruit new employees with a more forward-looking attitude. To reinforce this progressive reinvention of the company, the agency requested that the designers from STUDIOS Architecture create offices that would encourage people to give up their preconceptions when they entered. In effect, the design is meant to set a dynamic example by juxtaposing materials, colors, and textures in unexpected ways. This daring technique worked especially well given that the agency is located on a typically conservative floor in a downtown high-rise building.

McCANN-ERICKSON ADVERTISING
San Francisco, California

Architecture and interior design by STUDIOS Architecture, San Francisco

A sense of motion and tension is achieved by the interaction of differing textures and curving forms in metal and plaster wrapped around the elevator lobby and reception area. These intersecting forms also incorporate McCann-Erickson's work, as do many of the office's

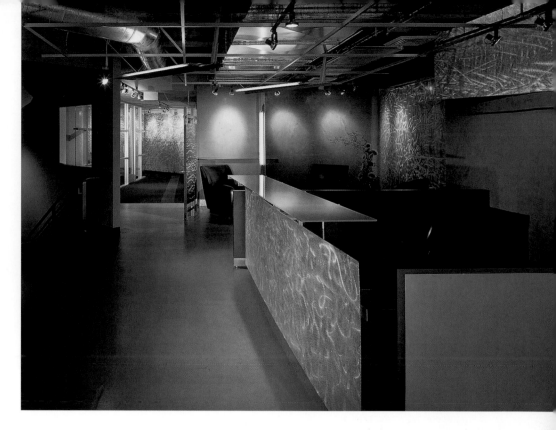

❖

Views of the reception desk, which is made of the dominant elements in the overall design: brushed metal, stained particleboard, perforated metal screening, and sandblasted glass. Gray and green plaster behind the desk contrast with orange and red at right. Exposed ductwork balances with the softer tones of plaster and bright yellow chairs.

integral elements. To convey a sense of openness and to enhance employee interaction and communication, open-plan workstations and informal breakout spaces replace many previously enclosed offices, and the office lunch room possesses a relaxed, flexible quality. By capturing the progressive new spirit of McCann-Erickson in colors, materials, and forms, the designers succeed in making the office an integral expression of the corporate image.

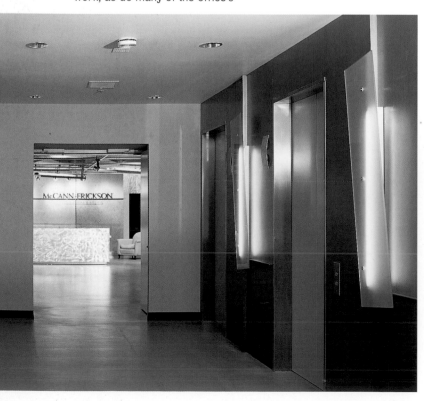

❖

The elevator lobby sets the tone, with surprising, contrasting materials— cold-rolled metal on the right wall, warm-toned plaster on the left wall. Custom light fixtures hold fluorescent tubes.

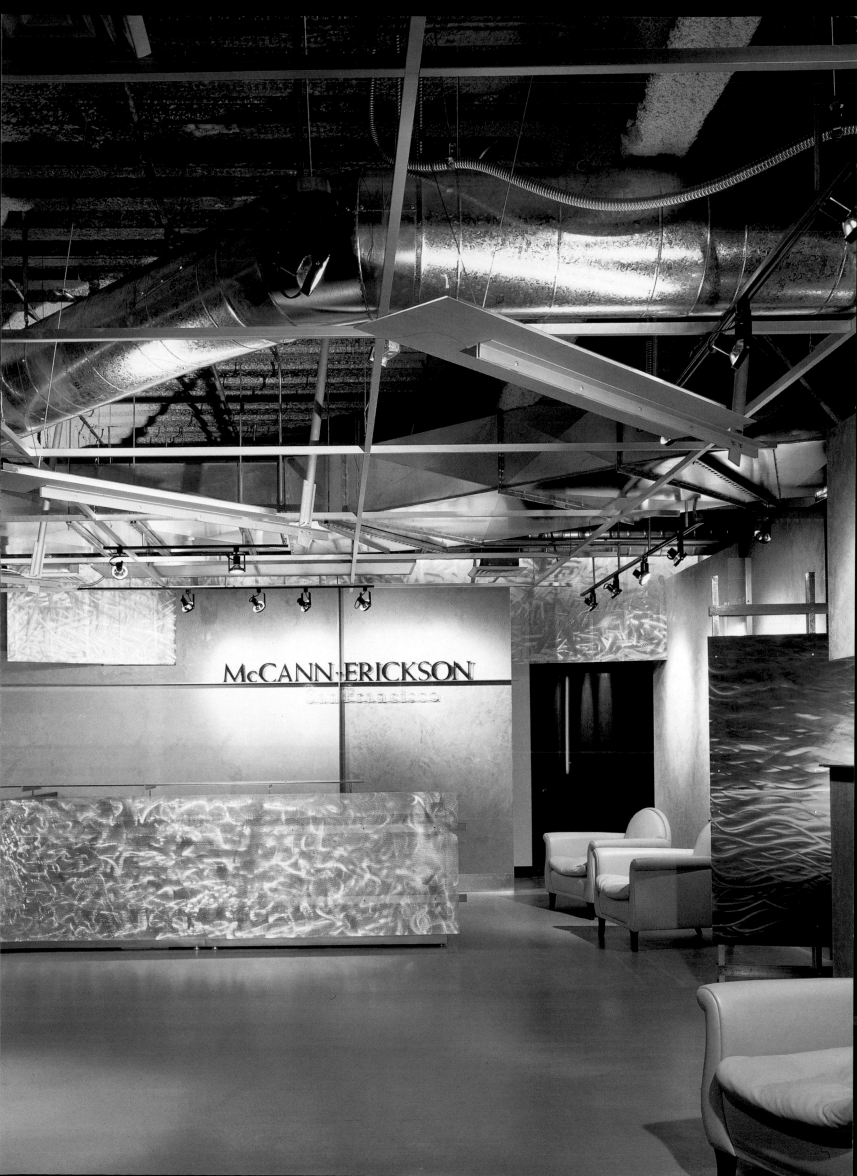

◈
Low walls and transaction counters that can be used as perching ledges enhance interaction among employees in the open-plan area. The number of private offices was downsized to further encourage communication.

◈
This glass "jewel box" conference room is used for informal meetings. The table is custom made, with the painting on top sealed under multiple layers of polyurethane.

◈
Different sizes, heights, and shapes of tables in the lunch room make the space more flexible, a necessity in this tightly programmed office. The copy room is behind the painted Sheetrock wall at rear.

Among the thousands of south Florida buildings devastated by Hurricane Andrew was the Burger King corporate headquarters in Miami. For months after the hurricane, workers from the chairman of the board on down were thrown together, forced to "camp out" in temporary quarters in which all employee hierarchies had been abandoned. During this time, corporate officers couldn't help but notice that morale and productivity shot up. Therefore, when NBBJ came on board to redesign the 250,000 square feet (22,500 square meters) of interior space, Burger King management asked for a new plan that incorporated some of the accidental, nonhierarchical qualities of those temporary offices.

BURGER KING
Miami, Florida

Architecture and interior design by
 NBBJ, Seattle

NBBJ principal Scott Wyatt and his design team responded with a plan that organizes each of the three floors along a main "boulevard" with open office areas arrayed around culs-de-sac, thereby directing circulation into the boulevard, or "Main Street." This enhances interaction and, with the open

◆

Red doors and carpet swirls signal intersections or conference or meeting space; gridded white walls separate open-plan office spaces from the circulation corridor.

◆

The interplay of angularity and sinuous curves in both the shapes of walls and the patterns in the carpets visually energizes the interior.

◆

The designers specified workstation furniture with different wall heights and finishes to allow employees some control over the level of privacy in their workspaces.

staircases connecting all three levels, fosters the sense of community sought by the corporation. By positioning traditionally "back office" spaces such as the copy, file, and coffee rooms as well as conference and meeting spaces along the boulevard, the designers increase opportunities for employee interaction.

❖

At right, a stair spills into the boulevard, creating an informal gathering place at an intersection. Stairs were moved in from the office periphery to provide another stage for increased human interaction.

❖

The overscale red doors signal "public" areas, like this conference room, along the main boulevard. Furniture is different in every conference space, reflecting the company's global reach.

❖

Translucent, glass-enclosed "ice cubes" serve as temporary meeting rooms or semiprivate spaces for informal conferences or telephone work.

This retrofit for a high-end lighting design and manufacturing company consolidated the product showroom with customer service, sales, marketing, accounting, purchasing, and design departments into an existing 11,000-square-foot (990-square-meter) concrete shell. Key programming concerns included flexibility and light control in the showroom. The balance of the space is given to open-plan offices organized to enhance interdepartmental interaction.

BOYD LIGHTING COMPANY
San Francisco, California
Design by Brayton & Hughes,
San Francisco

The existing building was rebuilt to expand the usable floor area and for seismic stability, with new lateral steel bracing installed as a visible design element. A deviating wall plane divides the showroom from offices. The wall plane also carves off a secondary full-height zone that works as a showroom extension when required but can be used as a large conference space or gallery as well.

A translucent screen extended from the wall plane at a steep upward angle diffuses light by day

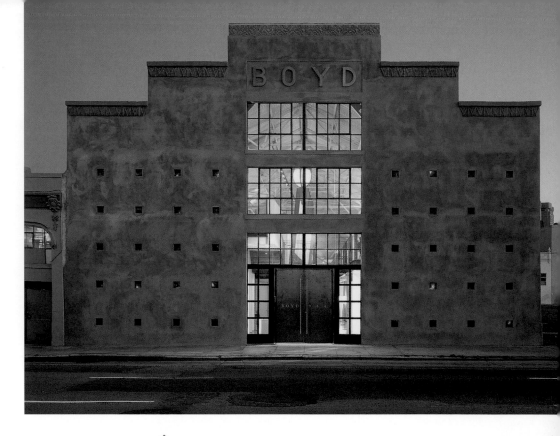

❖

The building, little more than a shell, was remodeled and seismically reinforced to house new offices and showrooms. The designers filled in existing openings in the facade and then punched in a decorative grid of small new squares filled with cast blue glass.

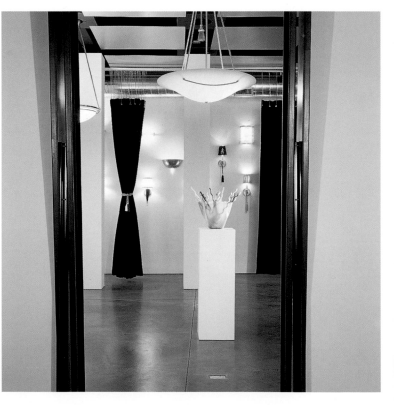

❖

Ground floor showroom displays Boyd light fixtures on walls and suspended from ceiling tracks located above square white ceiling panels.

❖

Ground floor design studios are screened from the gallery and showroom by perforated metal walls at left.

❖

To organize the interior volume, the designers developed a slightly off-axis wall plane, right, that defines the showroom area while filtering light into the two levels of studios and workspaces, left, via the slanting, translucent plastic-paneled wall at top center.

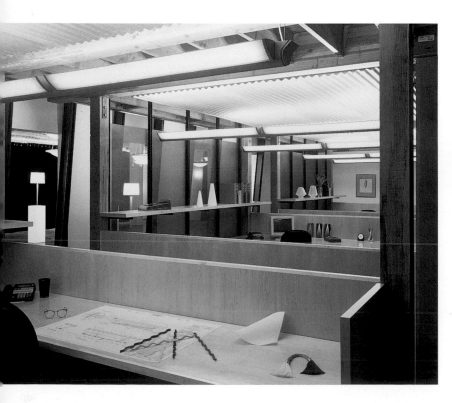

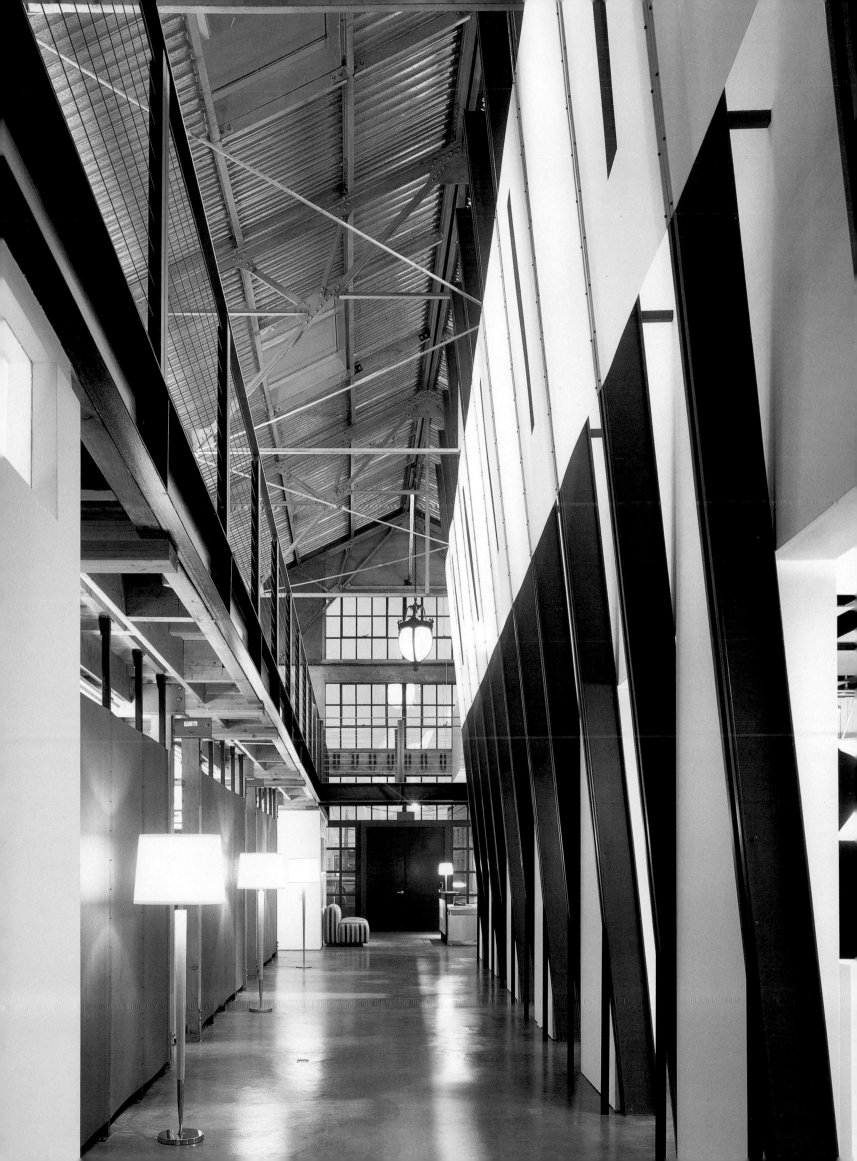

and by night glows like a giant light fixture itself, drawing illumination into the lower-level spaces. It also helps define the separation of upper and lower levels and creates dynamics by constantly changing with the light. Perforated metal screens also manipulate light levels in both showroom and office space.

The counterpoint of sleek new interiors and high technology within the existing rusticated shell paradoxically conveys a sense of tradition while transcending it.

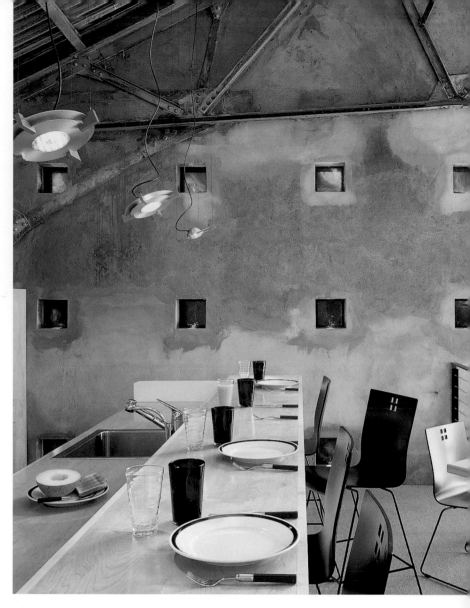

◈◈

Upper-level employee cafeteria is detailed with contemporary Boyd fixtures. The metal ceiling is a new element, while the metal strut system is preexisting.

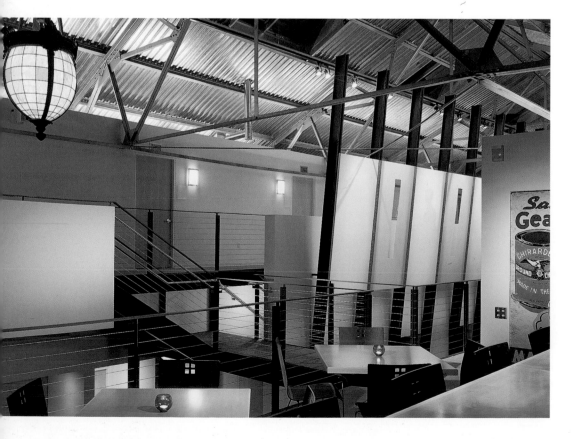

◈◈

View from the employee cafeteria shows catwalk to second, higher mezzanine on the other side of the interior. It contains private offices. The "acorn" pendant glowing at the left is a Boyd fixture dating from the 1930s.

◈◈

The reception desk is a custom design made of maple veneer with gunmetal blue legs and a translucent plastic screen.

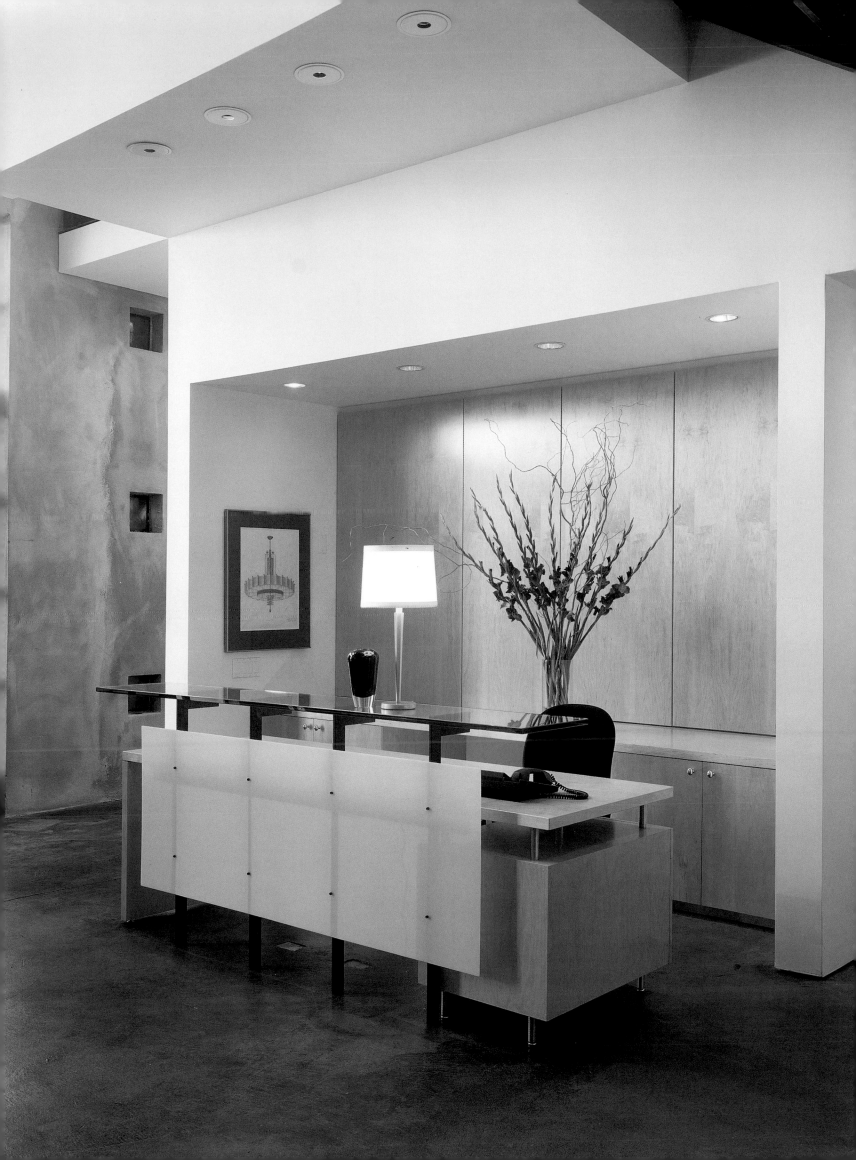

In HOK's offices in Houston, the design firm has created 21,000 square feet (1,800 square meters) of space designed to support the firm's open, team-oriented approach to work. Occupying the entire thirty-seventh floor of Houston's Transco Tower, the HOK office includes a small section—they call it a "living laboratory"—devoted to exploring what are called "alternative office concepts" such as "nonterritorial" workspaces and "remote" work.

HOK HOUSTON
Houston, Texas
Design by HOK Houston

This laboratory includes examples of fixed-address or traditional assigned workspaces; group addresses, devoted to a designated team for a specific time period; free addresses, or workspaces shared on a first-come, first-served basis; and home addresses, where the primary workspace is at home. Complemented by two "privacy harbors" for meetings or high-concentration tasks, the laboratory is intended to explore the viability of these new forms of working, especially as they are enhanced by wireless phones, laptop computers, and other tools. A flexible furniture

◈
Since the firm occupies the entire floor, the elevator opens directly into the reception lobby. Materials include limestone flooring, granite, painted drywall, wood paneling, and steel accent details.

system provides the essentials for the laboratory spaces; ergonomic considerations were more important than usual, since the furniture is used by different individuals on a regular basis. Common materials and finishes integrate the laboratory with the other 90 percent of the office.

HOK's corporate culture is marked by a commitment to accessibility and teamwork, and thus the balance of the office, if not devoted to workplace experimentation, is naturally open and team-oriented. Vibrant blue conferencing boxes at

the four corners of the floor mark transitions between departmental neighborhoods, with shared support functions placed in the core. A skewed ceiling plane plays off the static squareness of the floor, while angled architectural elements respond to the street grid below. To support the firm's commitment to sustainable design, the office uses natural, recycled, and recyclable materials, nonendangered woods, and sealers and adhesives with low toxicity levels. Finally, expanses of glass admit great quantities of daylight, minimizing the need for artificial light.

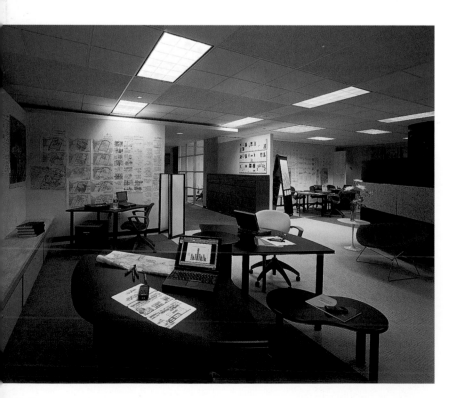

◈
This open area is the heart of the alternative office laboratory, where workers have no private offices or even permanently assigned workspaces. The furniture is specified for maximum flexibility. Workers organize and assemble data on the walls.

◈
The HOK designers call this corridor through the service core the "aisle of fun." Randomly patterned, durable linoleum squares make up the floor.

Retrofitted into a long-abandoned Coleman Lantern factory, this 24,000-square-foot (2,160-square-meter) advertising agency office features a design that signifies the "passing of the baton" from the twenty-five-year-old firm's founders to a new generation. Such a changing of the guard required a radical new design approach; at the same time, it is intended to honor the old.

SULLIVAN HIGDON & SINK
Wichita, Kansas
Design by HOK St. Louis

The design accomplishes this through juxtaposition—of old and new—of the original building and new materials and finishes within and around it. The designers worked with a team of twenty agency employees to make sure they got it right—right being a dramatically innovative space that would support the client-focused team approach that is the agency's hallmark. Client-focused teamwork means that people from separate departments work together from day one with the account executive and the client. It requires space planning that is utterly flexible.

There are no doors in this office— or rather, the doors have been

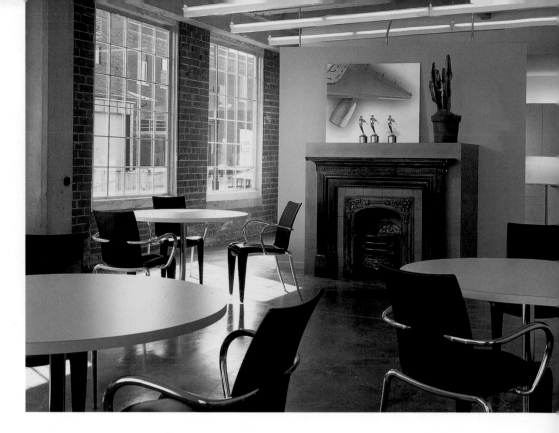

❖

Nowhere is the entertaining interplay of old and new more evident than in this break area, where original brick walls, gridded windows, and an old fireplace play off the new design's hip palette and cool, contemporary tables and chairs.

turned on their sides and are now used as desktops. Workspaces are laid out along spines containing power and communications lines. Workplace components are mobile and may be docked anywhere along these spines. Employees choose these components from a menu, and they are then configured and reconfigured within the limits imposed by a master plan. Each team's space includes a living room for interaction and relaxation, a home room for media formats, support space for filing and storage, and a small retreat for privacy. Each of the two floors also contains a multifunctional workroom and a central resources core.

The end result is a dynamic space that juxtaposes the latest in technology, traditional materials, and hip furnishings, adding up to an environment buzzing with creative energy.

❖

The reception area illustrates the bold interplay of old and new, as the bright colors, lively forms, and one-armed chairs in the foreground contrast with the antique cabinet against the wall at rear.

❖

The team meeting areas are flanked by semiprivate offices—there are no doors on the cubicles. Note the traditional pieces at left and rear center.

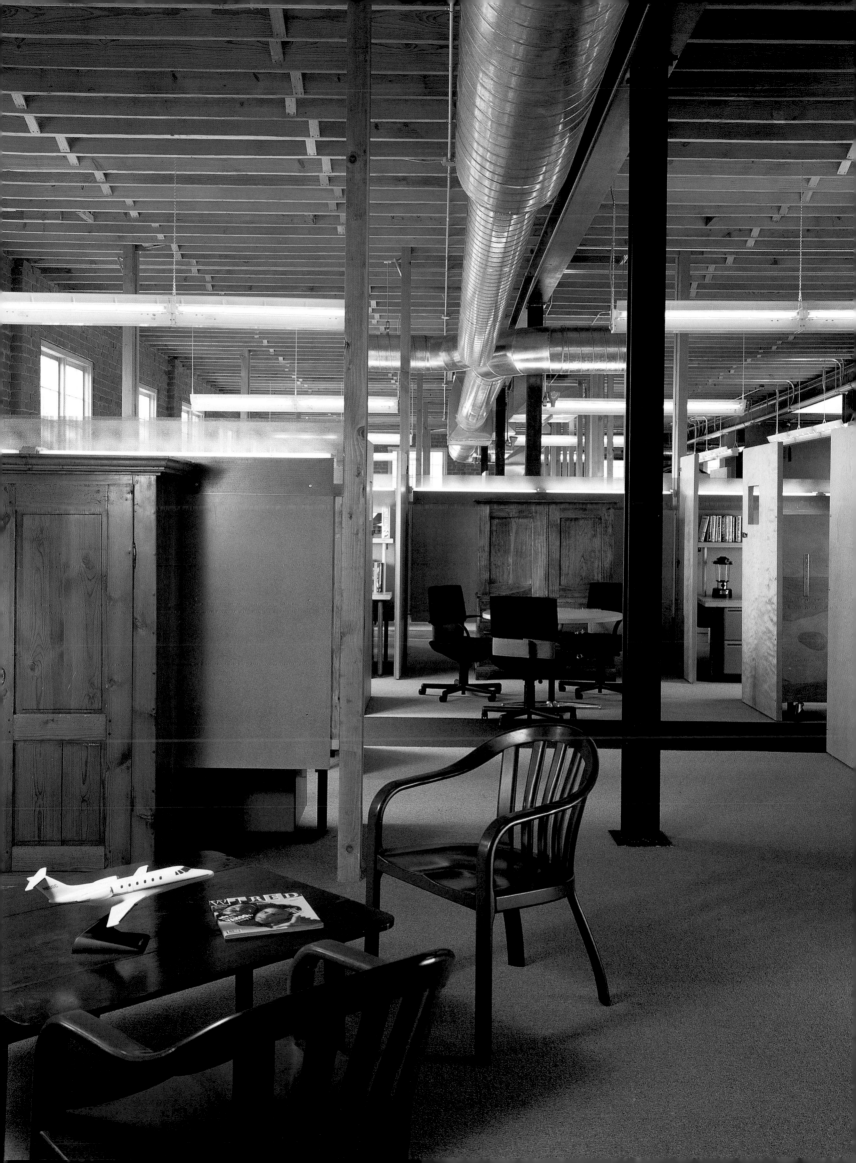

One of the nation's more innovative advertising agencies, Fallon McElligott has repeatedly expanded its headquarters as business has grown over the last five years. The design of this latest 18,000-square-foot (1,620-square-meter) expansion—the firm now occupies five and a half floors of a downtown Minneapolis high-rise—is consistent with the philosophy that has undergirded this agency's interiors since the beginning: The company strives for design with an attitude that fosters teamwork, communication, and creativity.

FALLON McELLIGOTT ADVERTISING
Minneapolis, Minnesota

Design by Perkins & Will/Wheeler, Minneapolis

To keep the lines of communication open, private offices do not have doors. Open-plan workstations are composed of birch-veneered panels supported by hot-rolled steel "boots." Sculpted, angular forms, exposed hardware, and dramatically sweeping curves energize the interiors, while soft, elegant lighting and the extensive use of warm birch veneer balance the formal tension, establishing a more relaxed, inviting ambience.

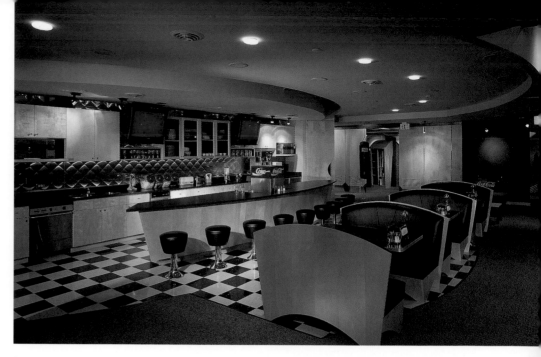

Counter seating, black and white checks, a quilted stainless steel backsplash, and a soda fountain lend the company meeting area and cafeteria a cool, 1950s-style diner look.

Perhaps the most appealing space in the office is the employee cafeteria and meeting area, large enough for up to 125 people. Here, the design team from Perkins & Will/Wheeler created a 1950s-style diner, with a soda fountain, booths with banquettes, and a black-and-white checked floor. Coolly retro without being corny, constructed of the same light wood to link it with the rest of the office, this bouncy, curvy diner suggests that employees are expected to have fun on the job.

The sculpted reception desk is detailed with hot-rolled steel legs and a steel transaction counter. Above, the swooping, arrow-shaped overhead canopy is studded with exposed nuts and bolts. The gridded floor is also hot-rolled steel.

Two arcing segments of a staircase create a dynamic visual element. The forms are dazzling and daring, and the birch-veneered finish is inviting and light—a well-executed counterpoint.

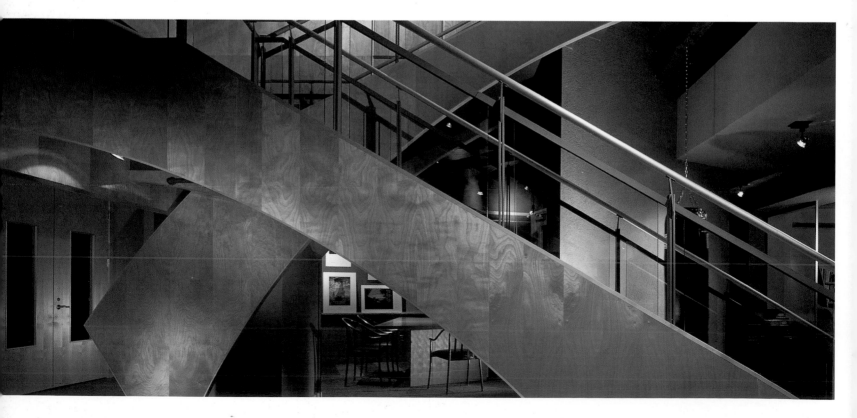

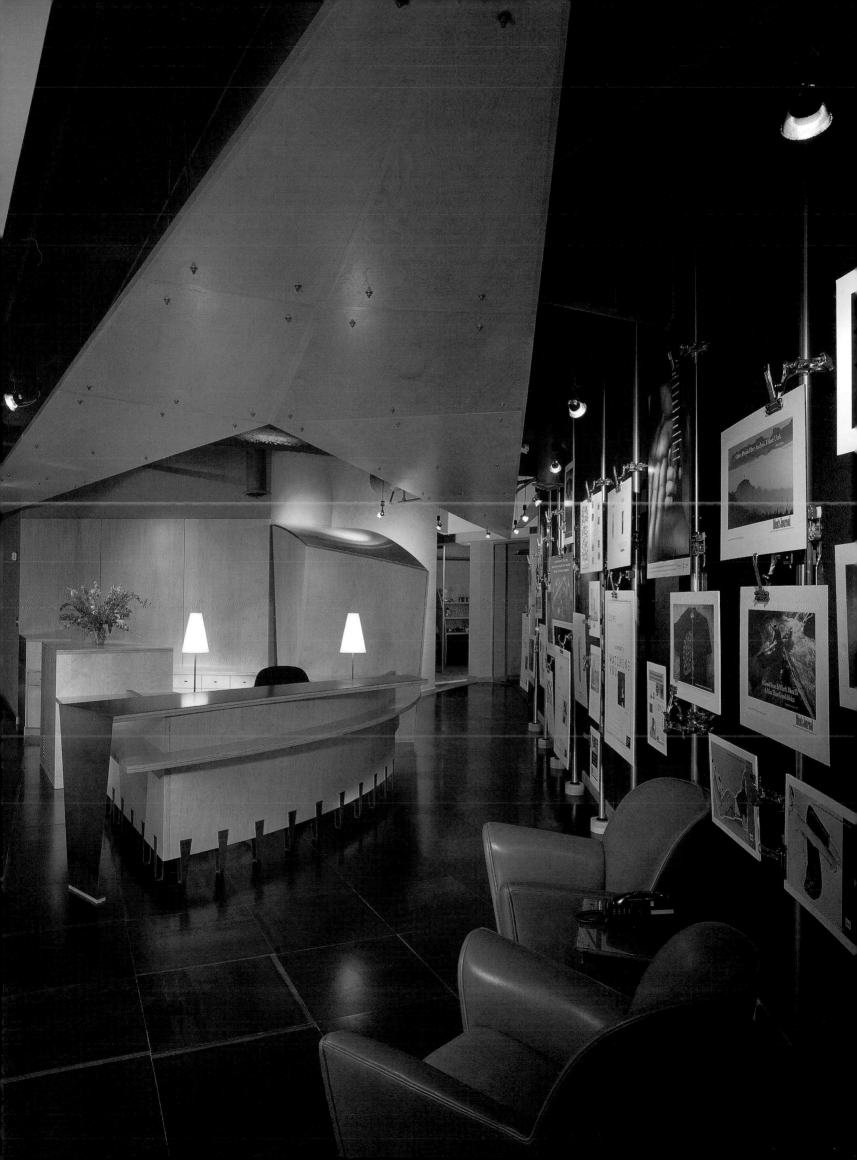

One of the great retail success stories of the 1990s, the fast-growing Seattle-based Starbucks Coffee recently moved its headquarters offices into an old warehouse building in an industrial area south of downtown Seattle. Starbucks' management then hired the Seattle firm NBBJ to work with its own in-house planning department to begin transforming the building and 17 surrounding acres (7 hectares) into an office environment that reflected the dynamic Starbucks corporate culture—and that maintained that culture's youthful vigor in the face of massive expansion. The master-planned project is also intended to encourage other companies to move into the area.

STARBUCKS COFFEE
Seattle, Washington

Architecture and interior design by NBBJ, Seattle, and Starbucks Planning Department

The program includes reconfiguring the facades of existing buildings, adding an elevator core and new mechanical and electrical systems, developing "green spaces" outside the buildings, and building three floors of office space—an amount that grew almost as fast as it could be planned, so rapid has been Starbucks' expansion.

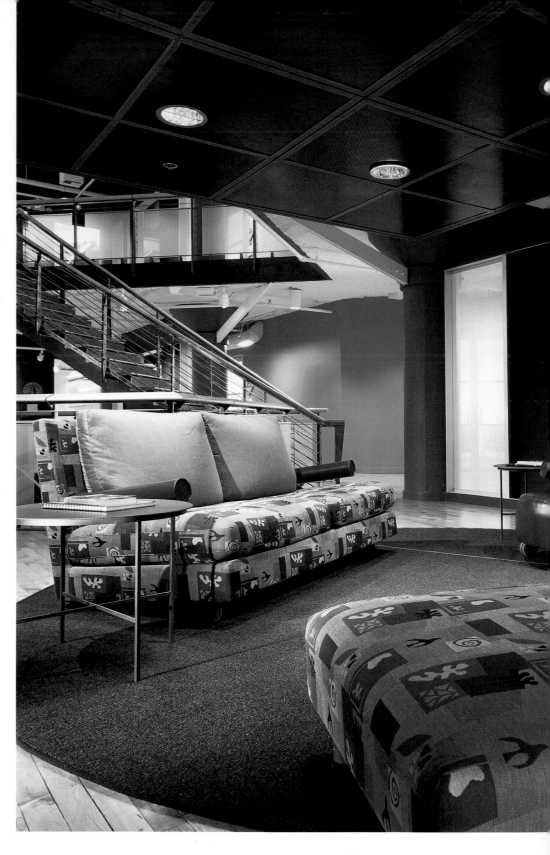

❖

In a reception area, lively graphics, warm colors, and contemporary furniture are part of the hip, youthful Starbucks appeal.

❖

Curving countertop in the chic, top-floor in-house coffee bar, designed by NBBJ in collaboration with the Starbucks Planning Department, displays samples of the company's dozens of different coffee products.

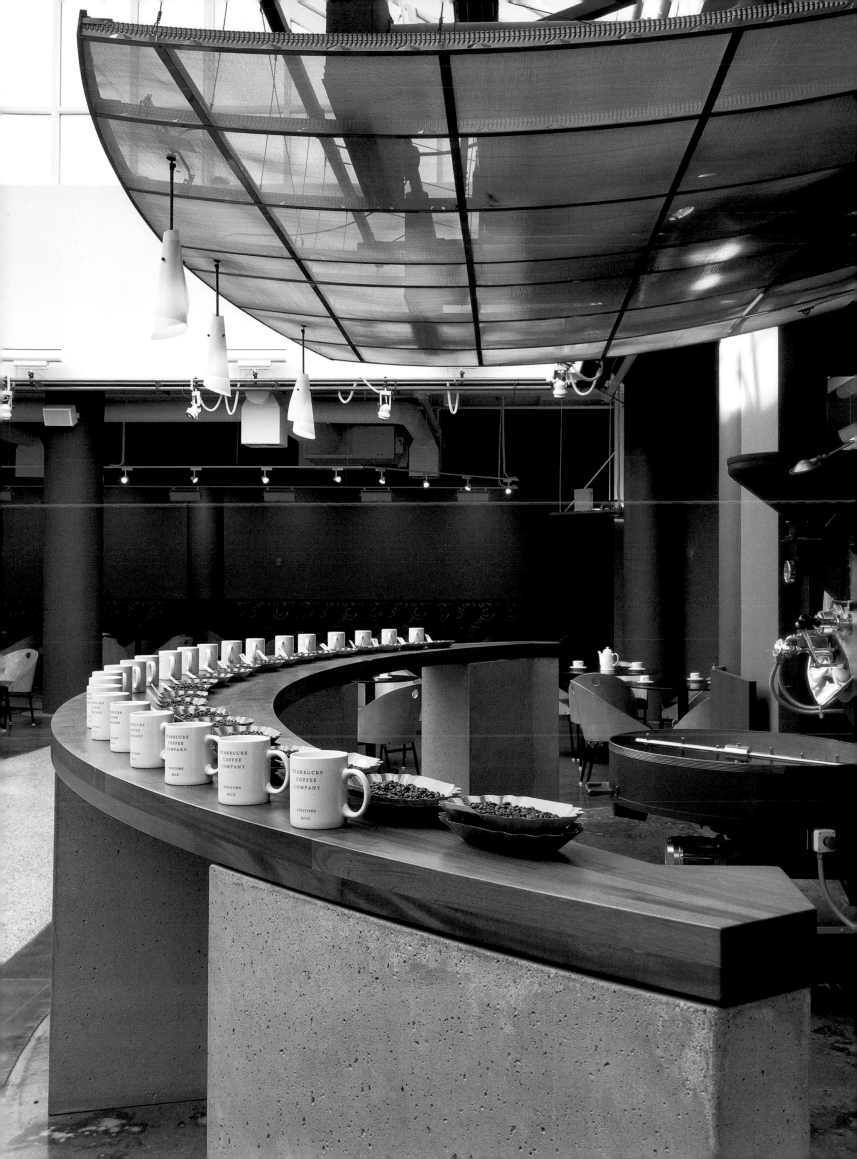

Worn brick, concrete, natural wood, and tropical colors taken from Starbucks' retail graphics animate the public zones of the office space. Each of the 130,000-square-foot (11,700-square-meter) floor plates is organized around an X-shaped pattern of diagonal corridors that push gathering areas—conference rooms, copy rooms, informal lounges, and espresso bars—into the foreground. The X-shaped corridors intersect in wood-floored central commons on each floor, creating informal meeting places for the company's mostly youthful staff.

◈

Stair rails are elegantly detailed in steel, glass, and wood.

◈

Four sets of steel and concrete staircases link the three floors of offices at points along the X-shaped primary corridors.

◈

The top-floor coffee bar, under an enormous peaked skylight, is the main employee hangout and coffee-tasting area.

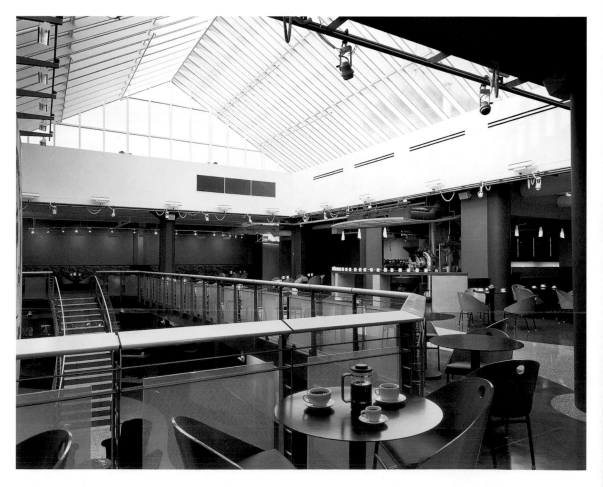

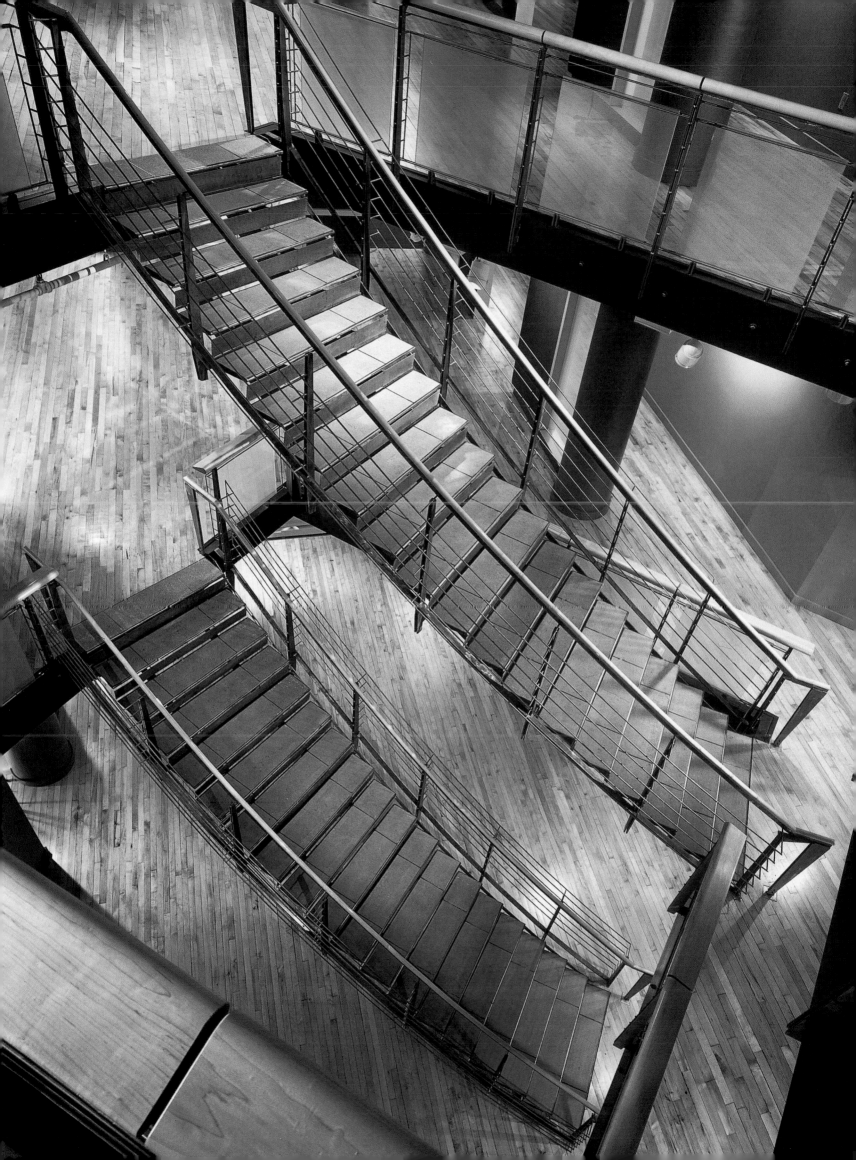

This project retrofits a beverage distribution company into a historically significant Minneapolis building that began its life as the Brown Livery Stables and more recently was a comedy nightclub. In putting the Phillips Beverage Company into this building with a past, the designers intended to illuminate and celebrate two histories: that of the company and that of the building.

PHILLIPS BEVERAGE COMPANY
Minneapolis, Minnesota

Design by Perkins & Will/Wheeler, Minneapolis

To accomplish this, the design team from Perkins & Will/Wheeler was careful to respect the powerful original elements of the building, including the massive fireplace, the skylights, the interior skin of brick and limestone, and the cedar joist ceiling system. For example, the new double-height conference room is open to the original ceiling and is designed around the original fireplace. Additionally, while the new space plan takes advantage of the high ceiling by adding a second floor of offices within the building, openings in the second floor maintain a visual connection between the ground floor and the ceiling and

◆
Second-story "bridge" is flanked by openings to the lower level, permitting light from the upper-level windows to reach the ground floor. Note the original cedar joist ceiling system.

also allow light to flow down from upper-level windows and skylights.

The designers added a "tasting bar" to allow clients and visitors a chance to check out the Phillips labels and products. Detailed in cherrywood veneer and flanked by massive posts, the bar is a warm, inviting new space, one that demonstrates respect for history without slavishly imitating an historical style. The same can be said for the whole 8,500-square-foot (765-square-meter) project.

◆
Designed to show off the original fireplace and ceiling, the new double-height conference room shows how new office functions were integrated neatly into the historic structure.

◆
The designers added this warm, cherrywood-veneered "tasting bar" to give clients and visitors a chance to experience the history of the company and the building.

The quality of light was the driving factor behind this award-winning New York City design firm's selection of this 5,000-square-foot (450-square-meter) space for its own offices. With 12-foot (4-meter) ceilings and banks of 9-foot (3-meter) windows on the north and south, the abundant wash of natural light infuses the interiors with a spirited richness, abetted by the designers' finish choices: pristine white walls, exposed ceilings, and natural wood floors.

IU & LEWIS DESIGN
New York, New York
Design by Iu & Lewis, New York

Architects and designers work in an open bay slightly askew of the orthogonal column grid. Behind the work bay, a conference room anchors the space; its textured-glass doors are framed in stainless steel, providing privacy for meetings while allowing light into the space. A less formal meeting area is located to the south, where window boxes full of red geraniums enrich the space with bold organic color.

Private and semiprivate meeting, office, and other dedicated spaces are arrayed around these central

Sinuous black lighting fixtures stand out against the plain white walls and open ceilings in a circulation corridor. Originally intended to light artworks, these playful elements instead have become artworks themselves.

volumes, linked by circulation paths highlighted with black flexible-wire lighting fixtures. These lively fixtures originally were mounted to provide light for artworks; instead, they have staked a claim as artworks in themselves, their playful, sinuous forms standing out like sculptures against the white walls and ceilings.

Slightly askew of the column grid, the open studio area is bathed in natural light from north and south windows, enhanced by artificial light from overhead fixtures.

Informal meeting space along the south wall is brightened by window boxes of bright geraniums. Principal Carolyn Iu's small private office is visible at rear.

Working with just 5,500 square feet (495 square meters) of space and a tight budget, architect Francine Monaco created these warm, colorful offices for a pair of feminist-oriented foundations. The two organizations are separate, but their common cause—active support for women's issues—led them to opt for sharing space in an effort to stimulate interaction and communication. Thus the offices, which are also shared with several other non-profit foundations, are designed to enhance communality and cooperation rather than individuality. Each tenant uses one or more perimeter private offices, with a changing cast of support personnel working at the open-plan workstations in the core.

ASTRAEA FOUNDATION/SISTER FUND
New York, New York
Design by Monaco/Architects, New York

The interiors are calm and spare, infusing the space with clarity and dignity. This understated ambience is then counterpointed with a rather rich palette and whimsical furnishings—big, bright red chairs in reception—and the grand, evocative presence of the conference room: a deep purple, oval-shaped volume that subtly evokes a classical

temple. Skewed off-axis to accommodate the immovable bulk of two structural columns, this powerful "female" form is a symbol of the cooperative spirit of the office.

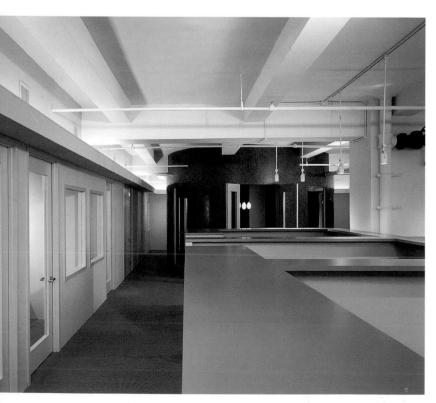

❖

The small reception area is located adjacent to open-plan workstations, with the reception desk situated next to a structural column. Expanses of glass on the walls enclosing perimeter private offices enhance visual access and the flow of light in both directions.

❖

Seen over the centrally located workstation area, the deep purple oval of the conference room has a striking sculptural presence. The room is off-axis to accommodate structural columns.

❖

The conference room interior is also finished in purple. Multiple doors evoke the structure of a classical temple and enhance the sense of openness and accessibility. The table and the light fixtures echo the shape of the room.

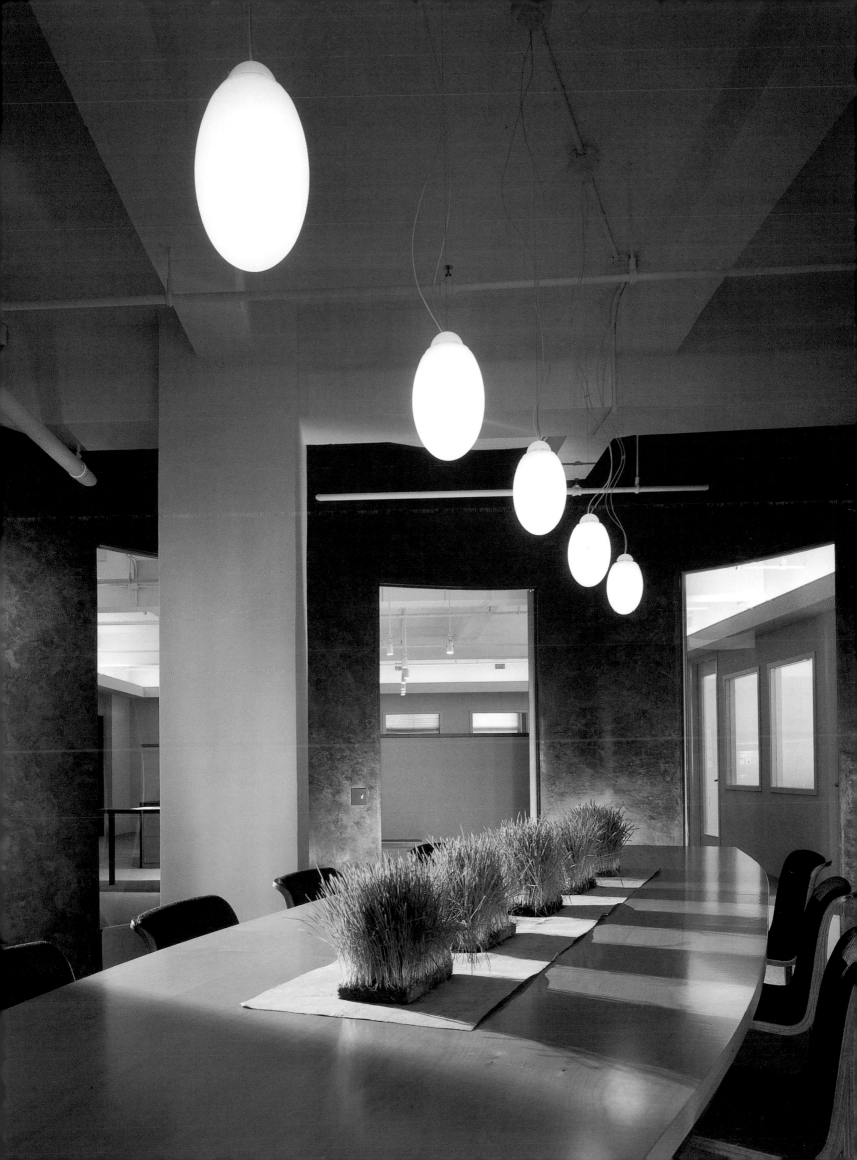

This major Detroit-area advertising agency came to Gensler with a full agenda: The agency needed to move its 360 employees out of cramped offices that had been occupied for over twenty-five years in three asbestos-ridden, non ADA compliant buildings in a suburban office park. What the client had in mind was more than just a move, however. It wanted the designers from Gensler to find and evaluate space for the new offices and to help the agency rethink its whole approach to the workplace environment. Gensler eventually found appropriate space—two and a half floors in a multitenant suburban low-rise building with 40,000-square-foot (3,600-square-meter) floor plates. The design team then developed a space plan that divides each of the full floors in half. It wraps open-plan office zones around a central core containing conference suite, auditorium, or multipurpose space along with elevator banks and reception lobbies. There are no closed offices in the design.

D'ARCY, MASIUS, BENTON & BOWLES
Troy, Michigan
Design by Gensler

Responding to the vision of DMB&B's management, the

◈
Red brick, particleboard, and vivid colors lend the interiors an energetic, dynamic quality. At left, a small informal meeting area.

◈
Small conference rooms are dedicated to specific brand teams and located in close proximity. The mix of cool, modern furniture and unusual finish materials such as red brick challenges the suburban location with urban-style juxtapositions.

◈
On the top, or fifth, floor, a double-height, skylit atrium space serves as a multipurpose space—presentation room, employee lounge, and informal conference room.

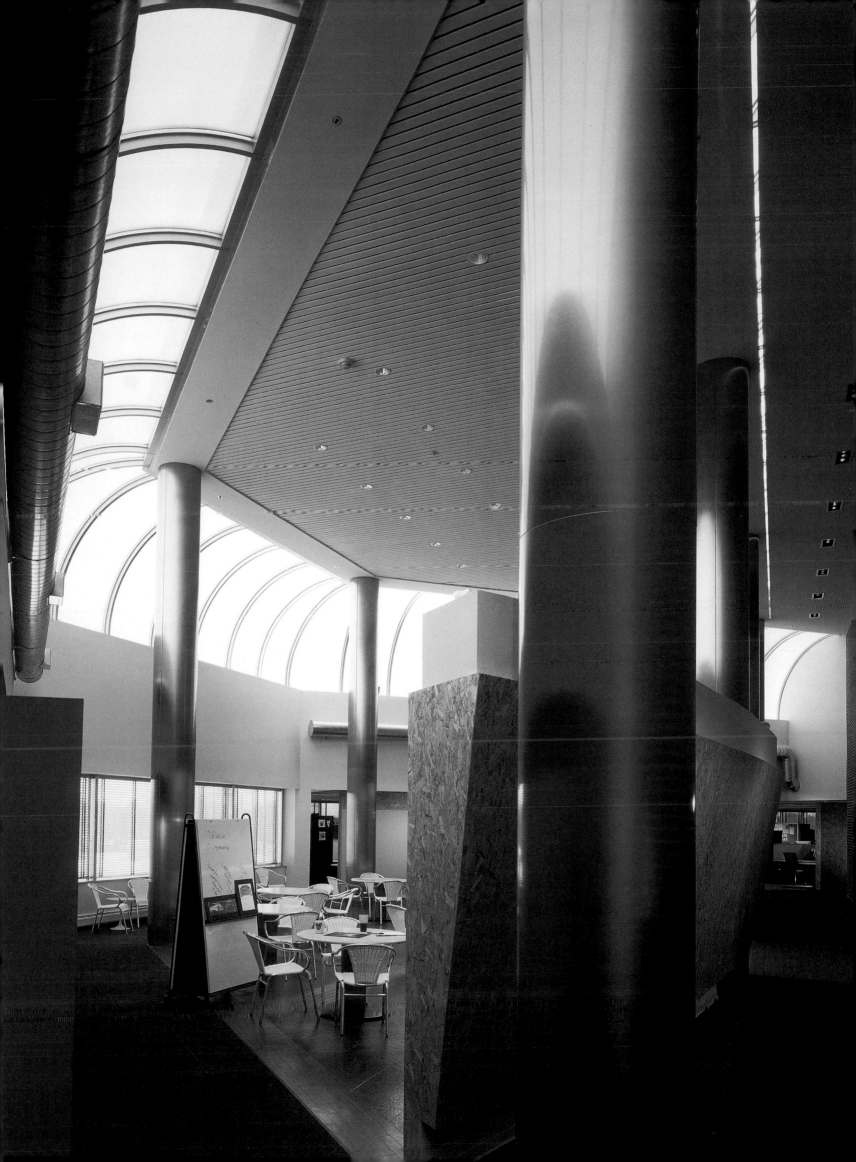

designers organized the office around the idea of brand teams, with each product's staff grouped in open workstations. Adjacent to the team areas are brand team-dedicated conference rooms for meetings and small private rooms for phone calls and privacy-requiring work. Two types of open-plan workstations replaced private offices, with flexible systems furniture specified to suit the varied needs of team members.

Circulation paths are slightly skewed off-grid, defined by colorful low partitions and occasionally interrupted by brick walls placed to shorten perceived corridor lengths. Fire stairs carry traffic between floors. Overhead, dropped ceilings were removed, exposing ductwork and structure. Floating ceiling tile and lighting grids are suspended from the structural ceiling, defining work areas. A purple and gold carpet sets the palette, while industrial-type materials, such as red brick and unpainted particleboard, lend the suburban location an urban feel. This edgy, industrial dynamic, coupled with the breakdown of hierarchical organization into a looser, more communicative environment, puts this suburban office into an energetic, contemporary urban mode.

Workers are grouped in brand teams and clustered in open-plan workstations rather than separated into private offices. Dropped ceiling panels signal the brand team groupings.

Modern furniture, offbeat materials such as natural-finished particleboard, and unusual choices in lighting lend this suburban office a degree of urban style, as is evident in the reception area.

The fourth floor conference and presentation room seats up to fifty and is equipped with state-of-the-art audiovisual gear. Translucent glass doors lend the room a luminous glow without sacrificing privacy.

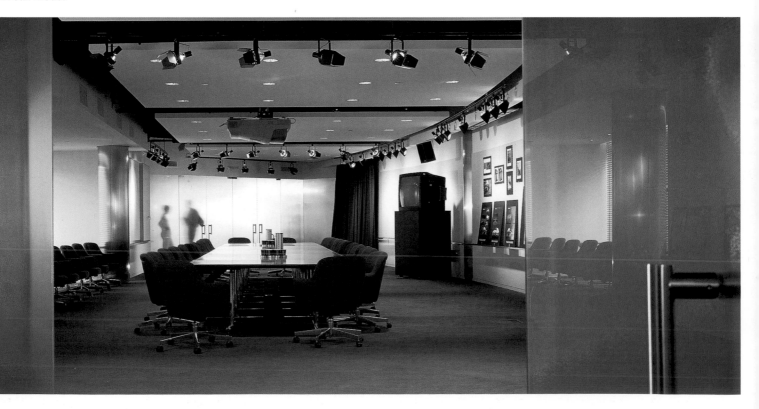

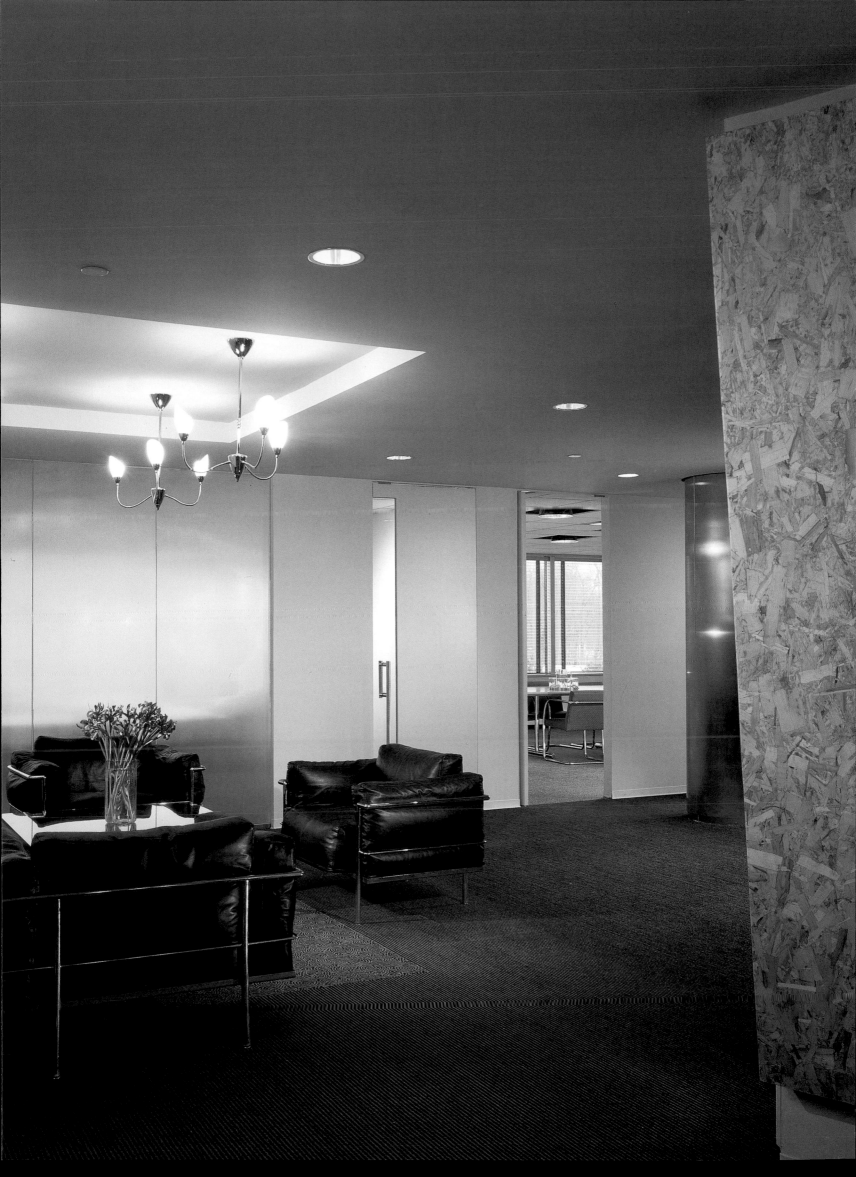

Located in a midtown Manhattan skyscraper, this light and airy new 21,000-square-foot (1,890-square-meter) office for a major New York construction company pulls together a haphazard, scattered array of dark, warren-like offices into a harmonious whole, simultaneously achieving a much-needed reorganization of space and a fresh new corporate image. The new space plan, worked out after a dozen variations were explored, is essentially quite simple, with a central reception area flanked by open-plan work areas to the right and executive offices and meeting rooms to the left.

MORSE DIESEL
New York, New York
Design by Brennan Beer Gorman Monk/Interiors, New York

With the floor plan established, the designers developed a new palette, one intended to convey a sense of lightness and accessibility. In the trapezoid-shaped reception area, cream-colored marble floors with green accents, cream-colored walls, natural sycamore millwork, and dark green upholstery set the tone, introducing the color scheme continued throughout. At once light in color yet rich in pattern, the

❖❖
The conference room can be subdivided into three smaller spaces with the partitions visible at right (top photo). The tables are shown here in two configurations.

❖❖
The office art collection consists of enlarged, sycamore-framed renderings of Morse Diesel construction projects—another enhancement of corporate identity.

natural sycamore wood is utilized as the primary finish building material, with the receptionist's desk, counters, doors, seats, and trim for the conference table all made of this pleasing material. The wood's swirling, flamelike pattern echoes in the reception areas marble floors and countertop, helping unify the project's separate elements. An art collection consisting of sycamore-framed renderings of major Morse Diesel construction projects adds a final, identity-enhancing flourish.

❖

Detail shows the beautiful, flamelike pattern of the natural sycamore, the primary finish building material in the office.

❖

The office art collection consists of enlarged, sycamore-framed renderings of Morse Diesel construction projects—another enhancement of corporate identity.

❖

The custom-designed conference table is trimmed with the same natural sycamore that is utilized throughout the office.

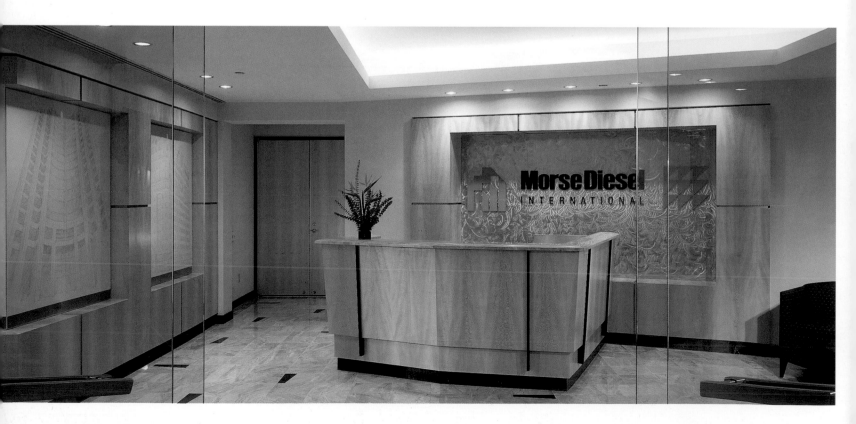

HIGH-TECH AND BIOTECH OFFICES

High-technology and biotechnology offices require certain distinct elements, such as sterile laboratory space or massive amounts of wiring, that can be unique to the genre. Yet perhaps more important than these functional requirements is a fundamental need to establish an image. With its arcane languages and complex machinery, high technology has something of a bad rap in some respects. It is daunting to many people and can stir a certain level of resentment, even fear. Thus, aside from functional needs, high-tech offices often take on a larger role, that of giving the company a friendly public face—a kinder and gentler way of being thought about. And so, for the most computerized firms in the world, you'll find office designs that might be described as high-tech with a human face. These offices, such as Sybase in Paris and Silicon Graphics in Mountain View, California, feature interiors with forms and imagery that clearly derive from the space-age style associated with high technology; yet, warm, bright colors, comfortable furniture, and expanses of glass make these firms more accessible—not only user-friendly but friendly to the person in the street.

Another thing about high-tech firms—the computer programmers, engineers, and other "tech heads" that work in these places often like to see how things work. Thus you'll find visible much of the stuff that is hidden behind walls and ceilings in most offices. Even the slickest of high-tech firms like to expose themselves. Take this approach to an extreme and you find the offices where Silicon Graphics and Dreamworks S.K.G. are collaborating on multimedia software: the very walls are left unfinished, with metal studs integral to the finished design. Of course, the exposed wiring has a practical purpose as well—computers change fast, as do the needs of their users. If some software engineer cooking up a new program at three o'clock in the morning needs more power to wire up a couple more hard drives, it makes it much easier to do so if the wires are exposed.

◈
**Silicon Graphics
Mountian View, California**

◈ **Chiron Corporation
Emeryville, California**

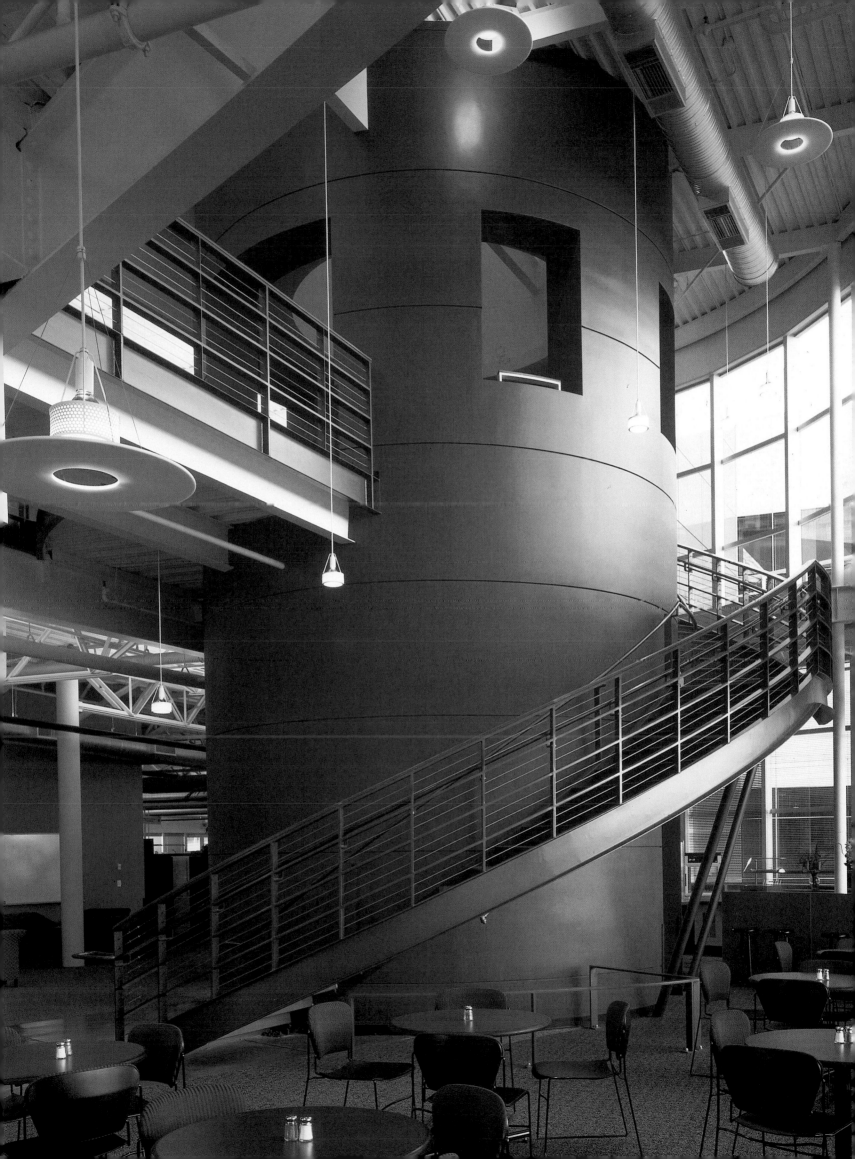

Architect Ross Anderson's distinctive design for this computer industry start-up company makes use of low-cost, offbeat materials in innovative applications. Located in an old warehouse building in lower Manhattan, the 3,500-square-foot (315-square-meter) project includes open-plan space for fifteen people, a computer laboratory, a conference room, private offices, and support space.

PREDICTIVE SYSTEMS, INC.
New York, New York
Design by Anderson/Schwartz Architects, New York

The focal point of the office is a gleaming white "building within the building." Housing computer hardware and networking equipment—the company's "nervous system"—the freestanding computer laboratory is enclosed in a skin of white marker-board panels crowned with a "shroud" of translucent Plexiglas. With a raised white floor and interior lighting, the laboratory glows like a lantern at night and diffuses and reflects light by day.

The office is organized around the laboratory, with workstations along

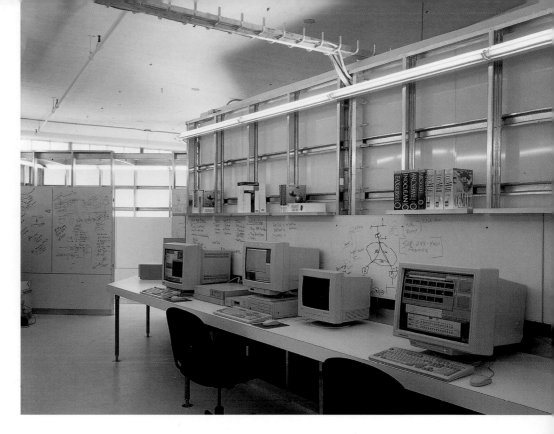

◆

Exposed structural systems and wire raceways become decorative elements, as does the multihued scrawl on the marker-board walls.

◆

Black chalkboards, left, and white marker-boards, right, divide spaces, serve as writing surfaces, and are thus transformed into decorative elements.

◆

The gleaming white "building within the building" houses the company's computers and networking equipment. The finish is white marker-board, with a translucent Plexiglas "shroud" on top.

the north wall and support areas to the south. In the entry, a linoleum floor pad indicates reception. The partners' offices and conference room are hidden behind pale green acrylic and translucent fiberglass panels framed with poplar studs. Light fixtures and floating cable trays connect the various areas; the original concrete floor also unifies.

Black chalkboard panels at the workstations and the white marker-board exterior of the computer laboratory are used as writing surfaces for brainstorming sessions. Covered with notes and equations, these surfaces then become decorative elements, the hieroglyphic scrawl animating the space with perpetually changing "functional" art.

A translucent, wood-framed fiberglass wall encloses private office space without cutting off light. The design explores and celebrates the integrity of low-cost materials.

Transparency and translucency are manipulated from space to space. Exposed hardware reveals the beauty to be found in functional things.

As is evident in this view over open-plan workstations to the computer laboratory in the white-enclosed cube, this office is stripped down to the basics, demonstrating the richness inherent in industrial materials.

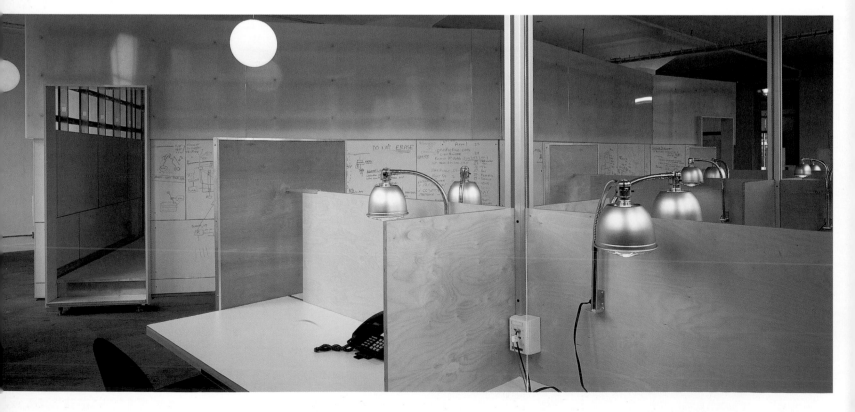

This innovative adaptive reuse project began its life as the Seattle City Light Steam Plant in 1911. Located on the south shore of Seattle's in-city Lake Union, the 100,000-square-foot (9,000-square-meter) structure is a striking visual landmark dominated by a row of smokestacks that give it the look of a beached ocean liner. Since ceasing operations as a steam plant in the mid-1980s, it was slated for condo conversion and designated a landmark by the city of Seattle.

ZYMOGENETICS
Seattle, Washington

Architecture by Daly & Associates and NBBJ, Seattle
Interior design by NBBJ, Seattle

Despite exterior rehabilitation work by local architects Daly & Associates, the condo plan fell through, and the biotechnology firm ZymoGenetics stepped in. ZymoGenetics hired the Seattle office of NBBJ to work with Daly on converting the structure into a somewhat unconventional office and laboratory complex. The relatively understated interiors evident in the renovation give no idea of the massive transformation involved. Steam-generating equipment weighing twenty-three million

◆

Twenty-three million pounds (10.4 million kilograms) of equipment had to be removed from the building before these biogenetic engineering laboratories could be installed.

◆

The laboratory bays are organized with a northwesterly orientation to open them to panoramic views of Lake Union. The skewed floor grid recalls the original building, which had been built with two overlapping structural grids.

◆

The glass-enclosed vestibule dramatically exposes the entry lobby and reception area—and fulfills a requirement to enhance the public's sense of accessibility to this former public-utility building.

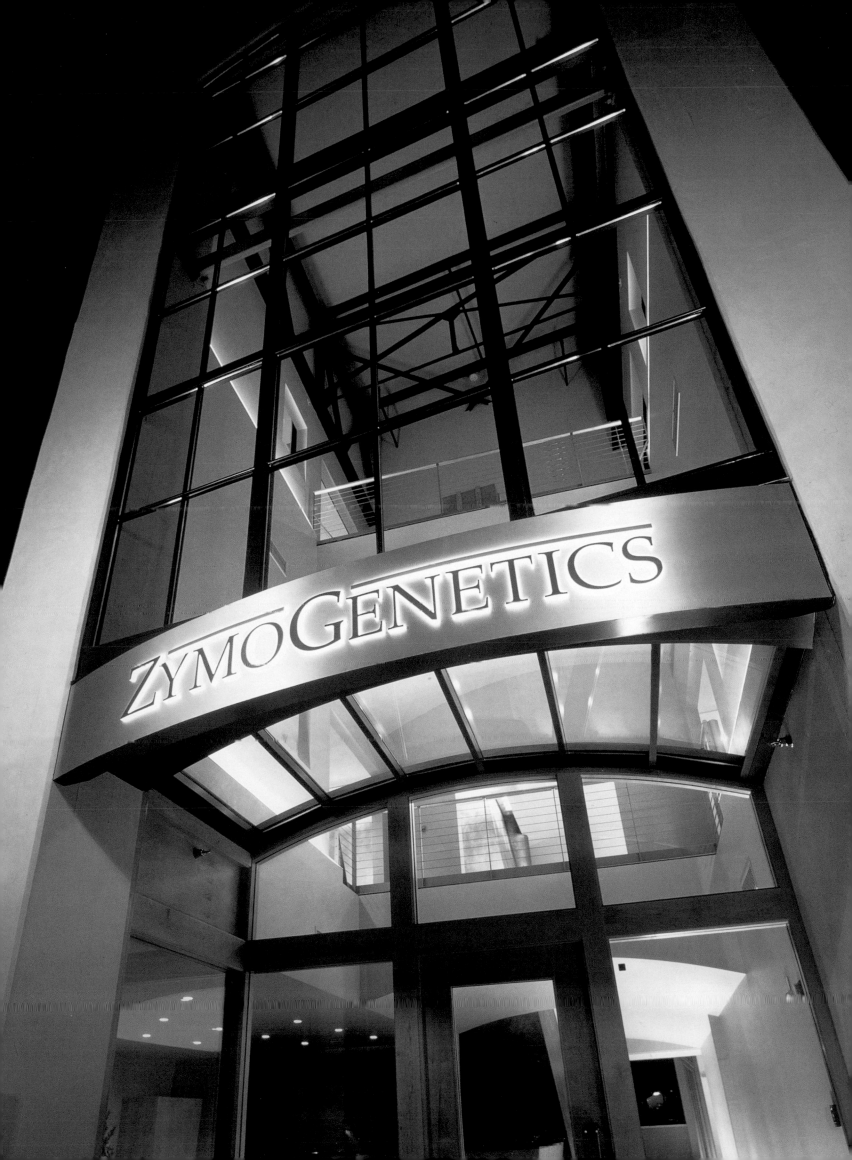

pounds (10.4 million kilograms) was removed; a first floor slab was taken out to make room for two levels of parking below ground.

Designed around a heavy, visually compelling, battered lead-finished wall, the first floor contains the lobby and offices; an espresso bar—this is Seattle, after all!—serves passersby on the ground-floor level. The upper floors house laboratories, laid out over the skewed, unpredictable floor patterns generated by the existence of two different structural grids. A twisting new staircase—inspired by an original spiral stair too dangerous to repair—was inserted to provide access to upper floors as well as to delineate sections of the building constructed at different times. On the top level the stair terminates in a corridor that visually links the building entry and the lake.

❖

Location is a big part of the appeal of this circa 1911 building, as is evident from this shot across Seattle's Lake Union. The steel smokestacks replace larger original ones.

❖

A battered, lead-finished wall thrusts through the lobby ceiling to great dramatic effect—one of the few architecturally bold gestures possible given the tight budget, the constraints of the building, and the complex functional requirements of the project.

Hollywood meets the cyberculture in this 100,000-square-foot (9,000-square-meter) warehouse project for a collaborative team of digital software pioneers. The venture joins Silicon Graphics with Dreamworks S.K.G. in an effort at developing new multimedia software applications. STUDIOS Architecture sought to create an environment that would foster an experimental, flexible, and innovative atmosphere.

SILICON STUDIO
Mountain View, California

Architecture and interior design by STUDIOS Architecture, San Francisco

The essence of this open plan is to enhance every opportunity for communications and brainstorming. There are no private offices in the facility, and several different types of custom workstations have been designed in an effort to accommodate the work styles of different individuals. Materials, forms, and spaces are intended to go against the grain of expectations. Raw, unfinished woods, plaster, and metal are the materials of choice, and circulation patterns meander unpredictably. Suspended "clouds" serve as lowered ceilings to foster

intimacy in gathering areas. Billboards and towers add urban icons to a compelling, seemingly random indoor landscape.

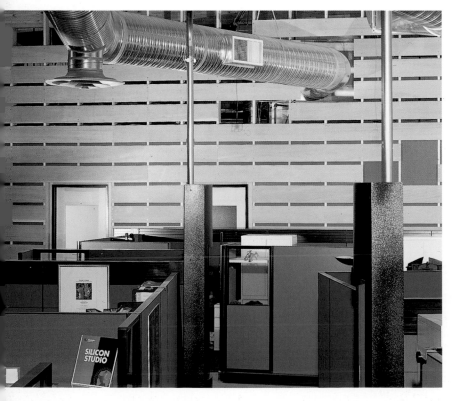

❖

One of the signature stylistic elements of high-tech company interiors—taken to an extreme in this project—is exposing beams, insulation, ducts, and everything else normally hidden above the ceiling. Exposed ductwork, high ceilings, and a 100 percent open-plan office enhance interaction.

❖

The employee coffee break area is delineated by a wall of white-painted Sheetrock below and exposed metal studs above.

Marking a shift from the entry/reception area to the open office area, a slanting wall of back-lit fiberglass is counterpointed by cable-carrying metal ladders, suspended track lighting fixtures, and exposed ducts.

The entry space sets the "anything goes" tone, with a custom reception desk on wood trusses and a galvanized metal wall separating the reception area from the office spaces.

A circulation corridor with typically offbeat elements: red doors, mixed wall finishes, and a slanted ceiling of exposed metal studs.

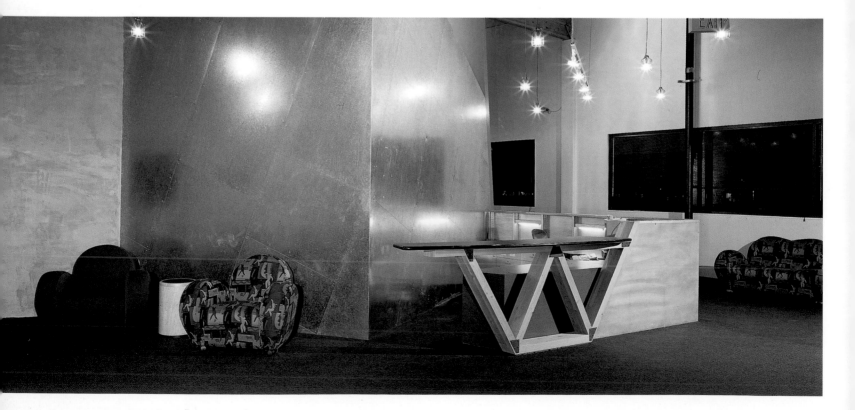

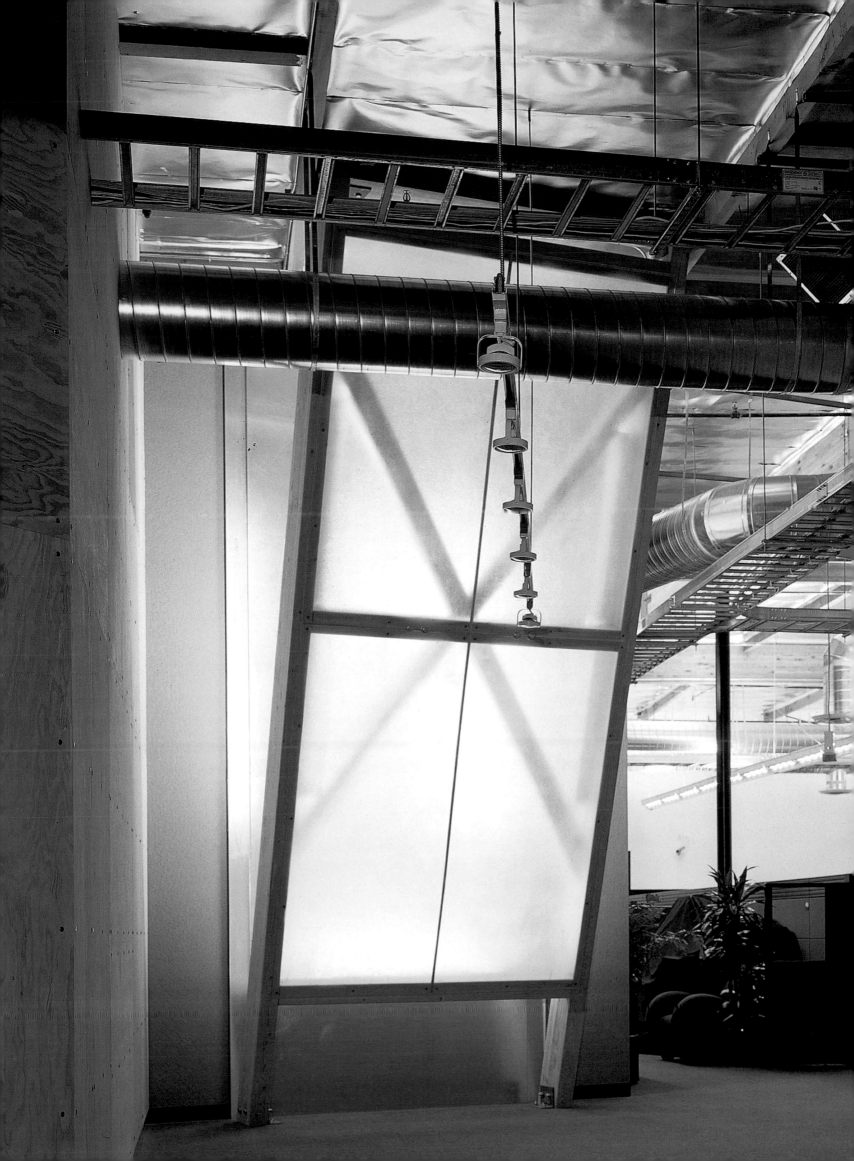

This low-cost retrofit into an existing brick and wood-trussed industrial district warehouse created 26,000 square feet (2,340 square meters) of open-plan workstations with a small number of private offices and extensive conference rooms for the finance department of this biogenetic engineering company. Given the three-year life span projected for this temporary office, the primary design directive was to keep the budget down without sacrificing style.

CHIRON CORPORATION
Emeryville, California

Interior design by Brayton & Hughes, San Francisco

The designers took their cues from the existing wood truss system and the alternating rows of industrial sash light monitors daylighting the brick-walled interiors. With circulation established via "streets" running perpendicular to the overhead light sources, each division within the office is clustered in a "village" of drywall "buildings," with three distinct wall heights suggesting urban street scales. The "street" edges are defined by panels of drywall painted by artist Mardi Burnham to evoke billboards,

◆

The semiobliterated graphics and other scrambled images on the walls suggest graffiti, billboards, and other elements of the urban landscape, reiterating the idea of the office as cityscape.

◆

View down a corridor into a "village." Each "village" contains clusters of three or four workstations. The high walls break what could have been a sea of workstations into smaller, more intimate spaces.

◆

The corrugated-steel dropped ceiling screens off mechanical equipment and also works as a lighting device, reflecting back the uplight from fluorescent fixtures.

graffiti, and industrial decay—
elements of urban neighborhoods
that typically go unnoticed. Lintels
of cold-rolled steel mark the open-
ings into "courtyards" within the
"villages." The "courtyards" serve
as open-plan work zones, while
flanking offices have doorways
reminiscent of storefronts.

Most of the ceiling is left open
to expose the existing structure.
Where needed, lowered ceilings
consist of suspended, corrugated-
steel "clouds." Supplementing the
available daylight, artificial illumina-
tion is provided by fluorescent and
halophane fixtures, with track-
mounted monopoints utilized to
highlight the art on the walls.

❖

Light-filled employee cafeteria is separated from the office zone by an
interior "street" at right. Note original wood ceilings and trusses.

❖

View shows how the high, hand-finished walls painted by artist Mardi
Burnham separate the inner cluster of workstation "villages" from other
perimeter work zones.

Located in the heart of California's Silicon Valley, this 111,600-square-foot (10,044-square-meter) structure, called the Shoreline Building, is intended to build on an architectural presence already established by a successful, innovative high-tech company. The design challenge for high-tech firms is maintaining the "techy" quality that defines this kind of enterprise while creating an architecture and interior design that also evokes a humane, warm corporate image—in this case one that is open and accessible to the surrounding community.

SILICON GRAPHICS
Mountain View, California

Architecture and interior design by STUDIOS Architecture, San Francisco

Extensive use of glass on the facade literally exposes the interiors to the community and to those speeding past on the nearby freeway. Within the building, bright, saturated colors washed with daylight, myriad intersecting and juxtaposed angles and curves, exposed structural elements, and contemporary furnishings and light fixtures establish a dynamic, high-tech ambience that signals the company's progressive, technologically sophisticated culture yet is also visually and physically appealing.

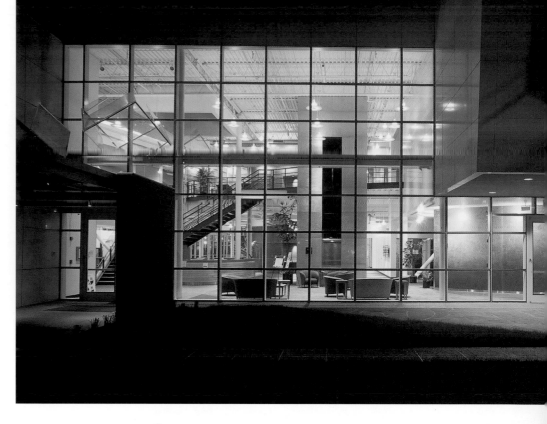

The high-visibility lobby enhances the sense of public accessibility and community outreach. Bright colors are a keystone of Silicon, producer of graphics products for computer systems.

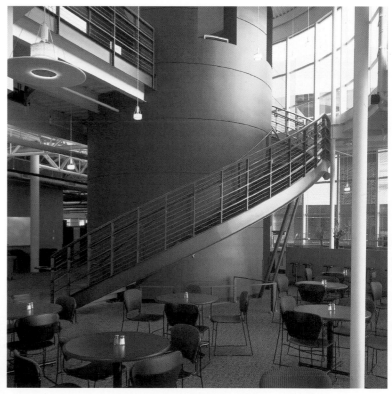

The deep purple column shows off what Silicon does best: color. The stylishly furnished employee café is meant to get the workers out of their offices, to mingle and communicate.

Glass walls open the building to the community. The sense of openness is more than symbolic, since Silicon Graphics has made meeting space in the building available for community groups and civic organizations.

The café, below, seen from the upper-level espresso bar. Multiple public spaces are intended to encourage employees to spend more time "hanging out."

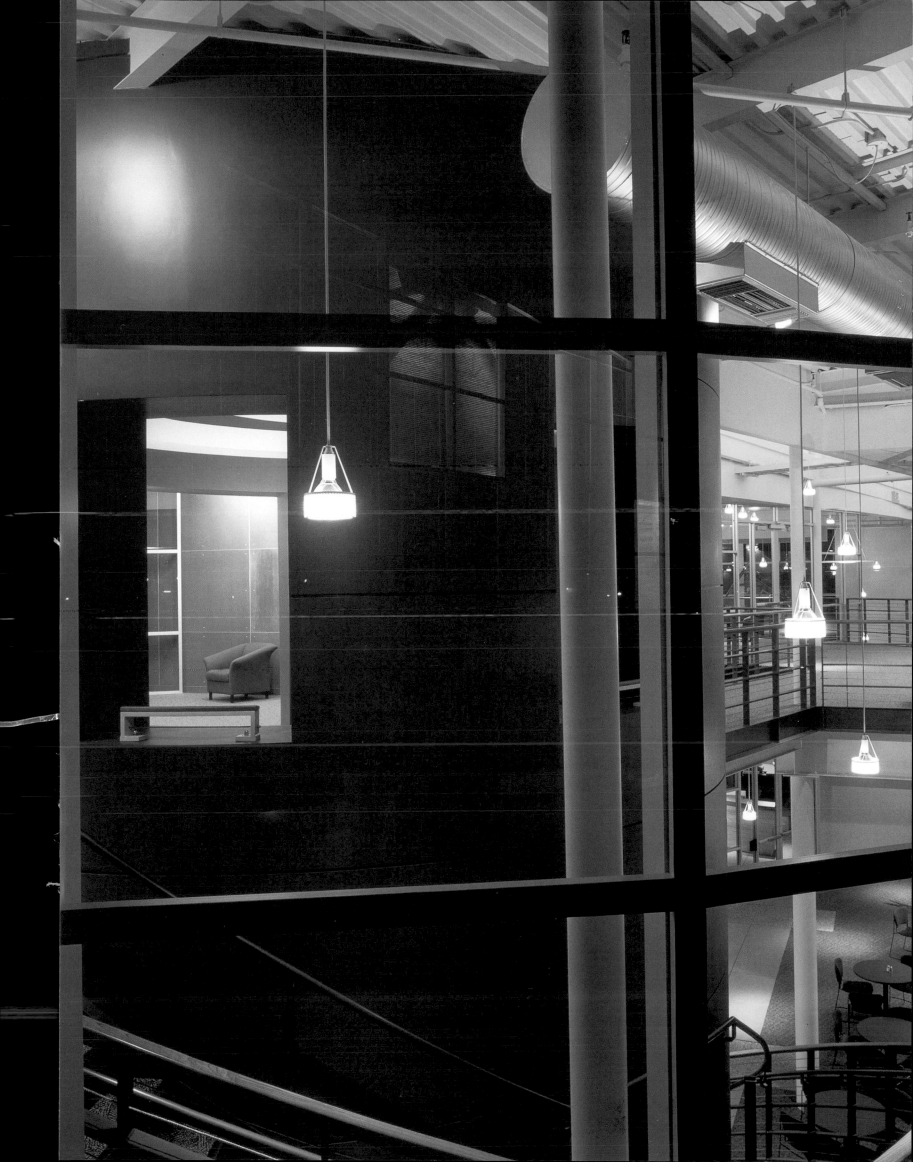

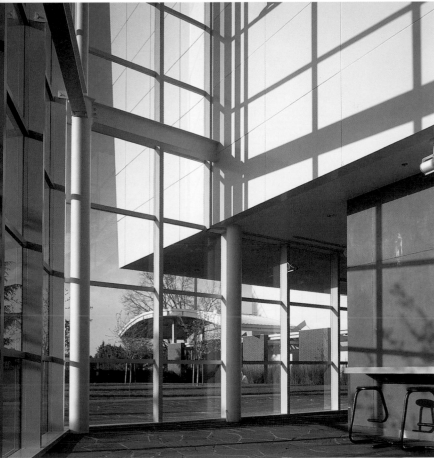

❖

This upper-level catwalk serves as a kind of spine, or axis, that bisects the building and organizes space on both sides. All employees work at open-plan workstations except for research and development personnel, who need more privacy for their intense efforts.

❖

A breakout area adjacent to the building's training facilities is bathed in daylight from windowwalls.

❖

A circulation corridor on the perimeter where light-saturated open-plan offices are located behind the wall, left. Exposing cables, ductwork, and other structural elements is a signature of high-tech offices, where employees like to see how things work.

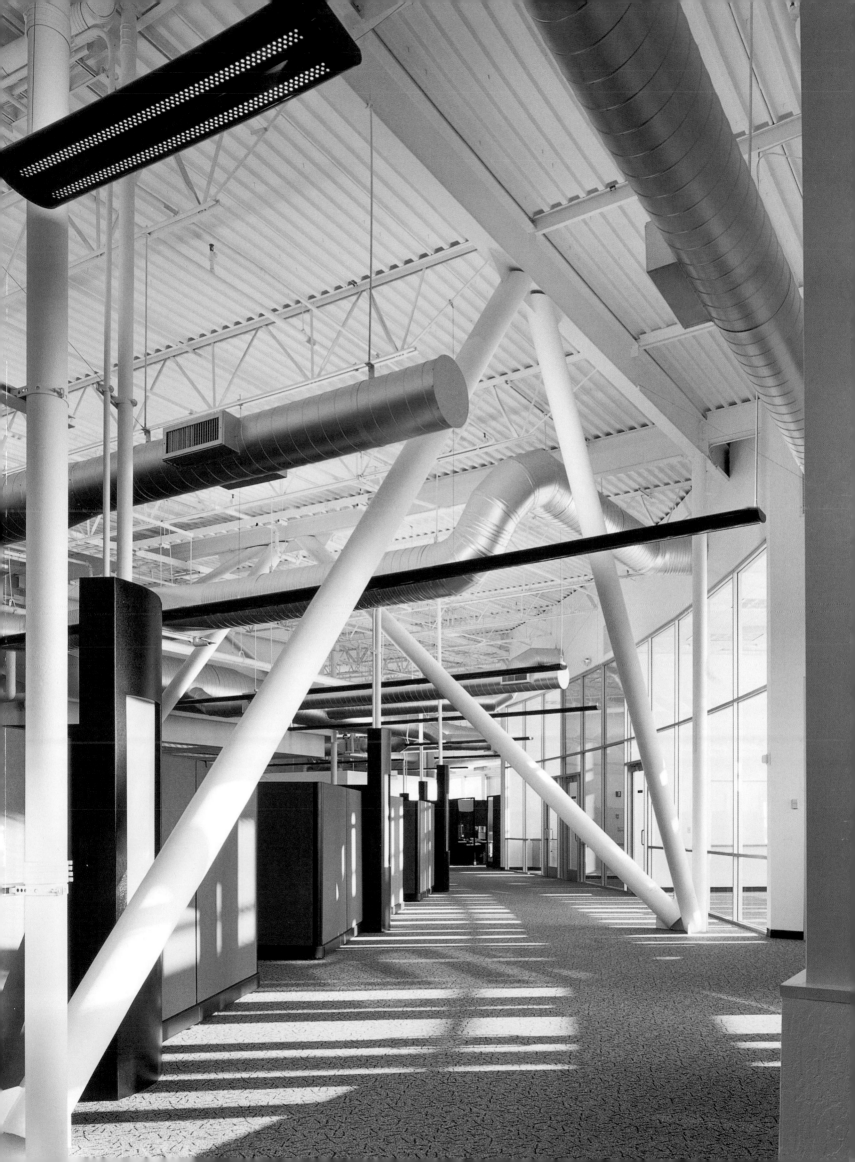

The Paris office of STUDIOS Architecture created this European headquarters for the software company Sybase, which has its home offices in Emeryville, California. The interiors include conference, seminar, and training space on the ground floor and office space on upper floors. Many of the shapes utilized in the interior finishes and furnishings play off Sybase's spiral-shaped logo, while the warm, bright colors are intended to humanize the image of the company.

SYBASE CORPORATION
Paris, France

Architecture and interior design by STUDIOS Architecture, Paris

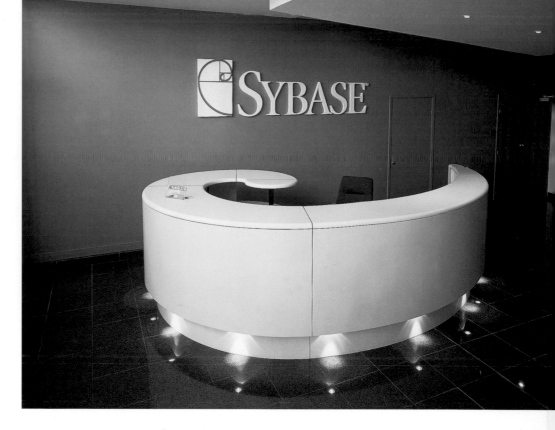

◆ The reception desk in the entry is white Corian sculpted into the shape of the corporate logo. The countertop is white laminate.

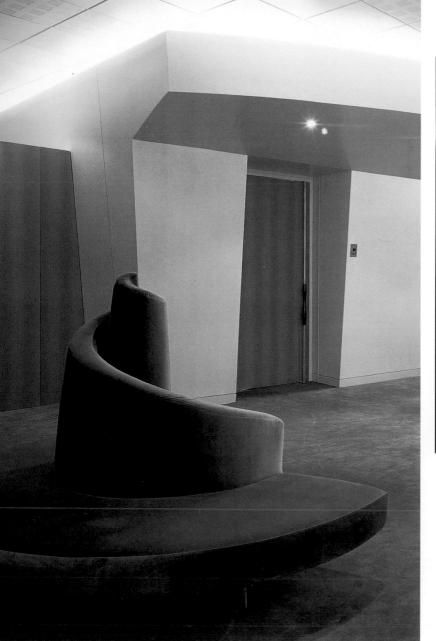

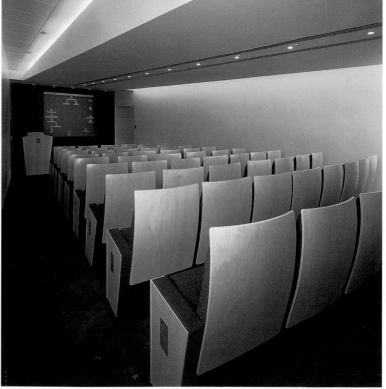

◆ The facility includes a small auditorium with a rear-view projection system for presentations and seminars. Seating is customized with higher backs.

◆ Spiral sofas in the breakout area on the ground floor are reminiscent of the corporate logo. The saturated colors, natural wood, and sparkling lights create a high-tech yet appealing ambience.

◆ The black, diamond-grid panel outside a cluster of classrooms is a purely decorative object, added to provide visual and textural interest.

Open-plan office space occupies the upper floors of the project. Individual workstations are something of a rarity in French offices, which usually are either open without separating cubicles or completely private.

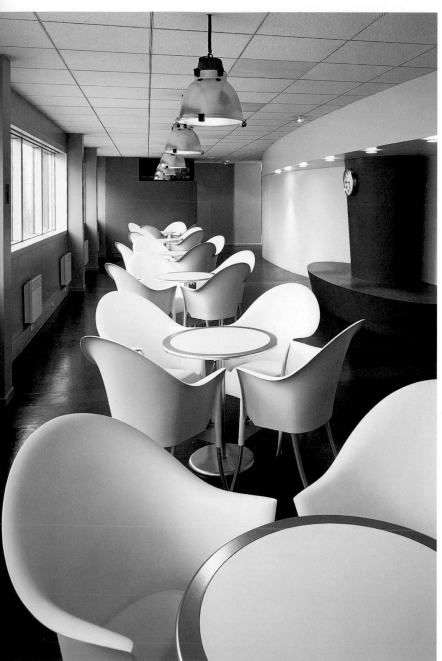

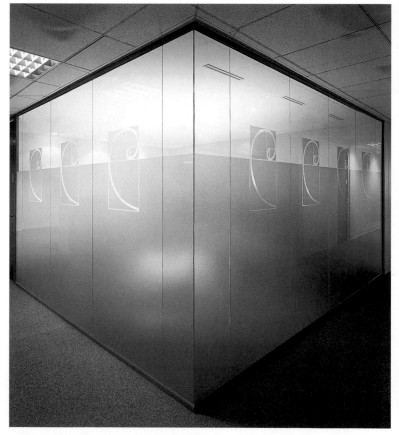

❖

A glass-enclosed corner conference room. For privacy, the lower parts of the glass walls are coated with a special film, with the corporate logo designed into them.

❖

Cafeteria space adjacent to first-floor classrooms is equipped with furniture and light fixtures with a kind of retro-futuristic appeal.

❖

Curving walls and rich colors highlight a classroom breakout space on the second floor.

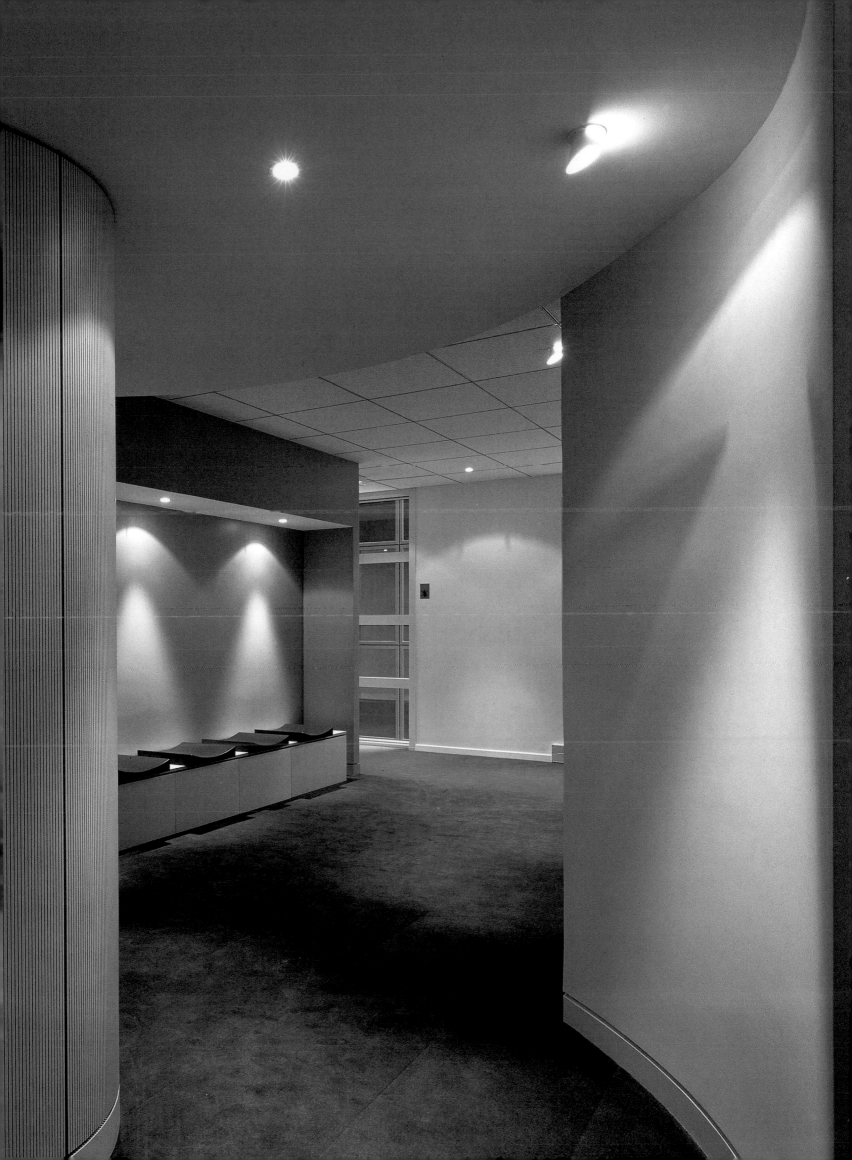

Located in an old 7,400-square-foot (666-square-meter) warehouse, the SoftImage office and studio integrates vibrant colors, sculpted forms, and exposed structural elements in a lively composition that effectively orchestrates complex high-tech functions. A maker of motion-capture software, SoftImage required open and private office spaces, large quantities of power with sufficient cable to carry it to computers, and an expansive open volume for product demonstration and development.

SOFTIMAGE
Santa Monica, California
Design by Callison Architecture, Seattle

Callison Architecture's floor plan for the project is organized by a curving blue wall that establishes a circulation path, with enclosed volumes along one side and open space on the other. Beneath skylights and an exposed ceiling, colorful partial-height walls screen off other functional areas, but the emphasis is on openness. To this end, the design team created a series of mobile pods—oval-shaped workstations wrapped in translucent fabric—that can be moved about on a raised computer floor. Software designers can teamwork

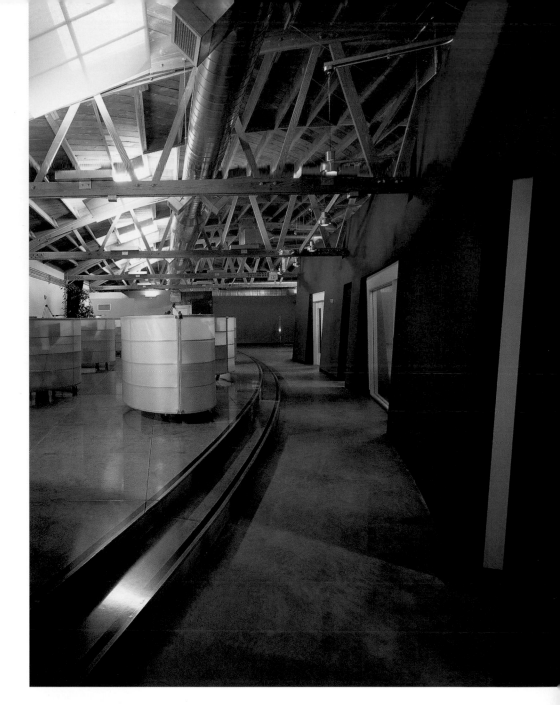

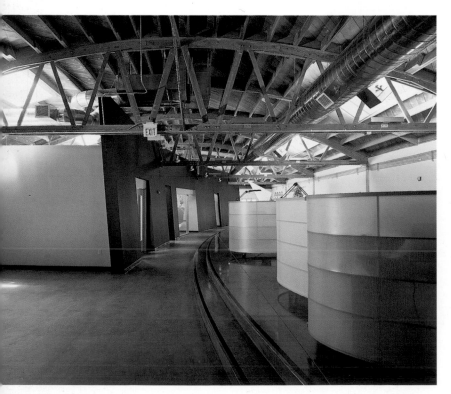

in this area, reconfiguring the pods at will or moving them aside for demonstrations or promotional activities. These odd little pods and the play of bright colors, angled forms, and curved walls against original structural elements add up to a stimulating expression of cybercultural style.

❖

The curving blue wall at right establishes a circulation path and screens private office space from the open area at left. The translucent oval pods are mobile workstations sitting on a raised computer floor equipped with multiple outlets so that the workstations can be moved.

❖❖

The oval pods are wrapped in translucent fabric and can be moved around on the raised computer floor. The new floor was stained to match the stained concrete of the original floor at right.

❖

The counterpoint of vibrant forms and colors and trendy furniture poised against original materials—wooden ceilings, concrete floor—is classic late-1990s high-tech design. It demonstrates appreciation of the integrity of existing structures coupled with a willingness to be playful and unpredictable: to tweak the old with the new.

Located on three floors of a 1940s San Francisco building with a hint of Moderne in its original architecture, the new offices for Kinetix represent an effort by the HOK design team to establish a separate identity for this highly creative division of a large corporation, Autodesk. Working for Hollywood and multimedia clients such as Dreamworks S.K.G., Kinetix employees produce bright, colorful animation software. The Kinetix culture is based on flexibility and teamwork. At once vivid and bold yet comfortably residential, the design of the offices is inspired by both the look of the product and the informal style of the corporate culture.

KINETIX
San Francisco, California
Design by HOK San Francisco

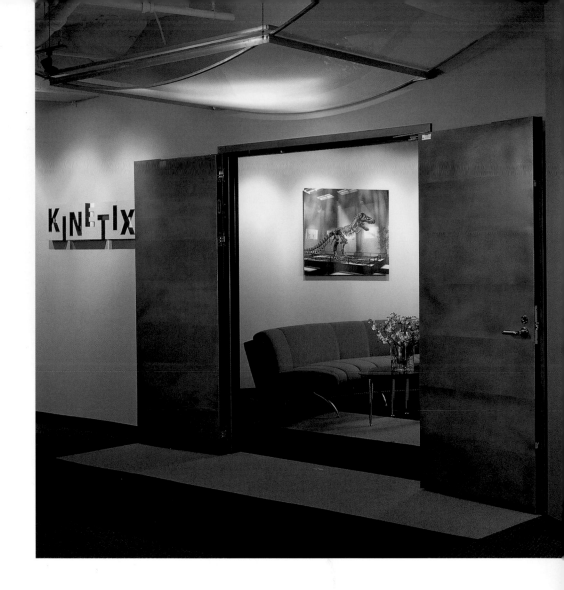

The designers began by stripping the interiors to reveal the concrete structure and to enhance the flow of natural light into the building. They then set out to establish a non-traditional work environment that supported telecommuting, shifting teams of collaborative workers, and workers on different schedules. The typical work area is an open space furnished with a desk system that consists of an interchangeable kit of

parts. Other furnishings include mobile file units and lockers. With private offices virtually eliminated, private and open meeting spaces are provided, along with areas for chance encounters—the informal, freewheeling brainstorming sessions that often are the source of breakthrough ideas in the rapid-fire environment of multimedia. The floor plan also provides space for a training room, an executive briefing center, a penthouse-level break area, and a communications center. The bright, lively colors—lime green, ochre, and indigo blue—infuse the space with energy that recalls the vibrancy of the product.

❖

The offices' bold palette and comfortably informal sensibility are established in the reception area.

❖

The work areas are left open, permitting shifting teams of workers to use them at different times. The furniture has been specified for flexibility and mobility.

❖

View from a meeting room down a circulation corridor. When employees do not have private office space, they use lockers—in the wall at rear—to store their personal belongings.

HOK London became involved in this project after initiation of the design process. At the time, HOK was brought in to provide interior design for Glaxo's R&D facility administration building, one of six on the corporate campus, and to specify color, furniture, and materials for other projects. Eventually, Glaxo also requested that the HOK team redesign the administration building, creating enough flexibility to allow the inclusion of executive offices. The administration building also houses a lobby, auditorium, library, cafeteria, private dining and breakout space, and a health center.

GLAXO
Stevenage, Hertfordshire, England
Design by HOK London

HOK also managed some changes in other building plans as well, redesigning the breakout "nodes" where research scientists would gather when not working in their laboratories. The designers also provided color and materials specifications for the laboratories and assisted in creating a landscape plan that would integrate the buildings more seamlessly into the natural terrain. Although they arrived on the scene too late to master-

plan the facility, HOK designers made significant contributions that improved the appearance and the functional quality of this 1.5-million-square-foot (135,000-square-meter) facility.

❖

The two-level research library is organized around a spiral stair. The library has been placed in a very visible location, suggesting the importance of research to the company.

❖

The two-level employee cafeteria is furnished with fresh, contemporary seating and features a view of a man-made lake on the corporate campus.

❖

A view of the stainless steel, wood, and glass reception counter. The curving glass wall behind it carves off a corridor.

This fast-track, low-budget, 10,000-square-foot (900-square-meter) office might have turned out a cross-cultural hodgepodge if it had not been put together with so much verve. Here we have the Japanese headquarters of a rapidly expanding mobile phone company that originated in Finland (Nokia is the second-largest manufacturer of cellular phones in the world, after Motorola) designed by an American-based firm. The Gensler designers began with a space search and evaluation on behalf of the client, and by the time they had chosen the building, they were just three months from opening. Gensler then sped up the design and construction process by bringing the contractor in as part of the development team.

NOKIA MOBILE PHONE (JAPAN) KK
Tokyo, Japan

Design by Gensler

Nokia's image is about change. Ten years ago, the company was buttoned-down, blue and gray, and fundamentally conservative. In the last decade, the company has gotten a lot more colorful, to say the least. The last annual report was unconventional in layout and colorfully energetic; this office design is

meant to convey the same sense of vitality. And yet the budget was strictly limited, and the design was done in a hurry. To make the most of little money, the designers utilized low-cost products, such as colored glass and red-painted metal frames, along with plenty of bright, bold colors counterpointed by light sycamore wood installed to identify and celebrate the company's Finnish roots. The design succeeds in fulfilling the corporate requirement for a fresh, contemporary image while providing comfortable, functional, and flexible workspaces.

❖

The reception area sets the tone, with light sycamore wood counterpointed with plenty of color, including red-painted metal frames. The rotating purple door/panels can close off this room for private meetings. When open, they enhance the aura of accessibility that defines the style of the office.

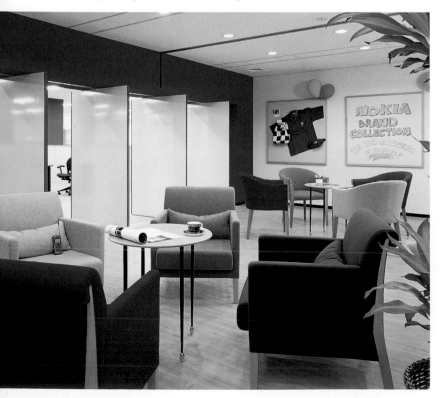

❖

Translucent rotating door/panels do double duty as a wall and writing surface when closed; when swung open, they create access into this informal gathering space from the adjacent open-plan work areas.

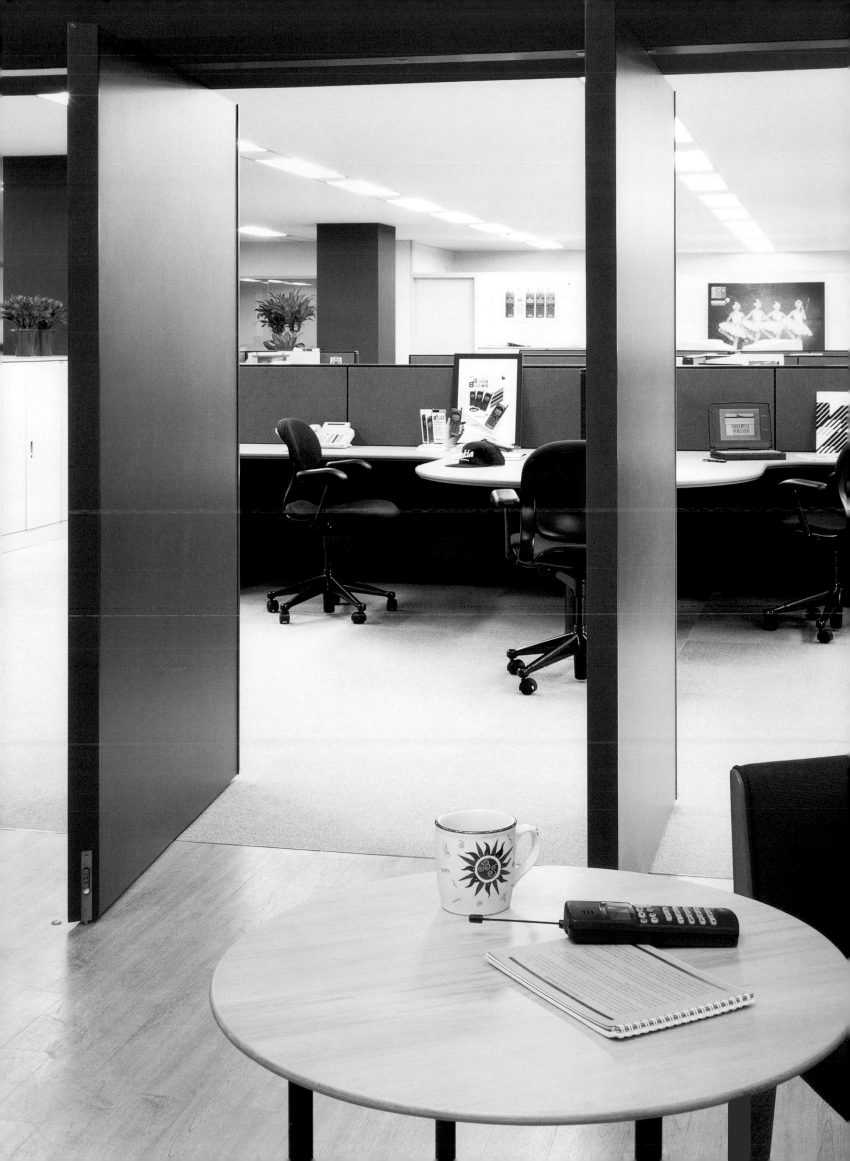

BANKING, INSURANCE, CONSULTANT, AND LAW OFFICES

While these office types have diverse functional requirements, they share a similar sensibility: buttoned-down, traditional, conservative, perhaps more hierarchy- and status-conscious than those found in more adventurous workaday realms. However, within the parameters of these traditions, rules are currently being stretched to the breaking point under the influence of technology, globalization, and other elements that are redefining the way business is done as we approach the millennium. Consider this kind of office as you might consider an elegant, well-cut suit: There is room for stylistic innovation, but you are still conforming to a dress code.

Whatever one thinks about the vast armies of lawyers practicing in America, their numbers alone pretty much guarantee some diversity in their office designs. At the same time, it behooves lawyers to mimic their clients to some extent, to establish a comfortable level of familiarity. Traditional corporate law firms look, well, corporate; firms devoted to high-tech clientele take on some of the adventurous aspects of their clients' style. And so on. And as is evident in the pair of offices Brayton & Hughes did for the California firm of Orrick Herrington & Sutcliffe, there is room for diversity even in different branch offices designed for a single client. Likewise, while the Chicago branch of a Japanese bank has its Japanese elements, it also looks at home in Chicago.

Ultimately, as is evident in these projects, good design of these traditional types of offices is innovative without being iconoclastic. You can bend the rules, but you'd best not break them. What you see in these elegant spaces is money well spent to create an atmosphere appropriate for dealing with legal, financial, and other business matters that are inherently conservative. "Conservative" no longer implies dark or stuffily traditional, but frequently it does connote a less adventurous approach. This is not to say less elegant or less beautiful. For the most part, these offices are quiet, modern classics.

Scudder, Stevens & Clark, Chicago

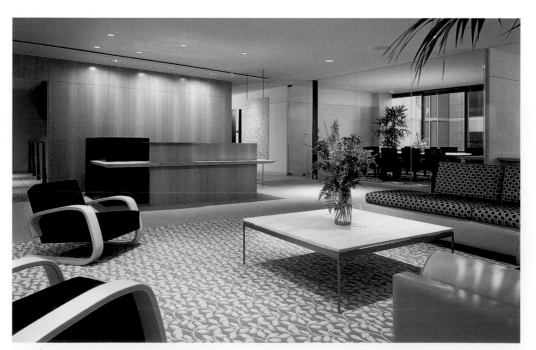

◈ **Latham & Watkins, San Diego**

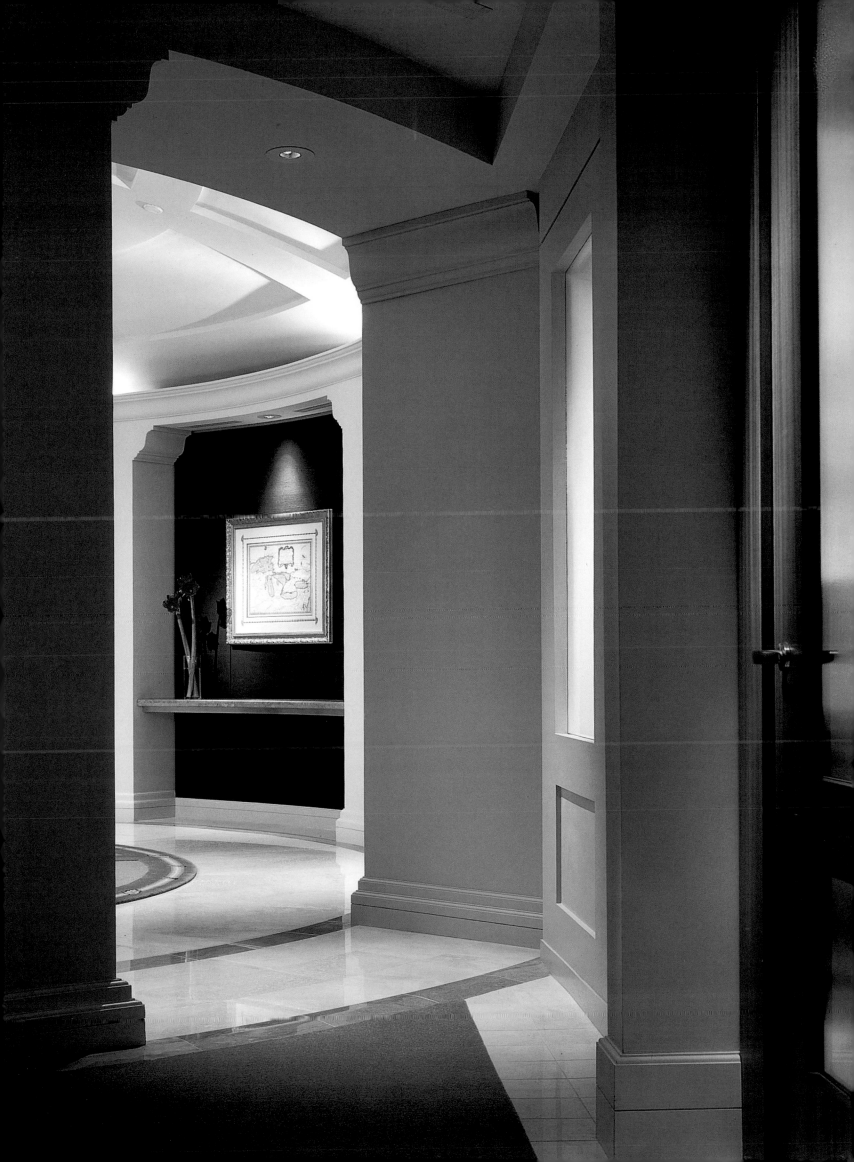

For the Chicago branch of a major Japanese bank, a design team from Perkins & Will created offices that evoke both Japanese and American cultures. The elegantly minimal public spaces are subtly infused with a sense of Japan, while the work areas are set up to function in classic corporate American style—with a twist: Japanese corporations are more hierarchical than their American counterparts, and this office reflects that difference in some respects.

TOKAI BANK
Chicago, Illinois
Design by Perkins & Will, Chicago

The most dramatic spaces in this office are public, where employees meet clientele: reception, conference, and meeting rooms. In the serene "ceremonial" space that is reception, colors are neutral, materials rich: black granite floors, a massive sandstone bench, white lacquered screens, and stainless steel and limestone walls. The effect is spare yet luxurious.

In the open-plan work areas, the neutral palette continues, with less expensive materials. Space is tightly orchestrated, and the traditional hierarchies are upheld, with the executives near windows and lower-ranking employees closer to the core. The manager sits in the open, watching the workers, and partitions are no higher than 42 inches (108 centimeters) to keep his sightlines clear. This Japanese approach to office management rings a little strange in contemporary corporate America, but regardless of that, the office's two distinct zones are clearly articulated by the design, and the public spaces are a study in understated elegance.

◈

The workstation area shares a palette with the public areas, but the materials are less expensive. In the Japanese style, the partitions are lower than normal for American offices so that the general manager, whose desk rests against the gold wall, can observe employees at work.

◈

Reception and other "ceremonial" areas that will be experienced by the bank's clients are designed in a rich yet minimal style that owes a subtle debt to Japanese design. Materials include black granite floors, stainless steel and limestone walls, a sandstone bench, and white lacquered screens.

◈

The elevator lobby introduces the unembellished yet materially luxurious palette, with white lacquered screens and blue sandblasted glass panels.

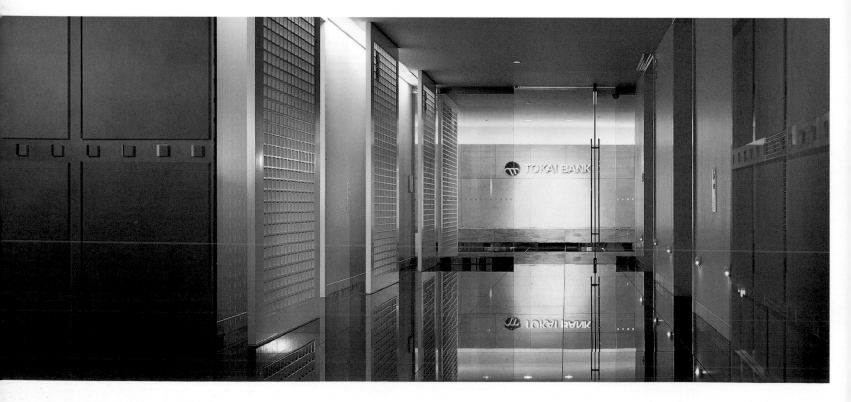

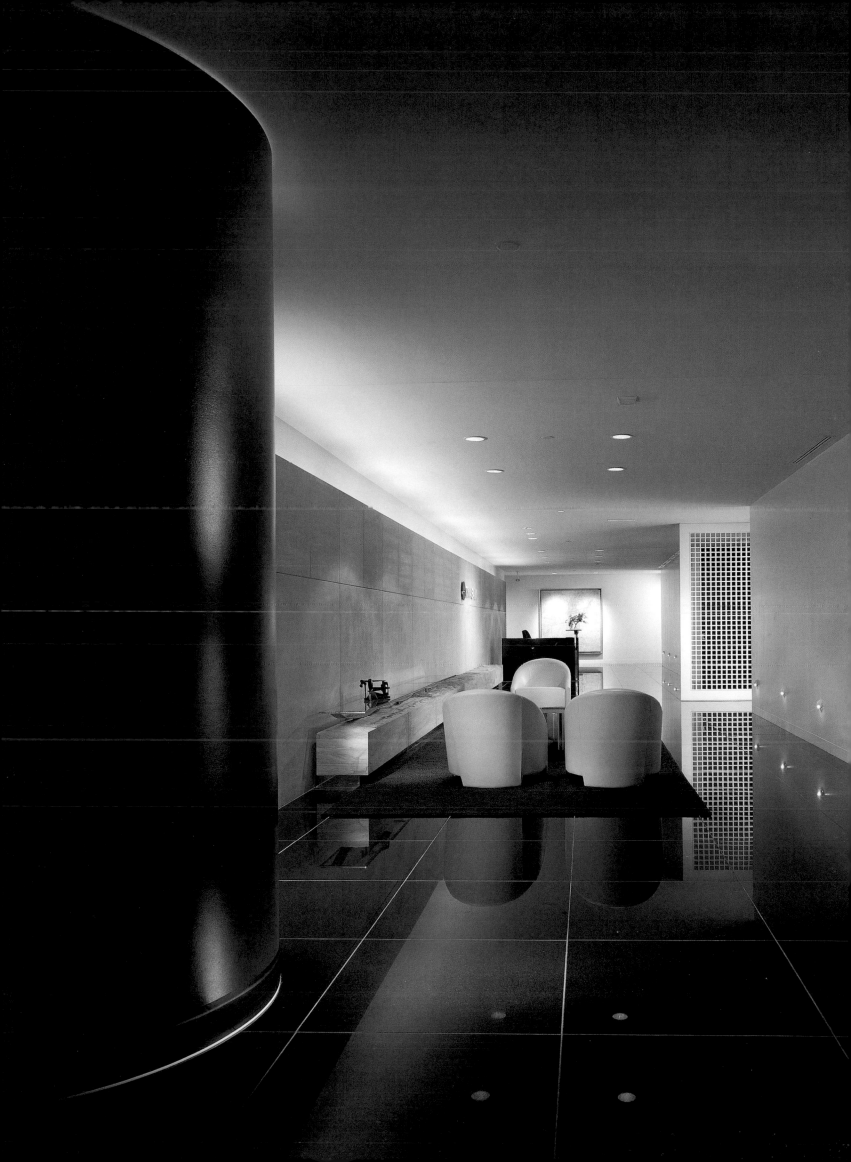

This 3,000-square-foot (270-square-meter) project for a three-person venture capital firm is remarkable for its mobility, among other things. The interior has been constructed with few permanent elements, allowing most of the design to be relocated in the future.

VOLPE WELTY ASSET MANAGEMENT
Alameda, California
Design by Brayton & Hughes,
San Francisco

Aside from this clever and economical flexibility, the office is a beautiful essay in modernism. The entire project consists of an open reception and conference area with three private offices opening off one side. The most striking design element is the multicolored, multitextured, cubist-like assemblage of cabinets, screens, and display space separating the reception area from the conference space. Containing concealed audiovisual equipment as well as a number of elegantly displayed artifacts from the client's collection, this wonderful piece is an artifact in itself—a lovely homage to the most significant design movement of the twentieth century. Along with all the furniture in this office, it reaffirms the pure, timeless beauty of modernism.

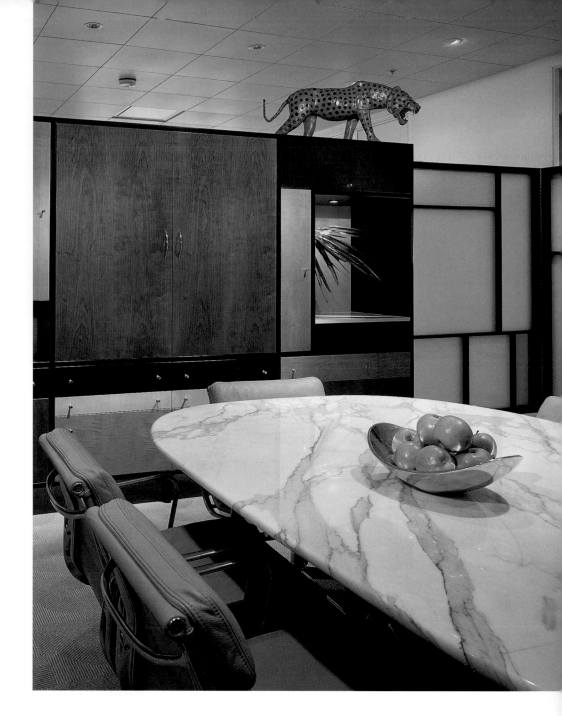

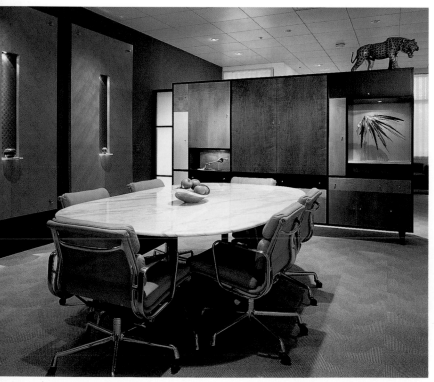

❖

An oval-shaped, irregularly veined marble tabletop and several carefully selected and displayed artifacts stand out beautifully against the modernist rectilinearity of the design.

❖

A view of the conference room looking back toward reception. The colors and proportions of the doors and display spaces in the cabinet/screen completely change from one side to the other.

❖

Translucent glass panels extend the screen/cabinet to the perimeter wall. Myriad woods, colors, and finishes give this simple, elegantly designed piece a surprising visual richness.

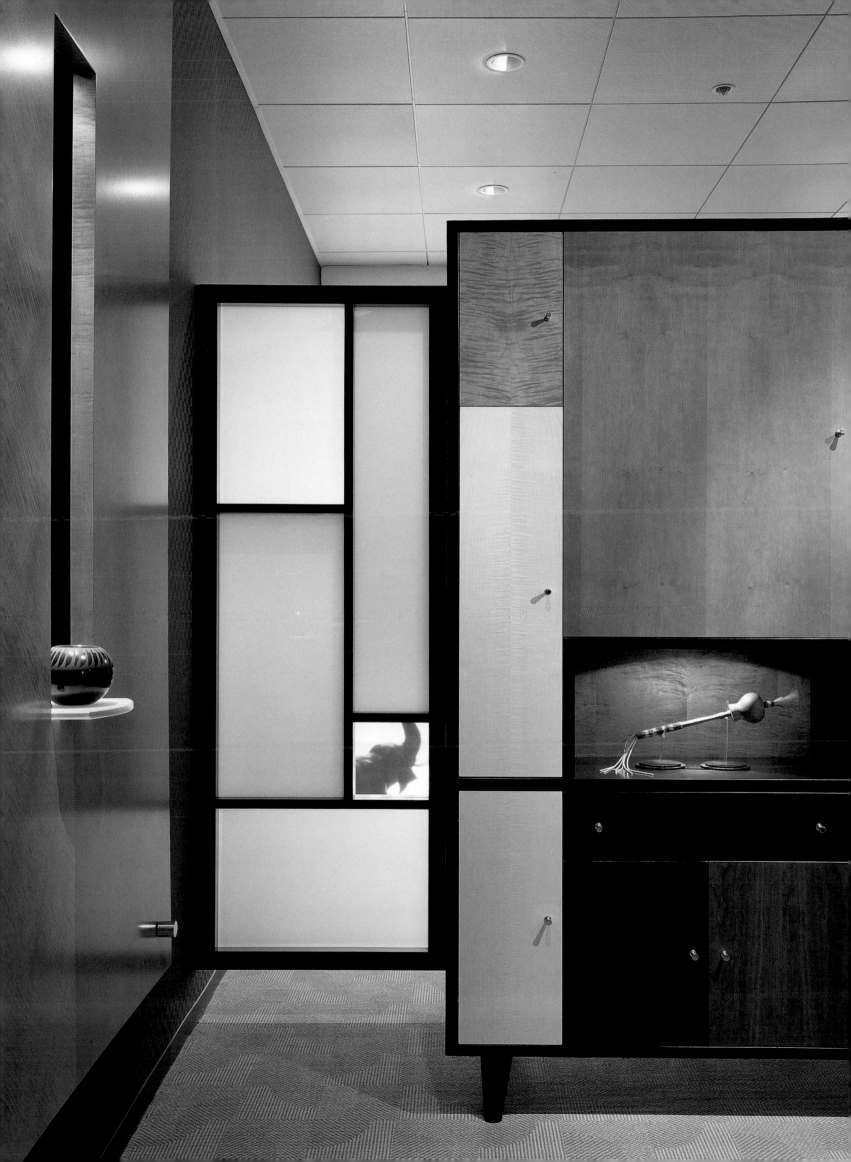

In creating new offices for the
Melchor Investment Company, an
eight-person firm, in a building that
once housed a glass factory,
designers from Brayton & Hughes
created a distinctive interior while
preserving the industrial character
of the original structure. Within the
tight confines of 3,000 square feet
(270 square meters), the design
team squeezed reception, confer-
ence, a private office, restroom,
pantry, work counter, and
storage space.

MELCHOR INVESTMENT COMPANY
Palo Alto, California

Design by Brayton & Hughes,
 San Francisco

Two boxy forms separated from the
existing concrete walls contain ser-
vice functions; the solidity of these
forms is balanced by a yellow,
trellis-like wall, composed of lattice
screens and structural portals,
which forms a longitudinal axis
dividing the workstations from a
small open-plan work area and the
open conference room. Preexisting
elements—the exposed ceiling
truss system and a concrete floor
stained the color of earth—ground
the design and lend the interiors a
measure of industrial integrity; the
vibrant yellow latticework wall adds
a refreshing, provocative edge.

❖

The rough, natural finishes of concrete, zinc, and steel are beautifully
counterpointed by the ceiling truss system and vivid yellow latticework
wall. The floor is original concrete stained a deep earth tone to "ground"
the design.

❖

A view of a workstation, shown between sections of the yellow lattice-
work wall. The table is custom-designed with a zinc top.

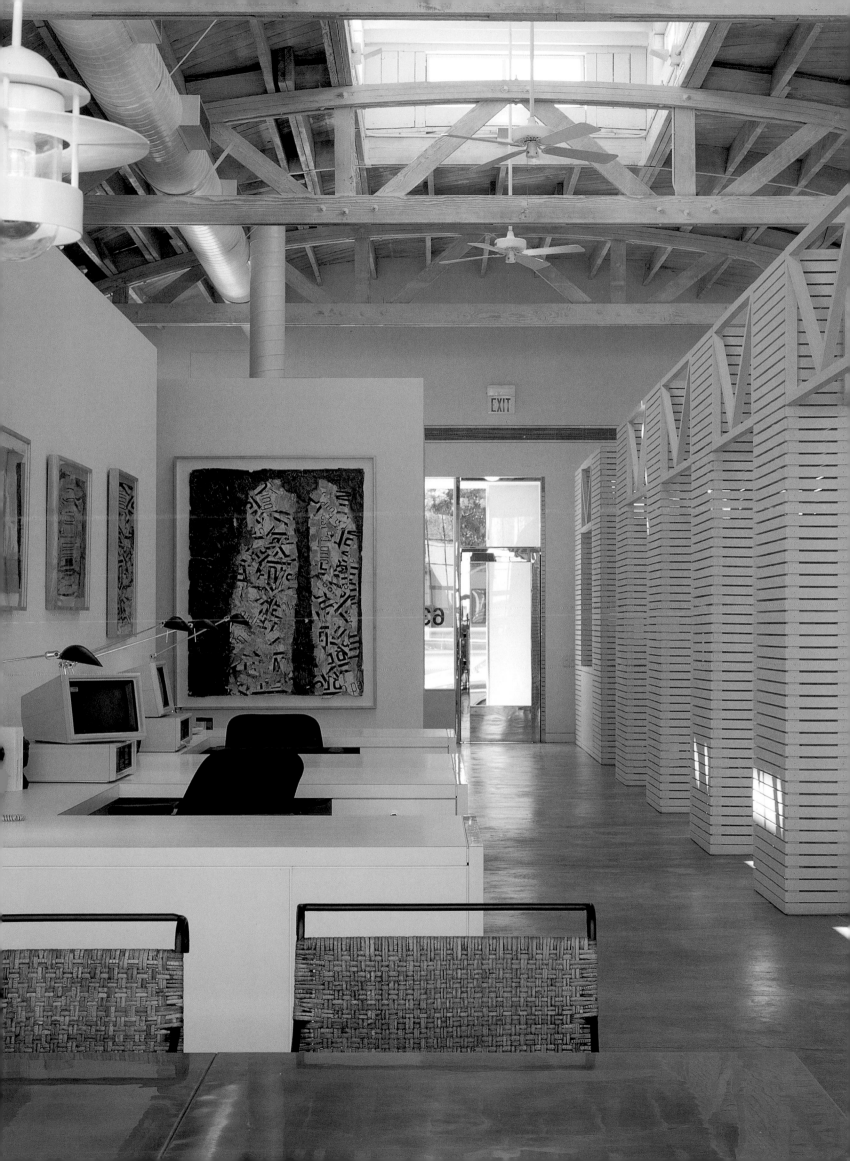

When the consulting firm A. T. Kearney planned a move to a larger headquarters office in Chicago, the firm's planners seized the opportunity to make their own new offices a demonstration for the management ideas they are paid to give their corporate clients. According to Kearney, today's successful corporate culture emphasizes teamwork, flattened hierarchies, and open communication—and so the designers from Perkins & Will created these striking new interiors as a working model of the ideal contemporary office.

A. T. KEARNEY
Chicago, Illinois
Design by Perkins & Will, Chicago

The centerpiece of the 100,000-square-foot (9,000-square-meter) office is the staircase linking all four floors. Rather than sitting out front in the traditional, client-impressing location, the open stair, with its furnished landings intended to promote communications and teamwork, is suspended in a central atrium—the most desirable real estate in the interior—and enclosed in glass walls. Highly visible behind these walls are board rooms, conference rooms, and the library.

Wrapped around the central staircase and its meeting areas, the offices use the idea of openness and accessibility as well. Corner offices, usually reserved for high-level management, are shared by groups of consultants. Custom-designed workstations balance openness with privacy needs. Materials include cherry wall panels, black granite tables, and leather upholstery in the work areas. By contrast, public areas are finished in slate, terrazzo, and precast concrete, with stainless steel and bronze details. The reception desk and the staircase emerge as dominant design elements, their gracefully sculpted forms taking on the role of functional art.

◈

The four-story staircase in a glass-enclosed atrium at the heart of the interior is the literal and figurative expression of the open, team-oriented philosophy that guides the company. The boardroom is visible through the glass wall at rear.

◈

Computers in the company library provides access to all major online information services. The library is positioned adjacent to the central atrium, serving as a highly visible hub of corporate activity.

◈

Seen from the elevator lobby poised against a wall paneled in slate, the reception desk is a striking piece of functional sculpture.

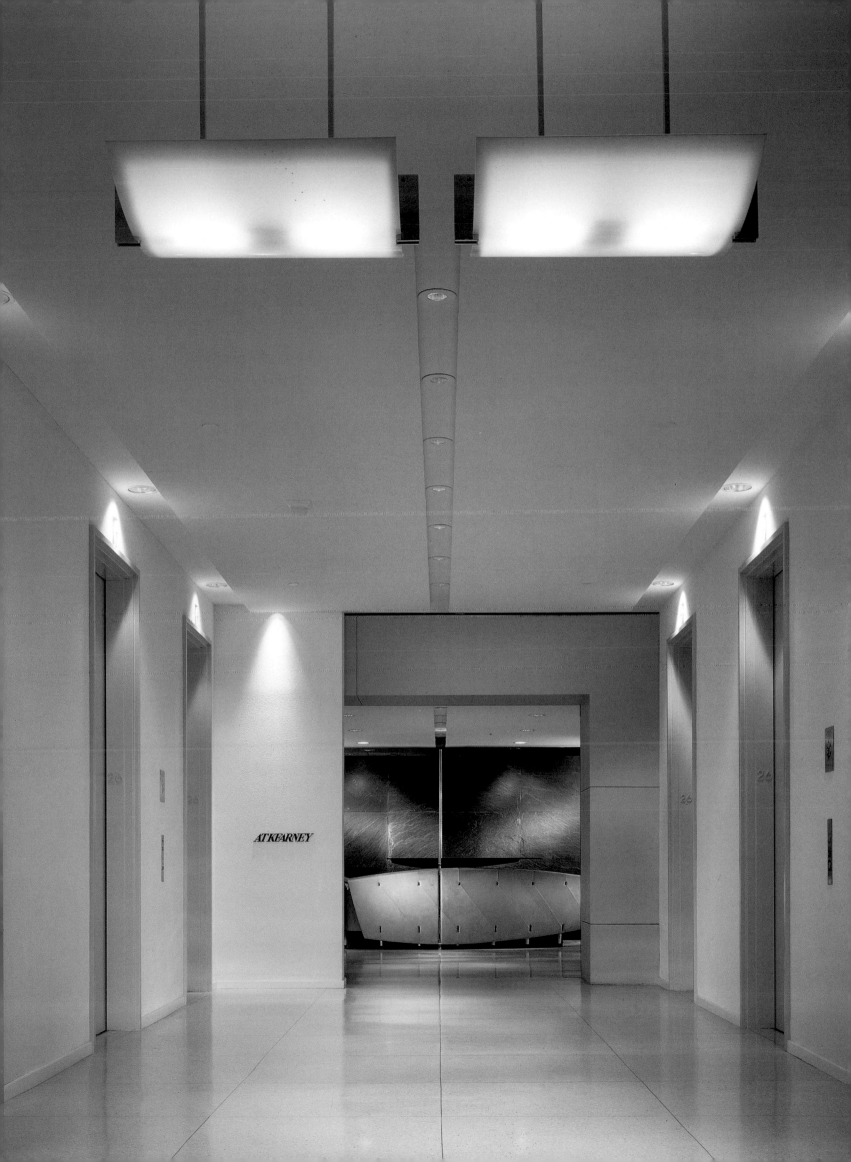

Located on the two top floors of the Wells Fargo Center in Sacramento's Capitol Mall, this 24,000-square-foot (2,160-square-meter) law office accommodates thirty-five attorneys and support personnel, with room to expand to fifty attorneys in the next five years. The program required perimeter offices for partners and associates, centrally located open-plan areas for support staff, and extensive conferencing facilities as well as "back office" function space.

ORRICK HERRINGTON & SUTCLIFFE
Sacramento, California

Interior design by Brayton & Hughes, San Francisco

The designers began by transforming a 30-foot- (9-meter-) wide double-height north–south gallery running the length of the building into a symbolic and literal "forum"—a high, dramatic space that contains the entry, the reception gallery, and conference rooms. These overscale, centrally situated volumes are oriented toward the river and city views and are bathed in natural light from expansive windows.

The "forum" is symmetrically flanked by partner and associate

offices, clerical workstations, and support function zones. Low wall separations between workstations enhance the flow of light, while eliminating double-loaded corridors expands the amount of open space. Natural light reaches deeply into the interior by way of paired glass entry doors and sidelights.

❖

The materials and palette in the reception area set the tone of unobtrusive elegance free of the traditional heaviness associated with law offices. The wall panels are Nordic ice birch; the custom-designed desk is laminate and zinc.

❖

The secretarial areas are furnished with custom millwork built around stock cabinets, a budget-saving device that upholds the elegance of the palette.

❖

A conference room with a double-height ceiling. The space is organized to take advantage of the top-floor views, while frosted glass walls permit privacy yet allow plenty of daylight to enter.

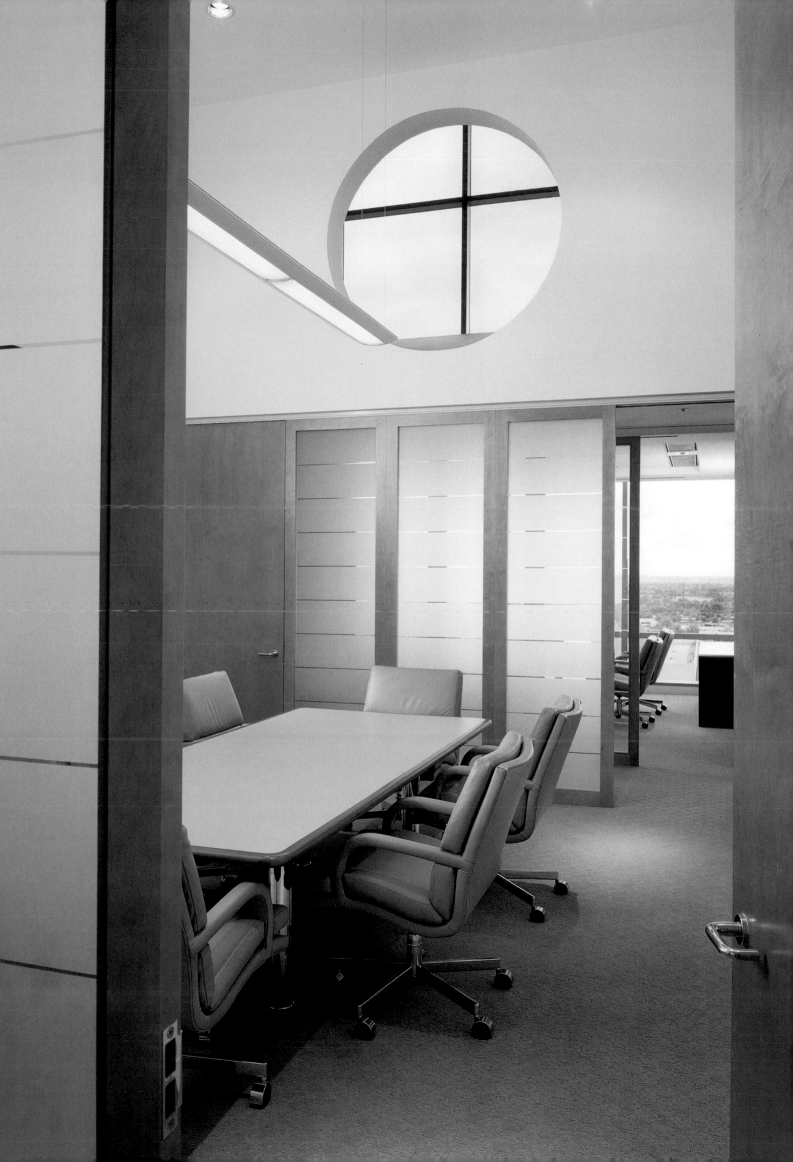

The design of this 30,000-square-foot (2,700-square-meter) branch office of a prestigious San Francisco-based law firm illuminates an important skill—that of finding a style appropriate to both client and location. Here in Silicon Valley, where the firm's high-tech corporate clients are likely to be younger and more adventurous than those in its Sacramento and San Francisco offices, the designers have chosen an upbeat, even experimental, aesthetic expressed through materials, including concrete pavers, metallic-leaf wall covering, aluminum-clad doors and frames, plastic laminate, and offbeat chairs specified for the reception area.

ORRICK HERRINGTON & SUTCLIFFE
Menlo Park, California

Interior design by Brayton & Hughes, San Francisco

The designers standardized two exceptionally small office types for private spaces to maximize access to the 5-foot (2-meter) window module. Support personnel for these downsized partner and associate offices are located directly across circulation to enhance communication. Downsized storage areas—a tacit recognition of the increasing

use of electronic filing—are also situated along the corridors to ease access and to absorb sound. Open-plan workstations combine built-in storage systems with movable furniture elements for increased flexibility.

The general tenor of these new law offices is fresher, more challenging, and far less rigid than the traditional design qualities associated with prestigious law firms. Although the fundamental hierarchies are unchallenged, these bright new offices suggest that major changes may be afoot in the field of law office design and planning.

❖

The curving reception desk lies at one end of an spiraling, egg-shaped zone meant to symbolically represent the high-tech firms the office seeks as clientele.

❖

Workstations are furnished with off-the-shelf components, but the designers added a custom-designed plastic front to create a more uniform look.

❖

With seating by Frank Gehry and integrally stained concrete on the floors, it is immediately obvious in reception that this is not your typical law office.

This elegant 7,000-square-foot (630-square-meter) office suite for a Chicago investment company is an essay in interior design symbolism. Maple veneers, brushed stainless steel, lacquer in eye-catching colors, and other tantalizing finishes create a bold first impression, but the design works on a more subtle visual level as well.

ARIEL CAPITAL MANAGEMENT
Chicago, Illinois
Design by VOA Associates, Chicago

Ariel has made its name by promoting investments of the slow and steady school rather than speculative, high-risk ventures. In the race between the tortoise and the hare, Ariel identifies with the tortoise. The clean, solid forms and materials utilized in this project are intended to convey a similar sense of patience and stability as a balance to the volatility of the market.

Symbolically, the market is first represented on the front of the reception counter, where an upward curving line defined by two types of juxtaposed maple veneer represents the rising market. Behind this counter, a backdrop wall of gridded glass and stainless

The motif of the curve recurs not only in symbols but in actual structure, as is evident in these curving walls. At rear, note the conference table's pyramid base.

The conference table is custom-designed, maple-finished, and supported by three pyramids—the strongest and most stable of all geometric forms—whose flat tops are an integral part of the table surface.

A view from reception into the workstation area. The photo montage at left contains images—frequently changed—of companies Ariel recommends and invests in.

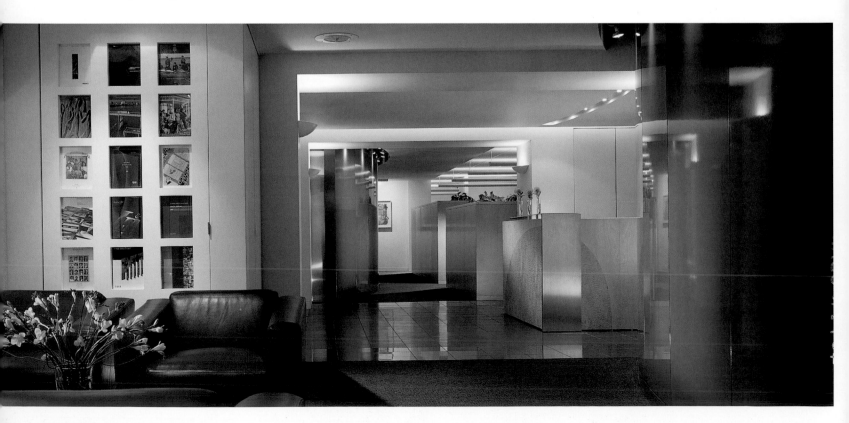

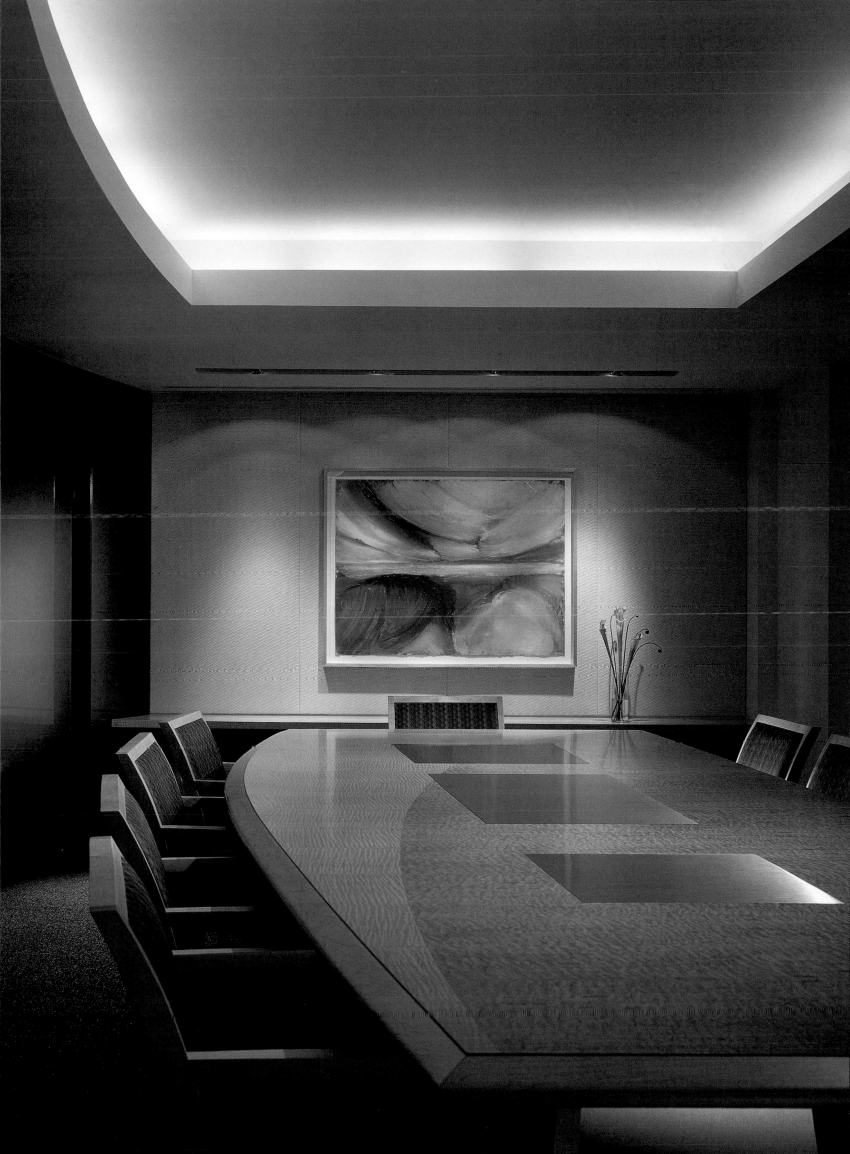

steel (installed to block out the boring views through existing windows) is highlighted by a curve going in the opposite direction, representing the falling market. A steel disk inset into the glass gridded wall represents the market in its entirety. Accepting and contending with these inevitable ups and downs of the market is the firm's business, and thus iterations of this symbolic curve motif recur throughout the office.

Curving blue lacquered walls designate circulation zones and add compelling visual depth. A stainless steel transaction counter atop the reception desk flows off the side of the desk and then ripples and curves like a ribbon—a gracefully flowing counterpoint to the cubist box of the reception desk itself. Contemporary art selected and displayed with museum-like finesse further animates the space, enhancing an overall image that might be described as stable with an adventurous edge. After all, even the most conservative of investment companies are risk-takers to some degree.

❖

Workstation area with shifting wall heights providing differing privacy levels. Fluorescent uplights bounce light off the ceiling, minimizing glare on screens.

❖

The stainless steel transaction counter atop the reception desk flows off and turns into a ribbon, a free-flowing wrapper for the cubist form of the desk.

❖

In the reception area, rich materials set the tone, while symbolic curves— on the front of the maple-veneered reception counter and in the glass and steel wall behind the counter—represent the movements of the stock market.

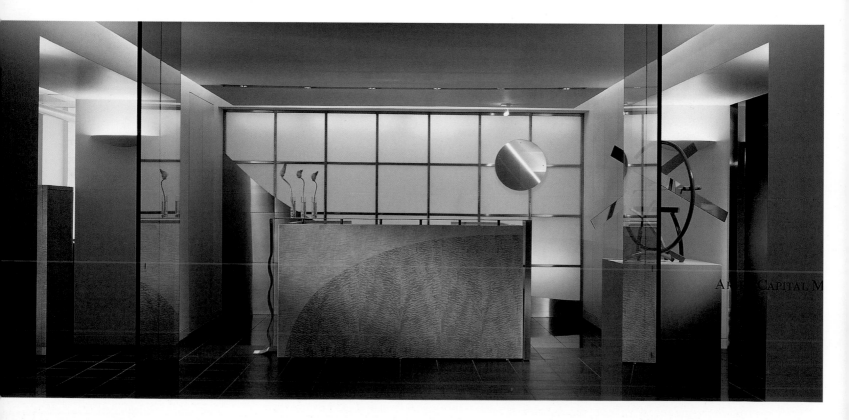

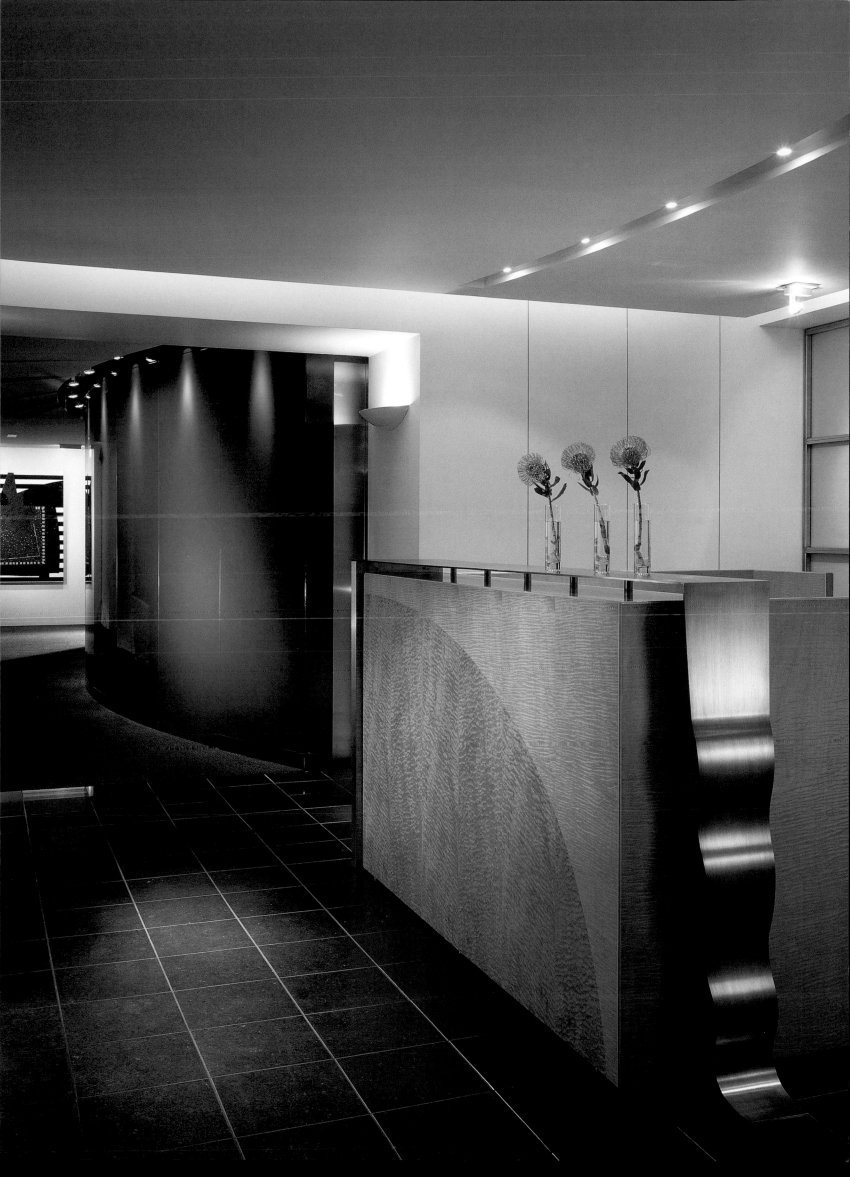

For a law practice devoted to issues of intellectual property—in this case start-up businesses—the designers from Gensler elected to abandon predictable law office design practices in favor of an approach more supportive of the entrepreneurial spirit of the client. This 13,500-square-foot (1,215-square-meter) interior is designed to enhance and reinforce innovative thinking by moving away from some of the more hidebound law office traditions.

WEIL, GOTSHAL & MANGES
Menlo Park, California
Design by Gensler

The "attorney wall," separating the attorney offices from the circulation corridor and the core, is entirely glass, enhancing the flow of ambient light and promoting a more open sensibility. Conference rooms are equipped with full-height markerboard panels for brainstorming; they also contain state-of-the-art audiovisual equipment, team-oriented reconfigurable tables, and ergonomic chairs.

Traditional built-in millwork is replaced with a single furniture system, in private offices and open-plan areas, and all personnel sit in

the same type of chair, ensuring flexibility—and signaling a real commitment to a less hierarchical office practice.

❖

In order to promote an egalitarian atmosphere, the designers have used the same furniture systems and the same chairs for everyone in the office.

❖

The glass "attorney wall" at right encloses attorneys' offices. By making this wall transparent, the design signals a more contemporary sensibility—perfectly in keeping with the firm's entrepreneurial clientele.

❖

In the reception area, light woods, tile floors, a sense of spaciousness and accessibility, and a concrete structural column left in its original weathered state establish that this is a law firm with a nontraditional agenda.

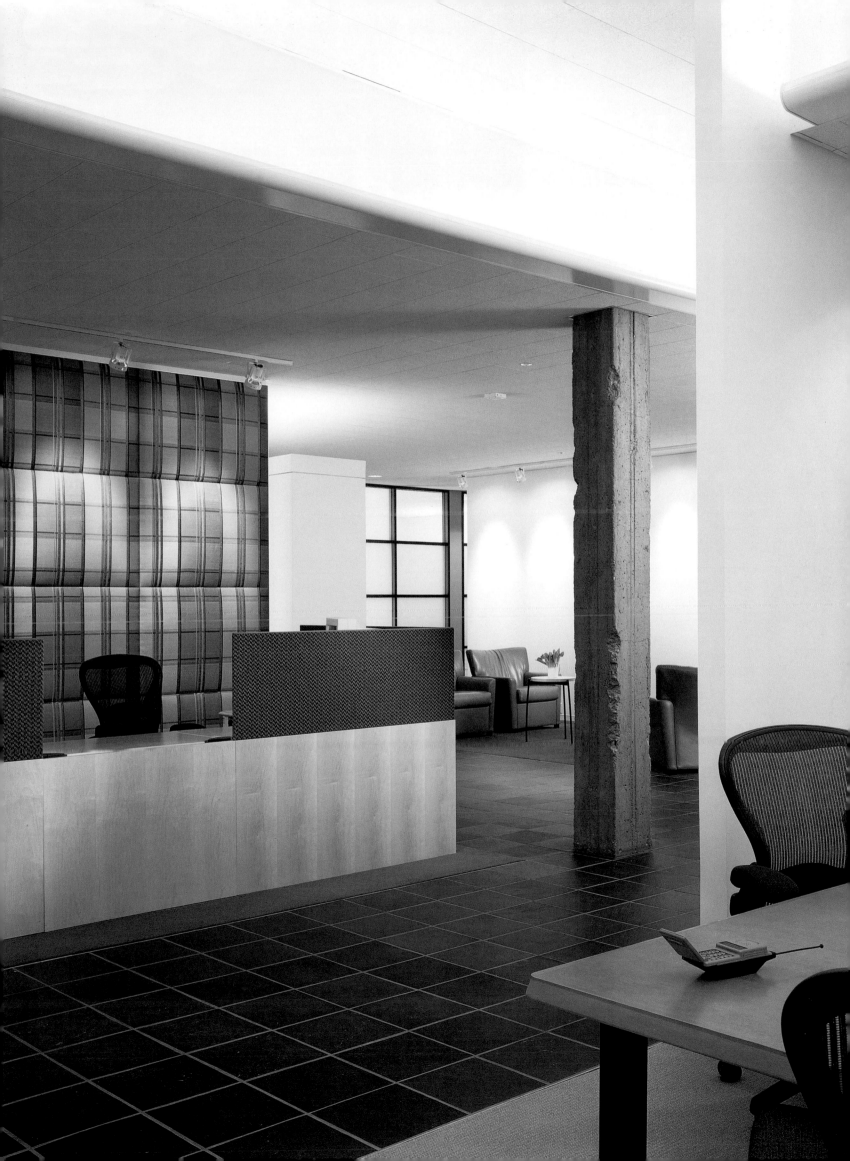

When this major multicity law firm renewed the lease on 50,000 square feet (4,500 square meters) of space on three floors in a downtown building in San Diego, it was rewarded by the building owners with a budget to upgrade the offices. The firm then hired Seattle-based Callison Architecture to take on this more or less cosmetic office overhaul. Callison designers inspected the property and convinced the office managers from Latham & Watkins that they could get much more design for their dollars if they left the perimeter attorney offices alone (since they were in fairly good shape) and instead concentrated their spending on reorganizing and refitting the rest of the rather poorly planned office. The firm heeded the designers' advice, and the Callison design team set out to create a new space plan for the interior core.

LATHAM & WATKINS
San Diego, California
Interior design by Callison Architecture, Seattle

The new design centralizes formerly scattered basic spaces, including file room, library, mailroom, paralegal areas, case rooms, and reception, making much more efficient

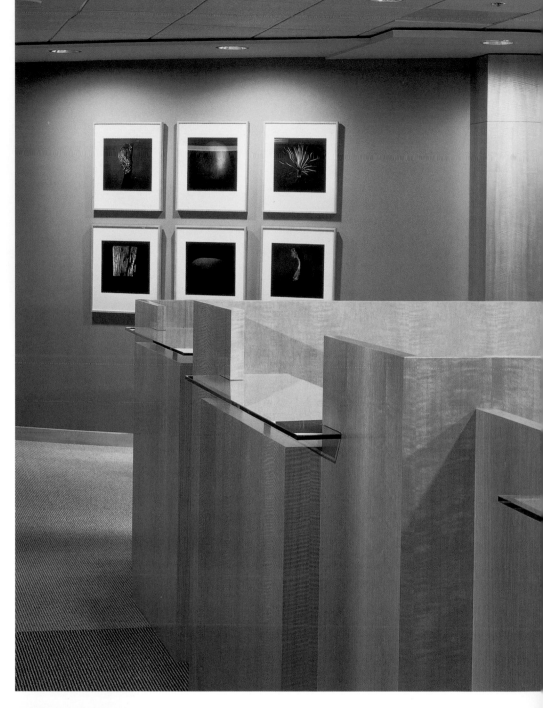

use of available space. By consolidating several haphazardly located reception areas into one, for example, the designers establish a focal public space and a single checkpoint for security, with the office's high-profile main conference rooms in visible proximity via glass walls. Budget limitations precluded the use of high-end materials, so the designers specified warm, anigré wood paneling throughout and opted for patterned carpeting and upholstery to add texture and depth. Reception area furniture is contemporary yet slightly softer and more traditional rather than hard-edged, as is appropriate for a law office in the somewhat conservative city of San Diego.

◈

The designers created new secretary stations with anigré wood partitions and glass transaction counters. The photographs at rear are from Latham & Watkins' extensive archive of art photography.

◈

New reception area finishes include anigré wood paneling, patterned carpeting and upholstery to add texture, and glass walls enclosing a conference room at right.

◈

The firm had hoped for open staircases to enhance communication between floors, but they had to be enclosed in a stairwell for fire code reasons. Still, even within the confines of a stairwell, metal details and warm wood lend a measure of elegance.

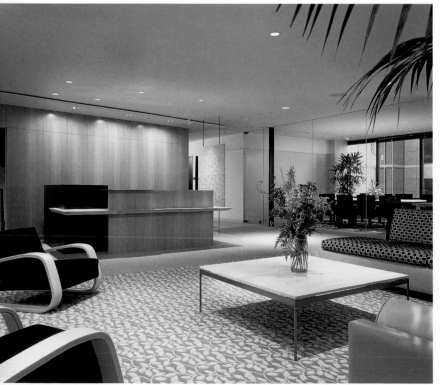

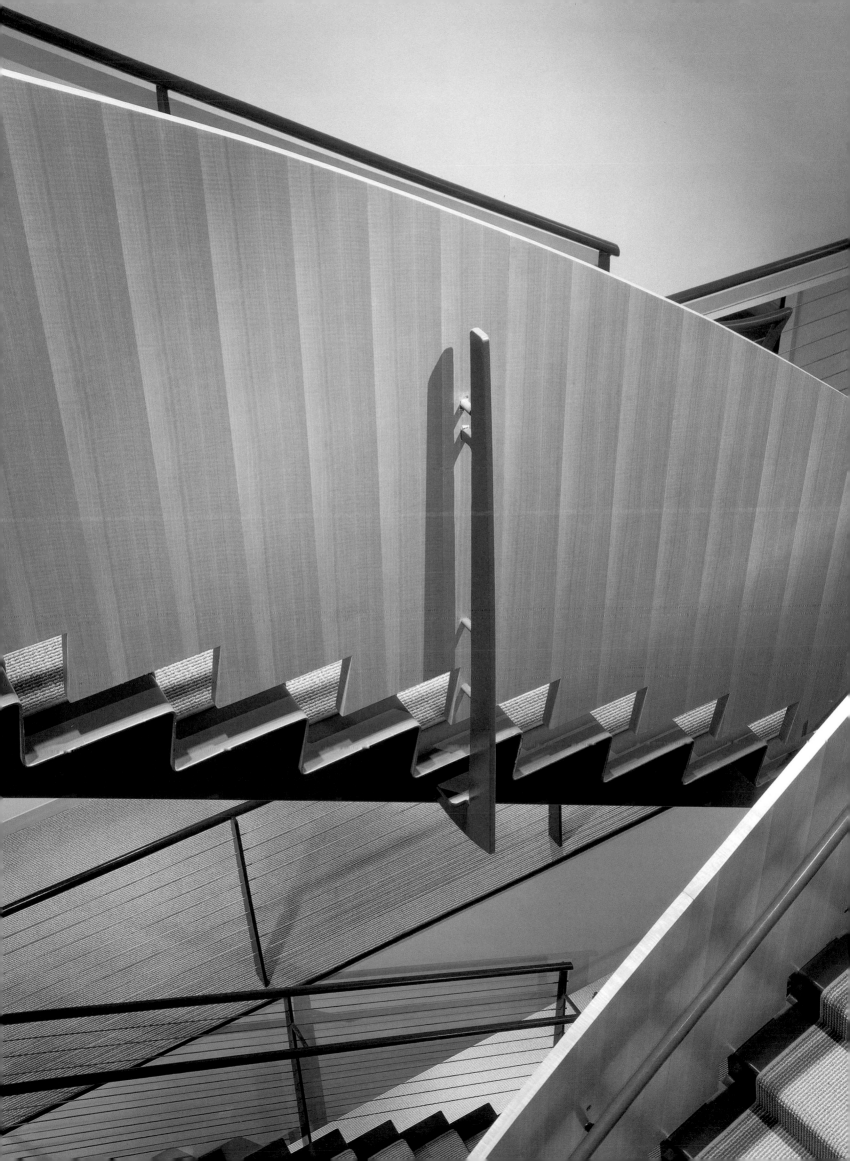

MEDIA COMPANIES

Designs for the offices and studios of film, music, and other media companies tend toward the adventurous in the same way that high-tech offices do, for they share an *au courant* cultural sensibility. The people who run these kinds of businesses are driven by the need to appear hip, cool, and iconoclastic. To paraphrase the television commercial, image isn't everything, but it sure plays a major role. Media and high-tech companies also share an understandable fascination with the latest in electronic and cyberspace gadgetry.

How this translates into design is, of course, an individual matter, to be discovered by the client and the designer. What is evident in many of the projects that follow is a fairly high level of aestheticism, even artiness, coupled with a frequently informal approach to space planning, hierarchical organization, and other elements that could undermine the individuality or originality of employees and clients. The attitude is "keep it loose, even unpredictable." These kinds of businesses thrive on creative, impulsive,

even anarchic energy, and their environments are supposed to succor an atmosphere that lets it all hang out. And yet—it takes careful planning to make spaces that are informal without being chaotic, or funky without being lame. Don't think for a minute that this kind of design comes easy: For all their casual, cool, and easy style, these spaces are intensely *worked*.

◈
Sony Music International, Miami

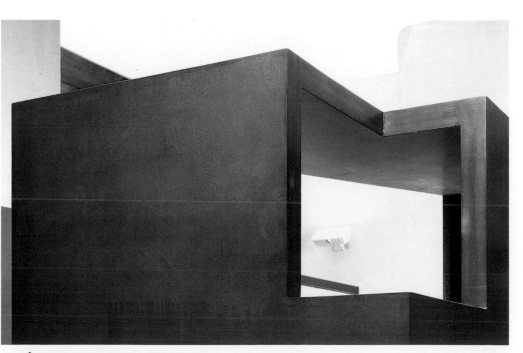

◈ **Steve Gold Productions, New York**

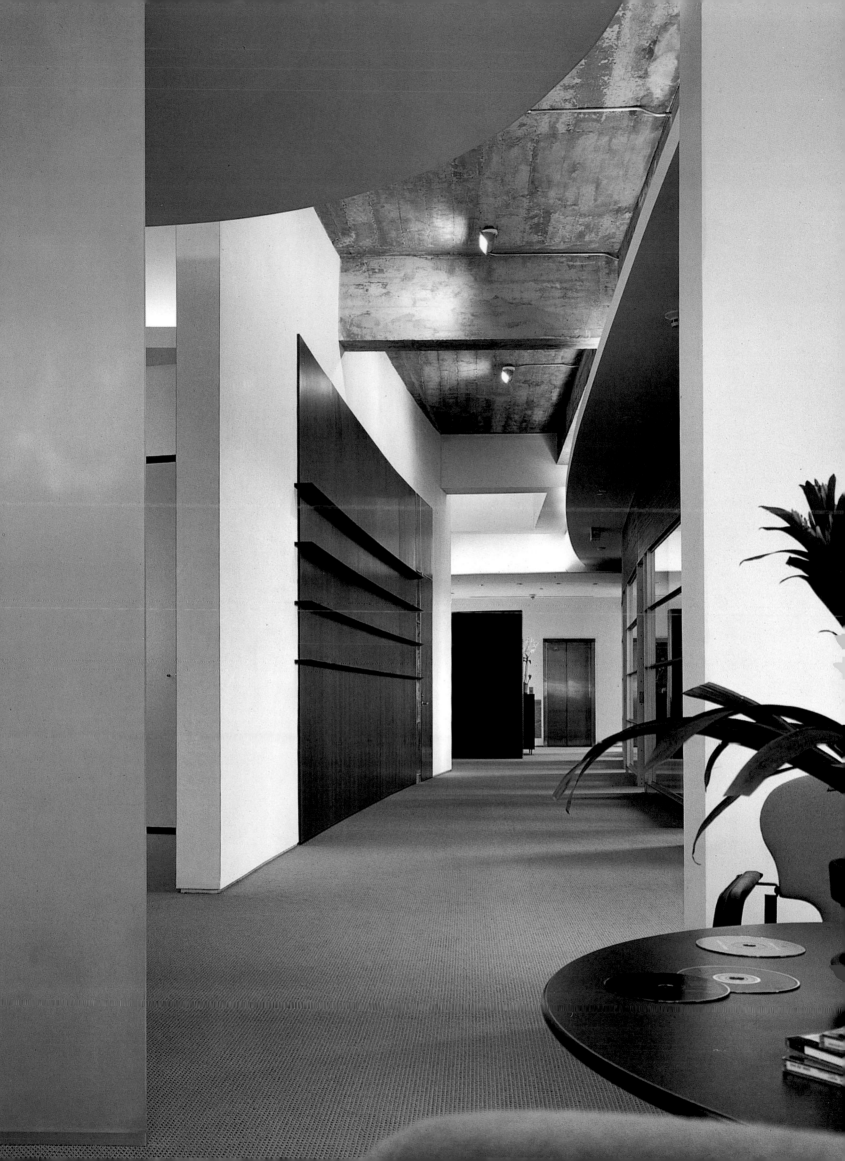

As the first full-service post-production house to open in SoHo in downtown Manhattan, SMA Video is a significant, high-profile project. The trendy neighborhood is currently undergoing a renaissance as a multimedia and high-tech center; the clientele—feature film and commercial makers and television producers—are on the cultural cutting edge; and SoHo's architectural riches, from the cast-iron exteriors to the artist loft interiors, are renowned.

SMA VIDEO, INC.
New York, New York
Design by Anderson/Schwartz Architects, New York

The tenth-floor loft space housing the facility is a former printing plant, and architect Ross Anderson has left the pitted concrete floor untouched. He also developed the meandering floor plan in counterpoint to a rectilinear grid of existing, mushroom-capped concrete columns. The minimalist environment evokes the gritty street textures of New York while deftly orchestrating the intricate demands of film and video production.

❖
Seen from the other end of the central circulation zone, the reception room is a floating cubist jewel constructed of fiberglass on a wood frame.

❖
The interplay of powerful, gritty materials is immediately evident in the entry, with densely textured metal walls counterpointed by scarred, heavy-duty wooden posts and beams. A long view down one of the interior's two primary axes opens up a light-filled balance to the toughness of the materials at hand.

❖
The waiting area, in foreground, is furnished with twentieth-century classics. The reception counter is visible toward the rear. The wall at right screens off a series of private offices and the art department.

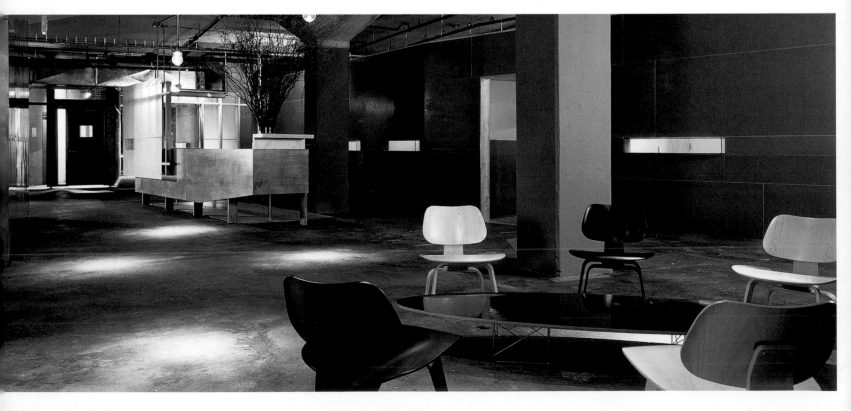

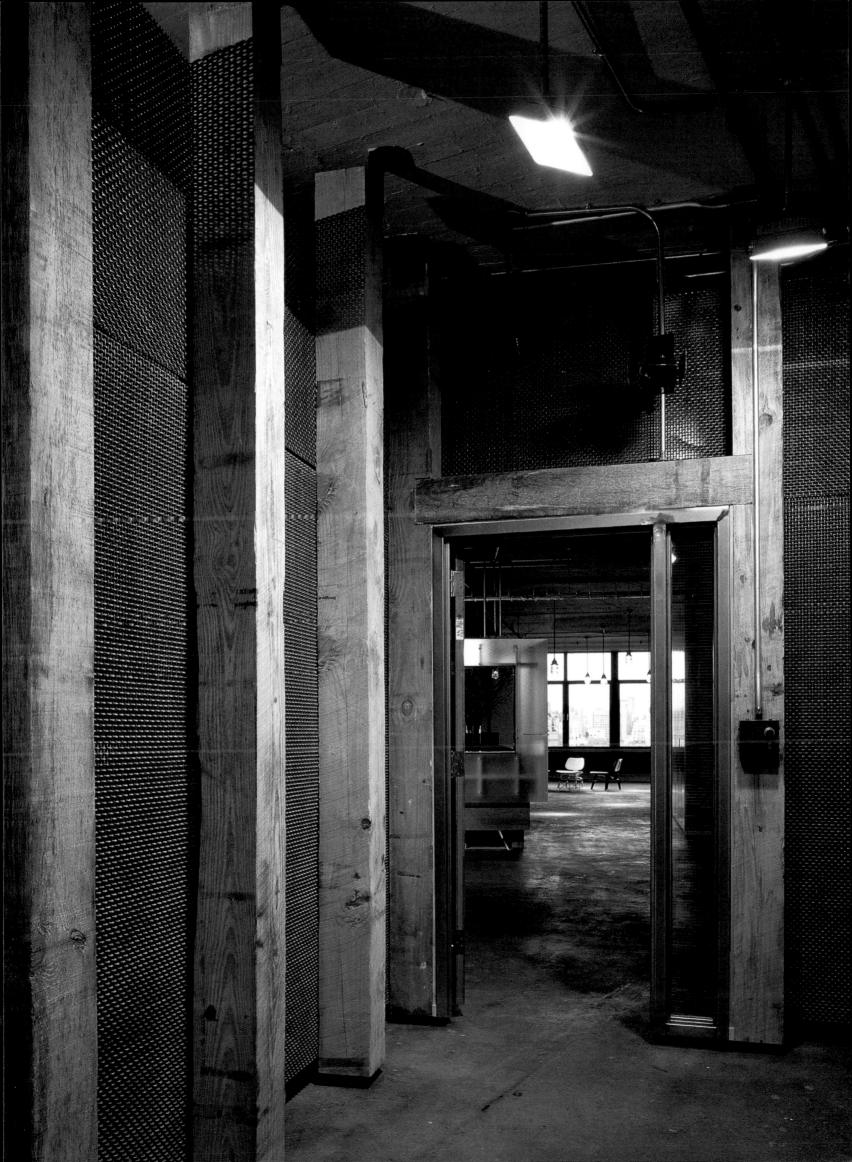

The reception "box," a raw cubist jewel assembled out of birch, poplar, and fiberglass, attaches to one of several freestanding and/or semilinked "buildings" that populate the project's interior "streets." This first "building" contains offices and the art department and separates reception from a workstation and conference zone. Roughly perpendicular to this first "building," a second consists of editing and production rooms positioned along a meandering central corridor. These rooms are entered via portals on the opposite side, where the architect has set the freestanding interior "building" walls back from the "real" building's walls to enhance the sense of streetlike layering. The setback also provides greater acoustical and light control, critical in a facility requiring low light. A machine room paralleling the production rooms on the interior side accesses the cables that serve the equipment. Across the corridor, a soundstage is surrounded by storage, mechanical, and other "back of house" facilities.

Although functionally well organized, with its skewed angles and leaning walls, the floor plan is highly irregular. This irregularity creates nonspecific zones that serve as backgrounds for shoots, equipment

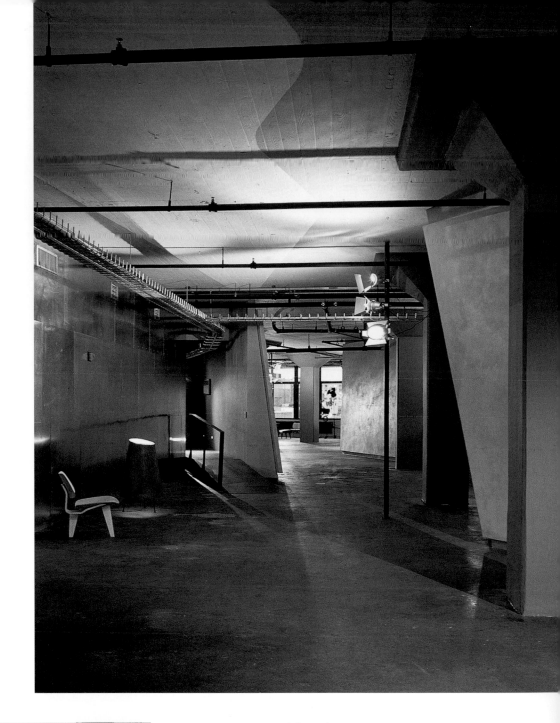

storage areas, or even informal meeting space (as denoted by yellow "puddles" painted on the ceiling).

The flawless balance of street vernacular, coolly manipulated high-tech elements, and fine-tuned programming places this project in the realm of architecture as functional art.

❖

A meandering central circulation path evokes a streetlike ambience, reinforced by gritty materials, including the old warehouse's original concrete floor.

❖

Separated from the studio area by the freestanding structure that contains the private offices at left, the workstations are organized in rows flanking storage shelving partially enclosed in translucent fiberglass. The architect has an uncanny talent for celebrating the intrinsic beauty in offbeat, low-cost materials.

❖

Skewed, angular walls create tension, adding a sense of streetlike unpredictability to the interior architecture.

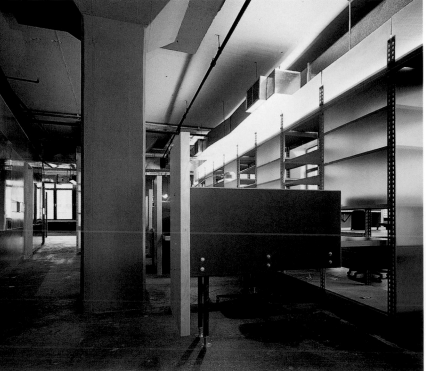

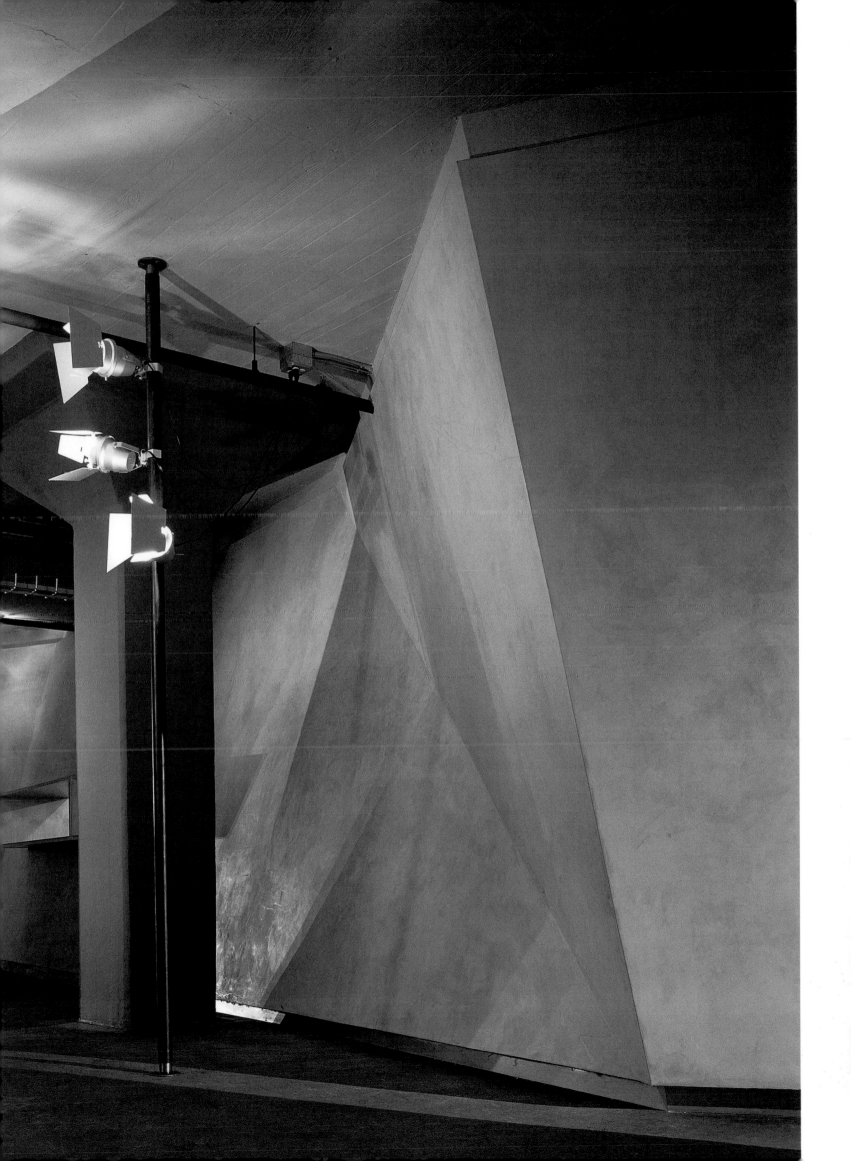

Ownership of the Beatles catalog alone would serve to make EMI Records in London one of the most important music companies in the world, but EMI is in fact home to a number of other internationally renowned performers (Diana Ross, Pink Floyd, and Queen among them) and music labels, each in need of a measure of autonomous identity under the EMI corporate umbrella. Thus, when the London design firm Sedley Place planned the company's office interiors, the challenge was to establish a coherent overall identity while carving out distinct niches for the various labels and other entities that are part of the parent company.

EMI RECORDS
London, England
Design by Sedley Place, London

The design solves this fundamental problem with a number of ploys: Flooring materials change from area to area, a custom-designed graphic display system allows individual labels to display promotional material related to current releases, and each department is defined by different colored levers on the custom-designed door handles.

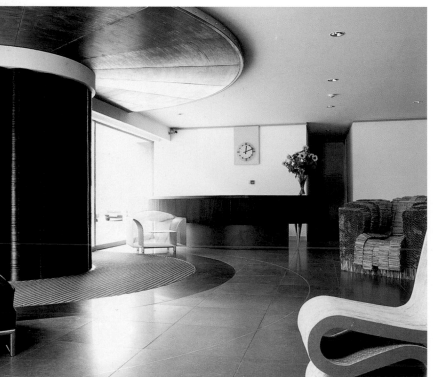

Beyond these departmental identities, the overall image is achieved through more dramatic gestures. At the entry, the canopy is made of a giant CD protruding out of the building, supported by a column made out of thousands of vinyl records. One leg of the reception desk is a stylus. On the ground floor, a garden atrium leads to a bar and restaurant in a triple-height space highlighted with a balustrade that incorporates a stair balcony originally seen on the cover of the Beatles' Red and Blue anthologies. Composed of abstract steel and glass cutouts, this balustrade is one of the more dramatic elements in a interior that forges EMI's facets into a unified image, one that is functional, comfortable, and hip.

Glass-walled street entry is signaled, and dominated, by a giant CD canopy supported on a column made from thousands of old vinyl records.

Arty chairs, columns made from stacked records, and a reception desk supported on a "stylus" column establish a sophisticated, hip image in the reception area.

The multilevel restaurant features a balustrade incorporating abstract slabs of glass and steel.

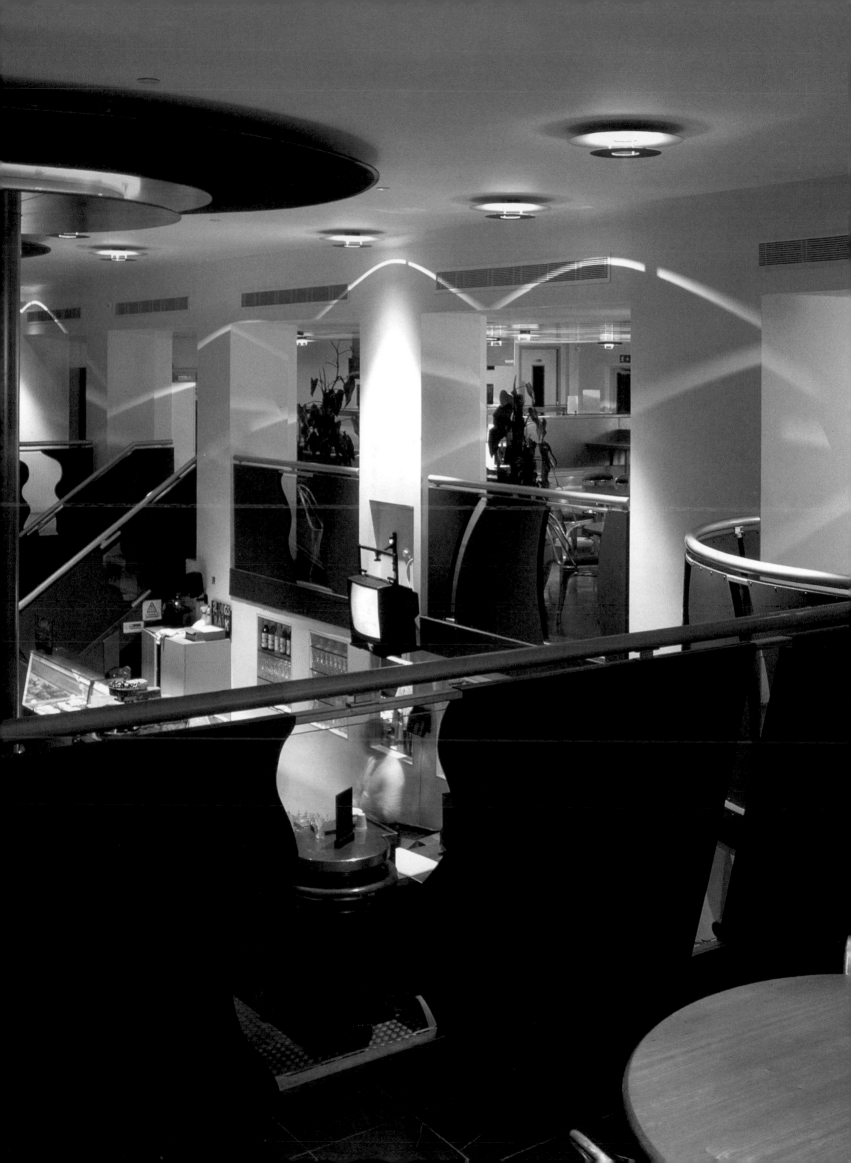

Miami in the 1990s is a city of multiple influences. The most Latin—especially Cuban—of all North American cities, it also has long been an outpost of Jewish New York. More recently, good weather, great beaches, and the photogenic allure of the Art Deco district have transformed Miami's South Beach into an ultratrendy, media-savvy scene. Call it SoHo South. Models, fashion designers, and photographers have set up shop. There are hotels designed by Philippe Starck and restaurants owned by movie stars. Chasing after what's hot, every creative corporation with a stake in the burgeoning Latin American market wants to set up shop in Miami.

SONY MUSIC INTERNATIONAL
Miami, Florida
Design by TAS Design, New York

Sony Music International's new Latin American headquarters has been located in South Beach, on the top two floors of a circa-1936 seven-story structure originally created as a showroom for Packard automobiles. The building lies on the Lincoln Road Mall, a pedestrian shopping promenade developed by famed (for the over-the-top gaudiness of his designs) Miami architect Morris

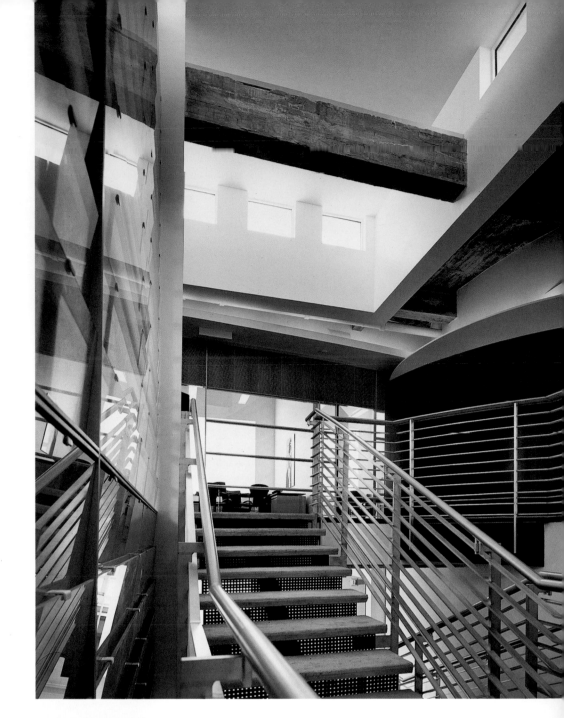

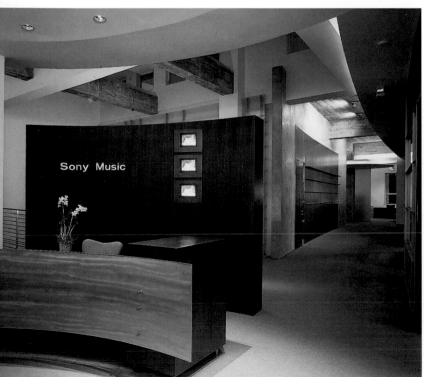

❖

The open stairwell connecting the two floors of the office has keystone treads—a hint at Miami tradition—with steel stringers and "Decoesque" aluminum rails.

❖

Backed by an 8-foot (2-meter) cherry wall, the reception area initiates the layered interplay of old and new materials, hard and soft textures, and sharp angles and soft curves.

❖

Narrow horizontal shelves/fins in wooden wall paneling add a subtle Art Deco touch, as do the disks positioned to organize circulation.

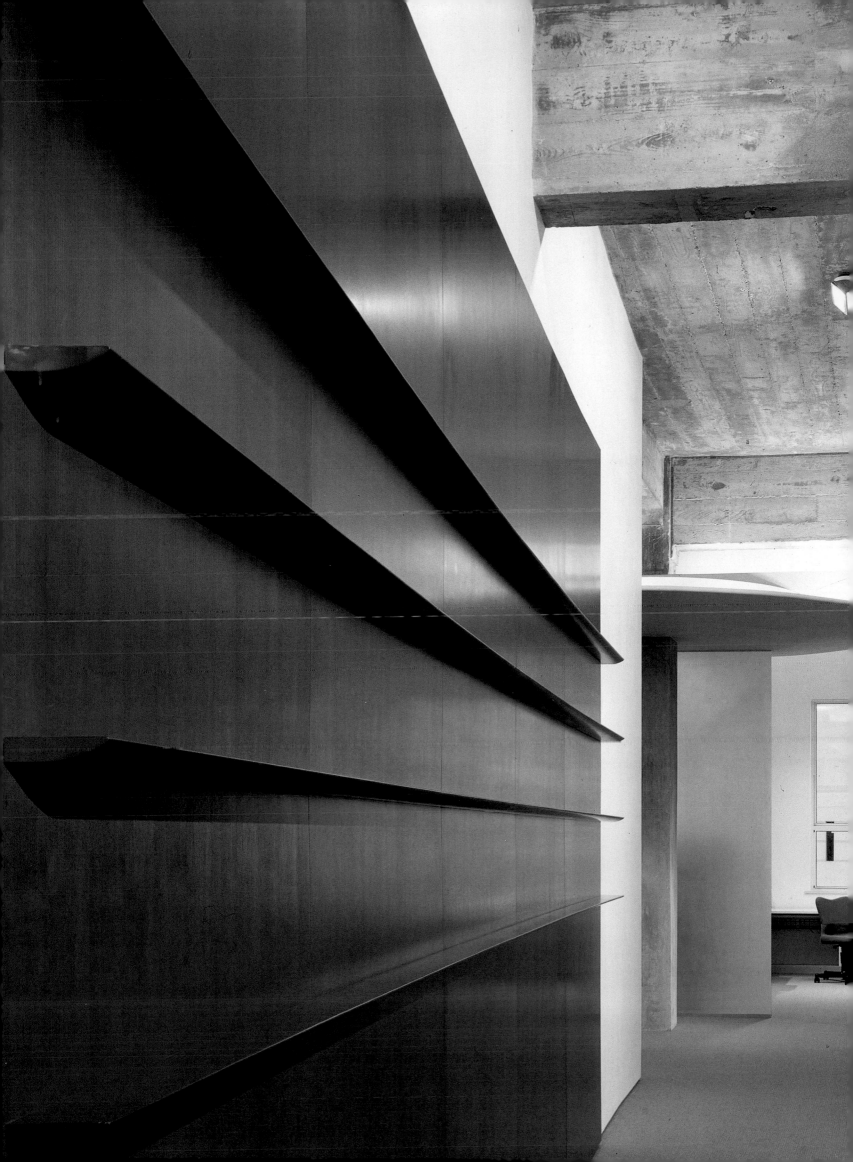

Lapidus in 1958. The mall is a classic Lapidus confection, complete with flamboyant follies, shade pavilions, and assorted architectural diversions of questionable but always amusing taste. An Art Deco building, a Morris Lapidus mall, Latin American music—a typical 1990s medley in multicultural Miami.

The architect of the Sony offices, Thomas Sansone of the New York City firm TAS Design, neither blindly embraces nor arrogantly rejects these influences. Instead, he absorbs them and reinterprets them in subtle ways. In doing so he tunes the project to the building, the district, and the region. For example, the two-level floor plan is organized to provide numerous meeting points, where workers can pause to chat or take breaks. These casually designed spots might be defined by a framed view, or a stair landing, or a disk overhead. They are informal, only hinted at by the architecture, but according to Sansone, they are inspired by the siting and style of the shade pavilions and other follies along the Lapidus-designed urban promenade below.

Four sides of glass walls connect the interiors with the light-filled and spacious exterior landscape, both

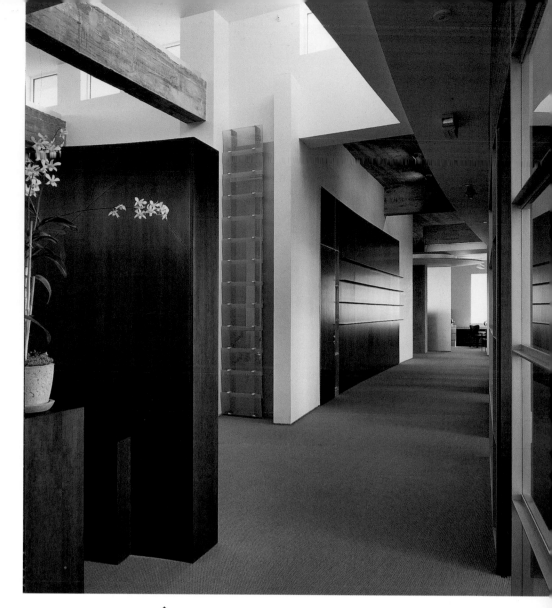

◈
Refined, smoothly finished materials are elegantly knit together in these offices; the rough concrete of the original ceiling makes for powerful contrast.

natural (beach and sea) and man-made (city and mall). This sense of airy spaciousness is extended throughout the offices via interior walls of clear and etched glass, an open stairwell linking the floors, and layered, interwoven ceiling planes establishing connections among separate volumes. The office and workstation walls, partitions, and furnishings are composed of textured-aluminum panels, integrally colored plaster, and clear and etched glass, with panels and millwork of cherry and ebonized oak adding contrast and warmth. On the upper floor, near-double-height ceilings allowed the designers to create layers of formal and visual activity: At a height of 10 feet (3 meters), circular disks act as markers in the circulation pattern—and recall exterior pavilions. Above the disks, linear elements unify groups of partitioned offices and/or workstations. Still higher, above the smooth white layers, the original concrete ceiling slabs and beams have been left exposed, a scarred and gritty counterpoint and a perfectly appropriate element in this muscular yet refined office design.

◈
In the administrative work area, a sweep of lowered ceiling with a double row of light fixtures serves as a unifying element over the aluminum-faced workstations.

◈
Cool, airy, and spacious, the offices are visually dynamic yet serene, balancing subtle Art Deco influences with tough, basic materials—all bathed in lavish washes of daylight.

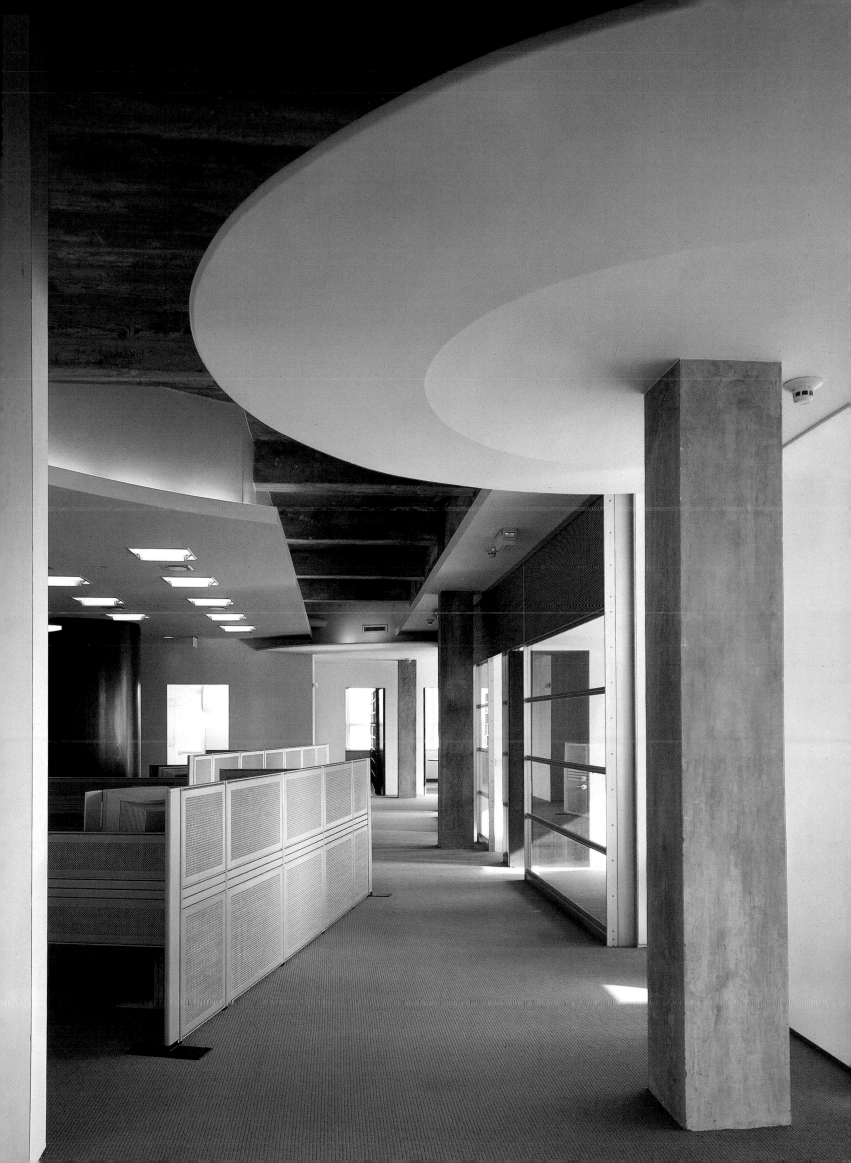

Given 1,800 square feet (162 square meters) of cramped and virtually windowless space to work with in creating office and production space for video and film producer Steve Gold, designer Carl D'Aquino at first advised against taking the space at all. When Gold insisted, D'Aquino relented and, with his design team, proceeded to transform these tight quarters into a vibrant little office. By manipulating colors, materials, textures, and forms, the design team—an interior designer, a sculptor, and an architect—creates a sense of spatial openness and unity while carefully covering all the functional and programmatic needs of the firm. They also have created a lively, dynamic space for the firm to entertain and work with clients—no small feat given the limited room and budget.

STEVE GOLD PRODUCTIONS
New York, New York
Design by Carl D'Aquino Interiors, New York

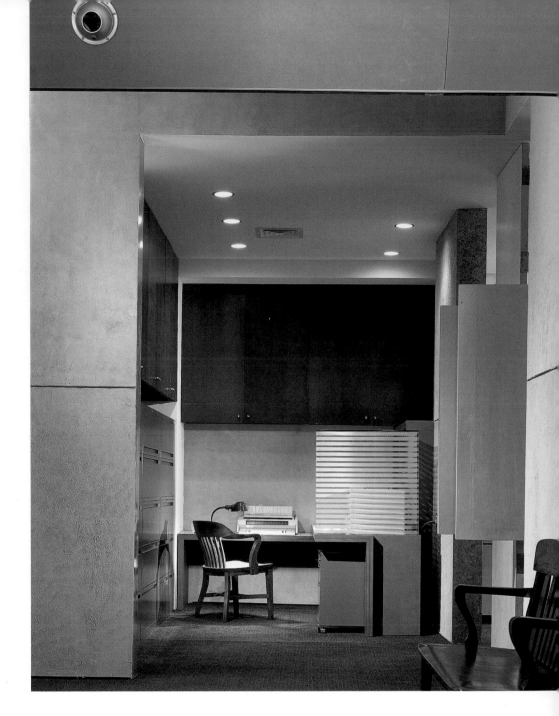

❖

The president's assistant utilizes the end-of-corridor workstation. The materials are consistently low budget, but a carefully chosen palette warms this section of the office.

❖

Close-up view of the "red house" section of the reception counter. The cutout is a lively detail that provides a transaction area as well as another perspective on the space.

❖

The green and yellow painted duct carriers at the top traverse the entire length of the office. Conference room, left, doubles as a video screening room. Unique pivoting panels are made of stained ash.

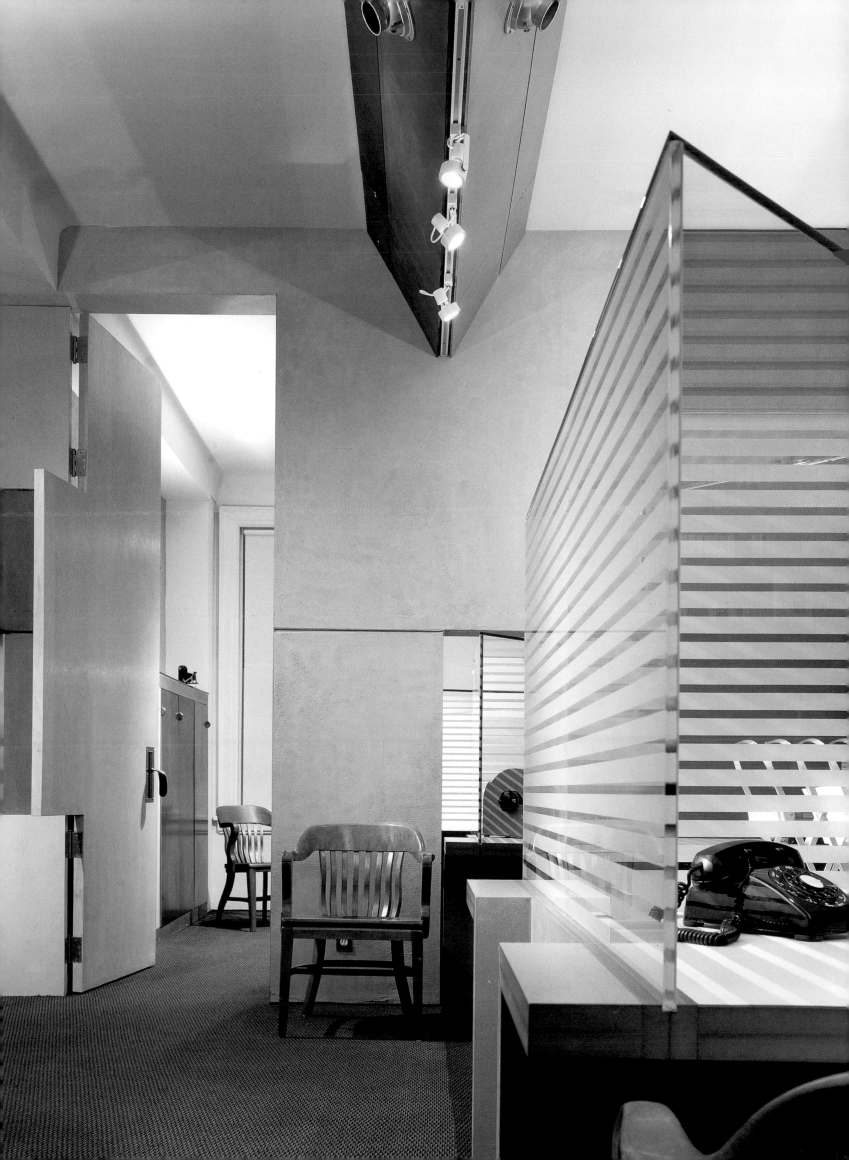

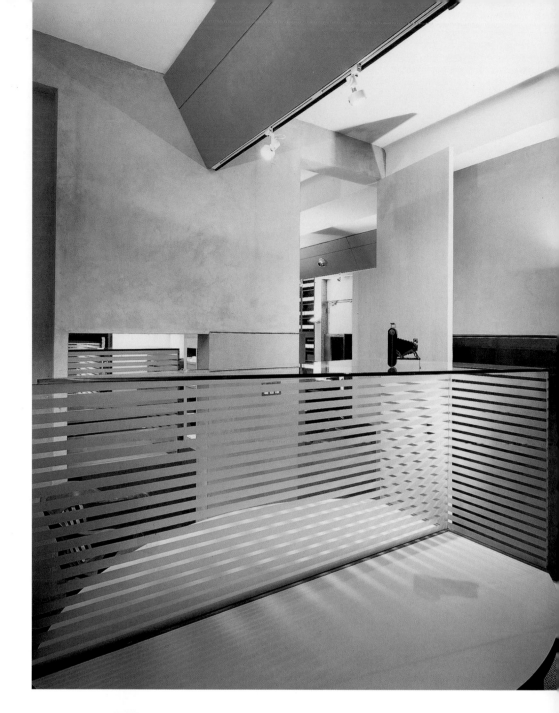

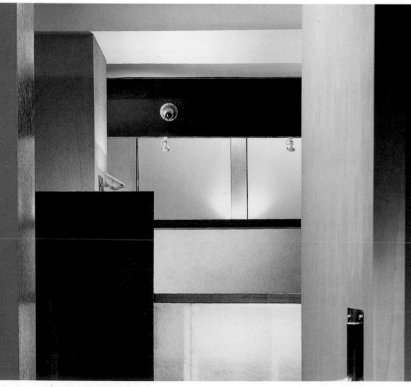

◈

Daylight diffuses through the portal and the wall opening. The horizontal reveal is scored in at 5 feet 4 inches (160 centimeters). The same height is used consistently throughout the office to provide a visual break at an "idealized viewer's" eye level.

◈◈

A view of the reception area from the conference room shows how the designers layered colors and forms to create a sense of depth. The door handles are made from plaster trowels.

◈

The reception area. The desk is made of translucent fiberglass that reveals the wooden studs of its structure. It intersects the "red house," a second reception station.

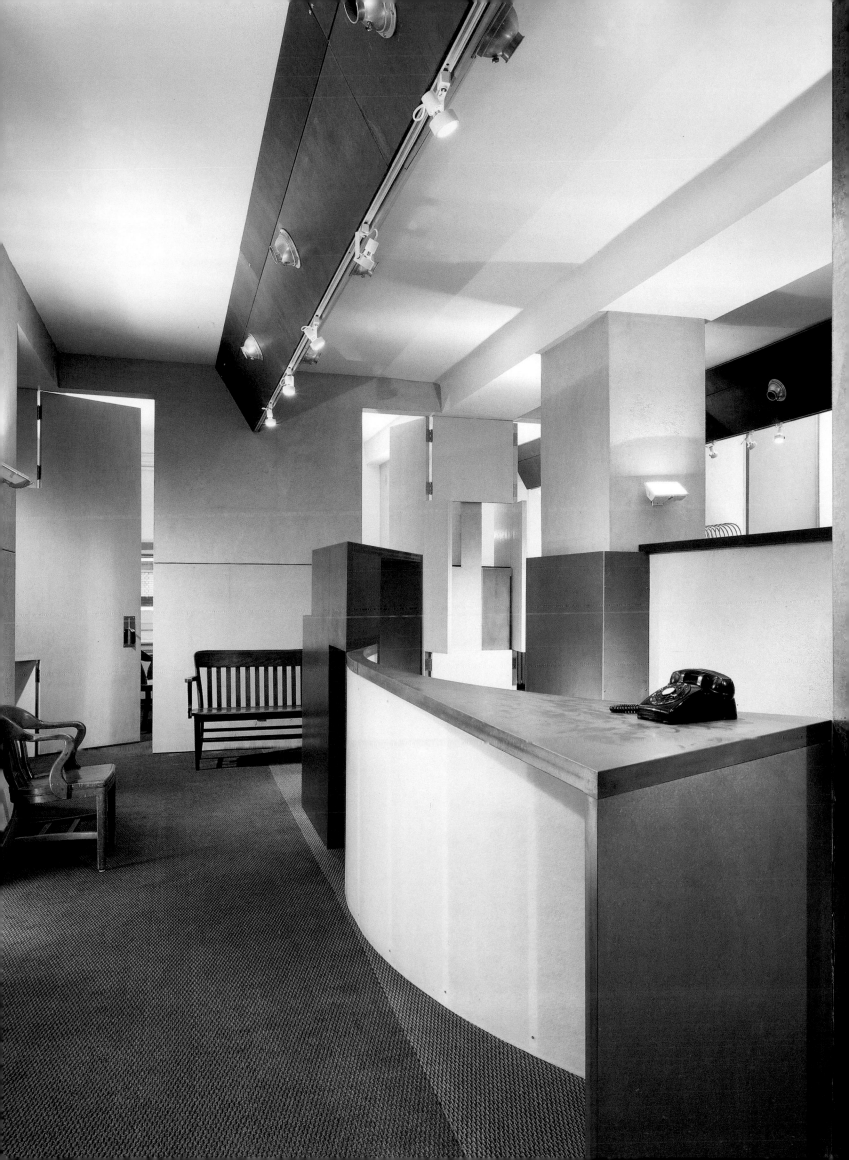

In designing offices for Wired Digital, the online/interactive Internet version of *Wired Magazine*, the San Francisco-based firm of Holey Associates took an informal, low-tech approach, counterpointing the high-tech business of the client. The 44,000-square-foot (3,960-square-meter) offices house 230 employees on the two top floors of a former coffee warehouse built in San Francisco in 1922. The primary challenges included creating the appropriate mix of collaborative areas and private research, production, and meeting rooms while preserving Wired Digital's youthful, community-oriented corporate culture.

WIRED DIGITAL
San Francisco, California
Design by Holey Associates,
 San Francisco

This culture succeeds in part due to high levels of interaction and visibility, and so the office is based on an open plan. To enhance the sense of openness, the designers added skylights as well as new windows in the north and west walls, letting in more daylight and establishing urban views where none existed before.

◈
The glass wall in the foreground provides acoustic but not visual privacy for this meeting room. The warehouse building that contains the offices was built in 1922.

◈
Even the production rooms are somewhat low tech, with wood trim and repainted original brick walls. Note the thick bundles of wiring in the exposed track running up the wall and across the ceiling.

◈
The designers added four of these new open-web steel staircases to provide easy visual and physical access between the two floors.

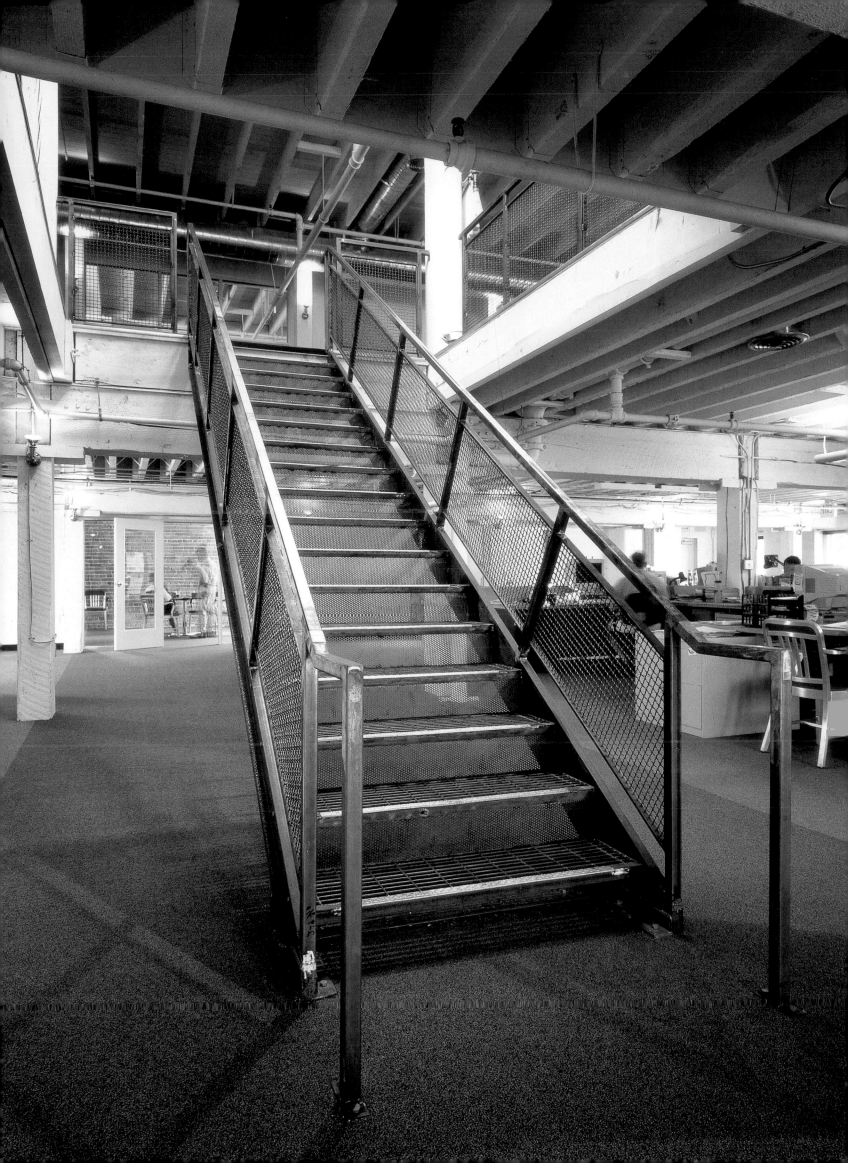

Wood trim and detailing at the work-
stations create a warm, low-tech
ambience and provide a balance to
the high-tech work and the basically
industrial quality of the space. To
promote interaction, some of the
open work areas lack not only
dividing walls but even panels to
separate the desks. For meetings
requiring privacy or acoustic isola-
tion, small and large conference
rooms were installed in the interior
on both levels, leaving the existing
perimeter windowwalls unblocked.
The meeting rooms are walled with
glass, further enhancing the sense
of openness.

Informal gathering areas for breaks
or brainstorming sessions are sig-
naled with sofas and tables. Four
newly installed industrial-strength
staircases with open-web treads
and metal mesh and steel balus-
trades link each of the four sections
on the two floors. The stairs are
also positioned to encourage inter-
action by creating open views and
easy access to the entire office.

Behind the casual informality and
open planning lies a state-of-the-art
technical operation, with four T1
lines—forty times faster than a
28.8K modem—installed to serve
production, editing, sound, media,

server, and digital library rooms.
For all its user-friendly features,
this high-tech media office is totally
wired for the twenty-first century.

❖
**A completely open office culture implies no separation—so there are no
partitions or panels between the desks. Note exposed ceilings, ductwork,
and wiring—typical of a high-tech media office.**

❖❖
**Wood trim lends the workstations a warmth intended to counterbalance
the high-tech nature of Wired Digital's online business.**

Located in a prominent spot on the one-way, honky-tonk-lined street that is Nashville's Music Row, Warner Bros.' new country music headquarters building is something of a metaphor for country music itself: infused with down-home charm, yet chic, savvy, and technologically state-of-the-art. Like the funky honky-tonks in the neighborhood, the new building makes space for individuality and artistic quirkiness; at the same time, its sophistication reflects the stature and economic power of country music in the 1990s.

WARNER BROS. RECORDS
Nashville, Tennessee
Architecture and interior design by Tuck Hinton Architects, Nashville

The local firm of Tuck Hinton Architects assembled the building with enough indigenous materials to maintain a kind of regional identity—to enhance the sense of "country" in an increasingly urban and internationally marketed musical genre. With a base of Tennessee fieldstone supporting a limestone and gray brick facade, the L-shaped building is sharply angled toward the street but presents an open facade to traffic cruising Music Row. On the exterior, rows of

❖

The building terminates in a sharp angle close to the street. The forms are contemporary, while the materials are regionally quarried and produced.

❖

The stairs in the glass-enclosed lobby are positioned against walls of black-stained fir. The curving wall of Warner Hall, the reception area, is visible above.

❖

Two sets of lobby stairs lead to Warner Hall, the upper-level reception area. The maple panel screens the garage door.

differently sized windows break the facade in a rhythmic pattern, alluding to the music produced within.

Enhancing the down-home motif, a vine-draped timber trellis extends over the double-height glass-walled lobby. From the lobby, two stone staircases climb to Warner Hall, a curving, maple-paneled reception area decorated with music awards and regional artwork. Adjacent to the lobby, a temple-like form shelters a large conference room furnished with an enormous round table and fully wired for live-performance broadcasts. An outdoor terrace expands the conference room's capacity as a performance venue.

The private offices combine personalized pieces—employees were encouraged to pick their own from an array of modular furniture and accent colors—with the latest in video, data, communications, and teleconferencing capabilities. The offices are individualized but share a common 19-inch (48-centimeter) furniture module (dictated by the size of audio equipment) and a neutral background palette. Soundproofed, equipped with modern energy-management systems, and wired for every conceivable

electronic activity, these offices are primed for the twenty-first century. And yet not for an instant does the technology overwhelm the "southern comfort" that gives this project its real character.

❖

The large conference room is equipped for recording, broadcasting, and live performing. The table seats up to twenty-five and can be reconfigured ten different ways.

❖

A curving wall decorated with local artworks and numerous music awards lends a welcoming quality to the upper-level reception area, called Warner Hall.

❖

The use of indigenous materials such as maple and black-stained fir is balanced by the sophistication with which they are used, as seen in this elegantly crafted passage.

Thirty-seven years after its founding in Detroit, Motown Records is a major presence in the pop music business. Motown's new 80,000-square-foot (5,400-square-meter) offices in midtown LA reflect that elevated stature, providing the company with a corporate identity that is both upscale and hip. The interior architecture is the work of RAW Architecture. After extensive interviewing of employees and a study of the interaction of Motown's thirty departments, the RAW design team developed a program with a coherent space plan and clearly marked circulation paths—no easy feat in a labyrinthine complex requiring literally dozens of small private offices—and finished this logical plan with a sleek, appealing interior palette.

MOTOWN RECORDS
Los Angeles, California
Design by RAW Architecture, Los Angeles

In the work areas, natural light from slotted windows opening onto the atrium and the exterior help illuminate corridors and offices, while splashes of bold color on walls and in carpets signal different departments and indicate circulation patterns. Broad corridors are

stepped, forcing perspectives, with graphic guides at significant corners.

The standout statements of corporate identity lie in the public areas. Taking off from the previous Motown offices' black and gray palette, the designers created a black-walled, gray-carpeted elevator lobby illuminated by a patterned glass wall studded with gold disks at one end. Visible at the other end, where the narrow elevator lobby opens out into reception, a sculpted desk gleams atop a black granite floor; framed gold records are lined up on a wall, and sensuous black leather sofas and chairs furnish the waiting area. Throughout these public spaces, natural wood plays off hard, reflective surfaces, and curves and angles intersect rhythmically. The drama is enhanced by a sophisticated lighting system and the insistent presence of Motown music and videos on monitors in multiple locations.

With elements for lighting artwork suspended from an angular black ceiling grid, the waiting area is furnished with classic black leather-upholstered seating, including a sinuously curving sofa. Framed gold records and monitors serve as artwork, with music videos providing a constant visual and audio backdrop.

The cool chic of the reception desk is elegantly counterpointed by the reception waiting area at left. Curving walls and natural beech are softening elements in this somewhat hard-edged, sleek interior.

Reflected in a sleek black granite floor, the reception desk is sculpted of wood, pewter, marble, and glass. The corporate logo is dramatically displayed on a wall composed of textured glass.

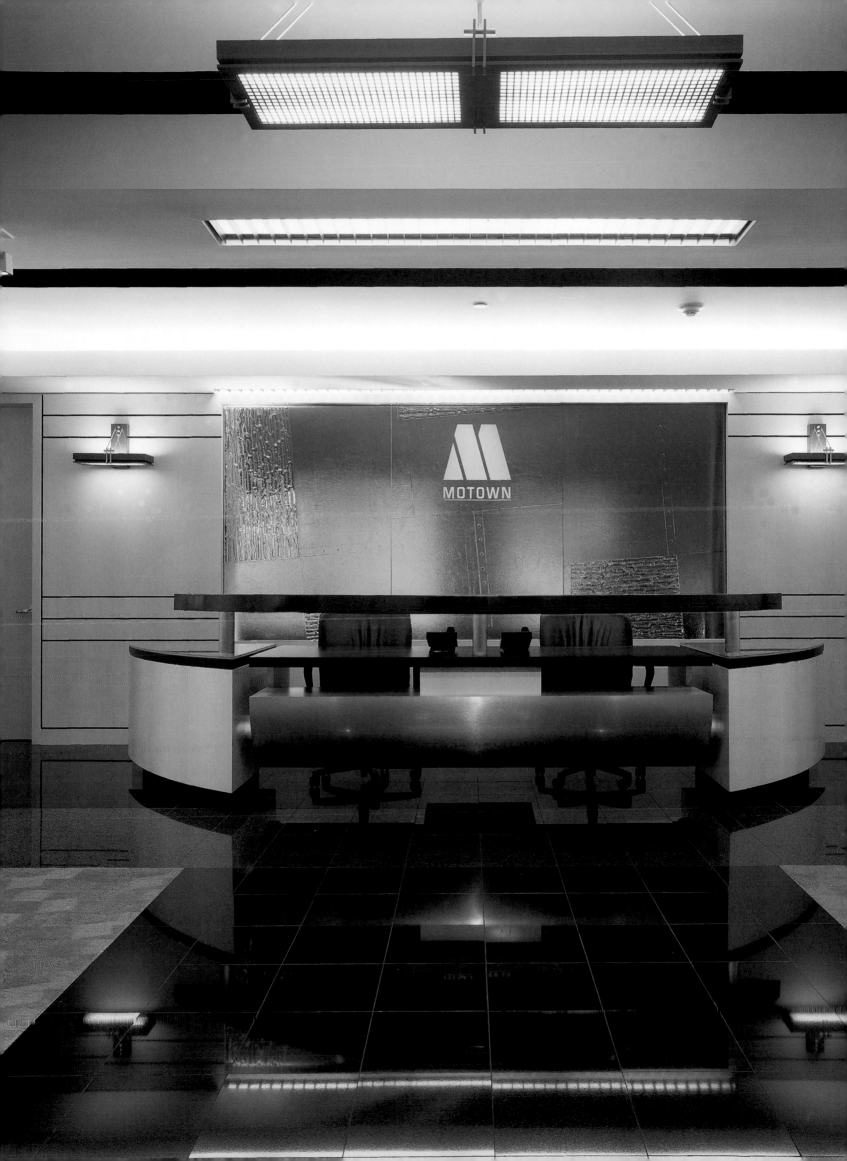

Designer Margaret O'Brien's new 12,500-square-foot (1,125-square-meter) offices for Virgin Records' A&R (Artists and Repertoire) Department and its Noo Trybe record label is an expansion of the company's headquarters building, and like that building (the former Beverly Hills Public Library, converted several years ago into offices by architect Frank Israel), the A&R Department is housed in what was once a public facility—an adjunct to the Beverly Hills City Hall. However, beyond this shared history, the two structures share little other than a common client, some sympathetic vibes, and the implicit requirement that the interiors be hip enough for A&R reps and their rock 'n' roll clientele (Virgin artists include the Rolling Stones, Janet Jackson, and Smashing Pumpkins). O'Brien's sophisticated lighting and creativity with offbeat, low-cost materials combine to establish a warm, inviting atmosphere without stinting on the hip image this industry demands.

VIRGIN RECORDS AMERICA
Beverly Hills, California
Interior design by O'Brien & Associates, Los Angeles

❖

Wooden window blinds add a homey touch and allow the office occupants different privacy options.

❖

An oval-shaped dropped ceiling works as a light reflector over the workstations. Low-cost materials are enriched with raffia and opalescent paint finishes.

❖

The breakroom is furnished with classic Aalto chairs and a coffee table from an LA prop house.

The primary lighting tool is an oval-shaped dropped ceiling plane suspended over the workstations and private offices that occupy the central area of the rectangular space. Acting as a unifying element, this plane reflects and expands the light from wall sconces at office entrances and fluorescent uplights built into the workstations.

The materials palette is creatively low cost, selected to lend the interiors a kind of handcrafted quality. Stained MDF panels, opalescent paint finishes on drywall, wooden window blinds, and raffia fronts on workstation panels add warmth, richness, and depth without straining the budget. A good piece of this budget went into large quantities of acoustic material in walls and ceilings, for many of the private office dwellers play rock 'n' roll, the company product, at full volume.

In addition to custom-designing furniture for two executive offices, O'Brien designed cabinetry and storage modules for the rest of the private, perimeter-located offices and then had the office users bring their own furniture in. The result is an eclectic, quirky, and above-all individualistic ambience—perfect for an industry that thrives on creativity.

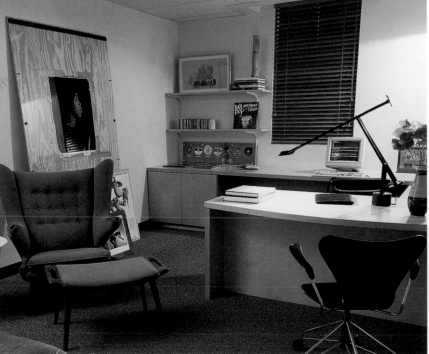

❖

Architectural cool prevails in a file storage area, with an unusual ceiling fixture providing a softening element, both visually and in illumination levels.

❖

The designers created the basic desk and cabinetry and then let the clients bring in their own stuff. This office is furnished with classic modern pieces and rock 'n' roll iconography.

❖

The designers created all the custom furniture in this executive corner office. The cabinets are maple with raffia fronts, and the table desk is maple-topped on a flagstone base. The residentially styled sitting room is equipped with a video system.

DESIGNER PROFILES

ADD INC

Winner of numerous design and building industry awards during its twenty-seven years in business, ADD Inc provides innovative architecture, interior design, and planning solutions for corporations, real estate and retail developers, institutions, and financial and legal services firms. It is a firm of talented professionals who are committed to providing design services and products that exceed client expectations and delivering the best design, value, and experience possible. ADD Inc also recognizes its environmental and social responsibilities through its commitments to reduce pollution, preserve natural resources, maximize the positive effects of its projects, as well as to give back to the community by supporting volunteerism and corporate gift programs.

OPPOSITE The design for this growing regional bank in Boston created shared conference rooms surrounding a dramatic two-story reception hub. ALL PHOTOS BY LUCY CHEN

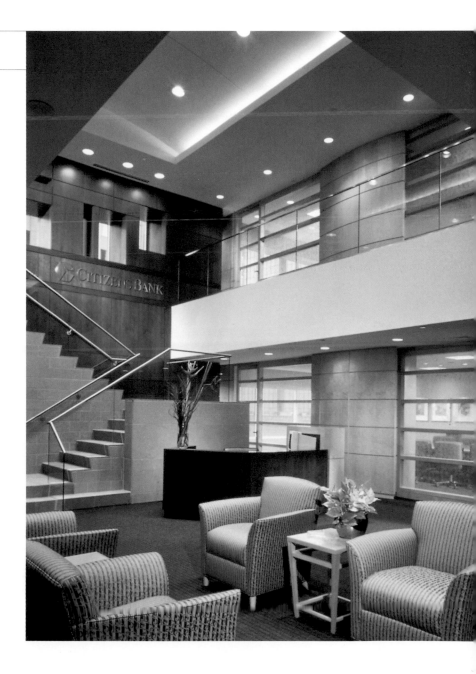

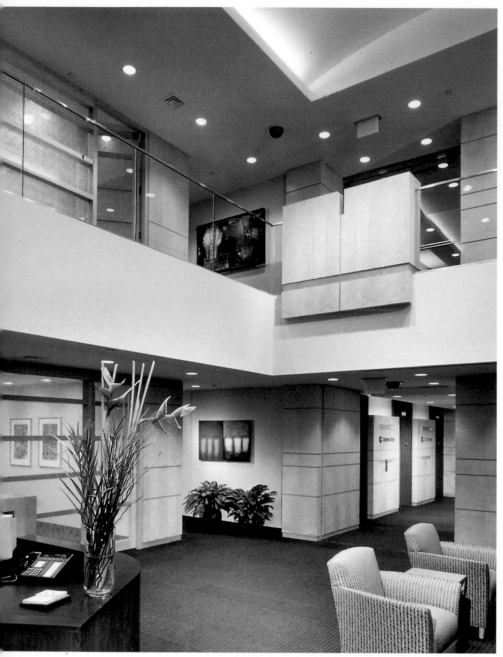

ABOVE Furniture and finishes express this bank's sensible approach by creating an aesthetic of fabric, wood, and frosted glass enhanced by the durability and cost savings of metal files and plastic laminate work surfaces.

RIGHT Workspaces emphasize openness and interaction, limit the number of closed offices, and convey a youthful, modern image.

FAR RIGHT Art niches with custom lighting were installed throughout the interior of this Boston firm to ensure that all staff members work with art in their surroundings.

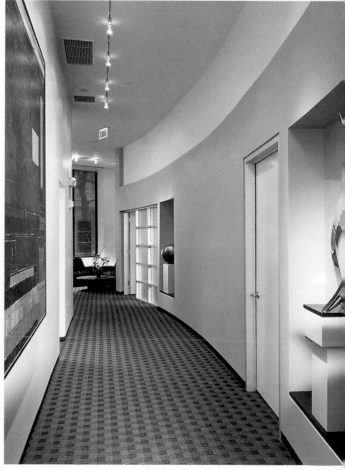

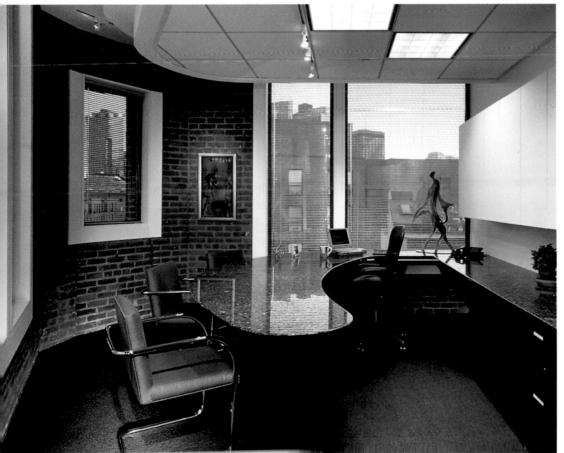

ABOVE The information services department conveys a high-tech image with an exposed server room and Netsurfer computer divans in which staff work at their computers in semi-reclining positions.

LEFT The design team worked with all of the firm's partners to customize the shape and granite selection for their desks. Twenty varieties of granite were specified, and each office received no fewer than three pieces of art.

A i

Established in 1984, Ai has grown and diversified with a commitment to provide the services and resources necessary for its clients to maximize real estate assets. In an increasingly competitive marketplace, the principals believe that ideal translates into the design of facilities that reduce occupancy costs, provide maximum flexibility, and support worker productivity. In support of that goal, the firm helps its clients find new ways to do business through effective cultural changes and alternative approaches to planning and work styles. Ai offers integrated planning, design, and management services.

OPPOSITE Administrative staffers work in groups of three in spaces that open to the reception area. The design employs lively, sustainable finishes to achieve a loft-like environment.
PHOTO BY WALTER SMALLING JR.

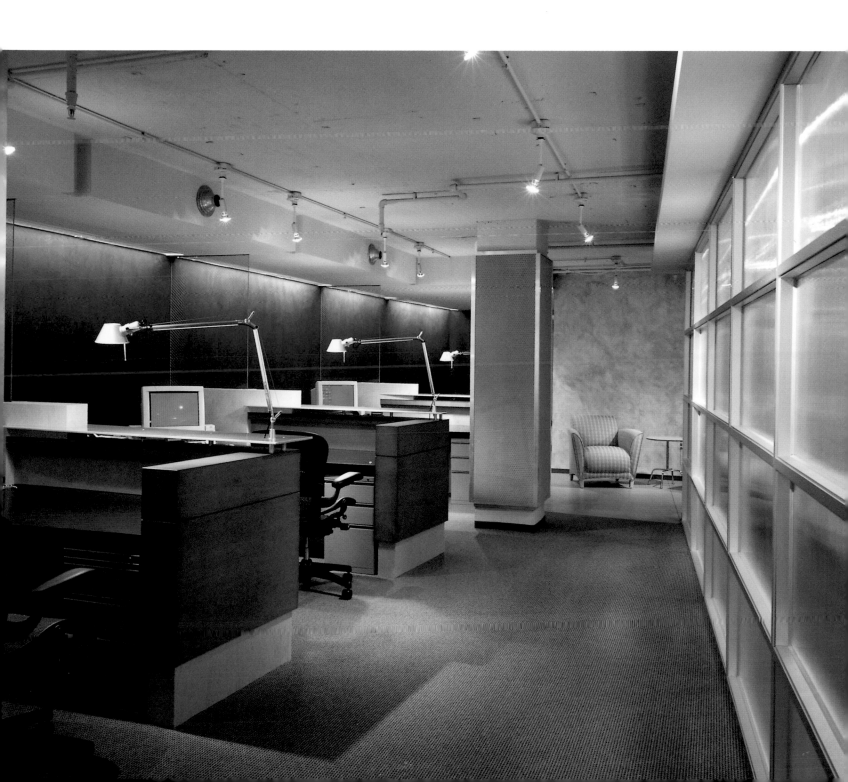

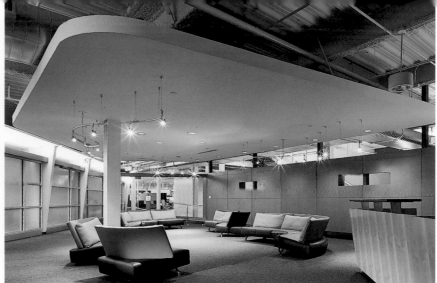

ABOVE LEFT Private offices with sensuous curved walls unite a composition that consists of numerous atria and conference pods. Expansive views of the interior space and landscape beyond enliven the offices and workstations.
PHOTO BY JEFF GOLDBERG/ESTO

ABOVE RIGHT In eight months, Ai converted a warehouse into a state-of-the-art office building, creating a flexible work environment, as well as an image appropriate for this global technology-based media company in Dulles, Virginia.
PHOTO BY JEFF GOLDBERG/ESTO

RIGHT The main conference room of this Washington, D.C., company is surrounded by partitions of anodized aluminum storefront systems infilled with plexiglass.
PHOTO BY WALTER SMALLING JR.

BELOW RIGHT The flexibility of this operations center in Reston, Virginia, is reflected in the dining area. Through the use of sliding opaque partitions, it can be divided into small seating areas or opened to create a single meeting space.
PHOTO BY WALTER SMALLING JR.

OPPOSITE From new rooftop monitors, light spills into informal seating areas used by employees for spontaneous team meetings and impromptu work sessions.
PHOTO BY JEFF GOLDBERG/ESTO

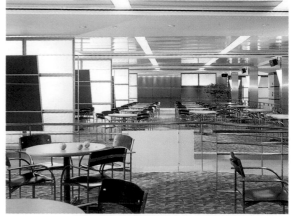

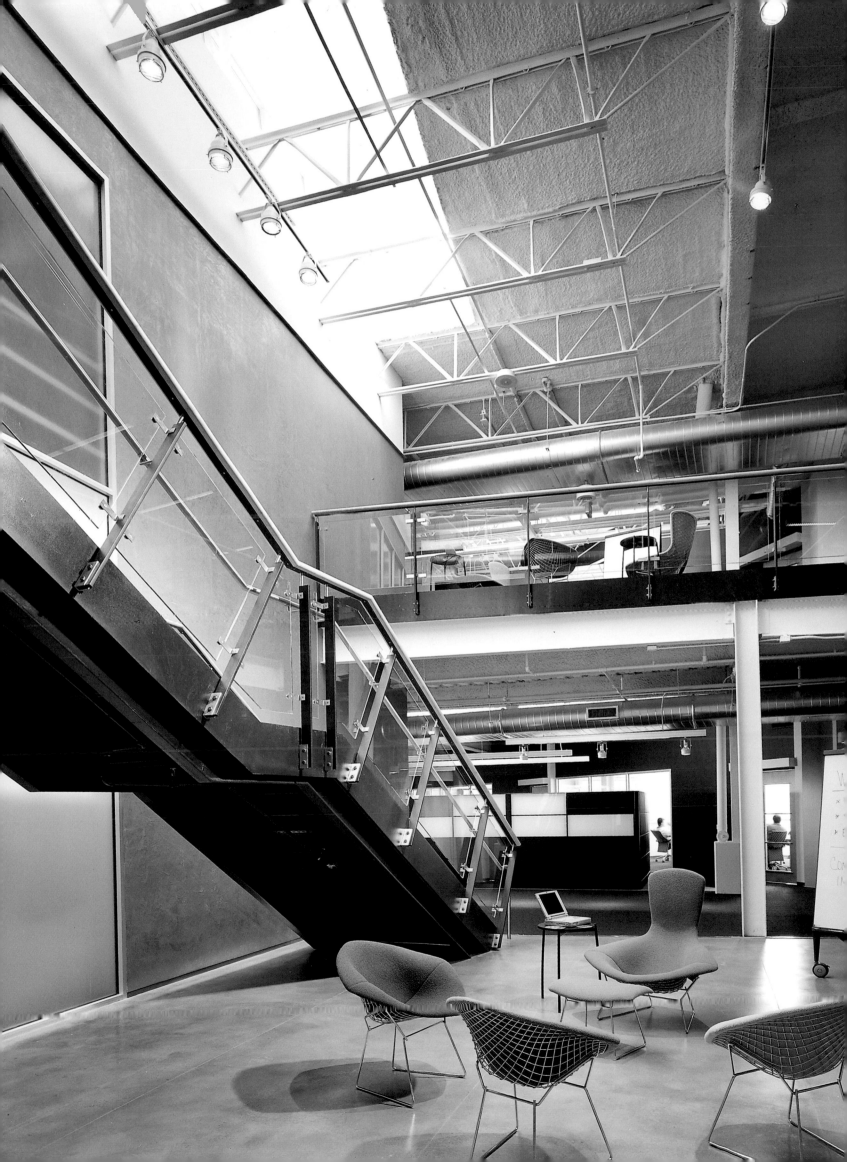

ARCHITECTURAL ALLIANCE

Architectural Alliance has built its success through a team-building approach, encouraging strong partnerships among employees, clients, contractors, and consultants. The firm services a wide range of clients including corporations, governments, institutions, property managers, retailers, airlines, and airports. Architectural Alliance joins with the most appropriate consultants for each project. The firm's architecture and interior design staff works closely with consultants to create quality projects in both renovations and new construction. The firm's longstanding relationships with clients have produced designs that are creative, functional, and responsive to physical and cultural influences. Founded in 1970, Architectural Alliance, Inc., is a multidisciplinary firm of seventy architects, planners, interior designers, and support staff providing architectural, planning, interior design, and construction observation services. The firm has received national and regional recognition and design awards, including the AIA Minnesota Firm Award in 1994.

OPPOSITE CLOCKWISE FROM TOP LEFT The wood-paneled ceiling in the conference room bows slightly along the length of the space, its shallow arc complemented by a custom-designed translucent light fixture. The feature wall offers both privacy and openness; it combines clear and sandblasted glass framed by aluminum fins that incorporate uplights.

The design of these Minneapolis offices capitalizes on the opportunities of a single-tenant floor by integrating the elevator lobby with the firm's more public activities.

A neoclassical vocabulary in the base building gave rise to the diverse materials palette—terrazzo and carpeted flooring, brushed aluminum, clear and translucent glass, and a range of exotic wood types, including cherry, anigre, mahogany, and ebonized walnut.
ALL PHOTOS BY GEORGE HEINRICH

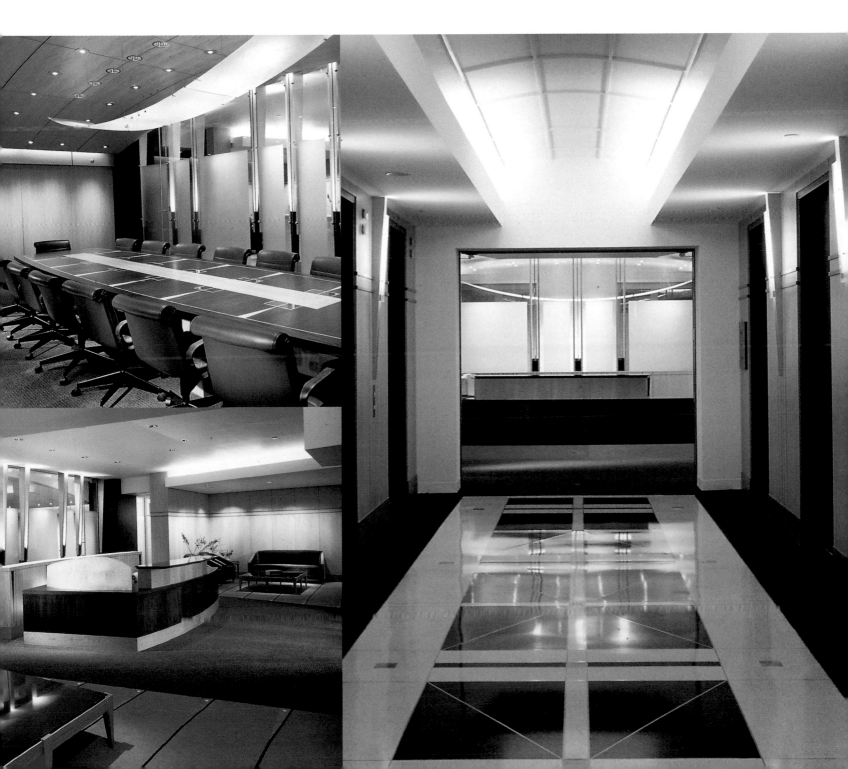

AREA

AREA bases its practice on entertainment, law, financial, and corporate firms, producing spaces with an architectural purity that is client-specific. Firm principals Walt Thomas and Henry Goldston, both registered architects, created the firm to serve clients who require a high level of personal attention and desire unique design solutions. Their past experience as managing principal of ISD Interiors and studio design director at Gensler, respectively, gives them the insight to realize that clients want spaces that express their individual image requirements, delivered on schedule and within budget. The firm's no-nonsense approach to the design process appeals to busy executives. AREA also strives to render and explain the character of its spaces to clients so that there are no surprises when the work is complete. While the firm's work is firmly based in the tenets of classic modern architecture, a palette of comfortable colors, lighting, furniture, and forms always take precedence over impersonal starkness or frivolous style.

OPPOSITE Taking advantage of the concrete structure in this vintage 1965 building, AREA left sections of the framework exposed and highlighted it with uplights in the public areas of these offices for a Beverly Hills talent management company.
ALL PHOTOS BY JON MILLER ©HEDRICH BLESSING

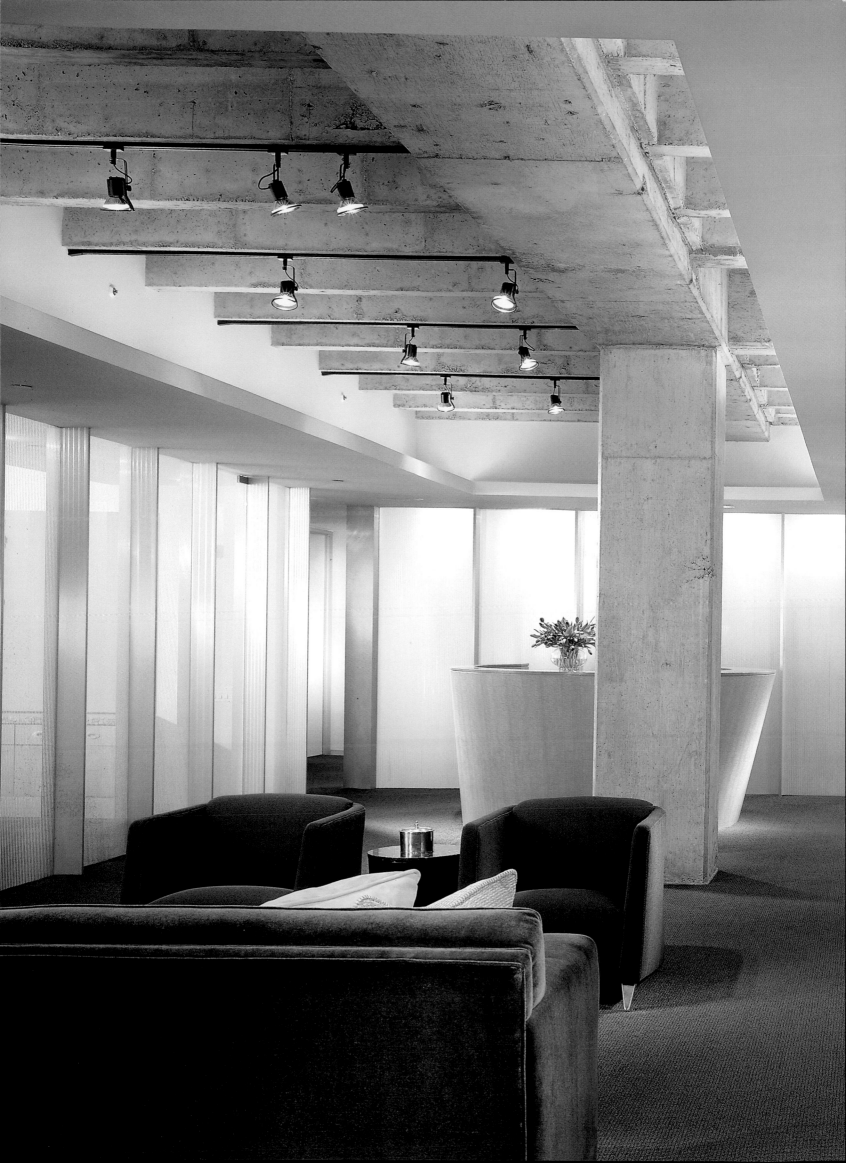

LEFT Stereotypes of glittery Hollywood are eschewed in these law offices, which feature clean architectural details. Rich olive green carpeting provides a backdrop for a range of wood species, such as English yew, East Indian laurel, wenge, and others that were selected for inlays and supporting millwork.

BELOW To achieve the feeling of "California casual" requested by their client, the designers developed a color scheme that emphasized the mixing of multiple shades of green upholstery accented with shades of red. The design incorporates an existing collection of art and furnishings.

OPPOSITE In these offices for a prominent Los Angeles entertainment law firm, the client desired a sense of permanence and longevity. Common-grade, figured American cherry was selected as the main wood statement because of its unusual variations, sap marks, and swarthy character. Floors are Brazilian cherry.

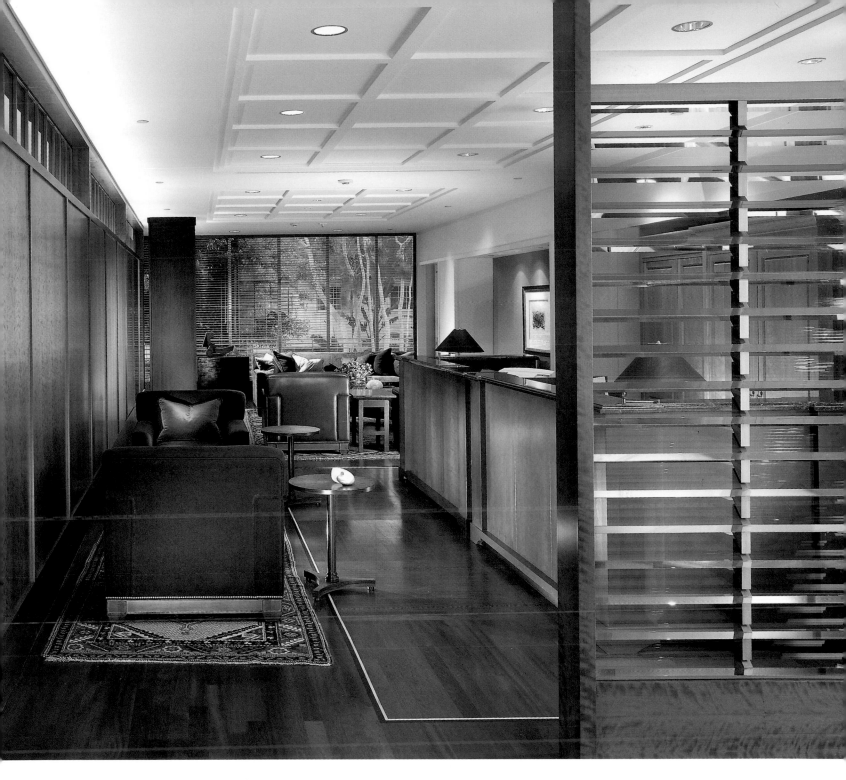

OPPOSITE Files are located in a storage wall that forms a partition embellished with a colored blade on top. At the center is the sales manager's cubicle, which is located strategically in the center of the building.

LEFT The sales manager's office occupies an enclosed space behind a canted yellow wall. It overlooks the open office area, where alternating sloped counters are arranged for viewing job tiles and customer artwork. Walls at the rear are unfinished tilt-up concrete panels.

BELOW LEFT The interior design solution in this low-cost tilt-up wall building blends a white "clean room" aesthetic with an infusion of geometric shapes and vibrant hues. Angled blades painted red, blue, and green sit atop banks of file cabinets, creating a colorful landscape.

BELOW RIGHT The 150-foot-long (45-meter-long) reception area for this TV animation studio in Burbank, California, includes a green room/employee lounge partially hidden behind a curved, orange "Googie" wall and a dripping, green slime staircase that leads to the mezzanine.

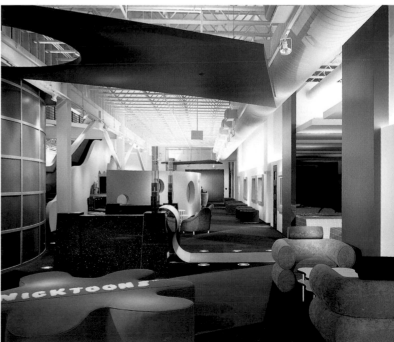

BERGMEYER ASSOCIATES, INC.

Founded in 1973, Bergmeyer Associates, Inc., is a seventy-five-person full-service architecture and interior design firm specializing in retail and food service design, housing, commercial buildings, and corporate interiors. Additional areas of expertise include image and identity analysis, prototype store design, and media technology. Bergmeyer works nationally as well as in Japan, Canada, and the United Kingdom.

OPPOSITE An inviting kitchen and informal arrangements of tables and lounge chairs encourage impromptu meetings and brainstorming sessions. Bright fabrics and colors reinforce the company's departure from a stale corporate image.

BELOW Using existing structural elements and raw building materials, Bergmeyer created a casual office developed around the way people work in the space.
ALL PHOTOS BY LUCY CHEN

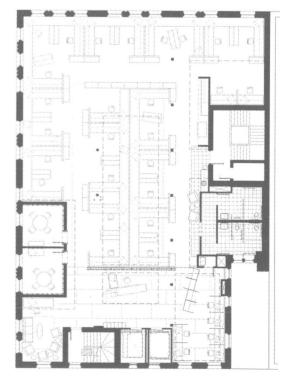

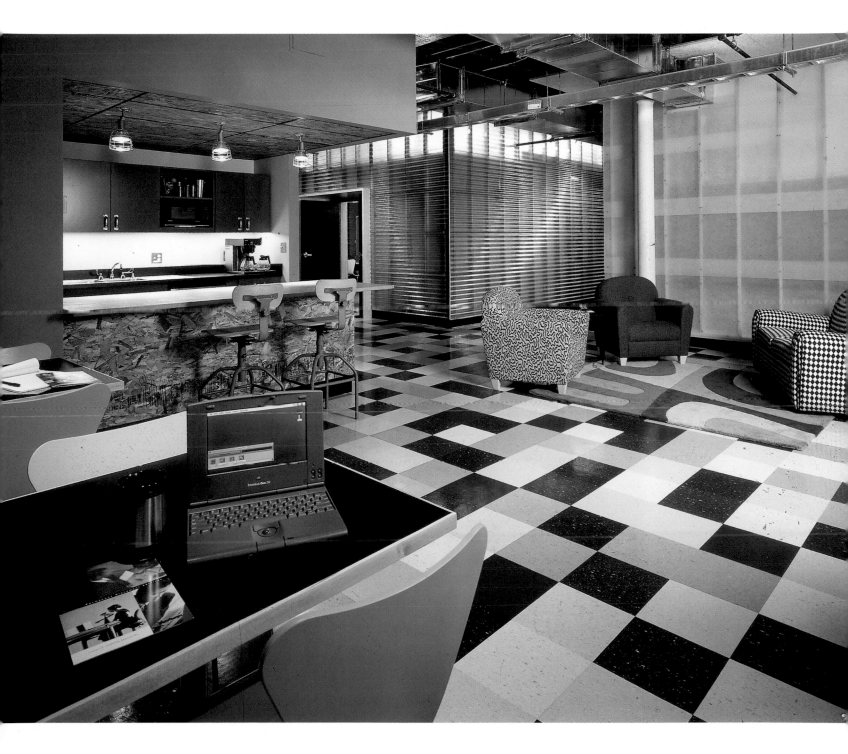

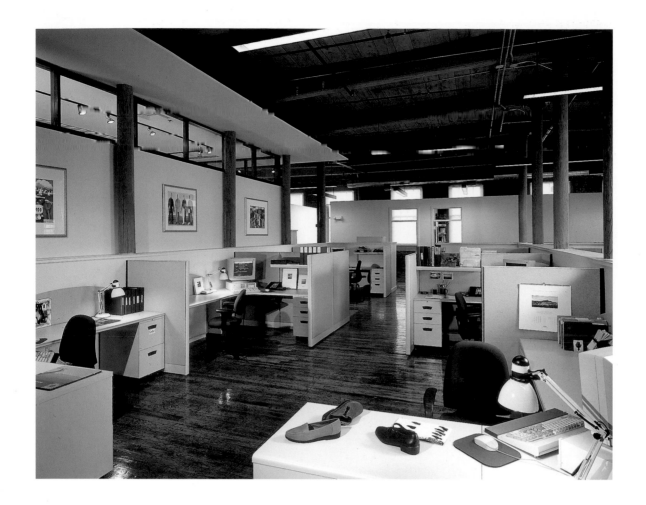

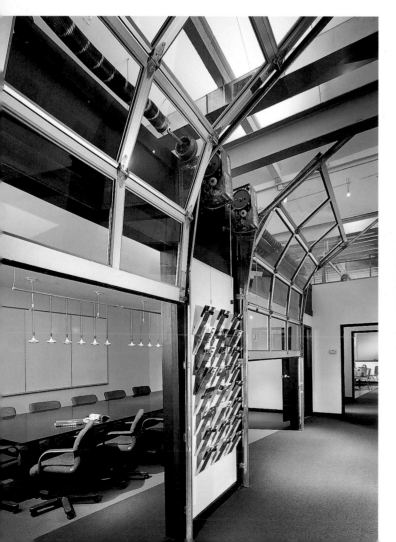

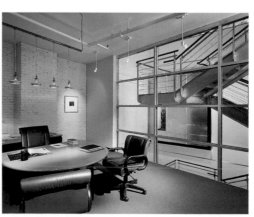

ABOVE Original features of a renovated mill building—hardwood floors, beams, and high ceilings—are combined with wood, leather, graphics, and storefront elements in these corporate offices for a specialty shoe manufacturer.

FAR LEFT When opened, the garage doors that enclose this firm's conference room become an awning extending into the reception area.

LEFT One of the firm's partners has an office that overlooks an atrium—and across the atrium into a galvanized steel bay that contains the office of his counterpart.

OPPOSITE The cantilevered atrium stair is made of exposed structural steel, pigmented concrete treads, stainless steel cable guards, and ebonized poplar rails.

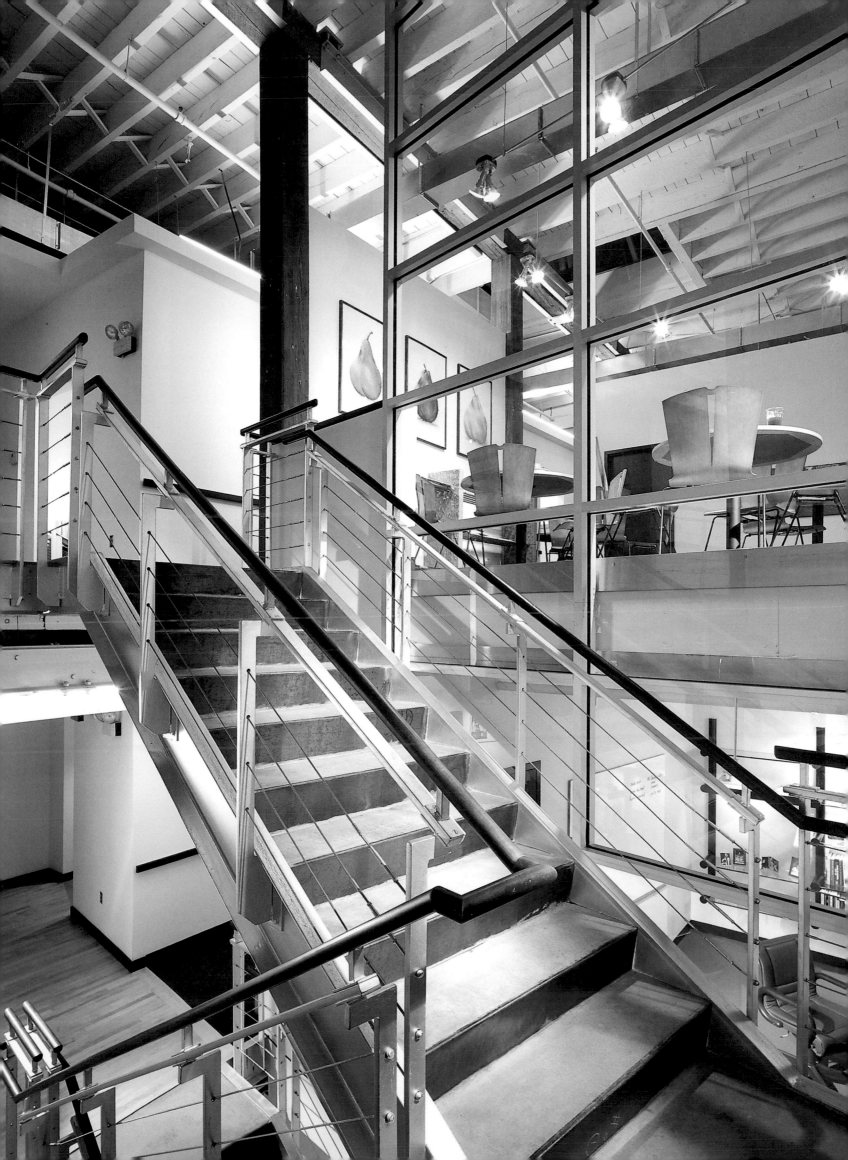

THE BOMMARITO GROUP/
GRAEBER, SIMMONS & COWAN

The Bommarito Group/Graeber, Simmons & Cowan has earned a reputation for design that is both innovative and sensitive to client requirements. Recognizing that design is a business as well as an art, the firm works with clients as an interactive team, searching for unique design solutions that also make good business sense. The design team possesses a diverse project portfolio, with experience in commercial, institutional, health care, hospitality, and advanced technology design. The firm offers comprehensive commercial interior architecture, interior design, and space planning services, incorporating the skills of interior designers and architects to provide clients with personalized service.

ABOVE RIGHT The juxtaposition of natural fiberboard and raw metal in the entry desk and mobile display unit reflect this multimedia firm's identity: both rough and modern, primitive and slick.

RIGHT The reception area of this law office houses the original judge's bench, platform, and witness stand that occupied the building when it was a federal courthouse in the early 1900s.

OPPOSITE Canted corridors and walls, stonelike portals, and ever-changing color are among the elements designed to reflect the creative nature of this Austin software games company and inspire its employees.
ALL PHOTOS BY PAUL BARDAGJY

BRAYTON & HUGHES DESIGN STUDIO

Founded in 1989 by Richard Brayton, who was later joined by Stanford Hughes and Jay Boothe, Brayton & Hughes has cultivated a design approach that offers unique solutions to each design by emphasizing the particulars of program and regional design influences. The firm serves both American and international markets, providing comprehensive architectural and interior design services for projects throughout the Pacific Rim, Europe, the Middle East, and the United States.

RIGHT An 11,000-square-foot office and lighting showroom in San Francisco combines a wide variety of functions within an existing concrete shell. Materials and details embody new construction techniques and finishes, with gestures such as the historic acorn pendant fixture introduced as a direct reference to a transcended past.

OPPOSITE Lateral bracing required in the existing facade provided a rich opportunity for its redesign. Openings that once held industrial sash windows were filled with concrete and punched with small squares filled with cast blue glass that transmits light into the mezzanine-level cafe.
PHOTOS BY JOHN SUTTON

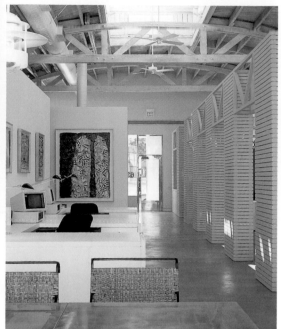

FAR LEFT Raised drywall panels painted by a local artist suggest a mixed message of billboards, urban calligraphy, and industrial decay in these temporary quarters for an Emeryville, California, company. These openings, framed by lintels of cold rolled steel, lead to "courtyards" that accommodate work groups.
PHOTO BY CHAS MCGRATH

LEFT Solid elements play against a garden-like trellis of lattice screens and structural portals at an investment banking firm that moved into a former glass factory in Palo Alto, California. Custom furniture includes plastic laminate desks and a zinc-topped conference table; existing concrete floors were stained a deep earth color.
PHOTO BY JOHN VAUGHN

BELOW Asian design themes lend a feeling of serenity to these San Francisco offices. The executive reception area features a banquette with silk pillows and restrained colors; indirect light washes across the grid-patterned beech wall.
PHOTO BY JOHN SUTTON

OPPOSITE Clean modernist space provides a showcase setting for the Cubist cabinet and screens that divide the conference areas at an Alameda, California, investment banking firm. The cabinet conceals audio-visual equipment while providing an ideal showcase for an eclectic collection of artifacts.
PHOTO BY JOHN SUTTON

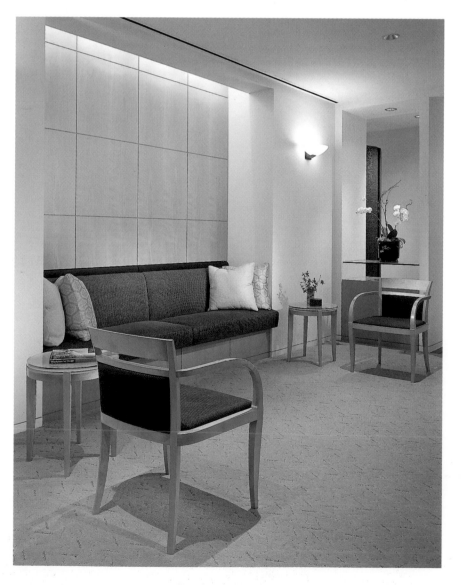

CALLISON ARCHITECTURE

Callison maximizes the design potential of each project through a balance of art, business, and technology. Founded in 1975, the firm develops innovative solutions in partnership with its clients, creating value by enhancing the clients' success. Callison provides full-service planning and design services to retail, hospitality, residential, health care, and corporate clients throughout the world. Services include architecture, master planning, interior design, graphic design, corporate facility consulting, and purchasing. The firm's specialties include corporate offices and campus planning, health care facilities, retail-based urban mixed-use developments, and a wide range of retail, entertainment, and hospitality projects. Based in Seattle, Callison is one of the largest architectural design firms in the United States, with a staff of more than 400 professionals. The firm also maintains offices in Hong Kong.

RIGHT Abundant natural light and awareness of the outdoors are emphasized in the design of this corporate headquarters in Redmond, Washington. Clerestory windows spill light into the informal gathering areas on the second-level gallery.

OPPOSITE The stone walls and recycled wood floors of the waiting lobby outside the executive wing reflect the design team's efforts to connect indoors and out. Mission-style furniture is from the client's own product line.
ALL PHOTOS BY CALLISON ARCHITECTURE, INC.

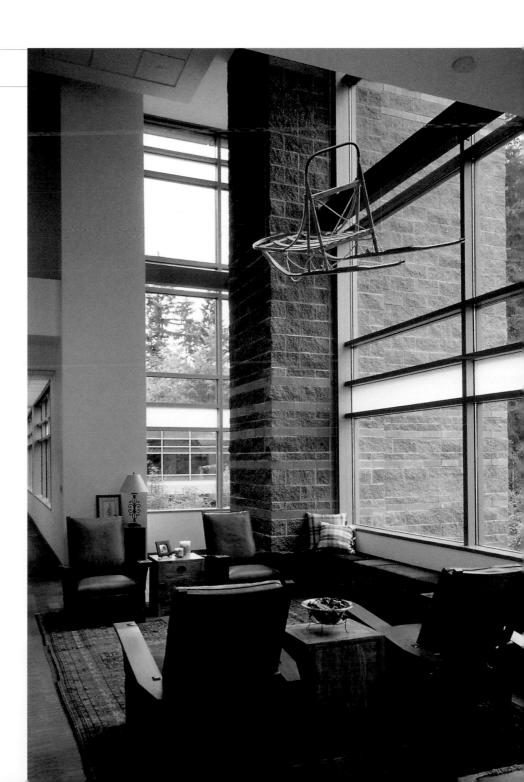

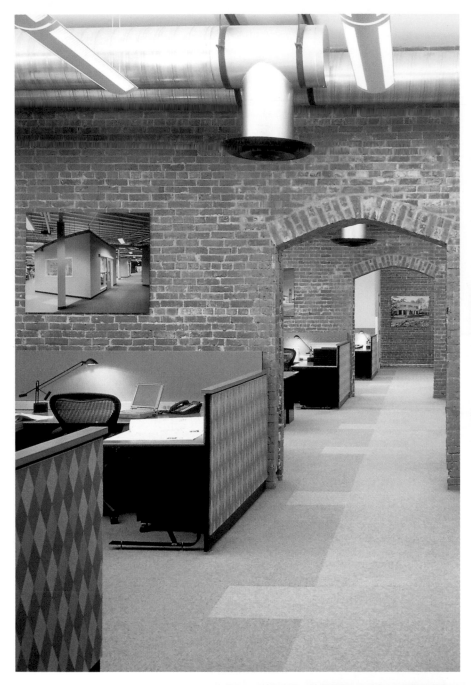

LEFT A contemporary palette of form, materials, color, and detail complements the historic building that houses this construction company's Seattle offices. The blue, green, and ochre color scheme evokes associations with the natural setting of the Pacific Northwest.

BELOW Wheeled workstations arranged on a raised floor allow the creative groups of this 3D animation software company to reconfigure swiftly into new combinations as assignments change.

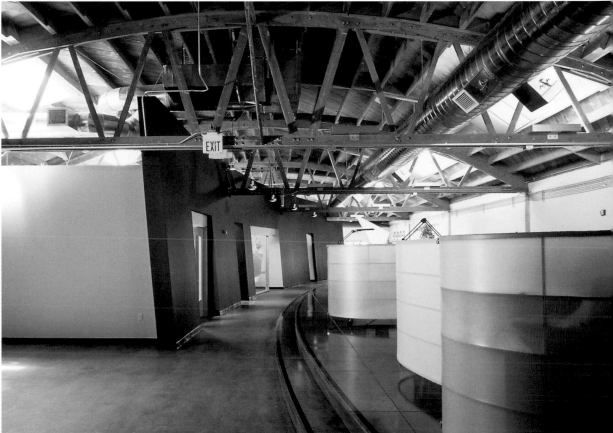

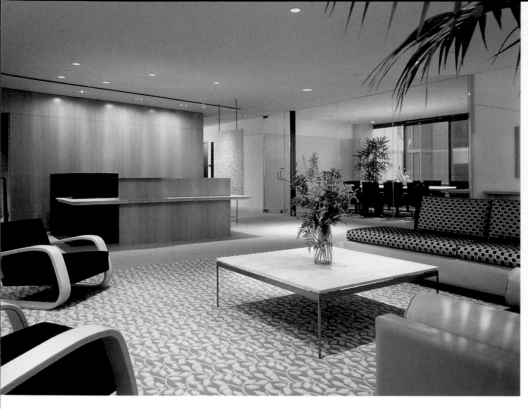

ABOVE LEFT To achieve the greatest impact on a tight budget, the office upgrade of this San Diego law firm refreshed and reused materials wherever possible. Soft muted colors and natural wood finishes reflect the context of the Southern California desert and evoke a sense of tranquility.

ABOVE RIGHT The redesign of this office minimized space previously dedicated to circulation while adding a three-level staircase to create more flexible, efficient circulation and establish a visual tie between floors.

CDFM² ARCHITECTURE INC

A diversified architectural services firm, CDFM² provides its clients with complete solutions through a full-service approach integrating architecture, interiors, and facility management. CDFM² believes that the most rewarding results are the product of a dynamic collaboration between owner and architect. The firm builds on the principle that a successful design concept is formed from equal parts of clear-eyed analysis and creative problem solving. CDFM², therefore, focuses on designing buildings from the "inside out," which means determining clients' needs in relation to an individual project's goals—then designing facilities around those needs. The intent is to achieve a creative, flexible, and practical scheme that will perform well into the next century.

OPPOSITE A small conference room, situated between two private offices, includes a custom conference table and leather chairs highlighted by a canopy light fixture, fabric panels, and anigre trim.
PHOTO BY TIMOTHY HURSLEY

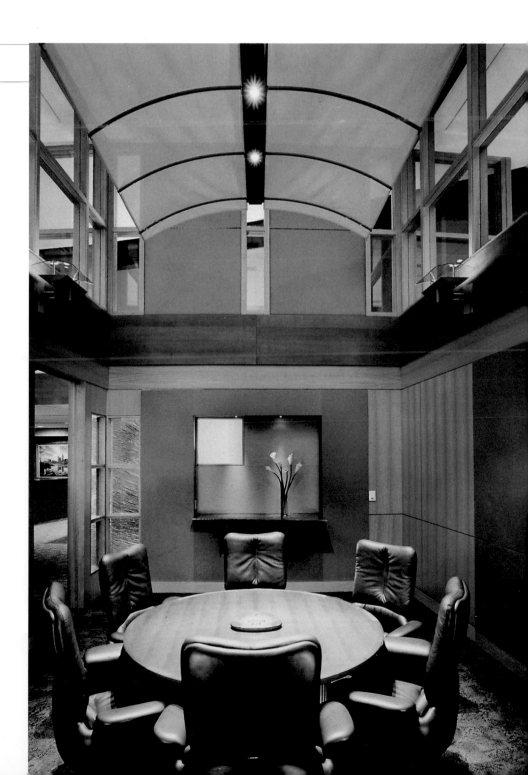

ABOVE Sandblasted and honed limestone create a checkerboard effect along the curvilinear back wall of this Kansas City company's reception area.

RIGHT The elegance of this large conference room is accentuated by a suspended glass light fixture. Patterned glass and the limestone wall continue into the reception area beyond.

PHOTOS BY TIMOTHY HURSLEY

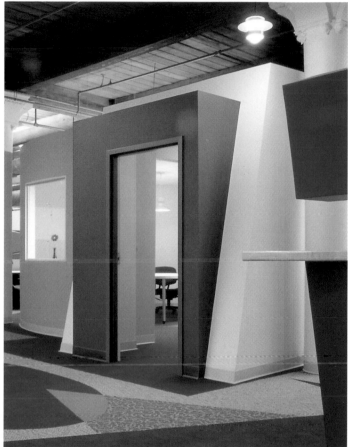

RIGHT Located along the internal street of this Kansas City company are seven "community centers" signaled by unique and colorful entryways. The centers are cross-functional spaces that accommodate conferencing, team meetings, and project work groups.

BELOW LEFT Changes in color, form, and lighting distinguish the resource zone from the idea and collaboration zone that exists within each community center.

BELOW RIGHT A free-flowing furniture layout with lower panel heights, body-pocket work surfaces, paper management toolbars, and mobile pedestals supports the user's change in work philosophy.

PHOTOS BY MIKE SINCLAIR

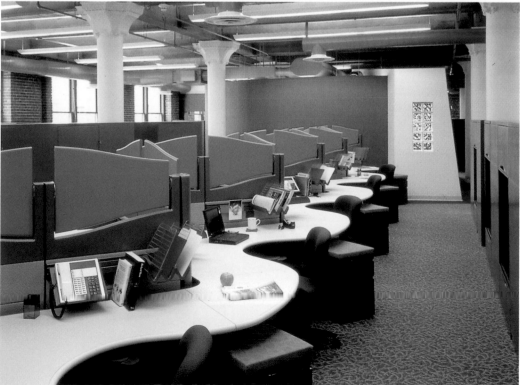

CORE

CORE cultivates a professional culture focused on producing high-quality work and delivering client satisfaction. Its primary business is design, with capabilities including architecture, interior design, master planning, historic preservation, and graphic design. Specializing in creative problem solving, CORE has a reputation for total image development. The firm pursues innovation in every aspect of its work, devising methods that respond to each client's unique and changing needs.

RIGHT The sculptural supervisor's tower creates a focal point between two open workstation areas and allows easy monitoring of operations on the floor. Existing structural glazed tile walls in some areas of the base building complement the new material palette.

OPPOSITE The company's focus on electronic warranty service is underscored by the display of antique electronic artifacts throughout the space. The building perimeter is reserved for private offices and a conference room, seen here behind one of the large sloped drywall partitions that create a series of colorful backdrops in the windowless environment.
ALL PHOTOS BY MICHAEL MORAN PHOTOGRAPHY

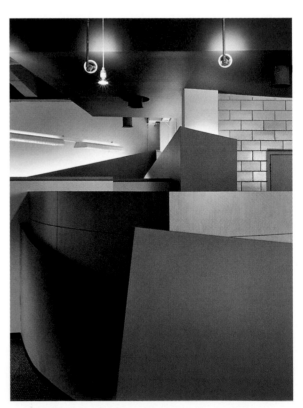

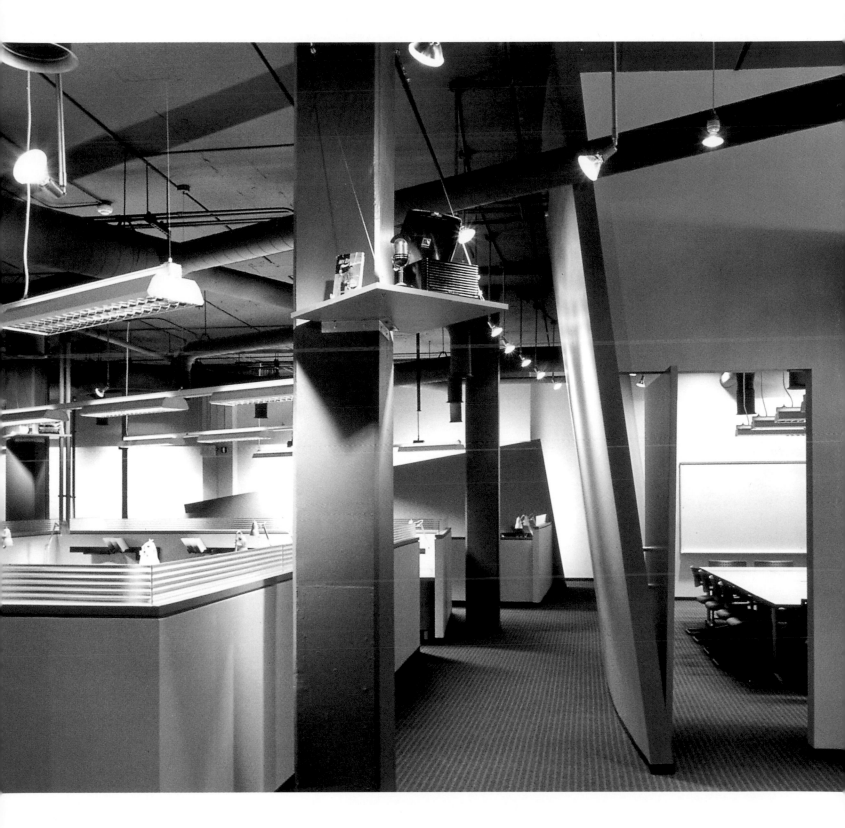

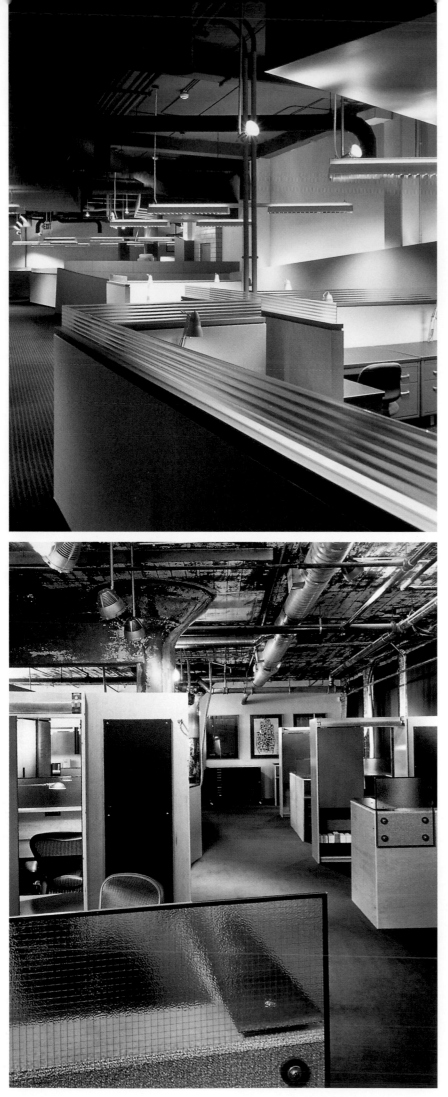

ABOVE Free-floating workstations in this Washington, D.C., graphic design firm are constructed of birch veneer plywood, medium density fiberboard, and cold rolled steel. Framed wire safety glass adds a level of privacy to each station, along with a movable panel that slides to allow communication between stations.

LEFT The layout of this call center in Great Falls, Montana, is composed of a series of open workstations organized in team clusters. Surrounding the clusters are low partitions that feed power and data cabling to the workstations. Panels of fluted glass on top of the partitions reinforce the retro look of metal desks.

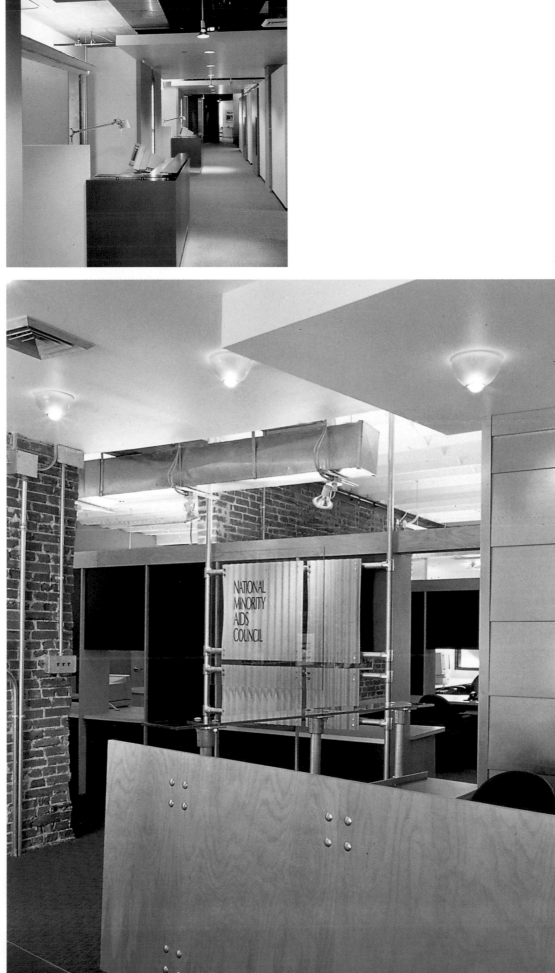

ABOVE RIGHT General work spaces at this Washington, DC, firm incorporate birch sliding doors, exposed concrete ceilings, and industrial carpet and light fixtures.

RIGHT By converting two derelict townhouses into a single building, the architects created new offices for their client. Counters, desks, shelves, filing cabinets, and chairs were designed to maximize space-efficiency and achieve dramatic results on a $700,000 budget.

ABOVE LEFT By employing a series of sliding and pivot doors, this conference room doubles as a meeting space or well-equipped reception area. Movable conference tables convert to buffets and, when its doors are open, the pantry doubles as a serving bar.

LEFT The minimalist aesthetic of the custom millwork and furniture reinforces a straightforward design approach borne of budget constraints, while allowing for an expressive use of color.

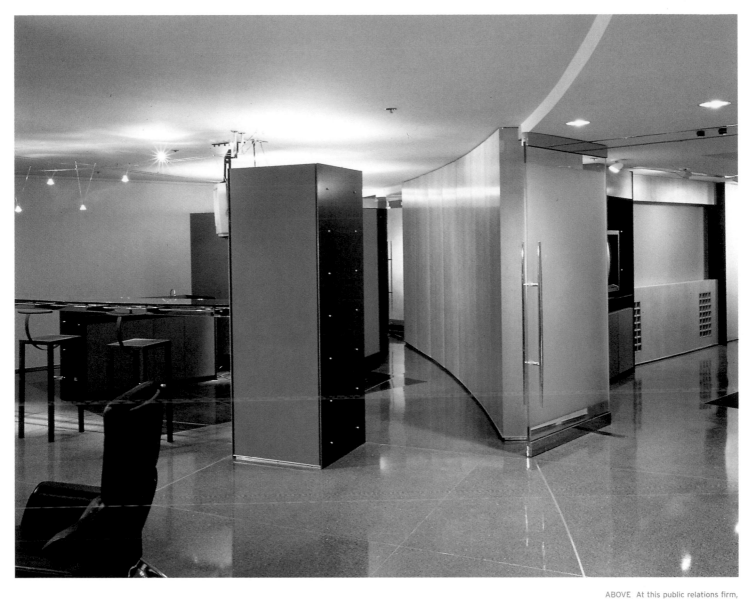

ABOVE At this public relations firm, the designers created a dynamic environment by layering lines, planes, and volumes. These elements inter-act to frame vistas and define informal spaces where employees work alone or on teams.

ELKUS / MANFREDI ARCHITECTS LTD

Founded by Howard F. Elkus, FAIA, RIBA, and David P. Manfredi, AIA, Elkus/Manfredi Architects Ltd, is a full-service design firm providing architecture, master planning, urban design, interior architecture, space planning, and programming. In its ten-year history, Elkus/Manfredi has been selected by CEOs and decision-makers around the country to make their goals tangible. The firm has helped clients evaluate their business processes and analyze future trends, at times leading to the development of a new prototypical design or implementation of a new way of doing business. Elkus/Manfredi's portfolio includes a rich diversity of projects that energizes the firm's work by a cross-pollination of ideas.

OPPOSITE Groupings of European-styled furniture and custom sculptures create focal points of interest in this two-story atrium, which is flanked by large conference rooms. Floors are polished concrete.
PHOTO BY MARCO LORENZETTI ©HEDRICH BLESSING

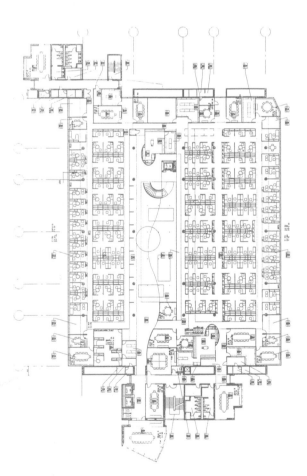

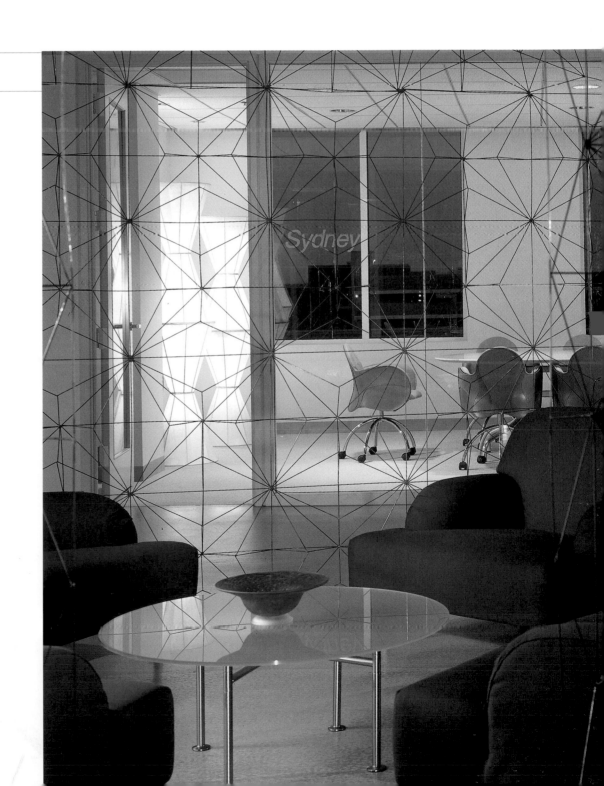

ABOVE Leather-tile flooring and Moroccan furnishings combine with iron-clad pulley doors to create a unique old-world feel in this conference room for a Boston ad agency.

FAR LEFT A new three-story atrium runs through the center of the entire building, spilling sunlight into the open office environment that surrounds the spaces. Both an elevator and curved staircase offer easy access between floors.

LEFT Large offices accommodate work, meeting, and seating areas. Typical offices in this six-floor interior are glass-walled to bring daylight into the rooms and provide visual connections between interior spaces.

PHOTOS BY MARCO LORENZETTI
©HEDRICH BLESSING

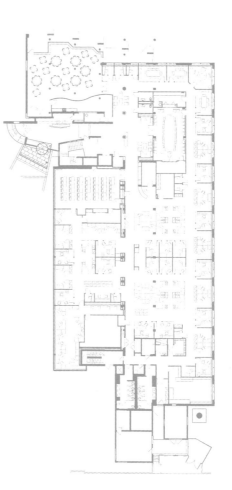

ABOVE Open seating areas (right) are intermingled among the private offices of this international consulting firm, whose spaces were designed with a flexibility to accommodate unpredictable growth.

RIGHT Large-scale photographic murals lining the interior "Main Street," such as the baseball players opposite the coffee bar, add vibrancy to the space and evoke themes of teamwork for this company, a longtime sponsor of the Olympic games.

PHOTOS BY GARY QUESADA
©HEDRICH BLESSING

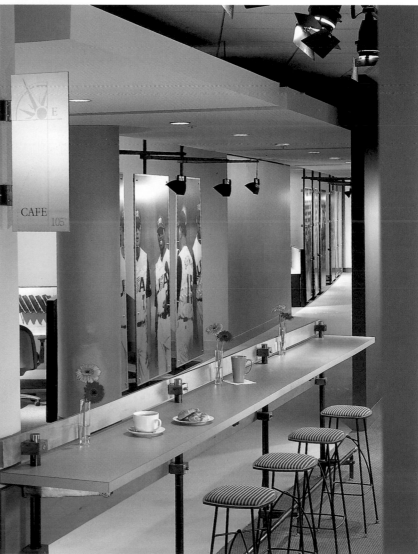

THE ENVIRONMENTS GROUP

Founded in 1991, The Environments Group is a service organization providing master planning and facility programming, interior design, and facility management. Although the firm's projects range in size from 2,000 square feet to nearly 2 million square feet (180 square meters to nearly 180,000 square meters), its mission on each assignment remains the same: to provide the highest standard of professional service and personnel to guarantee the fulfillment of clients' ongoing facility needs. The integration of planning, design, and management services throughout The Environments Group's project work has been vital to the growth of the firm and fosters a sharing of expertise among the different disciplines. The firm's service delivery approach addresses current and long-term business plans—providing clients with efficient means of utilizing their facilities.

OPPOSITE The reception area and entry to private work-spaces in these Sears Tower offices are framed by shell-stone and eucalyptus with brushed metal accents.
PHOTO BY STEVE HALL ©HEDRICH BLESSING

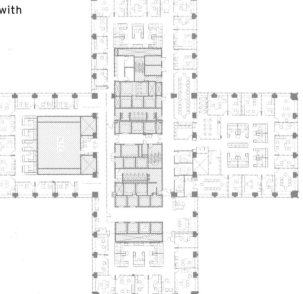

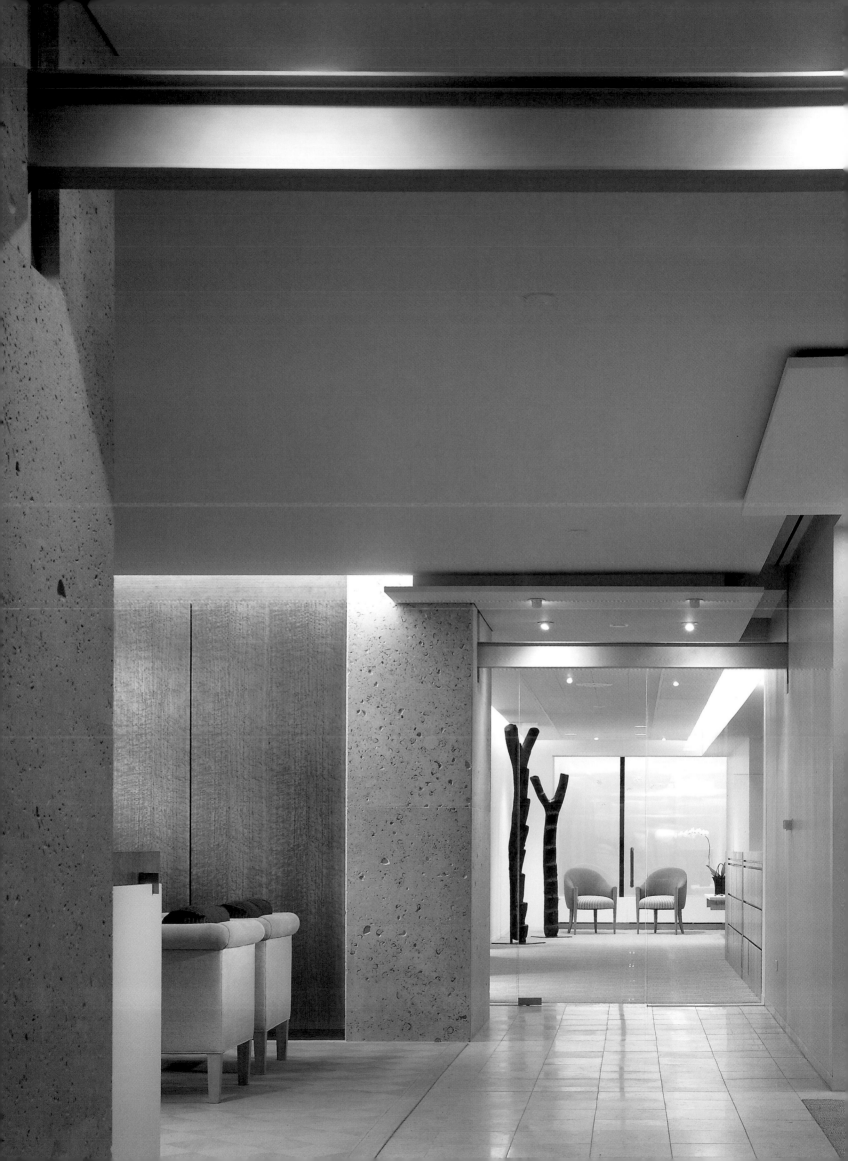

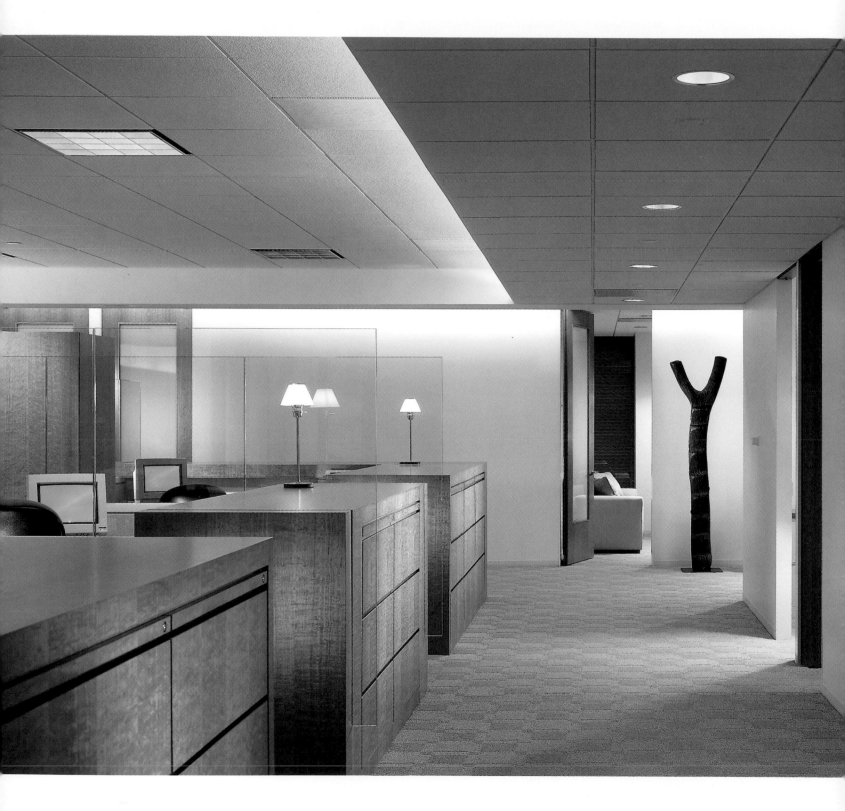

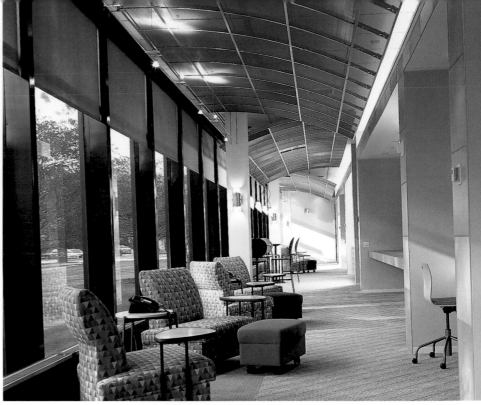

OPPOSITE The work area for executive assistants integrates filing and storage. Eucalyptus and glass enhance the work spaces and the entries to private offices.
PHOTO BY STEVE HALL
©HEDRICH BLESSING

ABOVE LEFT Muted colors and diverse images from around the world create a pleasing environment in the block of training rooms for this international company.
PHOTO BY CHRIS BARRETT
©HEDRICH BLESSING

ABOVE RIGHT Meeting rooms in this corporate training center open to a shared lounge where employees can contact their home office, download files, and send e-mail during breaks. Arched open ceilings, a rich mixture of colors, and flexible furniture create a relaxed feel.
PHOTO BY CHRIS BARRETT
©HEDRICH BLESSING

RIGHT The meeting and presentation space in The Environments Group's offices incorporates a glass wall with custom walnut millwork and layered blinds, allowing free circulation along the office perimeter without affecting light and views. The meeting table can be configured for a variety of uses.
PHOTO BY STEVE HALL
©HEDRICH BLESSING

BELOW RIGHT The firm's resource library is located along the perimeter circulation path, which is kept open to allow natural light to penetrate the space. Project storage is placed at the base of the curtain wall.
PHOTO BY STEVE HALL
©HEDRICH BLESSING

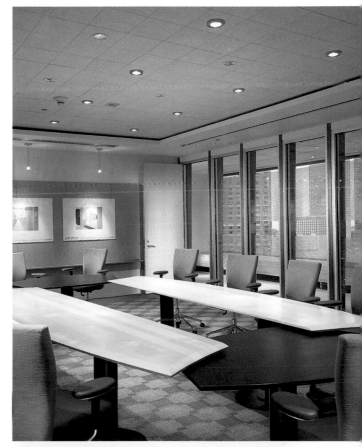

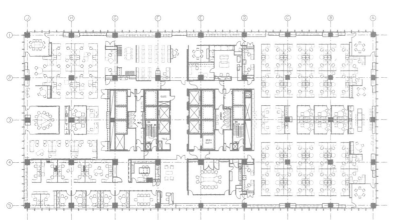

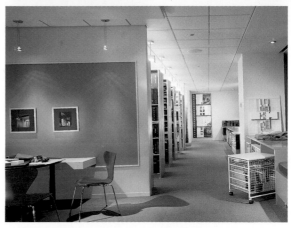

FOX & FOWLE ARCHITECTS, P.C.

Fox & Fowle Architects, P.C., is an architectural, interior design, and planning firm of fifty people. The firm provides a complete range of services including feasibility studies, program analysis, site selection, and post-occupancy evaluation for projects of every size and scope. Robert F. Fox, Jr. and Bruce S. Fowle formed the practice in 1978, establishing a diverse practice with much repeat work in the planning and design of investment-grade office buildings, corporate and institutional interiors, cultural and institutional facilities, residential buildings, and mixed-use, adaptive reuse, and renovation projects. Fox & Fowle's long commitment to interior design continues strong today. Heading the firm's interior architecture projects are design director Peter Jensen and studio director Rodney VenJohn. The interiors work covers a wide range of project sizes and types, from public spaces to boardrooms, from showrooms to educational facilities, and from high-end residential to back office spaces. A hallmark of the studio is its innovative use of "green" materials and the implementation of sustainable design guidelines throughout its work.

OPPOSITE The maple-floored "gallery" space connects the staff offices and showroom. Tack surfaces and chalkboards provide low-tech interactive elements that foster easily customized presentations.
ALL PHOTOS BY MARCO LORENZETTI ©HEDRICH BLESSING

OPPOSITE Staff offices exhibit a cross-section of available system furnishings in a conventional office configuration. Oval ductwork is exposed beneath the ceiling to reinforce the column/bay rhythm and allow the finished ceiling to be as high as possible.

ABOVE LEFT The office/showroom entry off the elevator lobby features an oversized panel door inlaid with the client's corporate logo, a fabric screen wall supported by aluminum poles, a multicolored slate floor, and layered mesh ceiling.

ABOVE RIGHT Views from the main conference room look into the technology demonstration rooms across a central waiting area. A warm palette of luxurious materials contrasts with the firm's high-tech products.

RIGHT This office entry features a sloping gridded wall with a custom, etched-glass logo set in a pearwood surround. Behind the metallic reception desk a mesh curtain wall obscures coat closets.

FAR RIGHT The conference waiting area is punctuated by pearwood portals "rotated" out of the surrounding wall and leading into conference rooms of various sizes.

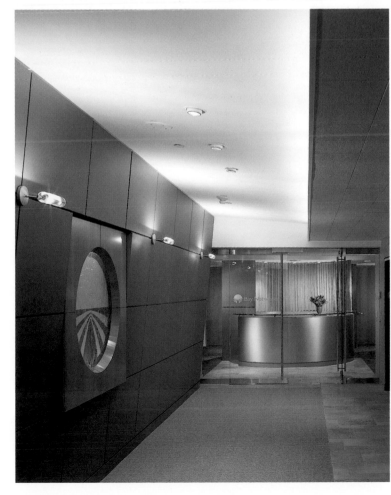

G.A. DESIGN INTERNATIONAL

G.A. Design is an international interior design firm whose projects range from full renovation to new construction of commercial offices, hotels, resorts, restaurants, and clubs. The firm's practice integrates the skills of architects and interior designers to offer clients the full scope of services needed to take a project from initial space planning and design through construction documents, furniture purchase, and installation. G.A. Design operates as a team, selecting the most qualified designer for each project from among the twenty designers in the studio. This expertise, combined with the many years of diverse design experience of the four principals—Werner Aeberhard, Harry Gregory, Terry McGinnity, and Maria Vafiadis— enables the firm to provide clients with unique and creative design solutions. Working within a wide range of budgets, the firm's designers welcome the challenges of creating both attractive and successful working environments.

RIGHT Contemporary furniture is mixed with the more traditional lines of the armoire unit adjacent to the chairman's desk. Door at right leads into the adjoining private dining room.

OPPOSITE This executive's office in Canary Wharf offers spectacular views of downtown London. Black leather upholstery complements the beige color scheme, with cherry and maple woods used for the desk, sofa, and side tables

PHOTOS BY NIALL CLUTTON

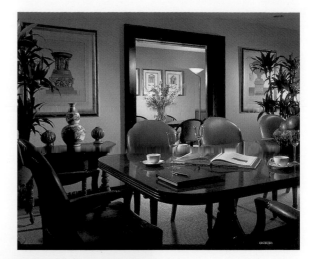

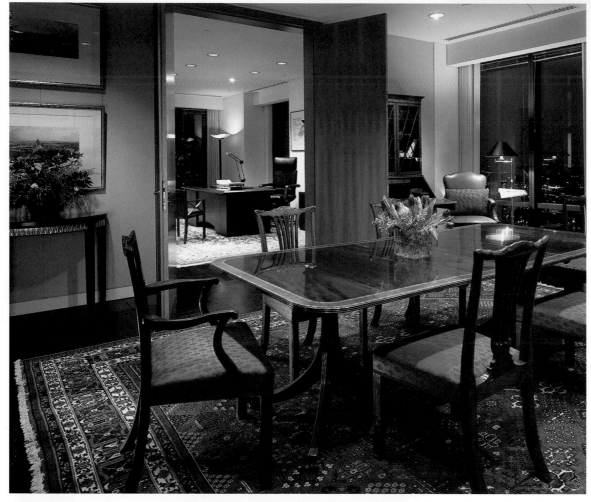

ABOVE A custom-made focal table and padded leather chairs enrich the luxurious boardroom. Sliding mahogany doors allow access to the partners' offices located on either side of the boardroom.
PHOTO BY ROBERT MILLER

LEFT The private dining room makes use of an existing collection of traditional furniture, but existing artwork was relocated and contemporary pieces such as consoles were added to update the space.
PHOTO BY NIALL CLUTTON

BELOW LEFT A richly detailed Oriental rug adds a warming and classical touch to the contemporary interior. The custom-designed armoire, seen at right, houses a television and mini-bar.
PHOTO BY NIALL CLUTTON

OPPOSITE A sunken, black granite entrance well leads into the London design firm's main reception area, which is anchored by a sleek mahogany desk. The space is finished with a polished oak floor; walls are lined with a warm Tuscany faux stone finish.
PHOTO BY ROBERT MILLER

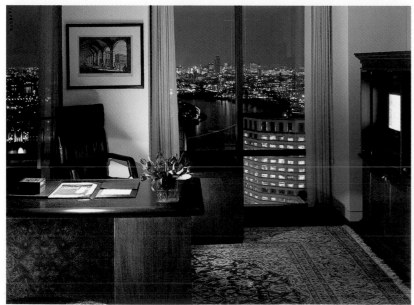

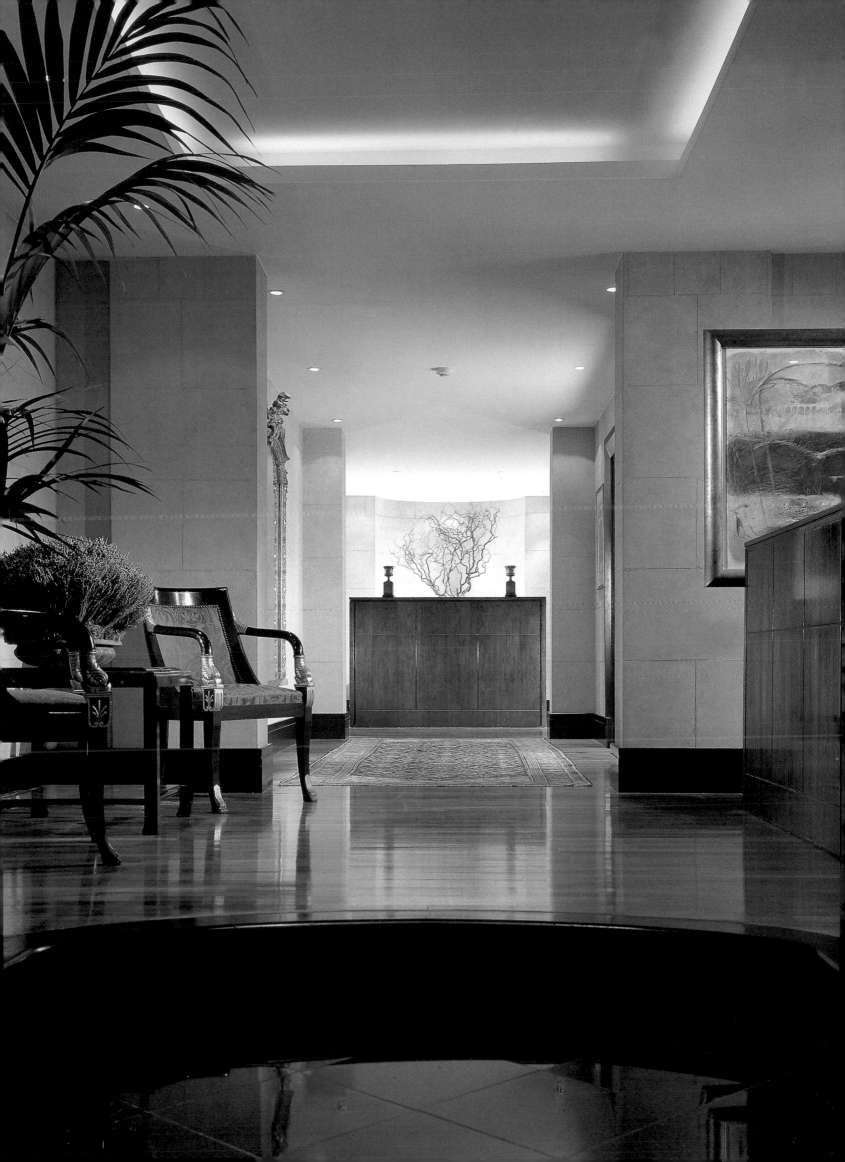

GENSLER

Described by *Fast Company* magazine as one of America's largest and most influential design firms, Gensler provides a full spectrum of comprehensive services in architecture, interior design, branding and communications, retail design, master planning, and design management. The small San Francisco-based group assembled in 1965 by M. Arthur Gensler Jr., FAIA, has grown into a team of more than 1,300 people in 16 offices. In fact, for nearly two decades, Gensler has been recognized as the largest U.S. interior design firm by *Interiors* magazine. In 1998, Gensler received the prestigious Arthur Andersen International Enterprise Award for Best Business Practices in Motivating and Retaining Employees. Progressive management, combined with team members who share a common philosophy, is at the heart of the organization. Beyond that, intangibles such as personality and character have given the firm its leading position in the design community.

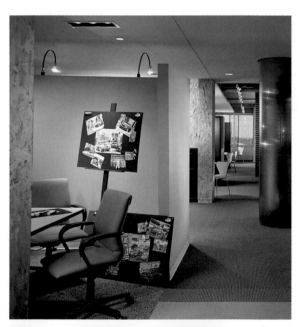

ABOVE RIGHT The main corridor is enlivened by walls with colorful finishes that range from bright green sheetrock to brick and particleboard. This informal gathering area, one of several in the work environment, reflects the client's vision of a "brand team" approach to office organization.

RIGHT Simple, sleek materials respond to an ad agency's desire for a lively industrial aesthetic in its offices. The atrium's curved particleboard, tall aluminum-clad pillars, and vaulted skylight create an airy environment for employees to eat lunch or hold casual meetings.

OPPOSITE The chairman's office at this Hawaiian bank has a large lounge seating area where meetings are conducted in an informal setting. The executive's desk and personal work area can be concealed with a sliding wood-and-glass shoji screen. Twelve-foot-high windows frame panoramic views of Honolulu's skyline. Appointments include maple floors, a large antique oriental rug, silk-covered walls, and classic modern furniture.
PHOTOS BY MARCO LORENZETTI ©HEDRICH-BLESSING

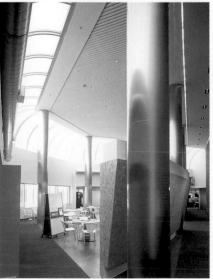

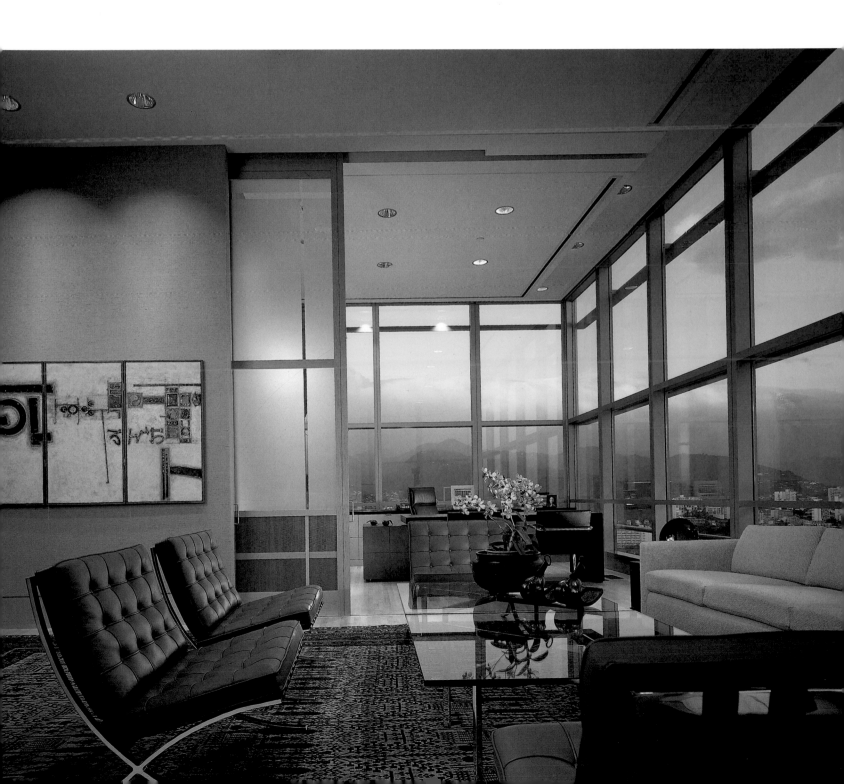

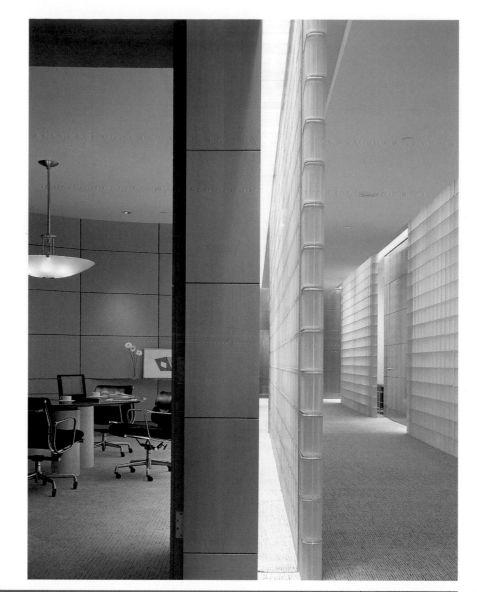

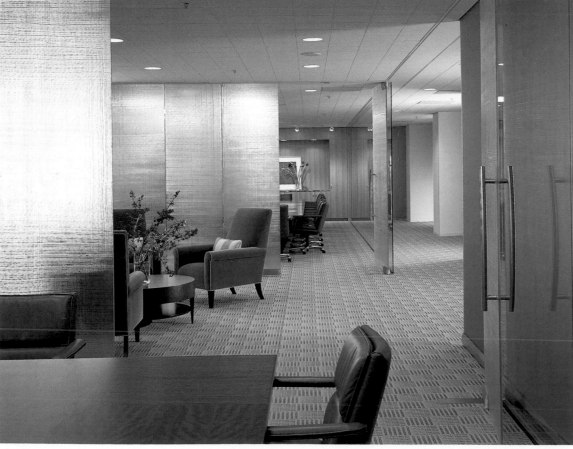

ABOVE LEFT The main corridor at this Swiss company's conference center features a layering of wood and sandblasted glass that screens off executive conference/dining facilities. The strong architecture and cool elegance typify the Swiss propensity for contemporary style.
PHOTO BY NICK MERRICK
©HEDRICH-BLESSING

LEFT Two large client conference rooms flank the reception area. All three spaces can be joined together for staff events by sliding the obscure glass walls into adjoining pockets. The green glass wall is a movable privacy screen chosen in lieu of drapery for the busiest conference room. Glass walls are textured cast glass, carpeting is woven in an oversized pattern, and movable walnut tables are custom designed.
PHOTO BY CHARLES MCGRATH

ABOVE LEFT This firm's original exterior arcade was enclosed in glass to provide a ceremonial connection between the main lobby and conference center reception area. The new arcade serves as a transition zone, juxtaposing patinated limestone, textured slate, and exterior steel with the interior's figured maple paneling, patterned glass, and polished stainless steel.
PHOTO BY JON MILLER
©HEDRICH-BLESSING

ABOVE RIGHT This lobby's figured wood paneling, floor pattern, and ceiling treatment coordinate to create a rhythm through space. Wood paneling was suspended in front of the wall and treated as artwork, facilitating a tight schedule by allowing millworkers to begin fabrication prior to demolition of the existing interior. The opaque glass door leads directly to the bookstore, a key contact point for public distribution of the firm's publications.
PHOTO BY JON MILLER
©HEDRICH-BLESSING

BELOW LEFT This client's CEO envisioned a contemporary yet classic design for new executive offices on the penthouse of a prominent downtown high-rise. Among his foremost desires: the suite had to make a powerful statement about the firm's solidity and leave a memorable impression on potential investors. Lighting enhances the color of the English sycamore wood, and provides ambient illumination in the CEO's private suite.
PHOTO BY JON MILLER
©HEDRICH-BLESSING

BELOW RIGHT The designer's goal for this Hawaiian bank's private dining and conference center was to create a contemporary space with strong Asian influences. Finishes in the elevator lobby include Botticino marble floors with inset custom wool carpets, walls paneled in honey-toned Anigre, and a custom wing-shaped ceiling of brushed and polished stainless steel. The lobby is prelude to a series of dining and conference spaces that seat as few as twelve and as many as 120 people.
PHOTO BY MARCO LORENZETTI
©HEDRICH-BLESSING

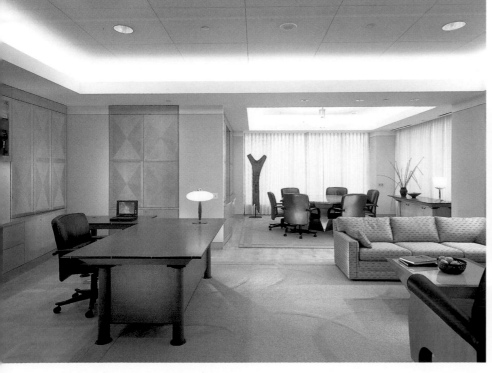

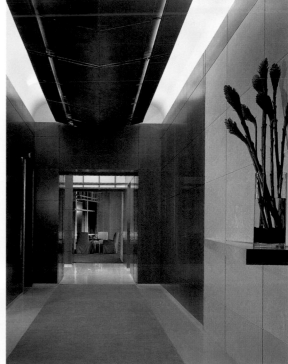

GREENWELL GOETZ ARCHITECTS, P.C.

In addition to its primary focus on interior architecture and design, Greenwell Goetz also provides an array of consulting and advisory services, including construction administration, on-call tenant interiors work for building owners and property managers, strategic facilities planning, space planning, building evaluation, and project coordination.

BELOW The public boardroom is a full-function, state-of-the-art meeting facility with ultimate flexibility to change configurations. Sound panels and carpeting in the space minimize noise and further soundproof the room.

OPPOSITE The reception area and bridge connect the entry portal to the building core. Because a large part of the client's business deals with excavating for water, themes relating to the earth and descent into the earth's crust are introduced by angled stairwells and stone and terrazzo flooring.
PHOTOS BY MAXWELL MACKENZIE

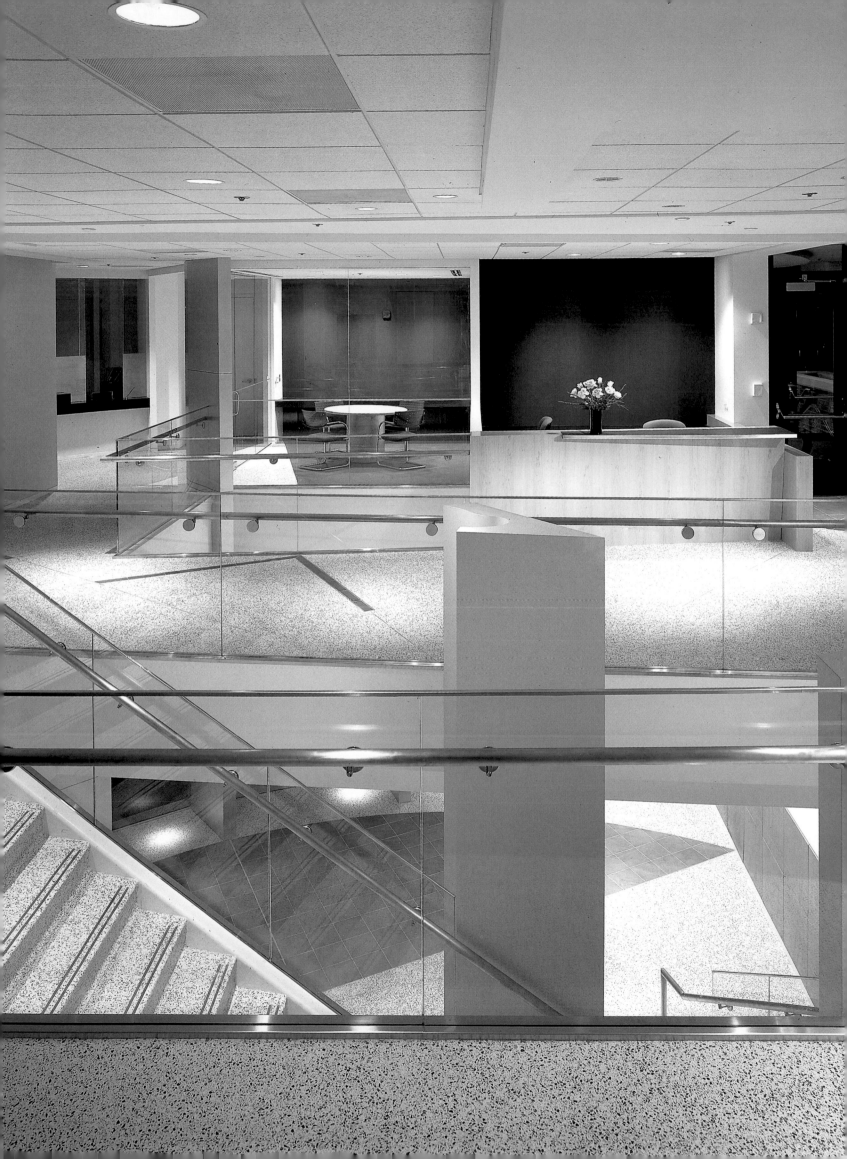

ABOVE LEFT The warm color palette in the workspaces complements the humane aspects of the firm—in sharp contrast to the cold look that often prevails in software companies. Because of heavy computer use by the staff, the designers specified indirect lighting above workstations.

ABOVE RIGHT Separating the reception seating area from the conference room, the thickened wall of eucalyptus panels tapers at each end to reveal a layer of brushed stainless steel beneath.

LEFT Foreground seating in the reception area allows for laptop hook-ups for visitors and office staff. The cafe beyond—which creates an informal environment where sales staff can meet with clients—incorporates a coffee bar and service area.

OPPOSITE In the reception area, a boldly patterned checkerboard terrazzo floor defines public and private zones. High-tech lighting was left exposed as an object in space. Unconventional finishes—such as metallic copper, orbitally sanded aluminum, and frosted glass—were used throughout.

PHOTOS BY JON MILLER
©HEDRICH-BLESSING

GRISWOLD, HECKEL & KELLY ASSOCIATES, INC.

Griswold, Heckel & Kelly Associates (GHK) designs workplaces that support the business processes of its clients and invigorate their office environments. Incorporated in 1955, GHK maintains a national network of offices located in Chicago, New York, Boston, Baltimore, San Jose, and Washington, D.C., with real-time communication and information exchange capabilities. The firm's design and facility planning and management professionals assist corporations in industries such as insurance, finance, consulting, high technology, biotechnology, and health care to create facilities that help reduce costs, improve workflow, and enhance productivity. GHK's ability to exceed expectations accounts for the firm's success with multiple Fortune 500 clients, some of whom have remained clients for more than twenty-five years.

OPPOSITE The customer center of this health care company is outfitted with ample seating, beverage and snack service, and even coat closets. The company's operating principles are outlined on the wall near the presentation room door.
PHOTO BY JON MILLER ©HEDRICH BLESSING

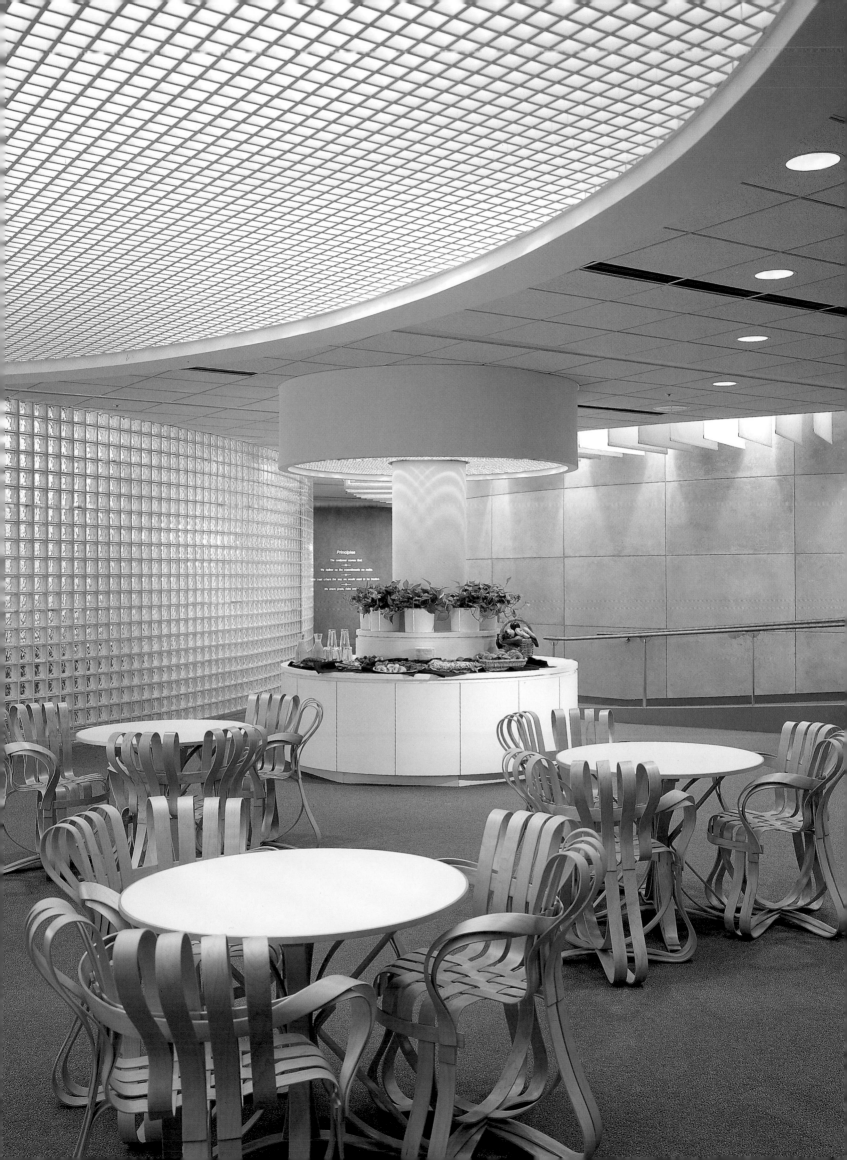

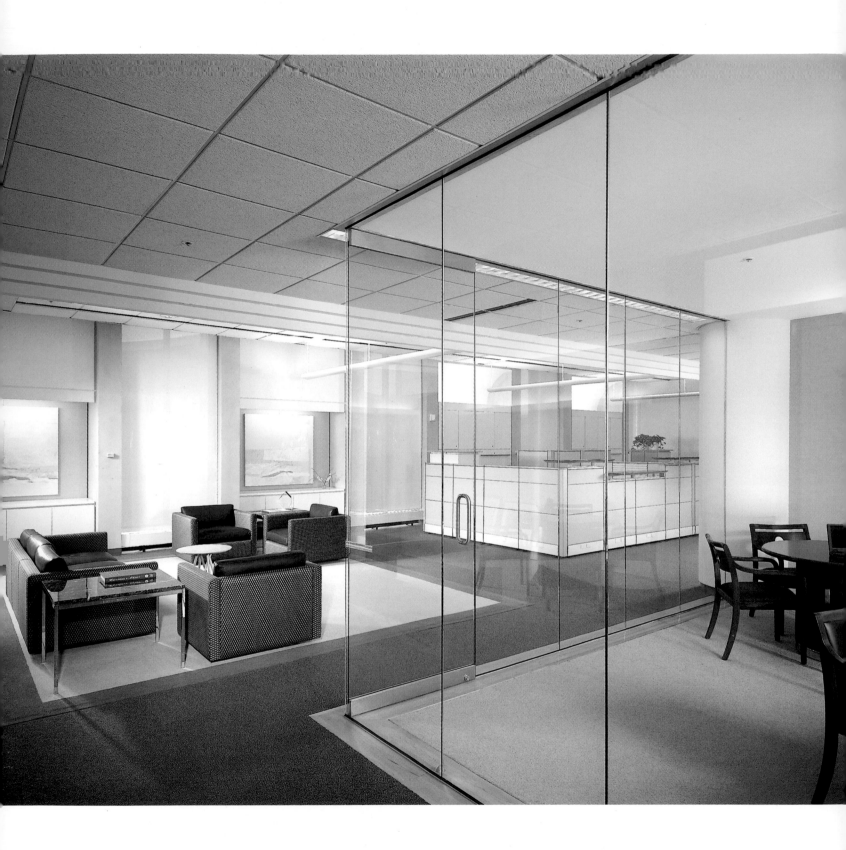

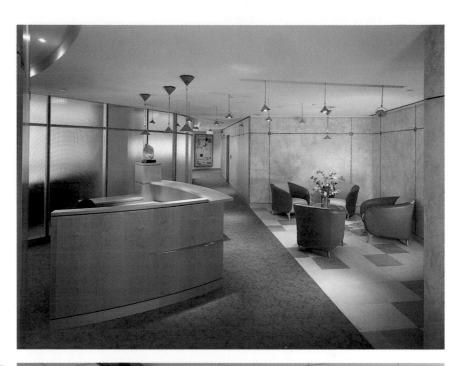

ABOVE RIGHT Two curved walls—one made of wood and the other textured glass and metal—define the firm's reception area. The sculptural desk, accentuated with metal fins, was placed where the two walls merge for dramatic effect.
PHOTO BY CERVIN ROBINSON

RIGHT GHK's design challenge was to create offices that emphasize teaming and flexibility. A modular facility that can be reconfigured overnight was created by using movable walls, lighting, and furniture.
PHOTO BY CERVIN ROBINSON

OPPOSITE Executive offices located near small, informal seating areas are walled in glass to make the company brass more accessible to the staff.
PHOTO BY JON MILLER
©HEDRICH BLESSING

BELOW LEFT To reflect the high-tech nature of this insurance company claim center, designers developed a futuristic theme that is reflected in the reception area and throughout the space.
PHOTO BY STEVE HALL
©HEDRICH BLESSING

BELOW RIGHT On the executive floor of this razor manufacturing company, the interior design relies on a muted palette, high-quality finishes, and attention to detail to create elegant and functional space.
PHOTO BY MARCO LORENZETTI
©KORAB/HEDRICH-BLESSING

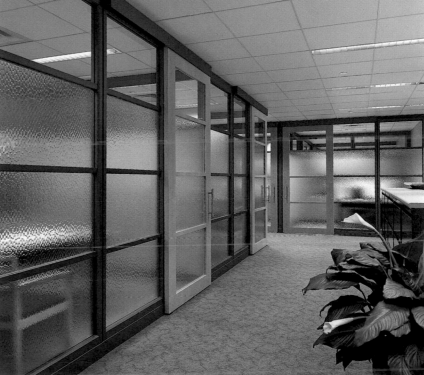

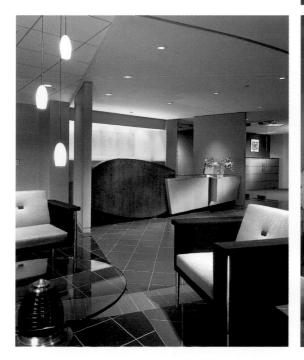

HAMMEL, GREEN AND ABRAHAMSON, INC.

At Hammel, Green and Abrahamson, Inc., company headquarters are no longer seen as static interpretations of the past. Instead, designers at the firm view corporate offices as dynamic, multi-use, interactive centers for work, research, and production. The firm believes evolving building technologies require highly specialized interior design expertise. Topping the list of considerations for each project are appearance, usefulness, safety, accessibility, cost, maintenance, and return on investment. HGA strives to achieve design excellence and an image that is appropriate to the client—all within the constraints of budget, user, needs, history, and time. The firm believes that design does not begin and end with appearance; it is a process that culminates quite naturally in a measurement of utility.

OPPOSITE-CLOCKWISE FROM FAR RIGHT In the massive complex for a St. Paul manufacturer, HGA met the client's goals of improving opportunities for spontaneous interaction and communication among employees by providing delightful common areas.
PHOTO BY GEORGE HEINRICH PHOTOGRAPHY

Within a limited budget and tight time frame, HGA designers combined unique uses of color and space to create this fresh, dynamic office in Uptown Minneapolis.
PHOTO BY DROEGE PHOTOGRAPHY

Movement is the theme for the corporate offices of this car rental company, whose lobby is animated by curved forms on the ceiling, floor, and walls. Cherry paneling, slate floors, color-saturated fabrics and carpeting, champagne-colored metals, custom glass, and commissioned artwork fill the space with a rich variety of colors and textures.
PHOTO BY DROEGE PHOTOGRAPHY

ATELIER CHRISTIAN HAUVETTE

"Christian Hauvette is the principal structuralist architect in France today," wrote Wojciech Lesnikowski in *The New French Architecture*. "Preoccupied with the study of mechanical aesthetics, he believes that the structuralist movement in architecture was shelved too quickly. In the final account, architecture for Hauvette consists of the making of images that generate visual messages in two different ways—in the spirit of structuralism... and in the spirit of descriptive, literary motifs that serve to formulate 'discovery journeys' for the users throughout the building." Hauvette describes himself as "a product of an engineering culture," attempting to explain, perhaps, his rejection of Romanticism and his ambiguous relationship with space. His architecture is both highly pragmatic and unabashedly preoccupied with expressive concerns, such as the power of light and shadow. Hauvette believes buildings must respond to the functional brief and, at the same time, imaginatively organize space, light, form, and structure. "The search for this conceptual clarity is associated with the search for tranquility and calm, which Hauvette believes architecture should always convey," writes Lesnikowski.

OPPOSITE Natural light from above floods the first-floor council room lounge of this large Paris bank. The space is furnished with Arne Jacobsen chairs; walls are finished with perforated cement-wood panels fit into an aluminum frame.
PHOTO BY JEAN-MARIE MONTHIERS

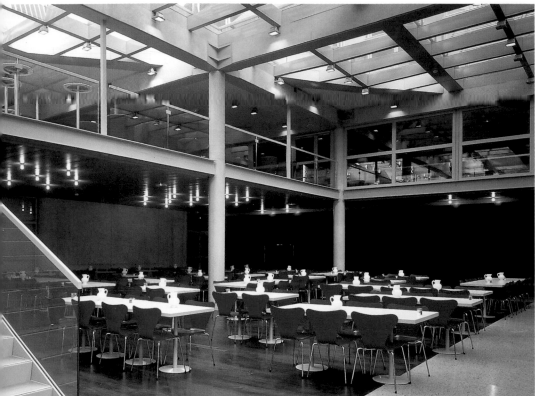

ABOVE LEFT Up to 280 employees are accommodated in the company restaurant, with cafeteria-style dining on the balcony level. Metal stairs leading down to the seating area have rubber-coated treads and a glass railing. Deep-stained wood floors have a broad terrazzo border.
PHOTO BY GEORGES FESSY

ABOVE RIGHT Offices are fitted with radial ceiling panels that produce a soft ambient light. Glass leading to the corridor is embellished with an herb pattern; metal dividing walls can be dismantled to accommodate changing space needs.
PHOTO BY GEORGES FESSY

MIDDLE A covered walkway runs the length of the building beneath the triangular office cores. The upper level, shown here, passes alongside a glassed-in dining area for company management.
PHOTO BY JEAN-MARIE MONTHIERS

LEFT Rows of private offices line a wood-paneled corridor in one of the triangular office blocks. A thin aluminum strip separates the flax-and-goat hair carpet from the wood border.
PHOTO BY GEORGES FESSY

OPPOSITE Leftover space outside the elliptical council chamber serves as a changing room. Flooring is aluminum-colored rubber; the coat rack on left is stained wood and stainless steel.
PHOTO BY JEAN-MARIE MONTHIERS

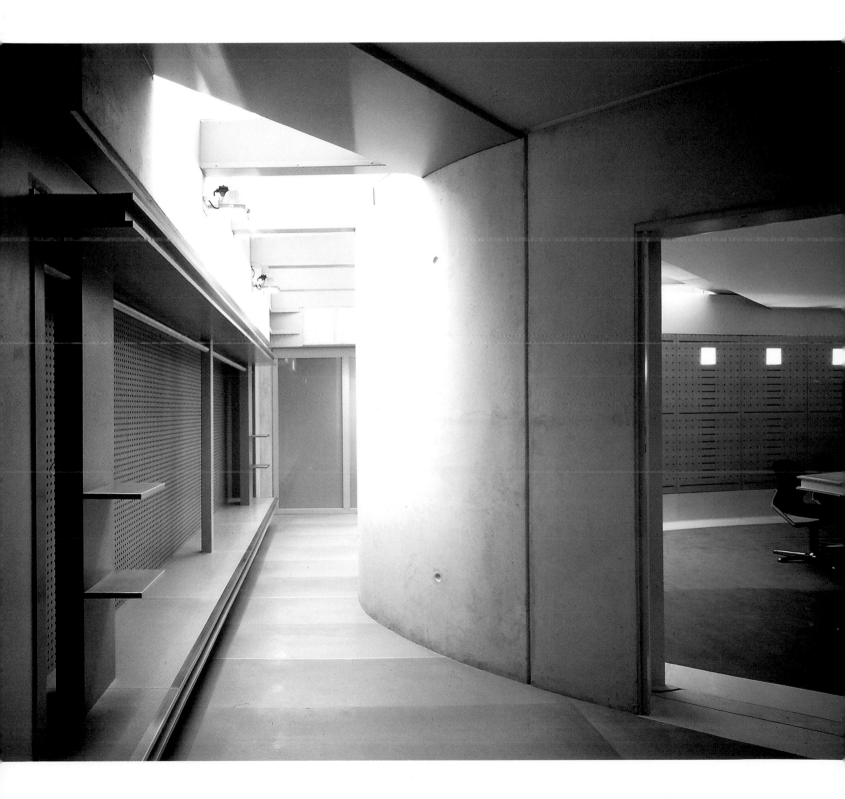

HERBERT LEWIS KRUSE BLUNCK ARCHITECTURE

Herbert Lewis Kruse Blunck Architecture is a growing continuation of the original architecture firm established in 1961. This collaboration of talents continues a tradition of high quality architecture–a tradition that has generated some of the region's most significant and enduring buildings. The firm displays a commitment to serve its clients by working hard to adhere to their needs. The diversity of projects accomplished over the past thirty-seven years is a testimony to the firm's architectural philosophy that deals with each client and project as a unique opportunity to teach and learn.

OPPOSITE In this project for a nationally recognized computer animation company, contrasting values of wood provide a range of tones that accent and enrich a composition of metal and glass planes.
ALL PHOTOS BY FARSHID ASSASSI, ASSASSI PRODUCTIONS

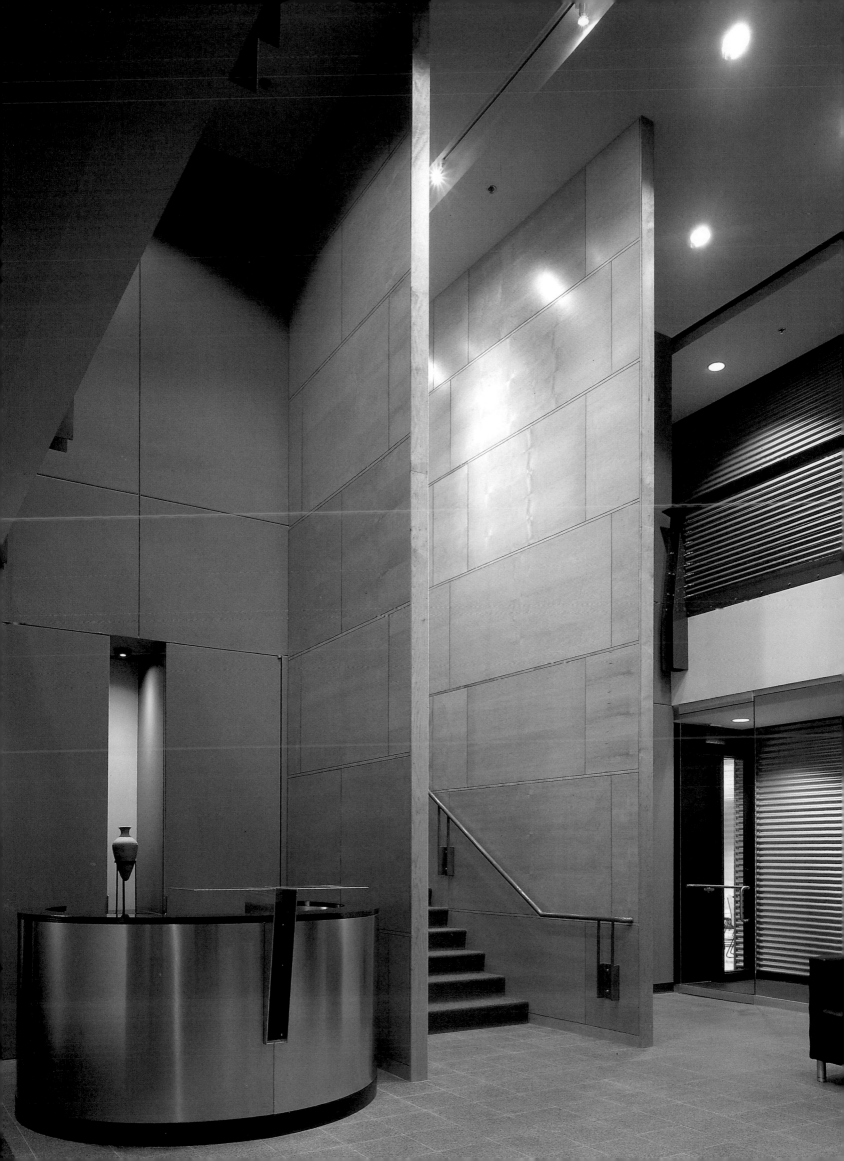

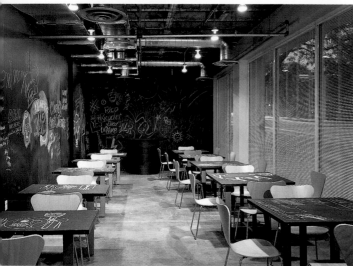

ABOVE Private offices and conference rooms in the headquarters of this Des Moines magazine publisher are placed at the building core rather than lining the perimeter, allowing daylight to illuminate most of the open offices.

LEFT Typical of the design for this advertising agency in Des Moines, simple everyday materials—cedar studs, plastic sheet, gypsum board, birch veneer plywood, chalkboard, and steel plate—are assembled with straightforward and exposed connections.

BELOW LEFT A skylight spine in the roof of this university's athletic department allows natural light to flood the interior court between rows of offices.

BELOW RIGHT Exploiting the existing building's warehouse aesthetic, the design for this food distributor's offices integrates glass block, masonry, and exposed structural steel into tactile, spatial experiences.

OPPOSITE In the central boardroom for this ad agency that caters to agribusiness clients, the scale and atmosphere of a lowly Iowa corncrib is convincingly recreated. Light drifts through the humble slat-wall enclosure; even the conference table's corrugated metal base picks up the theme.

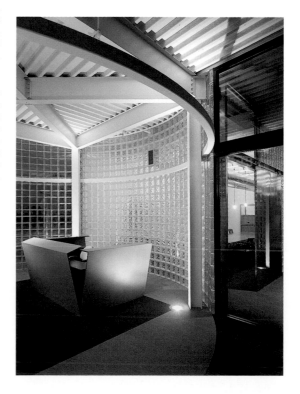

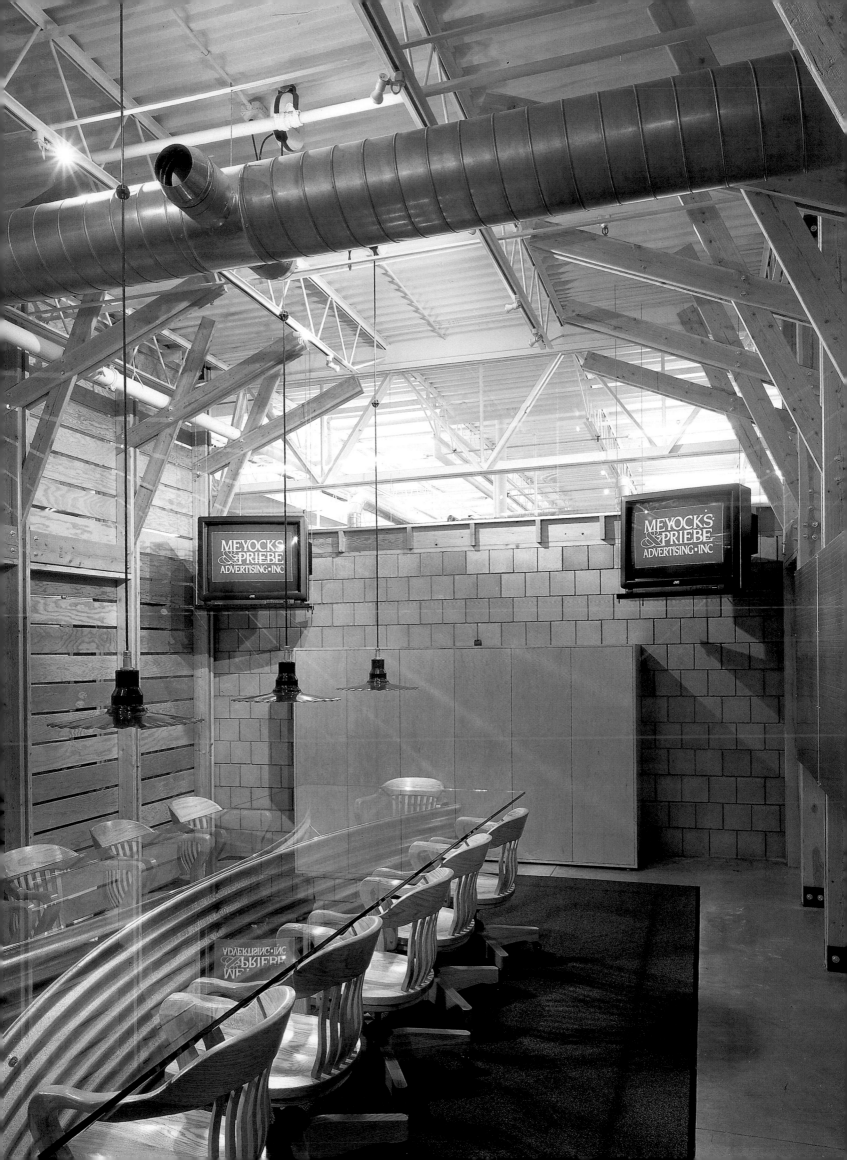

INTERIOR ARCHITECTS, INC.

Interior Architects, Inc. (IA) was founded to meet the workplace needs of corporations, professional service firms, and developers. The firm balances creativity and innovation with pragmatic concerns, such as budget and schedule, to achieve unique design solutions. IA believes that successful projects result from the combination of the hands-on involvement of IA senior management and the goals, insights, and vision of clients. An understanding of business objectives, workplace processes, values, and culture provides a basis for anticipating future project needs. From that understanding, the project team can develop solutions in response to specific workplace issues. Established in 1984, IA has grown to eleven offices providing services internationally. The firm's reputation for innovative and full-service solutions has propelled it into a leadership role within the interior design industry. A 1998 survey by *Interior Design* magazine ranked IA as the number one U.S. firm that exclusively provides interior architecture services. In the same survey, IA was rated the number one firm providing services to financial services firms.

OPPOSITE Visitors to the San Francisco offices of this independent energy provider are greeted with the presence of a two-story water feature illuminated from behind by fiber optic lights that refract through laminated glass. Polished limestone surfaces in the reception desk and flooring lend the interior a fitting sense of formality.
ALL PHOTOS BY BEATRIZ COLL

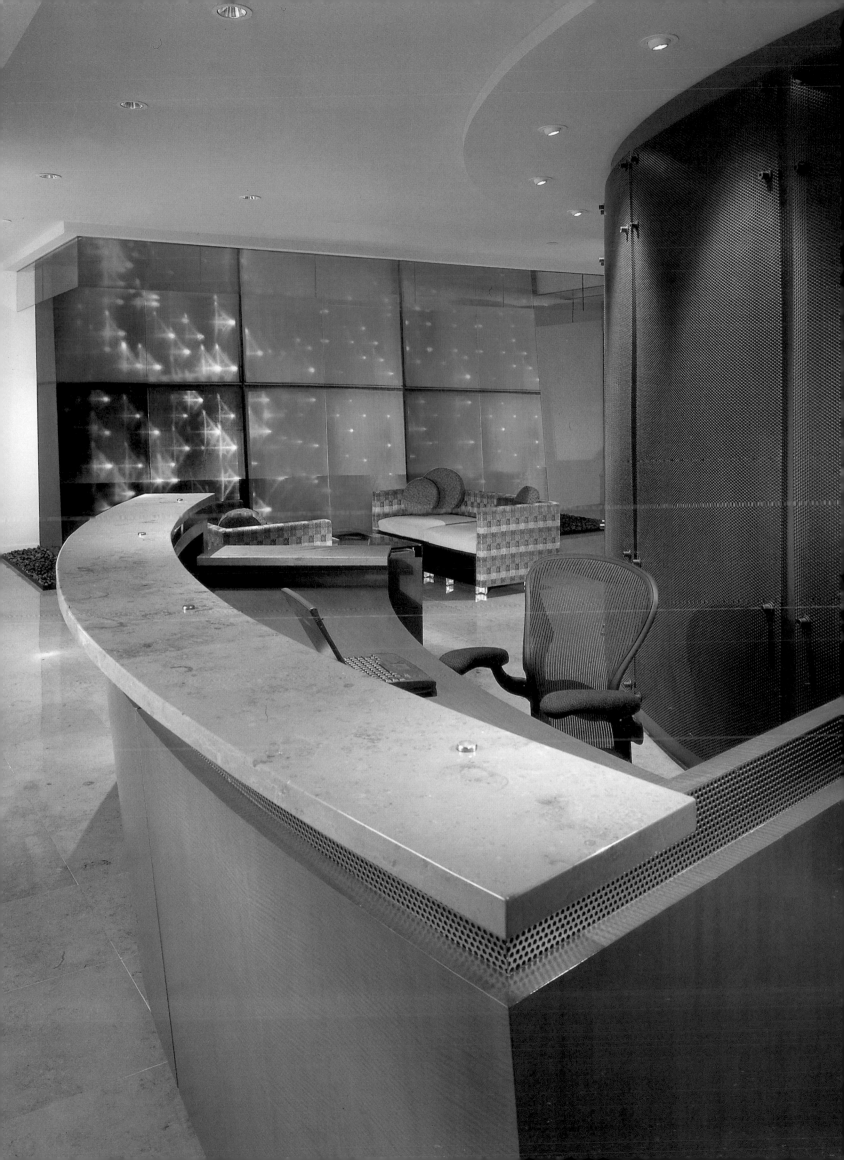

OPPOSITE In the design studio for a large consumer electronics manufacturer, a high priority was placed on conveying a light-filled, loft-like spatial quality while eschewing costly materials. Indirect lighting with specially lamped H.I.D. exterior fixtures mounted to concrete columns provide color-corrected, shadow-free illumination. Workstations are a combination of Haworth Race System and Crossings mobile tables and storage pedestals.

FAR LEFT Controlled aberrations in the carpet pattern articulate a seating area outside the main conference room. Sliding doors made of translucent patterned glass give privacy to occupants of the room while admitting light into the corridor. The limestone conference table is wired with microphones at each seat to aid videoconferencing.

LEFT German-made stools resting on beanbag-like bottoms are merely a perch—not a resting place—at the firm's "conference bar," which is tailored for brief business discussions. The curved Tuscan-red wall, finished with a troweled-on encaustic plastic pigment, separates the circulation space from the company's in-house coffee bar.

BELOW LEFT The high-bay spaces in this video production company made for a number of lighting challenges. In the firm's conference room, aircraft cables were strung overhead across the room and hung with MR-16 low-voltage lights, with two expressive Italian pendants suspended from the ceiling. The video monitor used for client presentations is housed in a custom-made, orange-stained particle board cabinet.

BELOW RIGHT In IA's own offices, the resource library is combined with the staff kitchen, in part to illustrate to clients that kitchens—if well maintained—don't have to be hidden in out-of-the-way places. The plastic laminate island is detailed with routed slots adjacent to the shelf where coffee cups are placed after washing.

JUNG / BRANNEN ASSOCIATES, INC.

Jung/Brannen's deep experience, commitment to understanding its clients' needs, and innovative use of materials result in beautifully designed, cost-effective solutions for interior design projects. Since its founding in 1968, Jung/Brannen Associates, Inc. has built its reputation as a leading international architecture, interior design, and planning firm by consistently delivering superior solutions to even the most complex projects. The firm offers every client the diversified services of a large organization along with the individual attention associated with smaller practices.

OPPOSITE Teams determined by function within the company are located in a pattern radiating from the free-form central stair that links the separate product groups of this manufacturer of high-design electronic products.
ALL PHOTOS BY RICHARD MANDELKORN

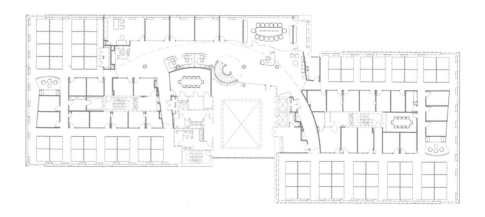

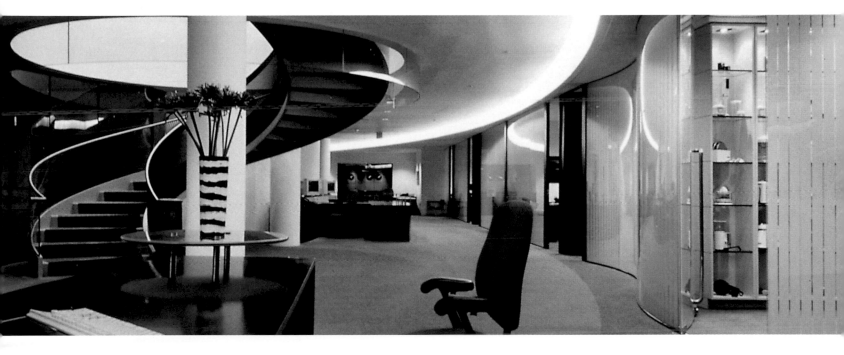

ABOVE The owner's product lines and materials are reflected throughout the interior—in this instance, by the textured metal wall and cobalt blue sofa.

RIGHT Designed as a point of congregation and informal gathering, one of the cafe-style "oasis areas" features a coffee bar, 150-gallon salt-water aquarium, and Internet access station. The perforated stainless steel screen references the styling of the company's products.

BELOW Guests arriving in the richly paneled reception area of this Boston firm are enticed by an obscured view through the translucent glass of the adjacent conference room.

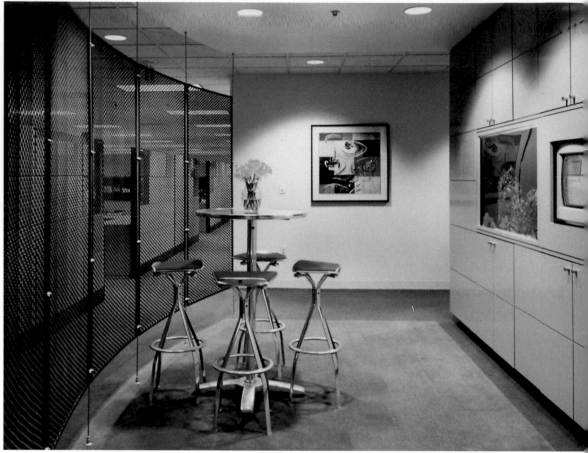

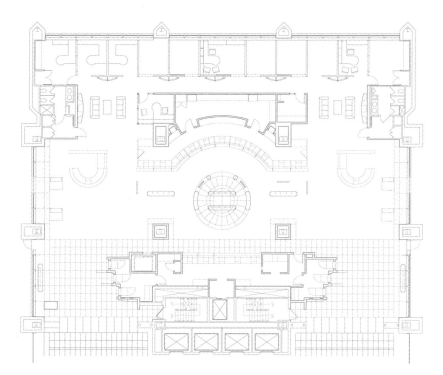

RIGHT The high level of finish and detail in this credenza and the private office it encloses evokes a feeling of warmth and comfort in chilly New England.

BELOW The adjacency of office cubicles and conference space in the financial services center of this Boston bank achieves a sense of privacy, security, and user-friendliness often missing from large banking halls.

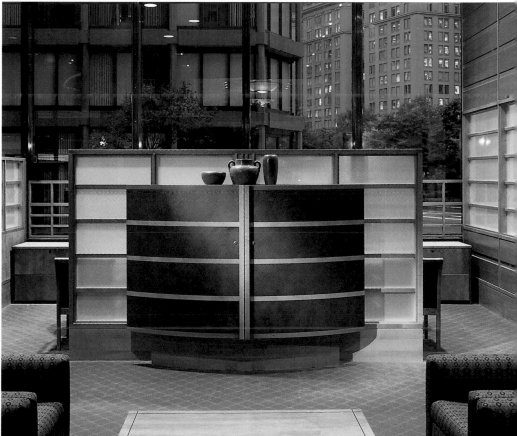

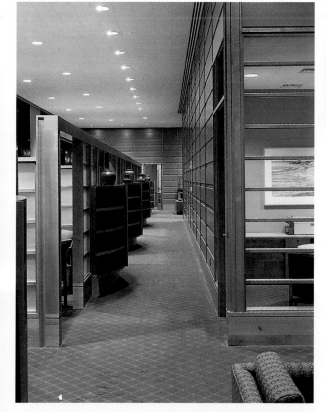

GARY LEE & PARTNERS

Established in 1993, Gary Lee & Partners has grown into a consortium of twenty architects and designers, each conversant with interior architecture, engineering, building construction, office technology, and the total interior environment. The firm subscribes to the belief that good design results from problem solving achieved through creativity, technical expertise, experience, and attention to detail. To ensure consistency, a core team of architects and designers is assembled to work directly and continuously with each client from project inception through completion. The final design expresses the culture of the client's organization, addresses the client's goals, and improves the client's efficiency and flexibility.

OPPOSITE Located on the office building's top floor, the sculptural stainless steel ceiling within the ceremonial Regents Room was raised to create a dramatic two-story volume.
PHOTO BY CHRIS BARRETT ©HEDRICH BLESSING

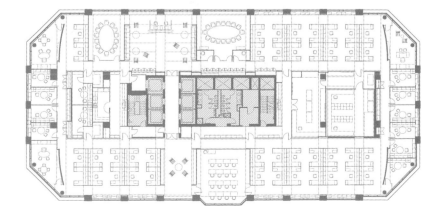

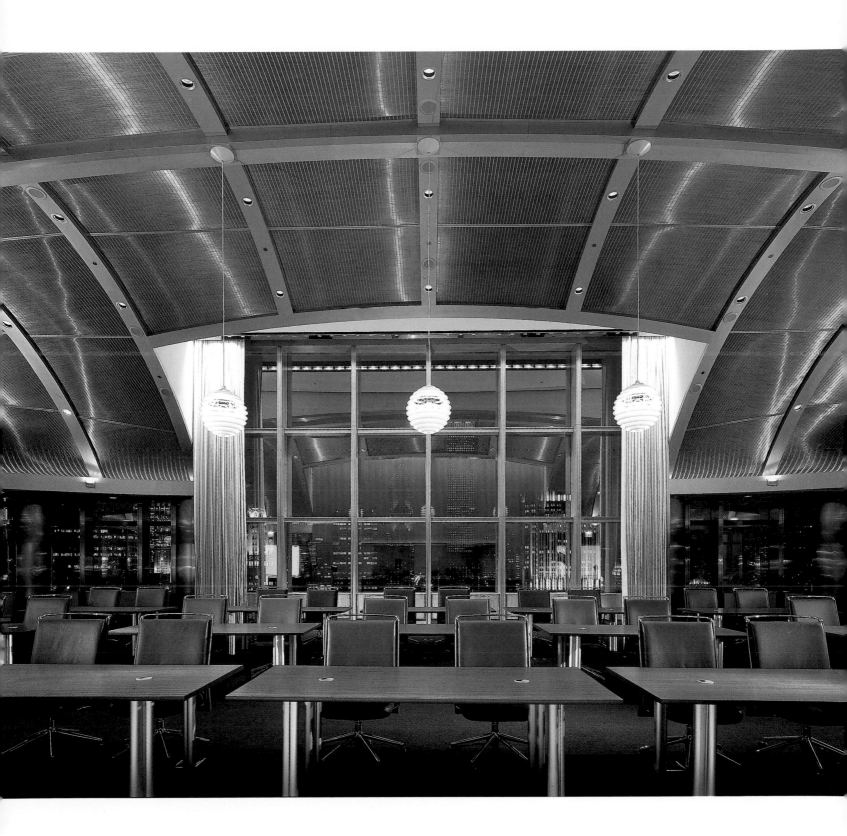

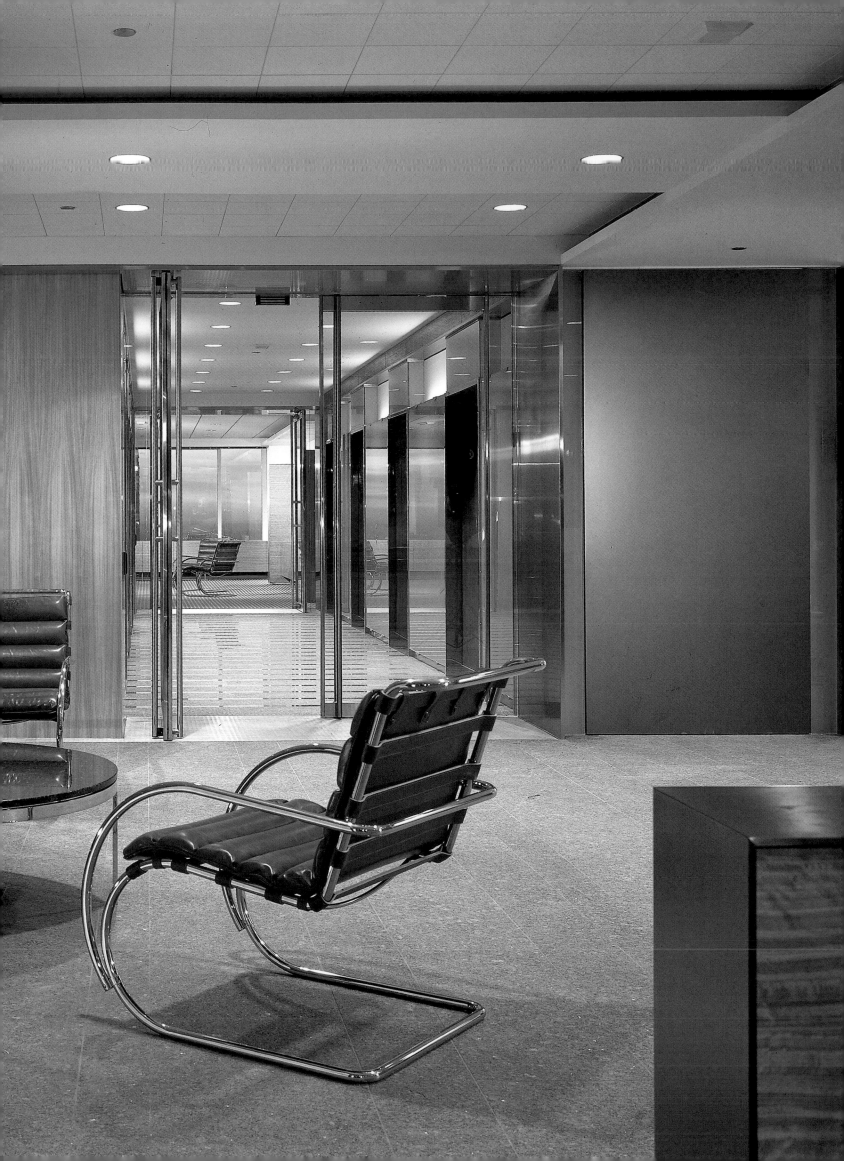

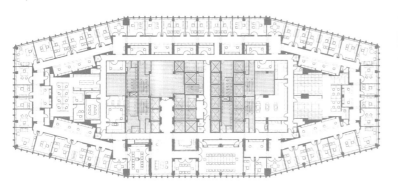

OPPOSITE Precise architectural detailing, refined finishes, and classic furnishings create a space that is commensurate with the image of this prestigious medical organization without overstating its prominence within the field of medicine.
PHOTO BY MARCO LORENZETTI
© HEDRICH BLESSING

ABOVE RIGHT Following the design principles of the workstations, custom desk units in private offices were designed to house ambient lighting, storage, and technology. Classic furnishings complement the design and foster a sense of timelessness.
PHOTO BY CHRIS BARRETT
© HEDRICH BLESSING

RIGHT Crisp simple lines impart a dramatic rhythm to the circulation passageways and internal stair.
PHOTO BY MARCO LORENZETTI
© KORAB HEDRICH BLESSING

FAR RIGHT Traditional styling was called for in this law firm's New York satellite office, where materials, patterns, and style combine to convey a strength of purpose appropriate to the firm image.
PHOTO BY MARCO LORENZETTI
© KORAB HEDRICH BLESSING

BELOW RIGHT Contemporary furniture hints at a classical influence, and art accents combine modern and historical elements to create a sophisticated setting.
PHOTO BY MARCO LORENZETTI
© KORAB HEDRICH BLESSING

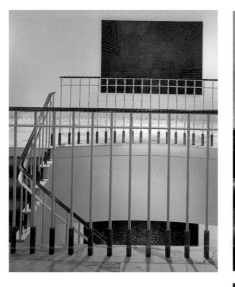

LEHMAN / SMITH / WISEMAN ASSOCIATES

Less than a decade after its founding in 1991, Lehman/Smith/Wiseman Associates has established itself as a leader in architecture and interior design. Principals who have collaborated for more than fifteen years on a broad range of projects manage the firm, which has a significant base of local, regional, and national clients. Projects are directly designed and managed by principals whose business philosophy is grounded in design excellence and client service. Lehman/Smith/Wiseman aims to design exceptional spaces that reflect the needs of the client, while rising above common solutions.

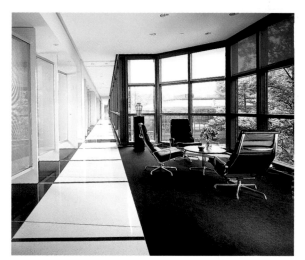

RIGHT Window bays projecting from the primary circulation spine at a large bank in Birmingham, Alabama, provide ideal informal meeting areas. Fritted glass screens allow light into the central office core, yet maintain a sense of privacy.

OPPOSITE A wavy ceiling of painted metal and stainless steel incorporates direct and indirect lighting to accent the servery in the bank's cafeteria, which occupies a 20,000-square-foot (1,800-square-meter) bridge that has become the company's gathering place.
ALL PHOTOS BY JON MILLER ©HEDRICH-BLESSING

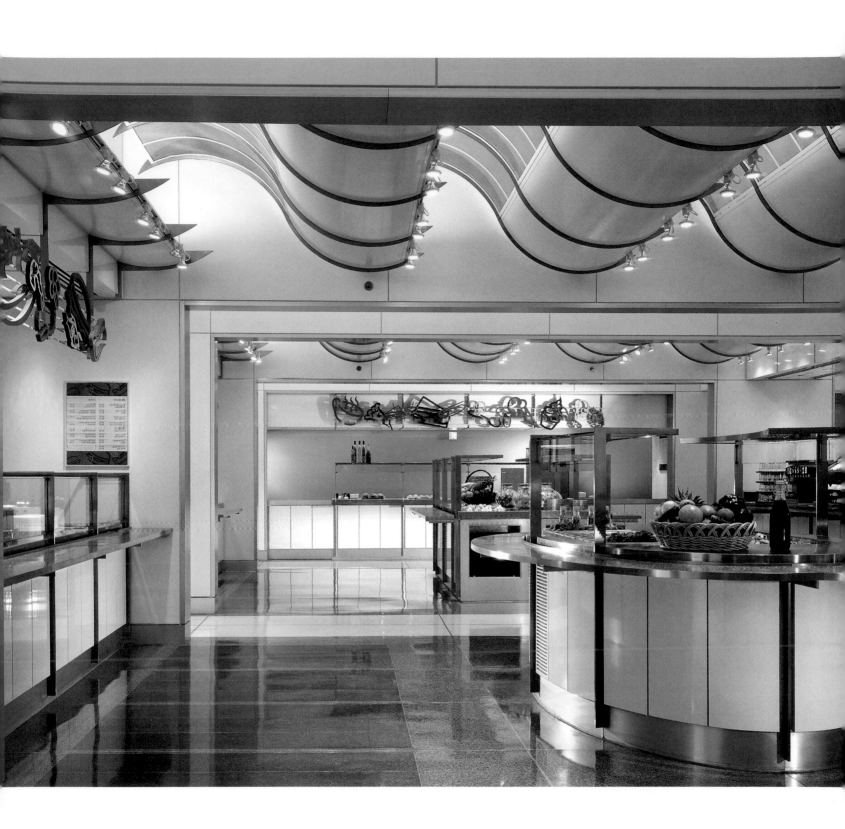

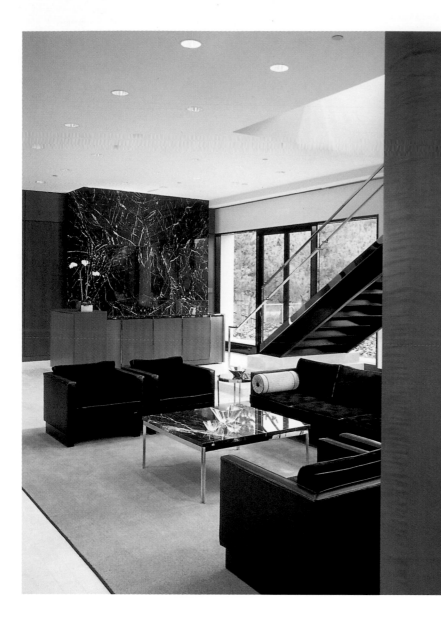

LEFT Limestone pavers, black St. Laurent marble, and pearwood paneling set the high tone of finish in the reception lobby of this Silicon Valley law office.

ABOVE The associate office features Translations systems furniture and a Montage moveable wall partition in pearwood, custom designed by Lehman/Smith/Wiseman.

BELOW For these executive offices in Houston, a high level of detail was warranted in the chairman's office, where the custom desk was built to match custom-figured maple wall panels. Leather lounge seating allows a more intimate alternative for private meetings.

OPPOSITE A conference room, wrapped in silk-covered walls and enclosed by a steel canopy, takes full advantage of natural light in the bright atrium of an investment trust in Rockville, Maryland. A natural cleft slate walkway leads from outside the building through the reception area to a grouping of Eames-designed chairs that doubles as informal meeting space.

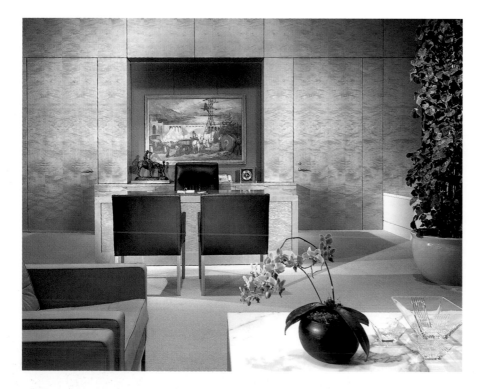

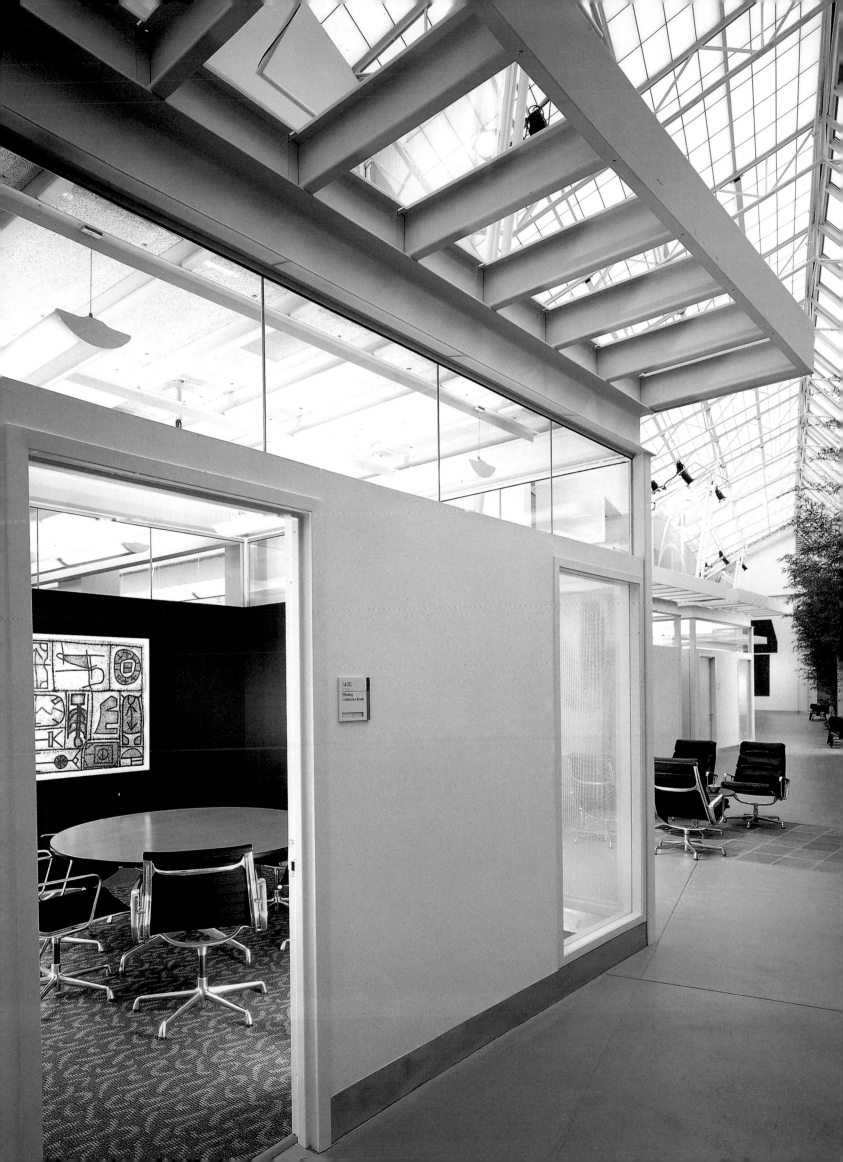

LIMINALITY LLP

LIMINALITY LLP is a full-service interior architecture firm that utilizes design to build a connection between workplace solutions and business strategies. For business owners and corporate executives looking to contain costs and maximize budgets, the firm offers a variety of services tailored to the needs of fast-growing companies. LIMINALITY's insight and experience with some of the country's most forward-thinking organizations allow the firm to complete assignments economically without sacrificing design integrity or the quality of the end product. As professional design consultants, the firm evaluates, analyzes, and provides options and solutions that are directly suited to clients' unique needs.

OPPOSITE The reception area for the corporate headquarters of a major aircraft manufacturer blends the influences of the company's European culture and its American location on the outskirts of Washington, D.C.
PHOTO BY MICHAEL MORAN

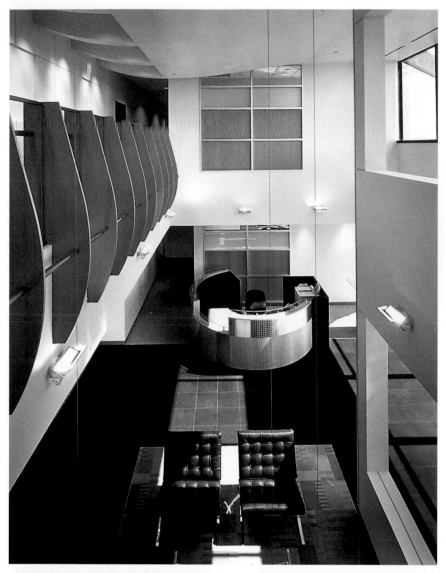

LEFT Striving to avoid trendiness in its design for this aircraft manufacturer's offices, the designers limited direct references to airplane vocabulary to shapes inspired by airfoils. These appear as signage elements, ceiling forms, and railing details.

BELOW The company's lunch room is located with windows to provide views near the top of an interconnecting stairway to encourage informal meetings among employees.

PHOTOS BY MICHAEL MORAN

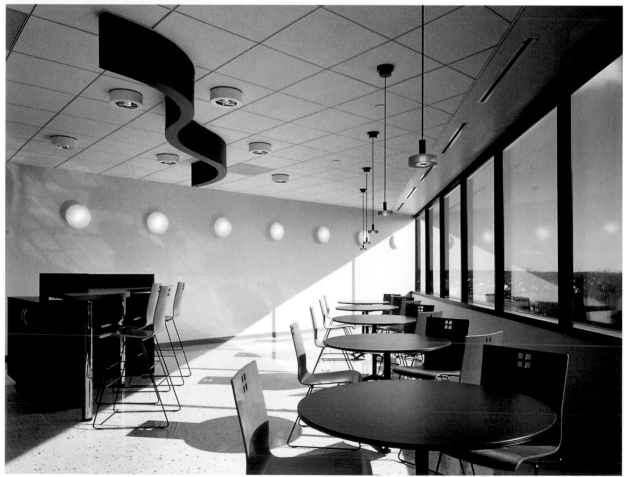

RIGHT In this Beverly Hills bank, a hanging soffit was introduced to visually connect three entries and provide an element that would house direct and indirect lighting fixtures.
PHOTO BY TOM BONNER

ABOVE LEFT Television monitors in the reception area of this Washington, D.C., ad agency air a steady stream of MTV and The Shopping Channel, lending a sense of irony and irreverence to the setting of a firm that eschews television advertising.
PHOTO BY MICHAEL MORAN

ABOVE RIGHT A wall of fiberglass panels and wood studs encloses the agency's conference room. Finland plywood was used in the construction of the reception desk and in elements such as the conference room light fixture.
PHOTO BY MICHAEL MORAN

MEYER, SCHERER & ROCKCASTLE, LTD.

Founded in 1981 by principals Thomas Meyer, Jeffrey Scherer, and Garth Rockcastle, Meyer, Scherer & Rockcastle, Ltd., (MS&R) regards interior design as equally important to architecture and strives to integrate the two in every project. This collaboration is most critical in the early phases of the work, so MS&R interior designers are involved from the very start. As the building footprint takes shape, the interior designers concentrate on meeting programmatic requirements. Furniture and equipment can then be test-fit into the space. In addition to furnishing and materials selection, MS&R's interior design staff is involved with programming, furniture layouts, millwork, and lighting design. This high level of involvement yields quality design and ensures harmonious and functional results.

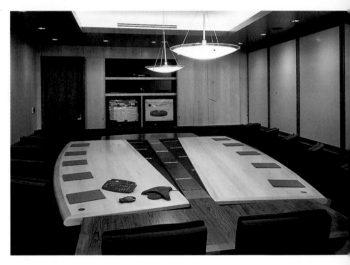

ABOVE RIGHT In the main conference room, the custom-made teak-and-maple table adjusts to meet demand: open for media-oriented sessions and closed for traditional meetings. Sliding screens made of sail fabric offer varying degrees of privacy.

OPPOSITE The identity wall for this Edina, Minnesota, investment firm is covered in hand-painted paper that is washed with light to set off the bronze lettering. In the waiting area, an area rug and lounge seating soften the hard flooring surface.
PHOTOS BY PHILIP PROWSE

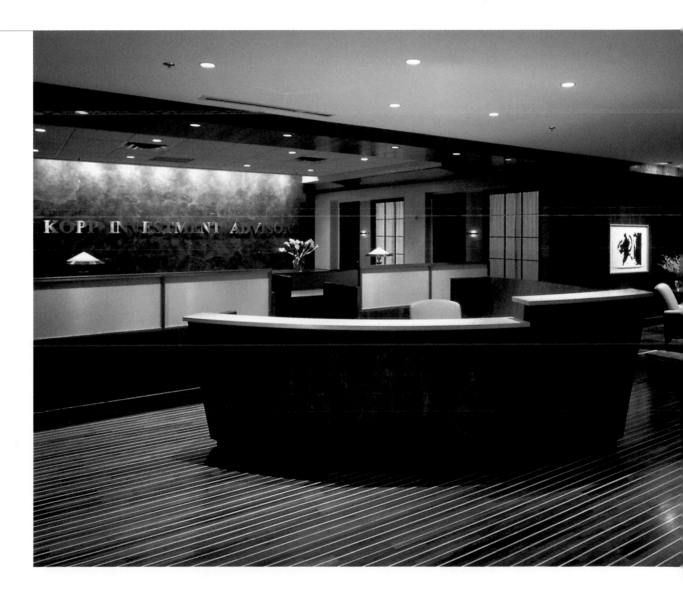

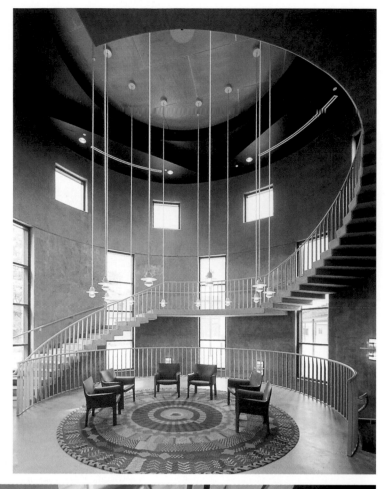

ABOVE A dramatic cylinder-shaped rotunda lies just beyond the lobby of this Pennsylvania investment company.

LEFT A typical building entry vestibule shows the playful use of color and exposed structure. Recycled materials, such as the rubber floor covering, are used extensively throughout the building.
PHOTOS BY TIMOTHY HURSLEY

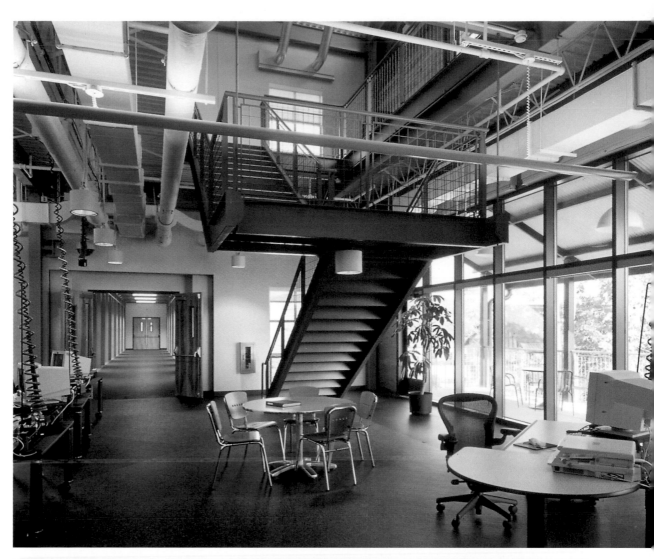

ABOVE RIGHT Because work teams are required to relocate quickly and adjust to changing market conditions, work stations were designed to be moved and reconfigured on a moment's notice.

RIGHT The company's training and seminar room is satellite-linked and fully interactive, with furnishings selected for flexibility and frugality.
PHOTOS BY TIMOTHY HURSLEY

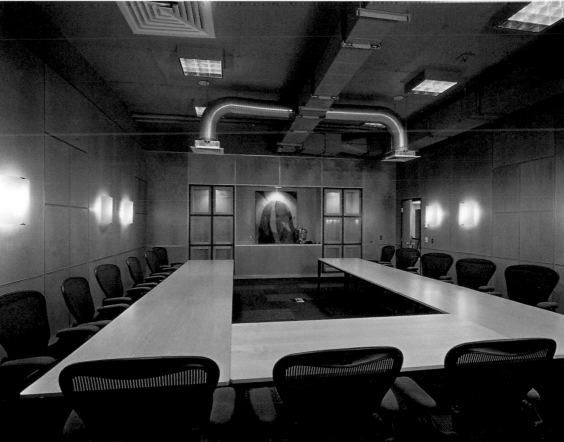

NBBJ

NBBJ is the world's fifth largest architecture firm with a staff of 800 and projects located throughout North America, South America, Asia, and Europe. Rigorously design-focused, the firm practices in twenty-one studios spread among six U.S. offices. Each studio is strongly committed to serving its clients and society through a balance of design, technology, process, and communication. No building or interior designed by the firm reflects a single style that defines the firm, but all are informed by the same set of complex principles. NBBJ is recognized for its innovative design solutions in corporate interiors, office buildings, mixed-use complexes, and a wide range of other building types.

OPPOSITE Tall birch panels surround the elevators beyond this software company's reception area. The lowered ceiling, distinct wood grains, and unique design elements contrast the raw and purposely exposed building structures.
PHOTO BY ASSASSI PRODUCTIONS

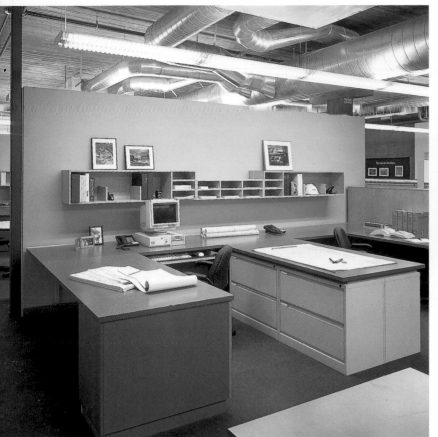

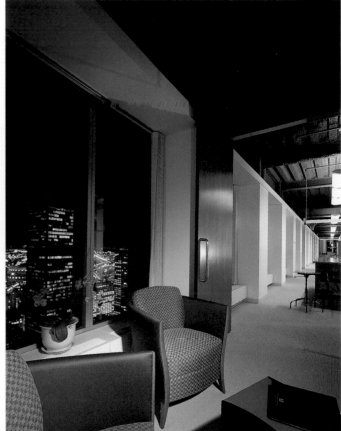

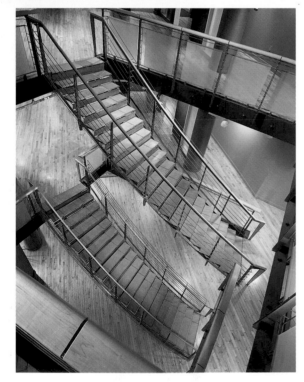

ABOVE LEFT Work areas with
brightly painted walls are located
in the office's central area and are
furnished with expansive work
surfaces, freestanding files, and
custom storage elements.
PHOTO BY DICK BUSHER

ABOVE RIGHT The "great hall" of
this property management company
in Seattle serves as the main circu-
lation path and houses administrative
services. With flexible furniture
configurations, the corridor strate-
gically mandates social interaction
and offers spectacular views of
the Puget Sound accessible to all
workstations.
PHOTO BY J. F. HOUSEL

LEFT The open floor stairways of
this Seattle-based coffee company
create a feeling akin to a warehouse
loft and enhance ease of communi-
cation among employees.
PHOTO BY PAUL WARCHOL

RIGHT Lounge areas with inviting
furniture along the primary
circulation paths offer places for
spontaneous meetings.
PHOTO BY PAUL WARCHOL

OPPOSITE This brand identity com-
pany's transparent conference
room offers audio-privacy to occu-
pants while allowing others to view
the activities taking place within.
PHOTO BY ASSASSI PRODUCTIONS

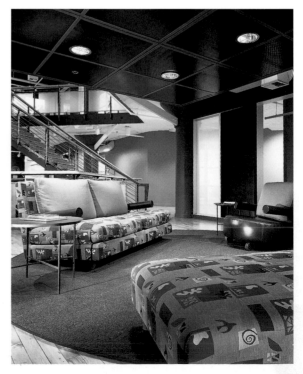

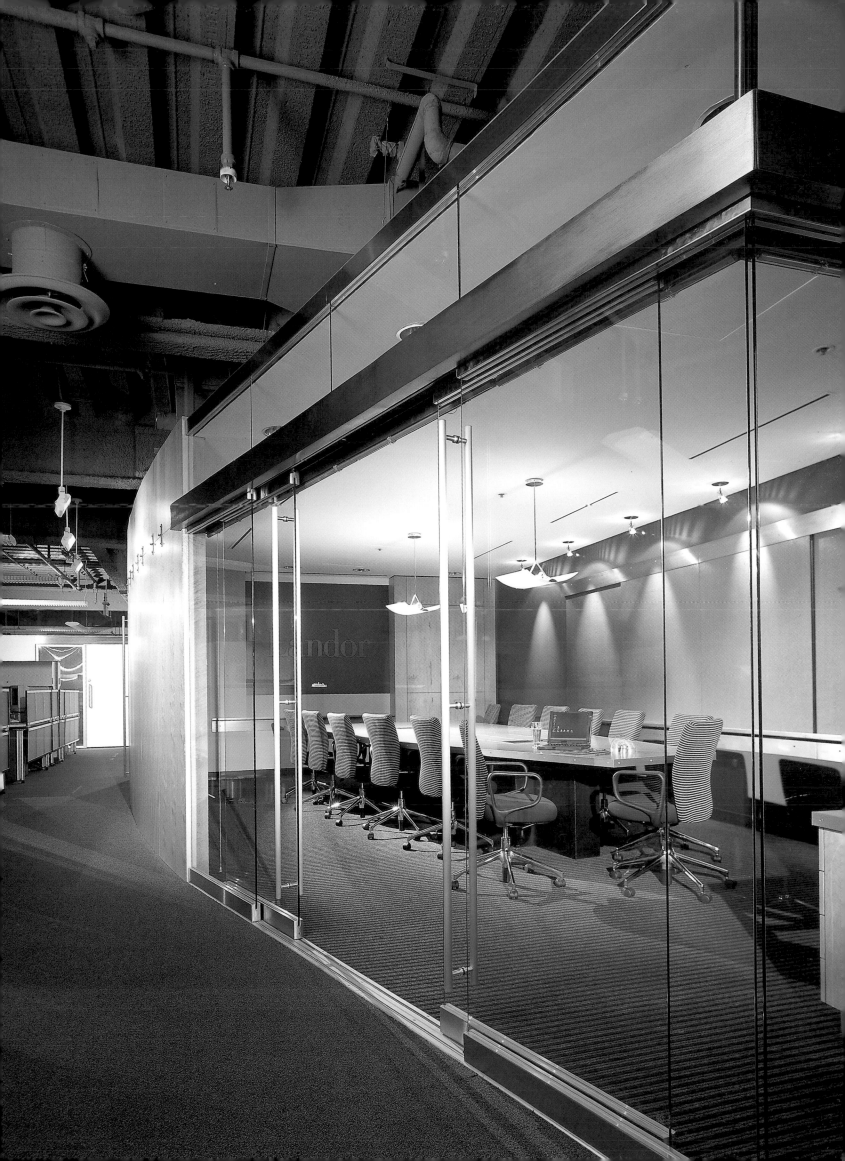

CREDITS/ DIRECTORY

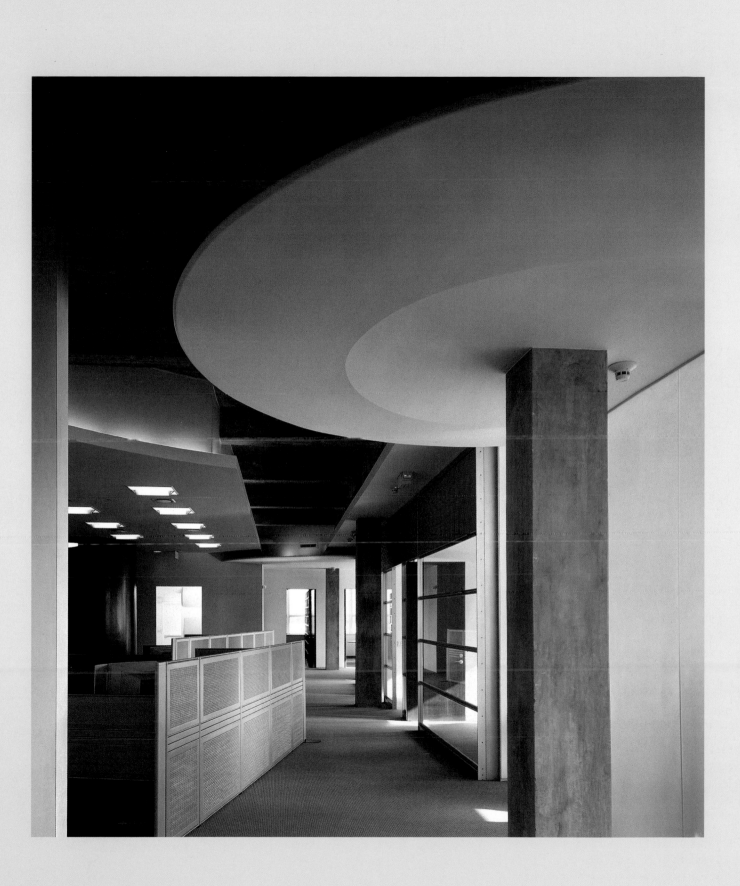

CREDITS

CORPORATE AND INSTITUTIONAL OFFICES

GUGGENHEIM DOWNTOWN–New York City. Design by TAS Design. Design Team: Thomas A. Sansone, principal, Mella Kernan, project architect, Carlos Sifuentes, Lisa Piper, George Perkins, David Hottenroth, Brian O'Tuama, Patrocinio Binuya, Margie O'Shea. Photography by Jeffrey Gross.

GUGGENHEIM–New York City. Design by TAS Design. Design Team: Thomas A Sansone, principal, Francine Monaco, project architect, Carlos Sifuentes, Javier de la Garza, Patrocinio Binuya, Thomas Rose, Margie O'Shea. Photography by Paul Warchol.

LOWE AND PARTNERS/SMS–New York City. Design by Sedley Place. Design Team: David Bristow, Mick Nash, Antonio Maduro, Matthias Felsch, Tim Hyman. Charles Patten AIA Design Team: Charles Patten, AIA, Bulend Medjid, Maureen Cornwell. Photography by Durston Saylor.

PAIGE ELECTRIC–Union, New Jersey. Design by David Ling Architects. Designer: David Ling. Photography by Todd Eberle.

McCANN-ERICKSON ADVERTISING–San Francisco, California. Design by STUDIOS Architecture. Design Team: Thomas K. Yee, principal, Philip Luo, Michelle McCarthy. Photography by Michael O'Callahan.

BURGER KING–Miami, Florida. Design by NBBJ. Design Team: Yuji Boraca, Robin Dalton, Christopher Larson, Kathryn McCollister, John Odell, Teri Sato, Ed Storer, Scott Wyatt, Alan Young, Gordon Ramstrom, Larry Haddow, Anne Forestieri. Photography by Paul Warchol.

BOYD LIGHTING COMPANY–San Francisco, California. Design by Brayton & Hughes. Design Team: Richard Brayton, David Darling, Ross Dugan. Photography by John Sutton.

HELLMUTH, OBATA + KASSABAUM, INC. (HOK) HOUSTON–Houston, Texas. Design by HOK Houston. Design Team: Michael Shirley, project executive, Timothy Conroy, project manager, Sofia Fonseca, facility programmer, Loretta Fulvio, Jalal Zeitoune, Jamie Smith, interior designers, Saadeddine Dimachkieh, electrical engineer, Gary Kuzma, mechanical engineer, Gary Marsh, plumbing engineer. Photography by Joe Aker.

SULLIVAN HIGDON & SINK–Wichita, Kansas. Design by HOK St. Louis. Design Team: Nora Akerberg, project manager, Mark Herman, project designer, Peter Dorsey, project architect, Tom Kaczkowski, lighting designer, Roger McFarland, director of interiors. Photography by Steve Hall, Hedrich Blessing.

FALLON McELLIGOTT ADVERTISING–Minneapolis, Minnesota. Design by Perkins & Will/Wheeler. Design Team: James E. Young, ASID, CID, Amy L. Kleppe, ASID, CID, Stephen M. Busse, AIA. Photography by Dana Wheelock.

STARBUCKS COFFEE–Seattle, Washington. Design by NBBJ. Design Team: Amy Baker, Randy Benedict, Andy Bromberg, Amy Cockburn, Arthur Furukawa, Michael Kreis, Daniel Skaggs, Stephen Wood, Scott Wyatt. Photography by Paul Warchol.

PHILLIPS BEVERAGE COMPANY–Minneapolis, Minnesota. Design by Perkins & Will/Wheeler. Design Team: James E. Young, ASID, CID, Amy L. Kleppe, ASID, CID, Heather L. Sheehan. Photography by Dana Wheelock.

IU & LEWIS DESIGN–New York City. Design by Iu & Lewis. Design Team: Carolyn Iu, principal-in-charge, Iu & Lewis Design, project team. Photography by Michael Moran.

ASTRAEA FOUNDATION/SISTER FUND–New York City. Design by Monaco/Architects. Design Team: Francine Monaco, Enda Donagher. Photography by Bret Morgan.

D'ARCY, MASIUS, BENTON & BOWLES–Troy, Michigan. Design by Gensler. Design Team: Margo Grant Walsh, Robert Cataldo, Mark Morton, Jeanne Nutt, Katherine Phillips, Toufic Saad, Frank Aviles. Photography by Marco Lorenzetti, Hedrich Blessing.

MORSE DIESEL–New York City. Design by Brennan Beer Gorman Monk/Interiors. Design Team: Julia Monk, AIA, ASID, partner-in-charge, William Whistler, AIA, design partner, Jo Anne Becker, project architect, Regula Onstad, designer. Photography by Peter Paige.

HIGH-TECH AND BIOTECH OFFICES

PREDICTIVE SYSTEMS, INC.–New York City. Design by Anderson/Schwartz Architects. Design Team: Ross Anderson, partner-in-charge, Aaron Bentley, project architect, MJ Sagan, Stephen O'Dell, Caroline Otto, Paul Cali. Photography by Michael Moran.

ZYMOGENETICS–Seattle, Washington. Architecture and Design by NBBJ, Daly & Associates. NBBJ Design Team: Scott Wyatt, principal-in-charge, Brad Leathley, lab planner, John Palewicz, project manager, Peter Damento, Doug Sabatke, Cathryn Kraus, Rysia Suchecka, Roger Stocker, Ed Storer, Steve Bettge, Karen Hillam, Jacqui Evanchik. Daly & Associates Design Team: Jim Daly, AIA, John Schwartz, Dean Longwell, Frank Martin, Jim Saunders, Ken Chipman, Rob Hutchison. Photography by J. F. Housel, Steven L. Rosen.

SILICON STUDIO–Mountain Park, California. Design by STUDIOS Architecture. Design Team: Eric Sueberkrop, David Sabalvaro, principals, Karnala Mostert, Eliot Freed. Photography by Michael O'Callahan.

CHIRON CORPORATION–Emeryville, California. Design by Brayton & Hughes. Design Team: Richard Brayton, David Darling, Joel Villalon, Susie Yamaguchi. Photography by Chas McGrath.

SILICON GRAPHICS–San Francisco, California. Design by STUDIOS Architecture. Design Team: Erik Sueberkrop, David Sabalvaro, Charles Dilworth, principals, Kelly Haeglund, Eliot Freed, Jeffrey Benningfield, Bill Cooperman, Michael O'Callahan. Photography by Richard Barnes, Paul Warchol.

SYBASE CORPORATION–Paris, France. Design by STUDIOS Architecture, Paris. Design Team: Pierre Pastellas, principal, Bertrand Neel, project manager, Jean Pascal Crouzet, project architect. Photography by Jean-Philippe Caulliez.

SOFTIMAGE–Santa Monica, California. Design by Callison Architecture. Design Team: Shannon Rankin, project designer, Michael Medina, David Staczek, Kyle Gaffney, Kim Jennings.
Photography by Paul Bielenberg.

KINETIX–San Francisco, California. Design by HOK San Francisco, CA. Design Team: Nancy Jones, project executive, senior designer, Clarinda Bischegoia, project manager, Dimitri Avdienko, project designer.
Photography by Nick Merrick, Hedrich Blessing.

GLAXO–Stevenage, Hertfordshire, England. Design by HOK London. Design Team: Bill Stinger, principal-in-charge, Teresa Mulford, facilities consulting, Ralph Courtenay, Frank Effland, project managers, Aileen Asher, Terri Hogan, Alison Patterson, Bob Brendle, Denise Fuehne, Loretta Fulvio, interior designers, Isobel Bedawi, Mike Giltenane, architects, Mark O'Brien, architect, construction administration, Sherralyn Rowlands, Paul Simms, CADD operators, Laura McCanna, graphic designer, Steve Parker, illustrator.
Photography by Niall Clutton.

NOKIA MOBILE PHONE (JAPAN) KK–Tokyo, Japan. Design by Gensler. Designer: Steven Louie.
Photography by Nacasa & Partners.

BANKING, INSURANCE, CONSULTANT, AND LAW OFFICES

TOKAI BANK–Chicago, Illinois. Design by Perkins & Will, Chicago, IL. Design Team: Neil Frankel, principal-in-charge, Jeffrey Liggett, project manager, Dennis St. John, senior designer, Ken Susinka, senior technical coordinator, Carol Stolt, Frank Scalia, Carol Simpson, Peggy Hoffman, Vicki DuVuono.
Photography by Marco Lorenzetti, Hedrich Blessing.

VOLPE WELTY ASSET MANAGEMENT–Alameda, California. Design by Brayton & Hughes. Design Team: Richard Brayton, Angie Klein, Kathleen Johnstone.
Photography by John Sutton.

MELCHOR INVESTMENT COMPANY–Palo Alto, California. Design by Brayton & Hughes. Design Team: Richard Brayton, Tim Gemmill, David Darling.
Photography by John Vaughn.

A. T. KEARNEY–Chicago, Illinois. Design by Perkins & Will, Chicago, Illinois. Design Team: Neil Frankel, principal-in-charge, Barb Falconer, project manager, Jim Prendergast, senior designer, Carol Simpson, technical coordinator, Erin Langland, Tim Cozzens, Ray Viquez.
Photography by Marco Lorenzetti, Hedrich Blessing.

ORRICK HERRINGTON & SUTCLIFFE–Sacramento, California. Design by Brayton & Hughes. Design Team: Richard Brayton, David Darling, Nina Chiappa, Ross Dugan, Joel Villalon.
Photography by Chas McGrath.

ORRICK HERRINGTON & SUTCLIFFE–Menlo Park, California. Design by Brayton & Hughes. Design Team: Richard Brayton, Kathleen Johnstone, Joel Villalon, Marian Morioka.
Photography by John Sutton.

ARIEL CAPITAL MANAGEMENT–Chicago, Illinois. Design by VOA Associates, Inc. Design Team: Nicholas J. Luzietti, AIA, IIDA, principal-in-charge, Al Fiesel, project architect.
Photography by Steve Hall, Hedrich Blessing.

WEIL, GOTSHAL & MANGES–Menlo Park, California. Design by Gensler. Design Team: Doug Zucker, Louis Schump, Steve Suzuki, Alvaro Rodriguez, Brian Braganza.
Photography by Chas McGrath.

LATHAM & WATKINS–San Diego, California. Design by Callison Architecture. Design Team: Andrea Vanecko, principal designer, Lynn Hamilton, project manager.
Photography by Roland Bishop.

MEDIA COMPANIES

SMA VIDEO, INC.–New York City. Design by Anderson/Schwartz Architects, NYC. Design Team: Ross Anderson, partner-in-charge, Stephen O'Dell, project architect, MJ Sagan, Aaron Bentley, Caroline Otto, Paul Cali.
Photography by Michael Moran.

EMI RECORDS–London, England. Design by Sedley Place. Design Team: David Bristow, Mick Nash, directors, Antonio Maduro, designer, Matthias Felsch, product designer, Tim Hyman, architect.
Photography by Mark Luscombe-Whyte, David Burton.

SONY MUSIC INTERNATIONAL–Miami, Florida. Design by TAS Design. Design Team: Thomas A Sansone, principal, Skip Boling, project architect, Ileana Fernandez, Patricinio Binuya, Carlos Sifuentes, Kim Sippel, Robert Thorpe.
Photography by Paul Warchol.

STEVE GOLD PRODUCTIONS–New York City. Design by Carl D'Aquino Interiors Productions. Design Team: Carl D'Aquino, ASID, principal, Paul Laird, John Chow.
Photography by Paul Warchol.

WIRED DIGITAL–San Francisco, California. Design by Holey Associates. Design Team: John E. Holey, Carl Bridgers, Rob Wooding, Paul Dent, JoAnne Beren, Molly Johnston.
Photography by Chun Y Lai.

WARNER BROS. RECORDS–Nashville, Tennessee. Design by Tuck Hinton Architects. Design Team: Seab Tuck III, AIA, Kem G. Hinton, AIA, Virginia Campbell, AIA, Kent McLaughlin, AIA.
Photography by Rion Rizzo/Creative Sources Photography.

MOTOWN RECORDS–Los Angeles, California. Design by RAW International. Design Team: Steven Lott, Lisa Comfort, Steven Stone, R. Steven Lewis, Segun Abegunrin, Steven Bassler, Shelley Lee.
Photography by Adrian Velicescu.

VIRGIN RECORDS AMERICA–Beverly Hills, California. Design by O'Brien & Associates. Design Team: Margaret O'Brien, principal, Loran Atreide (Arrix Studio Consultants), Howard Barnett, environmental consultant.
Photography by David Glomb.

DIRECTORY OF FIRMS

ADD Inc
80 Prospect Street
Cambridge, MA 02139
t: 617-661-0165; f: 617-661-7118

Ai
1445 New York Avenue, NW
Suite 400
Washington, DC 20005
t: 202-737-1020; f: 202-737-0879

Anderson/Schwartz Architects
180 Varick Street
New York, NY 10014
t: 212-741-3021; f: 212-741-2346

Architectural Alliances
400 Clifton Avenue South
Minneapolis, MN 55403
t: 612-871-5703; f: 612-871-7212

Bergmeyer Associates, Inc.
286 Congress Street
Boston, MA 02210
t: 617-542-1025; f: 617-338-6897

The Bommarito Group/Graeber,
Simmons & Cowan
100 Congress Avenue
Suite 2200
Austin, TX 78701
t: 512-480-8898; f: 512-480-9451

Brayton & Hughes Design Studio
250 Sutter Street, Suite 650
San Francisco, CA 94107
t: 415-291-8100; f: 415-434-8145

Brennan Beer Gorman Monk/Interiors
515 Madison Avenue
New York, NY 10022
t: 212-888-7667

Callison Architecture
1420 Fifth Avenue, #2400
Seattle, WA 98101-2343
t: 206-623-4646; f: 206-623-4625

Carl D'Aquino Interiors
180 Varick Street, 4th Floor
New York, NY 10014
t: 212-929-9787

CDFM2 Architecture Inc.
1015 Central
Kansas City, MO
t: 816-471-1080; f: 816-471-4362

CORE
1010 Wisconsin Avenue NW
Suite 405
Washington, DC 20007
t: 202-466-6116; f: 202-466-6235

Elkus/Manfredi Architects Ltd
530 Atlantic Avenue
Boston, MA 02210
t: 617-426-1300; f: 617-426-7502

The Environmental Group
303 East Wacker Drive
Chicago, IL 60601
t: 312-644-5080; f: 312-644-5299
Fox & Fowle Architects
22 West 19th Street
New York, NY 10011
t: 212-627-1700; f: 212-463-8716

G.A. Design International
4 Delancey Passage
Delancey Street
London NW1 7NN
England
t: +44 171 387 4002;
f: +44 171 387 4003

Gensler
600 California Street
San Francisco, CA 94108
t: 415-433-3700

Greenwell Goetz Architects, P.C.
2000 L Street, NW
Suite 410
Washington, DC 20036
t: 202-682-0700; f: 202-682-0738

Griswold, Heckel & Kelly Associates,
Inc.
55 West Wacker Drive, Sixth Floor
Chicago, IL 60601
t: 312-263-6605; f: 312-263-1228

Hammel, Green, and Abrahamson, Inc.
1201 Harmon Place
Minneapolis, MN 55403-1985
t: 612-337-4100; f: 612-332-1228

Atelier Christian Hauvette
16 bis avenue Parmentier
75011 Paris, France
t: +33 1 43 70 2990;
f: +33 1 43 70 8617

Hellmuth, Obata + Kassabaum Inc.
(HOK) St. Louis
211 North Broadway, Suite 600
St. Louis, MO 63102
t: 314-421-2000; f: 314-421-6073

HOK Houston
2800 Post Oak Boulevard, Suite 3700
Houston, TX 77056
t: 713-407-2000; f: 713-407-7809

HOK London
216 Oxford Street
London W1C 1DB
England
t: +44 20 7636 2006;
f: +44 20 7636 1987

HOK San Francisco
71 Stevenson Street, Suite 2200
San Francisco, CA 94105
t: 415-243-0555; f: 713-882-7763

Herbert Lewis Kruse Blunck
Architecture
202 Fleming Building
Des Moines, IA 50309
t: 515-288-9536; f: 515-288-5816

Holey Associates
1045 Sansome Street, Suite 204
San Francisco, CA 94111
t: 415-397-3131; f: 415-397-2857

Interior Architects, Inc.
350 California Street, Suite 1500
San Francisco, CA 94104
t: 415-434-3305; f: 415-434-0330

Iu & Lewis Design
57 East 11th Street
New York, NY 10003
t: 212-982-3633; f: 212-982-6006

Jung/Brannen Associates, Inc.
34 Farnsworth Street
Boston, MA 02210
t: 617-482-2299; f: 617-482-4886

Gary Lee & Partners
1743 Merchandise Mart
Chicago, IL 60654
t: 312-644-1744; f: 312-644-1745

David Ling, Architects
110 East 17th Street
New York, NY 10003
t: 212-982-7089; f: 212-475-1336

Lehman/Smith/Wiseman Associates
1150 18th Street, NW
Suite 350
Washington, DC 20036
t: 202-466-5660; f: 202-466-5069

LIMINALITY LLP
1627 K Street, NW
Fifth Floor
Washington, DC 20006
t: 202-463-2340; f: 202-822-3650

Meyer, Scherer & Rockcastle, Ltd.
119 North 2nd Street
Minneapolis, MN 55401
t: 612-375-0336; f: 612-342-2216

Monaco/Architects
180 Varick Street, Fourth Floor
New York, NY 10014
t: 212-727-7452; f: 212-929-9225

NBBJ
111 South Jackson Street
Seattle, WA 98104
t: 206-223-5555

O'Brien & Associates
222 Washington Avenue, #12
Santa Monica, CA 90403
t: 310-458-9177

Perkins & Will
330 North Wabash Avenue
Chicago, IL 60611
t: 312-755-0770; f: 312-755-0775

Perkins & Will/Wheeler
701 Fourth Avenue South
Minneapolis, MN 55415
t: 612-339-1102; f: 612-337-5040

RAW International
606 South Olive Street,
Nineteenth Floor
Los Angeles, CA 90014
t: 213-622-4993; f: 213-614-0536
Sedley Place
68 Venn Street
London SW4 0AX
England
t: +44 171 627 5777;
f: +44 171 627 5859

STUDIOS Architecture
99 Green Street
San Francisco, CA 94111
t: 415-398-7575; f: 415-398-3829

STUDIOS Architecture Paris
63 avenue des Champs-Elysees
75008 Paris, France

TAS Design
145 Hudson Street
New York, NY 10013
t: 212-334-8319

Tuck Hinton Architects
410 Elm Street
Nashville, TN 37203
t: 615-254-4100; f: 615-254-4101

VOA Associates
224 South Michigan Avenue,
Suite 1400
Chicago, IL 60604-2595
t: 312-554-1400; f: 312-554-1412

ABOUT THE AUTHORS

Justin Henderson is a Seattle-based freelance writer specializing in architecture, interior design, and travel writing. He served as a senior and contributing editor to Interiors Magazine for ten years and has contributed articles to numerous design and general interest publications, including *Metropolitan Home, the New York Times Magazine, the Village Voice, Architecture, Interior Design,* and *Metropolis.* Henderson is the author of *Museum Architecture, Jungle Luxe,* and *Casino Design,* all from Rockport Publishers.